Gay TV and Straight America

Gay TV and Straight America

RON BECKER

RUTGERS UNIVERSITY PRESS
New Brunswick, New Jersey, and London

LIBRARY OF CONGRESS CATALOGING-IN-PUBLICATION DATA

Becker, Ron, 1969–
 Gay TV and straight America / Ron Becker.
 p. cm.
 Includes bibliographical references and index.
 ISBN-13: 978-0-8135-3688-0 (alk. paper)
 ISBN-13: 978-0-8135-3689-7 (pbk. : alk. paper)
 1. Homosexuality on television. 2. Homosexuality—United States—Public
opinion. 3. Public opinion—United States. I. Title: Gay television and straight
America. II. Title.
 PN1992.8.H64B43 2006
 791.45′653—dc22 2005011266

British Cataloging-in-Publication data for this book is available
from the British Library.

Manufactured in the United States of America

For Marc

CONTENTS

ACKNOWLEDGMENTS

I AM DEEPLY GRATEFUL to the many people who contributed to this book. The Media and Cultural Studies program in the Department of Communication Arts at the University of Wisconsin-Madison offered a rare environment where I was both fully challenged and whole-heartedly supported. I could not have asked for a more supportive advisor than Julie D'Acci. Her belief in the project never wavered, and her own work has served as an inspiring model. John Fiske introduced me to cultural studies, and his perspectives permeate this project. Michele Hilmes and Michael Curtin provided important insights throughout the writing process, and I am grateful for having the chance to work with such unparalleled examples of teacher-scholars. I can't begin to express how lucky I feel to have taken seminars, taught courses, and attended colloquia with the immensely talented and generous graduate students whose feedback, perspectives, and encouragement were vital to this project at every stage. They will undoubtedly see their influence throughout. They include Mobina Hashmi, Dan Marcus, Jason Mittell, Mike Newman, Kim Bjarkman, Phillip Sewell, Megan Pincus, Dorinda Hartman, Madhavi Mallapragada, Clare Bratten, Ruth Goldman, Lisa Parks, Jen Wang, Kelly Cole, Jackie Vinson, and Bill Kirkpatrick. My parents, Lois and Marvin Becker, were always unquestioning in their support of my academic work and they kindly allowed me to use their wedding photo on the cover. With her unparalleled professionalism and experience, Leslie Mitchner, editor-in-chief at Rutgers University Press, was tremendously helpful, and comments from several anonymous readers have made the manuscript better in numerous ways.

I want to thank Greg Berlanti, Robert Bianco, David Crane, Scott Glaser, Maxine Lapiduss, Sally Lapiduss, Max Mutchnick, and Kevin Williamson. Each generously set aside time to be interviewed about their experiences working on gay-themed television. Their insights enriched this project significantly. I am also grateful to Stephen Tropiano who provided rare gay-themed episodes. Scott Seomin from the Gay & Lesbian Alliance Against Defamation (GLAAD) facilitated my connection with a number of writers and producers, and a GLAAD Dissertation Fellowship helped me complete a portion of this project. Miami University and my colleagues in

the Department of Communication have also provided valuable support and encouragement. Parts of chapter 4 appear in *Television & News Media* in revised form.

Four friends made it possible for me to finish this project. Elana Levine served as the intellectual sounding board in the early stages; she endured countless phone calls, patiently listened to rambling thoughts, and provided truly indispensable feedback on early drafts. A consummate wordsmith, Jeff Armstrong generously read final drafts and made numerous suggestions that helped fine-tune the writing and argument. Paul Wesselmann helped sustain my motivation through the arduous dissertation process; he has helped this effort in ways he can never fully appreciate. And Jennifer Fuller's sharp insights and wit have helped get the project to the finish line.

Finally, I owe an immeasurable debt to Marc Loy. I can never adequately thank him for his unwavering emotional and technical support, his truly remarkable generosity, and his saint-like patience. I could never have written this book without him, and I dedicate it to him.

Gay TV and Straight America

The Importance of Gay-Themed TV

> I honestly have to say this is the first time in my life I've understood the culture wars in the sense of being a guy who lives in New York and being helpless about the ability to control whatever political destiny occurs in my own area, and I realized it's sort of their revenge for us controlling the TV. . . . It's them saying we're not crazy about *Will & Grace*, so here's what we're going to do about it.
> —Jon Stewart, *The Daily Show*, November 3, 2004

THE DAY AFTER THE 2004 presidential election, a disillusioned Jon Stewart and his guest, New York Senator Charles Schumer, tried to figure out how George W. Bush could have won. Given the major issues dominating headlines at the time, the suggestion that a prime-time sitcom had helped put Bush over the top was both comically absurd and strikingly on the mark. For months, pundits had predicted that the election would hinge on the economy, homeland security, and the war in Iraq. In exit polls, however, a surprisingly large number of voters identified moral values as the issue they were most concerned about. According to post-election analysis, these so-called values voters were struggling, middle-class, middle-Americans, scared less by the chaos in the Middle East or by the employment vagaries of the global economy than by the supposed moral decline of American culture. Atop their list of threats were gays, lesbians, and the big-city politicians, activist judges, and liberal Hollywood elites working to destroy America's moral center. Trying to understand why voters whose economic and political interests were often ill-served by Bush's policies chose to reelect him, Stewart could only conclude: "It really seems like none of it trumped the idea of two dudes kissing."

Given the prominence of gay political and cultural visibility at the time, it isn't surprising that gay rights served as such a powerful wedge issue for Bush and the Republicans. During the summer of 2003, the politics of sexual identity seemed inescapable. That June, the U.S. Supreme Court overturned Texas's antigay sodomy law in a widely covered landmark decision heralded as the most important civil rights verdict in decades—one that might pave the way for gay marriage. With gay rights on everyone's minds, the divisive election of

I

the non-celibate, gay Reverend Gene Robinson as Anglican bishop of New Hampshire became headline news later that summer. Meanwhile, marketers and feature-story writers became fixated on the "metrosexual"—a supposedly new breed of straight man who comfortably adopted the consumer habits of his appearance-obsessed gay counterpart. Profiting from the metrosexuality buzz, Bravo's *Queer Eye for the Straight Guy* became the most talked-about show of the summer television season. The Fab Five seemed to be everywhere, bringing good taste, good hair, and good quips to America's gay-friendly straight men. And at the end of the summer, viewers watched "married couple" Reichen and Chip win CBS's *Amazing Race 4*.

Images of "married" gay and lesbian couples would become even more common in 2004 as the debate over same-sex marriage intensified. By February, the Massachusetts Supreme Court ruled that the state constitution required full and equal marriage rights for gays and lesbians, making it clear that same-sex couples would be able to get legally married there soon. Later that month, in defiance of California state law, city officials in San Francisco began issuing marriage licenses to gay and lesbian couples, and millions of Americans watched as hundreds of same-sex couples camped out overnight in a carnivalesque atmosphere of civil disobedience. Resistance to such moves proved strong, however, culminating in calls for an amendment to the U.S. Constitution that would limit marriage to heterosexual couples—a call that President Bush supported. And on November 2, voters in eleven states passed antigay marriage amendments to their state constitutions.

This book is primarily about the political and cultural dynamics at play behind the rise of gay-themed programming on U.S. network television in the 1990s. However, I start with Jon Stewart's comments about the 2004 election (and conclude the book by examining *Queer Eye*, metrosexuality, and the recent gay marriage debate) in order to suggest that the story I tell about the 1990s is highly relevant for understanding American culture in the 2000s. In other words, I would argue that Stewart's comments and the political context he describes are post-1990s in important ways. Although the culture wars Stewart refers to have deep historical roots, the idea that a national consensus had given way to a de facto civil war over irreconcilable value systems became a central preoccupation in the early 1990s. Similarly, the divide between cosmopolitan liberals and heartland conservatives—between the "us" that apparently control the media and don't have a problem with two dudes kissing, and the "them" who feel disenfranchised by mass media and do have a problem with two dudes kissing—reflects shifting political sensibilities and identifications that coalesced during the 1990s. Moreover, gay rights emerged as such a powerful wedge issue in 2004, in part, because of social anxieties stirred up ten years earlier. And finally, the fact that Stewart would use *Will & Grace* as the emblem of a divided American electorate indicates the connection between America's political

psychographics and the recent prominence of gay-themed television. That connection emerged in the 1990s, and this book traces its development.

Before *Queer Eye For the Straight Guy*, *Queer as Folk*, and *Will & Grace* helped draw so much attention to the visibility of gays and lesbians on U.S. television, gay material had already become a remarkable programming trend. Throughout its first four decades, television virtually denied the existence of homosexuality. The families, workplaces, and communities depicted in most network programming were exclusively heterosexual. As recently as the early 1990s, in fact, even the most astute viewers could likely spot only a handful of openly lesbian, gay, and bisexual characters in an entire year of network television. After only a few television seasons, however, gay-themed episodes and references to homosexuality were everywhere, and even the relatively casual viewer might have spotted several openly gay and lesbian characters in just one night. Between 1994 and 1997, for example, well over 40 percent of all prime-time network series produced at least one gay-themed episode; nineteen network shows debuted with recurring gay characters; and hit shows like *Roseanne*, *Friends*, and *NYPD Blue* (to name but a few) seemed to include gay jokes and references to homosexuality every week. American television seemed obsessed with gayness.

How do we account for the startling increase of gay-themed programming on prime-time network television in the 1990s? What does the emergence of this trend tell us about the changing dynamics of the industry that produced it? What does it tell us about the changing politics of the culture that shaped it? And what does it tell us about the changing anxieties and identities of the people who might have watched it? Those questions are at the core of this book. Unlike much of the work that examines the politics of gay and lesbian televisibility, this project's central goal is not to describe or assess how lesbians, gays, and bisexuals were or were not represented on television. Although such issues will arise, my primary goal is to understand how gayness operated within a specific circuit of cultural production in the 1990s. In other words, I not only examine how gayness appeared in the era's sitcoms and dramas, but I also map out what role it played within network programming strategies and niche-marketing principles; within debates over civil rights, multiculturalism, and America's supposed fragmentation; and within an emerging political ethos. More importantly, I trace the way gayness functioned among these various sites.[1] How, for example, did narrowcasting and the economics of audience fragmentation relate to identity-based civil rights politics and the Supreme Court's decision in *Romer v. Evans*? What did the rise of gay material have to do with intra-network competition? In what ways did mistaken-sexual-identity plotlines relate to anxieties about America's deepening diversity? And how do the trends that developed in the 1990s echo in the contemporary politics of gay and lesbian visibility?

After looking at the era's gay-themed programming in these wider contexts, I argue that the rise of gay material reflected and contributed to what I call American culture's straight panic. In a March 1990 cover story, *Newsweek* tried to predict "The Future of Gay America."[2] As it turns out, even *Newsweek's* astute contributors couldn't have anticipated what the upcoming decade would hold for Gay America or how much its future would come to affect Straight America. Just three years later, for example, the cover of the *Nation* announced that America found itself in the midst of "The Gay Moment." According to Andrew Kopkind, "The gay moment is unavoidable. It fills the media, charges politics, saturates popular and elite culture. It is the stuff of everyday conversation and public discourse. Not for thirty years has a class of Americans endured the peculiar pain and exhilaration of having their civil rights and moral worth—their very humanness—debated at every level of public life."[3] Gays and lesbians weren't alone in experiencing an odd mix of emotions at a time when the politics of sexual identity were so socially central and contested. Most specifically, *straight panic* refers to the growing anxiety of a heterosexual culture and straight individuals confronting this shifting social landscape where categories of sexual identity were repeatedly scrutinized and traditional moral hierarchies regulating sexuality were challenged. In this process, the distinctions separating what it meant to be gay or lesbian from what it meant to be straight were simultaneously sharpened and blurred, producing an uneasy confusion. Straight America, once relatively oblivious to its heterosexuality and naïve about the privileges that came with it, was forced to acknowledge both, even as the stability of straight identity and dominance was being undermined.

Straight America's troubling confrontation with gay and lesbian visibility and the politics of sexual identity, however, was also part of wider social transformations crystallizing in the 1990s—a period in which America became increasingly preoccupied by debates over diversity, social fragmentation, and cultural relativism. American culture had certainly grappled with the impact of immigration and identity-based political movements for decades. In the early 1990s, however, multiculturalism helped intensify fears that such developments were undermining faith in the value and/or possibility of a unified American identity. More broadly, then, *straight panic* refers to the anxiety felt by mainstream America and Americans confronting a social landscape where monoculturalism seemed maligned and difference prized. Members of a naïve mainstream (which had long had the empowering luxury of ignoring what it meant to be white, male, straight, etc.) found it harder to assert the universality of their experience. They struggled to make sense of their newly exposed social positions and tried to navigate a culture where racial and gender as well as sexual identities mattered.

Such changes and the straight panic they fueled were accelerated by a shifting media landscape where niche markets mattered. Benedict Anderson,

Michele Hilmes, and others have argued that mass media play important roles in the construction and maintenance of national identities.[4] As the preeminent mass medium, especially during the classic network era in the 1960s and 1970s, television helped establish the common-sense notion that America had a mainstream. Since at least the 1970s, however, the social logic of late capitalism has transformed U.S. commercial media. New marketing strategies have broken Americans up into narrower and narrower psychographic groups targeted through direct mail, lifestyle magazines, and cable channels. Anxious to uncover new markets and more effectively build brand loyalty, marketers and commercial media outlets have tried to translate cultural differences into a panoply of consumer identities arranged into targetable niches. In the process, such media have worked to erode a sense of cultural unity. Although the broadcast networks remained stubbornly resistant to and relatively protected from such changes during the 1970s and much of the 1980s, by the early 1990s they, too, were forced to adapt to some of these pressures.

The rise of gay-themed programming was imbricated within this complex web of social changes, industry trends, and emerging anxieties. Network television's growing acceptance of gay and lesbian characters and issues in the 1990s certainly didn't signal an end to heterosexual privilege or homophobia. The Defense of Marriage Act and the continued increase in reports of antigay hate crimes attest to that. The very presence of so many gay and lesbian characters in prime time, however, did expose heterosexuality's once ex-nominated privilege—its taken-for-granted normative power made all the more effective by being taken for granted. Like the gays-in-the-military debate, the March on Washington, and lesbian chic, gay televisibility underscored the fact that heterosexuals weren't alone. Ubiquitous references to homosexuality and many of the era's specific gay-themed episodes revealed fictional characters keenly aware of the politics of sexual identity and nervous about how they fit into a world where being gay and lesbian wasn't always stigmatized and where being straight was something one had to think about. Such straight-panic narratives made it very clear that the rise of gay-themed programming was as much about heterosexuality as homosexuality. It revealed a nation more nervous about the future of Straight America than interested in the future of Gay America.

This book contributes to a growing body of valuable work that examines the politics of Lesbian, Gay, Bisexual, Transgender, Queer (LGBTQ) representation on television. Although there had been openly gay and lesbian characters on television since at least the 1970s (and decidedly queer characters since the medium's inception), their relative invisibility often led scholars interested in LGBTQ issues to turn their attention elsewhere or critique television's role in the "symbolic annihilation" of non-straight people.[5] With increasing gay and lesbian visibility on fictional television programming over the past two decades, however, more attention has been paid to the medium. Much of this recent

work analyzes how gay-inclusive programs provide highly circumscribed depictions of gay life. In her book-length study of gay visibility in American popular culture during the 1990s, for example, Suzanna Danuta Walters points out the discrepancy between "the *images* of gay life" embraced by network television and "the *realities* of gay identities and practices in all their messy and challenging confusion."[6] The value of such an approach is clear. If we believe that the media are important sites where a society's values and visions of reality are formed, reinforced, and circulated, understanding how and why gays, lesbians, and other sexual minorities are or aren't depicted becomes an important mission for cultural criticism—one to which this book will hopefully contribute. However, to understand the politics of sexual identity, it is also important to realize that gay-themed programming inevitably reveals as much about society's vision of straight life as its does about society's vision of gay life. Solely focusing on what gay-themed television says or doesn't say about homosexuality, bisexuality, and other marginalized identities might unintentionally reinforce heterosexuality's ex-nominated privilege. Thus, I hope to provide a useful perspective on the era's programming by asking what gay-themed TV reveals about heterosexuality in 1990s America.

Given that goal, it is important to point out that I don't only analyze the increase of gay characters. Popular and trade press coverage of gay-themed television almost exclusively focused on the increase in recurring and continuing gay and lesbian characters in prime-time series. Although the emergence and function of such characters will be a key component of my study, I'm also interested in gay material in its broadest sense. I examine special gay-themed episodes of series without recurring gay characters as well as gay jokes and situations in which gayness was narratively central, even when openly gay and lesbian characters were entirely absent. The number of ostensibly straight characters mistaken as gay or lesbian by other characters, for example, was remarkable. In fact, the device and the related gay jokes that follow became virtual genre conventions for the *Seinfeld*-like sitcoms that dominated network television in the mid-1990s. Although I define gay material broadly, I also want to acknowledge the wealth of gay content I *don't* examine. This period saw a dramatic increase in gay visibility on daytime television (both soap operas and talk shows) and a growing presence on cable series. There were also a significant number of prime-time news specials focused on gay rights. Given the already broad nature of my object of study, however, I've decided to focus on gay material that appeared on prime-time fictional series. Despite the erosion of their ratings during this era, the networks' prime-time lineups were watched by millions more viewers than daytime and cable programs and retained a cultural prominence that made the rise of gay-themed programming on prime time a social issue in and of itself.

This project assumes that the categories of sexual identity through which we make sense of our world and ourselves are historically specific. They are social constructs produced by, understood within, and managed through discursive regimes of power. In other words, the terms or labels a particular culture uses to think about sexuality—like *gay* or *straight*—don't simply refer to groups already constituted by some natural or intrinsic characteristic of people's true identities. Instead, taxonomies of sexuality work to channel the infinite diversity of human sexual desires and behaviors into a limited set of options that people are expected to identify with and conform to. Historians point out that cultures have often understood and organized sexuality through widely differing taxonomies. George Chauncey, for example, has detailed the very "different conceptual mapping of male sexual practices" operative in New York during the early twentieth century.[7] At that time, men who had sex with men identified themselves by terms like *queer, fairy, trade*, as well as *gay*. Far from interchangeable, these terms signaled very different types of people who engaged in different kinds of homosexual behaviors. Contemporary American culture, by contrast, tends to divide sexuality into a binary; people are expected to identify with and conform to one of two sexual identities— gay or straight. Grounded within such a perspective, then, this book analyzes how gay-themed programming in the 1990s emerged out of and participated in a historically specific struggle to define and legislate sexuality, identity, and social life.[8]

This project—and the notion of straight panic, in particular—are also predicated upon the assumption that these categories are relational, hierarchical, and ideological. As socially constructed concepts, homosexuality and heterosexuality are mutually dependent terms. One doesn't mean anything without the other. These two paradigmatic options also comprise a status hierarchy in which the dominance of heterosexuality is established at homosexuality's expense. Being straight has been moral, legal, and normal, because being gay has been constructed as immoral, illegal, and abnormal. Heterosexuality's normative status has been so taken for granted, however, that its dominance has been ex-nominated; it seems natural rather than the product of social power and, in the absence of evidence to the contrary, is presumed. Gays, lesbians, and bisexuals have to come out of the closet, straights don't. Gays, lesbians, and bisexuals have to claim a sexual identity, straights don't. Given this semiotic relationship between homo- and heterosexuality, gays, lesbians, and bisexuals' efforts to end the social policies that discriminate against them—their efforts to fight the stigma attached to being non-heterosexual—inevitably destabilize the meaning of heterosexuality and what it means to be straight. In this way, as queer theorists have pointed out, the fate of Straight America was and is intricately intertwined with the fate of Gay America.

This book also explores America's troubled relationship with the politics of
social difference in the 1990s. As the motto *E Pluribus Unum* suggests, forging a
unified American identity and culture out of a diverse populace has been a con-
scious endeavor for the United States since its founding. Balancing the recog-
nition of minority rights and the value of liberal pluralism on the one hand
with faith in assimilationism and the value of national unity on the other has
long been difficult. The seeming irreconcilability of difference and equality,
however, has been an even more pressing concern in what Van Gosse calls Post-
modern America.[9] Since roughly the early 1970s, Gosse and others have
argued, America has been transformed by a variety of forces that have drawn
the social center into question. Through the 1970s and 1980s, conflicts over
American values and fears about social fragmentation increased, triggered by
census trends that revealed America's deepening ethnic diversity; a series of
identity-based civil rights movements that demanded social recognition of mar-
ginalized minorities; an organized Christian Right and neo-conservative
nativism that called for a reaffirmation of founding values; an expanding Post-
Fordist consumer culture that encouraged the proliferation of consumption-
driven identity formations; and increasingly fractured media environments that
targeted niches rather than masses. By the early 1990s, America found itself
amid a so-called culture war as the nation became particularly preoccupied
with and divided over the politics of social difference.

Debates over gay rights and the rise of gay-themed television emerged out
of and revealed much about the tensions and anxieties of this specific social
climate. In the process, they offer insight into what, following Raymond
Williams, could be called a change in the structure of feeling—the elusive yet
distinct sense of what it's like to live in a specific culture at a specific time.[10]
Debates over multiculturalism made people keenly aware of the politics of
social difference, made them question the notion of mainstream culture, and
made them think about the relationship between the nation's majority and its
minorities in new ways. Numerous scholars have begun to trace the varied
political, legal, and affective responses of a once unmarked mainstream trying to
adapt to the shifting social landscape of a multicultural America. According to
David Roediger, Mike Hill and others, for example, the idea of a post-racial
America (the assertion that immigration rates, intermarriage, and the fluidity of
racial identification has or soon will make racial categories irrelevant) offers
white Americans a powerful narrative in the face of racial minorities' political
claims and America's changing demographic profile. Visions of a non-racial
future invalidate critiques of the structural racism that supports white privilege
even as whiteness loses its majority status.[11] Elsewhere, Cindy Patton has ana-
lyzed the New Right's effort to co-opt a civil rights strategy by claiming that
they represent America's true and endangered minority—a move that "effec-
tively destroys the administrative apparatus of civil rights by altering the modes

of staging minority."[12] Similarly, Lauren Berlant identifies a shift in notions of U.S. citizenship brought about by a Reaganist ideology that tries to undermine oppressed minority groups' political efforts by privatizing citizenship, relocating it within the carefully sanctified sphere of the family.[13] And, of course, the culture wars themselves—the very assertion that America was experiencing a national identity crisis—revealed a defensive nostalgia for an era when difference was manageable because it was someone else's burden. By looking at the relationship between gay-themed television and straight panic, this project hopes to contribute to our understanding of the ongoing response of America's formerly unmarked center to a shifting political context. I will specifically theorize how broadly liberal, gay-friendly heterosexuals—the supposed blue-state-minded Americans, the "us" of Jon Stewart's commentary—might have negotiated the politics of social difference.

The rise of gay-themed programming also illustrates the changing practices and representational politics of network television in the neo-network era. In the 1990s, ABC, NBC, and CBS were forced to adapt to a decidedly more fractured and competitive media marketplace. The rise of cable and niche marketing principles during the 1980s forced the networks to rethink many of their traditional broadcasting strategies. As a result, they altered the ways they conceptualized their audiences, interacted with advertisers, and scheduled line-ups. Television scholars have had to keep up with such developments, and this project aims to add to the growing body of work that tries to understand the contemporary commercial television industry. The proliferation of gay material on prime-time network television in the mid-1990s— the discussion around it and the industry forces at play behind it—offer a valuable case study through which we can better understand neo-network television.

This book, then, is about more than just the emergence of gay-themed programming. Its object of analysis includes American culture, the network television industry, and the politics of sexual identity and social difference during the 1990s. Its method of organization is designed accordingly. Rather than begin with a detailed analysis of the kind of gay material that proliferated on prime-time network television during the 1990s, I start by examining the ways gayness and categories of sexual identity operated in wider political and industry contexts. Only then do I turn to gay-themed television programming itself.

In chapter 1, I expand upon the concept of straight panic. Since the term intentionally echoes the notion of homosexual panic, the chapter begins with a genealogy of that concept. I also describe the confluence of social forces (e.g., multicultural initiatives, 1990 U.S. census reports, the family values debate) that helped fuel America's straight panic. The chapter ends with suggestive evidence of straight panic in American culture. This chapter provides a broad picture of the historical context within which gay-themed programming was imbricated. In chapter 2, I focus more narrowly on the mainstream gay rights movement in

the early 1990s. This chapter is not intended to chronicle key events in gay rights politics (although it does that to a certain extent). Instead, it traces the circulation of two paradoxical discourses about sexual identity within media coverage of scientific research into the causes of homosexuality and public debates surrounding gays in the military and Colorado's Amendment 2. Contradictory ways of thinking about the nature of sexuality, I argue, channeled and exacerbated America's straight panic—its anxieties about the etiological, moral, and social line between gay and straight, normal and abnormal, and the majority and its minorities.

In chapter 3, I concentrate on the changes in the television industry that help account for the growing acceptance among network executives of gay material on prime time. In particular, I describe the factors that led the Big 3 networks, with NBC in the lead, to adapt traditional broadcasting strategies in order to target a quality audience of upscale 18-to-49 year olds more aggressively. Trade press discourse and prime-time lineups suggest that in the minds of network executives, these upscale adults were sophisticated cosmopolitans who wanted edgy, risqué programming. Gay material became a narrowcasting-age tool used to appeal to such viewers. In chapter 4, I argue that gay material was successful for the networks because it appealed to the sensibility of certain straight viewers. By mapping out various discourses (e.g., multicultural celebrations of difference, constructions of an affluent gay market, Clinton-era neoliberalism), I suggest that gay material was appealing to a segment of Straight America because it fit conveniently into an affordable politics of multiculturalism. The growing interest in gay-themed cultural products in general, I argue, reveals a broadly gay-friendly and liberal response to straight panic. Consuming gay-inclusive television could help such viewers negotiate their anxieties about being members of a majority at a time when being on the margins held a certain cultural allure.

In chapters 5 and 6 I turn my attention to gay-themed programming itself. In chapter 5, I chronicle the emergence of gay-themed programming between 1989 and 2002. I provide a season-by-season catalogue of the era's openly gay, lesbian, and bisexual characters and gay-themed episodes, devoting particular attention to those episodes that played key roles in changing the industry's attitude toward gay material. Although the amount of gay material increased significantly during this period, the range of LGBTQ representations remained highly circumscribed. I conclude this chapter by underscoring some of the limits placed on images of gay life. In chapter 6, I analyze the texts themselves and identify some of the ways prime time's gay-themed narratives mediated America's straight panic through specific depictions of heterosexuality. I focus on three common tropes: the Hip Heterosexual, the Helpful Heterosexual, and the Homosexual Heterosexual. Finally, in the conclusion, I suggest how the dynamics at play in 1990s American culture and television continue to play out around

programs like *Queer Eye for the Straight Guy* and *Boy Meets Boy* and in the fractious debate over gay marriage.

For lesbian, gay, bisexual, and queer viewers who had long lived with a television universe that usually ignored their existence, the increase of gay material on TV in the 1990s was no doubt moving, affirming, frustrating, entertaining, and insulting. Although this book doesn't address the complex meanings nonstraight viewers made and the pleasures they found in 1990s television, it is important not to erase that activity. As I focus on the ways gay-themed programming reflected the anxieties of Straight America, it is important to keep in mind that such programming was important for many viewers, often for very different reasons.

ON OCTOBER 6, 1998, two young men lashed Matthew Shepard to a wooden fence in an isolated field outside of Laramie, Wyoming. Spewing antigay epithets, they pistol-whipped him and left him for dead. The twenty-one-year-old gay University of Wyoming student was discovered unconscious eighteen hours later, and on October 12, Matthew Shepard died. The brutal murder shocked many Americans, both gay and straight, and the story dominated local and national headlines for over a week, eclipsing coverage of President Clinton's sex scandal. *Time* and *Newsweek* cover stories joined front-page newspaper reports, and television newscasts transported viewers to distant Laramie and to the desolate, wind-swept crime scene. Near the end of a decade that had witnessed seemingly unprecedented legal, political, and cultural battles in the struggle for gay rights, the murder was both a symbolic and a far too real loss for the gay and lesbian community and its allies. Shepard's violent death was also a startling reminder of exactly what was at stake in the battle. While concerned citizens in cities across the nation held candlelight vigils, first in support of then in memory of Matthew Shepard's life, activist groups and politicians called for new, tougher hate crime legislation.

On Wednesday, October 14, just two days after Shepard's death, the networks' evening newscasts featured continuing coverage of the horrific crime and its aftereffects. Meanwhile, the rest of the television schedule kept on with the daily business of marshaling a stockpile of programming (both first-run and syndicated) in its effort to attract audiences that could be sold to advertisers like Proctor and Gamble, Ford, and Intel. Yet for those concerned with Shepard's death and the struggle over gay and lesbian rights, business as usual for television in the 1990s had become remarkable in a way that it had never been before. Coming home that Wednesday afternoon, someone in Madison, Wisconsin, for example, could have watched an entire evening's worth of gay-themed programming. Lifetime, which had been scheduling back-to-back reruns of ABC's *Ellen* from 5:00–6:00 p.m., aired two 1997 episodes in which newly-out Ellen Morgan faces the difficulties of coming out to her parents and

to her homophobic boss. Flipping to WGN at 6:00, that viewer could have watched a rerun of a 1992 *Roseanne* episode in which Roseanne and her sister discover that their best friend and business partner Nancy (Sandra Bernhard) is a lesbian. At 6:30, Madison's ABC affiliate rebroadcast a 1995 episode of *Friends* with a B-plotline that centers on Ross's recent purchase of cellular phone service to help him keep in touch with his pregnant, lesbian ex-wife who's on the verge of delivering his baby; in a wacky telecommunications mix-up, however, Ross keeps getting calls from men trying to reach an apparently well-endowed gay sex worker whose number (55-JUMBO) is too close to Ross's. And finally, at 8:30, ABC's short-lived sitcom *The Secret Lives of Men* featured a gay-themed episode in which one of the lead, heterosexual characters fears that a gay business client is coming on to him—an eerie coincidence, given that Shepard's killer would later argue that he beat Shepard in a panicked rage brought on when Shepard made a pass at him.

Juxtaposed against the harsh reality of Shepard's murder, the mundane business of producing entertaining TV programs used to sell dishwashing detergent and automobiles seems immaterial. This book, however, is predicated upon the belief that examining those television programs and the economic, institutional, and social forces at work behind them is essential to understanding the complex material and discursive struggles surrounding sexual identities. As cultural theorists have repeatedly illustrated, the realm of popular culture, especially in an increasingly mediated social order, is an important site of political contestation—a place where particular values struggle to become common sense and a culture's anxieties get exposed and negotiated.

CHAPTER 1

Straight Panic and American Culture in the 1990s

IN 1991 I WAS a closeted undergraduate at the University of Wisconsin—aware of my gay sexual orientation but fearful that others were as well. That year the campus gay and lesbian student organization (no doubt inspired by the direct-action strategies employed by ACT UP and Queer Nation) coordinated a Jeans Day as part of its coming-out-week activities. Overnight they covered campus sidewalks with impromptu chalk messages and plastered kiosks with flyers that called upon gays, lesbians, and bisexuals to show their pride by wearing jeans to school the next day. In those final years before the Gap-led khaki craze, jeans were as much a standard part of the average college student's uniform as a sturdy backpack and a fake ID. Walking to class the following morning, countless Levis-clad students like myself were shocked to discover that we had been unwittingly outed—to use a term quickly gaining currency in 1991. For the rest of the day, I was overwhelmed by anxiety. As I sat in class and walked across campus, I wondered if people knew I was gay. Of course, my panic was illogical. After all, just about everyone on campus was wearing jeans. But the constant insecurity of the closet overrode my reason. Every casual glance my way seemed to be an accusation about my sexual identity. When a woman sitting next to me in lecture asked what I thought about "the jeans thing," I was certain she had figured me out. I didn't come out to her or to any one else during that coming-out week. I only did so after the cultural curve was behind me, after Clinton was in the White House, after Jerry Seinfeld told me there wasn't anything wrong with it, after the gay nineties really got going. Nevertheless, Jeans Day did work on me. The flyers and signs all over school offered tangible evidence of something I knew only in theory—that I wasn't the only gay person on campus. And although the experience was disquieting, the day gave me a trial run at being out of the closet.

Jeans Day, however, was really targeted at my straight classmates. Like me, many heterosexuals showed up at school only to discover that their Levis had suddenly become symbols of gay pride. Despite their best efforts to dismiss

the flyers, they had to have felt self-conscious, wondering, if only for a moment, what those around them were thinking. Within the event's carniva-lesque ground rules, they became closeted heterosexuals, and I clearly remem-ber many students anxiously finding ways to out themselves as straight. For those unsure about the stability of their sexual identity, Jeans Day must have been a particularly anxious experience. But even for those secure in their heterosexuality, it was likely unsettling. For if it did anything, the event forced heterosexuals to recognize their heterosexuality—to acknowledge that being straight wasn't the only way of being. As they did with me, the flyers and signs all over campus offered straight students tangible evidence of something many of them likely knew only in theory—that they weren't alone. Gay people were in their midst. And in making homosexuality the norm du jour, in mak-ing heterosexuals feel marginalized by their sexuality (if even for just a minute), Jeans Day's logic stripped heterosexuality of its ex-nominated privi-lege. Being straight couldn't be taken for granted. In fact, by playing on the idea that anyone in jeans could be gay, Jeans Day made it perfectly clear that the boundary between being straight and being gay was anything but clear. Such realizations, no doubt, engendered a discomforting mix of lost naïveté, paranoia, and defensiveness.

Although Jeans Days may have been limited to college campuses, the cul-tural politics at stake and the social anxieties they stirred up certainly weren't. On the contrary, I'd argue that by the early 1990s, American culture was caught in the grip of what might be called a straight panic. My straight class-mates would not be alone in feeling uneasy during a decade marked by intense struggles over sexual identity. Over the next few years, the gay and lesbian civil rights movement and the dramatic increase of gay and lesbian cultural visibility would repeatedly force Straight America to think about homosexuality, heterosexuality, and the boundary between them more often and more profoundly than it ever had. Once all but invisible in American political and popular culture, gays and lesbians suddenly seemed to be every-where. They marched on Washington, up Fifth Avenue, and down Main Streets across the country. They appeared on the evening news, on political talk shows, and on the covers of *Time*, *People*, and *Vanity Fair*. They starred in sitcoms, Hollywood blockbusters, and Madonna videos. They held kiss-ins at local malls, sit-ins on college campuses, and die-ins outside St. Patrick's Cathedral. Gays and lesbians also seemed to ask for everything. They wanted to serve openly in the military. They wanted the right to marry and adopt children. They wanted legal protection from discrimination in employment and housing. They wanted their family values affirmed and their sexual iden-tities legitimated. They wanted to be part of the American mainstream. But for that to happen, it seemed as though the heterosexual mainstream would have to give. Straight America was asked to redefine many of its most sacred

institutions. It was asked to admit that what it believed to be timeless, universal values were, in reality, open for negotiation. It was asked to recognize that its way of living was only one among many. And it was asked to examine what it meant to be straight. In such demanding times, there were a lot of reasons for Straight America(ns) to panic. I use the phrase *straight panic*, then, to identify the repercussions of such developments on American culture in the 1990s.

This chapter will explore what I mean by straight panic and trace some of the broader cultural forces at play behind it. For those familiar with the legal debates surrounding antigay hate crimes or Eve Kosofsky Sedgwick's work in queer theory, my use of the phrase straight panic will no doubt bring to mind the long-established and variously inflected use of the phrases *homosexual panic* or *gay panic*. The similarity isn't coincidental. My use of straight panic was inspired by (and is in some ways a response to, revision of, and expansion upon) the concept of homosexual panic. Both address the complex and emotionally charged relationship between homo- and heterosexuality. Yet as I will demonstrate, straight panic identifies a different set of anxieties—specifically those fueled by a growing social acceptance of homosexuality. While the bulk of the book explores straight panic in relation to gay rights debates and gay-themed television, this chapter contextualizes the notion of straight panic in relation to gay panic and to the politics of social difference more broadly defined.

HOMOSEXUAL PANIC AND THE DEFENSE OF HETEROSEXUALITY

In the weeks after Matthew Shepard's brutal murder, the nation was left "wondering what dark hole [that] kind of ugliness bubbles up out of."[1] Looking for answers, the mainstream media conducted a postmortem on the crime. They asked what responsibility the bitterly antigay rhetoric of the Christian Right had. They pointed to the dangers of being "gay in cowboy country."[2] And they described Aaron McKinney's and Russell Henderson's troubled pasts and their reputations for selling drugs and getting into fights. But the press also investigated Matthew Shepard, asking what role he might have played in the tragic events. Several reports quoted McKinney's girlfriend, Kristen Pierce, who claimed that McKinney told her that Shepard had approached them at the bar and said that he "wanted to get with" them.[3] According to Pierce, Shepard "pushed himself onto" McKinney, embarrassing him in front of his friends.[4] Although the bartender working at the time refuted that version of events, claiming that McKinney and Henderson had actually approached Shepard, journalists followed Pierce's lead and investigated certain details of Shepard's past. *Newsweek*, for example, tried to complicate the emerging public image of Shepard as the unassuming, gentle, gay

boy-next-door by recounting an incident that took place just a few months before the murder. While on vacation, Shepard apparently met a waitress at a bar in Cody who invited him to join her and two male friends for a drive to a local lake. Once there, Shepard allegedly made a pass at one of the men, repeatedly asking him to go for a walk and tugging on his arm until "the man lost patience" and "punched Shepard twice in the face, knocking him unconscious briefly." According to *Newsweek*, "Shepard later told police he'd been raped. Hospital tests proved negative. No charges were filed."[5] Meanwhile, other stories drew Shepard's mental and emotional stability into question, reporting, for example, that Shepard might have suffered from post-traumatic stress syndrome caused by a rape that took place while on a trip to Morocco a few years earlier.

On October 25, 1999, a year after Matthew Shepard's death, McKinney appeared in court to face capital murder charges and a possible death sentence. During opening statements, his lawyer, Jason Tangeman, revealed McKinney's defense strategy. Once again, Matthew Shepard's sexual desires and past would become an issue. According to Tangeman, Shepard "was looking for a sexual encounter" when he approached McKinney and his friend at a local bar.[6] McKinney and his accomplice saw a chance to get some easy money, Tangeman claimed, so they pretended to be gay. They lured Shepard from the bar and into their truck with the sole intent of robbing him—or so they claimed. Once there, Shepard allegedly grabbed McKinney's crotch and tried to lick his ear. The defense argued that this gay sexual advance triggered "five minutes of rage and chaos" in McKinney who not only was drunk and strung out on methamphetamines that night, but more importantly, had "had some sexually traumatic and confusing events in his life."[7] Tanegman told the jury that McKinney had been the victim of repeated sexual assaults by a male neighbor when he was seven and had sexually experimented with a male cousin as a teenager. Thus, although McKinney confessed to the crime, the defense claimed that Shepard's behavior and the trauma of McKinney's past constituted mitigating circumstances. "I don't know what happened," McKinney told police after his arrest. "I blacked out. I felt possessed. It was like I left my body."[8] Considering the defendant's diminished mental capacity, Tangeman argued, the charges should be reduced to manslaughter. To make their case, the defense called several witnesses to establish that Shepard was prone to making unwanted advances on straight men. Michael St. Clair, for example, told the jury that Shepard had made a pass at him on the night of the fatal beating in the same bar where McKinney and Henderson met the gay student. "It was really offensive to me," St. Clair said. "It set off something inside me."[9] The defense strategy was clear. McKinney, like many other perpetrators of antigay violence, argued that he shouldn't be held fully responsible for his actions because had been caught in a homosexual panic.

Homosexual panic is a term that has been variously employed to explain what happens to heterosexuals when they come face-to-face with the socially stigmatized specter of homosexuality. The term first appeared as a psychiatric diagnosis, then as a legal defense strategy, and most recently as an analytical tool for cultural theory. While in dialogue with each other, each incarnation has defined homosexual panic in distinctly different ways. Edward J. Kempf, a clinical psychiatrist, coined the term "acute homosexual panic" in 1920 to describe the condition of patients who experienced "a panic due to the pressure of uncontrollable sexually perverse cravings."[10] Kempf's conception was grounded in Freud's bisexual theory of human sexual development in which homosexual impulses universally present within the normal sexual instincts of early childhood are sublimated on the path to normal adult heterosexuality. According to Kempf, acute homosexual panic can result when such homosexual impulses are not fully repressed, resulting in the latent homosexual who reacts with horror and disgust when his or her own "perverse cravings" threaten to overcome his or her self-image as normal.[11] Drawing upon nineteen case studies, Kempf claimed that homosexual panic most often occurs "wherever men or women must be grouped alone for prolonged periods" and can be triggered by a variety of factors, including the loss of a love interest, the absence of an important same-sex friendship, or set-backs (e.g., "fatigue," "homesickness," "misfortunes") that weaken a person's ability to control his or her "perverse" sexual desires. The resulting mental disturbance lasted from a few hours to a few months and was characterized by irritability, insomnia, increased blood pressure, elevated heart rate and adrenaline.[12] Bouts of acute homosexual panic tended to make patients feel helpless and passive, at times leading to deep depressions and suicide attempts.[13]

The term appeared sporadically in psychiatric and psychological reference books in the decades after Kempf's initial usage, but was never fully codified as a diagnostic classification and remained relatively obscure and rarely diagnosed. A handful of papers on the topic were published in the 1940s and 1950s and the disorder was recognized in the *Diagnostic and Statistical Manual of the American Psychiatric Association* (APA) in 1952. However, it did not appear in subsequent editions of the *DSM*, and several observers argue that existing literature never established a substantial or cohesive conception of homosexual panic as a psychological disorder.[14] Nevertheless, the concept was often mentioned in seminars and used in written case histories—evidence that it had gained a limited level of credibility in the profession. In the years since the declassification of homosexuality as a mental illness by the APA in 1973, the concept has faced increasing criticism from both psychiatrists and gay activists who argue that it is both bad psychology and homophobic. Consequently, mainstream psychiatry's always limited faith in the concept as a viable diagnostic tool has eroded completely.

As the McKinney trial illustrates, however, homosexual panic has not simply been used as a psychiatric diagnosis, but also as a legal defense strategy in gay murder and gay-bashing cases. In the homosexual panic defense (or gay panic defense, as it is increasingly called), the perpetrator of an antigay crime claims to have been driven to violence by the unwanted sexual advance of the gay victim. Since the first reported use of the defense in case law in 1967, the strategy has been argued on different grounds depending on the exigencies of each trial. In a few cases, the defense has argued that the threat of a homosexual advance triggered a psychotic reaction that rendered the defendant temporarily unable to distinguish right from wrong and therefore sought acquittal on grounds of insanity. In far more cases, the defense strategy relies on the legal concepts of provocation. In such arguments, the defense tries to convince the jury that the gay sexual advance (even if nonviolent) triggered such terror in the defendant that he shouldn't be held fully responsible for his actions. Therefore, juries are asked to reduce the charges on the grounds of diminished capacity.

The gay panic defense depends on the clinical concept of acute homosexual panic and its presumed ability to explain and, by extension, justify the behavior of the defendant. However, in appropriating the term, defense lawyers and courts misunderstood and/or willfully twisted key characteristics of the purported mental disorder. In the process, they have redefined the concept in striking ways. While the 1952 *DSM* psychiatric diagnosis clearly identified the patient's "uncontrollable perverse cravings" as the root of the panic, attorneys only rarely draw the defendant's heterosexuality into question. Instead, they are more likely to describe the defendant's intense personal disgust with homosexuality. Sometimes, as in McKinney's case, they may trace such strong feelings to the psychological problems stemming from traumatic experiences like childhood sexual abuse. Furthermore, defense strategies seeking to establish provocation identify the unwanted gay advance, not internal sexual confusion, as the trigger. Moreover, they argue that excessive, brutal violence targeted at the supposed gay assailant is beyond the control of the defendant and is a typical reaction for someone suffering from homosexual panic. In fact, such uncontrollable violent reactions become the disorder's defining symptom as articulated by defense attorneys.

Such claims distort the clinical case studies. First, patients who reportedly suffered from acute homosexual panic often did feel as though they were being attacked or were under the forceful control of others. However, patients hallucinated these attacks and did so only after they were in the panicked state. Second, while Kempf lists "the seductive pressure of some superior" as one possible factor in the onset of acute homosexual panic, the panicked state wasn't a sudden, violent reaction precipitated by a single, isolated gay advance.[15] Rather, the condition "developed after a period of time spent living in a same-

gender environment."[16] And finally, no patient described in case studies ever reacted violently towards someone else—even to someone delusionally perceived to be a threat or a controlling influence. The only violent behaviors observed were suicide attempts. It shouldn't be surprising that defense lawyers would revise the clinical concept in such significant ways. In appropriating the term, defense attorneys have tried to capitalize on the authority of medical science. In modifying it, they have tried to tailor the concept to fit the crimes and the homophobic attitudes of jurors and judges. Shifting the cause of homosexual panic from a conflict between homosexual desires and heterosexual identity within the patient to the aggressive, "perverse cravings" of the gay victim, for example, enables the defense to use the homophobic sentiments in the courtroom to its advantage rather than its detriment.

Defendants have had varied success using the gay panic defense. As a matter of legal process, each judge decides whether the homosexual panic argument can be used in a trial or not. If deemed allowable, the jury can then hear related testimony in order to decide whether it constitutes sufficient provocation to mitigate the crime. The last thirty years has seen a steady stream of cases in which the gay panic strategy played a role. A dramatic increase in the number of reported antigay hate crimes and a reenergized gay rights movement, however, drew more and more attention to the issue in the late 1980s and 1990s.[17] No case has ended in acquittal based solely on the homosexual panic defense, but some courts have found that even the suggestion of a homosexual encounter constitutes sufficient provocation to cause a reasonable man to lose self-control. As a result, charges have been mitigated. On October 7, 1998, for example, the same day that a brutally beaten Matthew Shepard was discovered outside Laramie, a jury in Honolulu found thirty-year-old Stephen Bright guilty of misdemeanor third-degree assault for his role in the beating death of fifty-eight-year-old Kenneth Brewer.[18] Bright, who identified himself in court as straight, met Brewer at a local gay bar. Bright testified that he went to Brewer's condominium to drink beer, but that once there, Brewer got undressed and made a sexual advance. According to Bright, he panicked and started punching Brewer. Bright then fled the scene. A roommate later found Brewer beaten to death. Although Bright was charged with second-degree murder and faced a possible life sentence, the jury, after hearing evidence about homosexual panic, reduced the charge and sentenced him to one year in prison. Bright was immediately released for time served.

Bright, of course, was not alone in getting away with gay murder because of the gay panic defense, but when the Matthew Shepard murder case hit national headlines, it seemed as though the concept of gay panic would have its most public airing yet. McKinney's gay panic defense, however, would not succeed. In fact, shortly after the trial began, the presiding judge announced

that the gay panic strategy could not be used and that the jury couldn't consider whatever sexual advance Shepard may or may not have made as provocation.[19] Such court decisions seemed to be increasingly common by the late 1990s. Anecdotal evidence suggests that the gay panic defense was losing its efficacy in the courts as more and more judges disallowed it and juries rejected it. Whatever efficacy the gay panic defense may have lost judicially, however, its underlying homophobic logic (i.e., that gay men are inherently predatory and that violence is a legitimate response to almost any unwanted, gay sexual advance) has not necessarily lost its cultural power. After all, even in failure, McKinney's gay panic strategy helped the concept reach its widest circulation ever. And press coverage of Shepard's past suggests that the concept continued to shape how American culture thought about antigay violence.

Defense lawyers weren't the only ones to find Kempf's original notion of homosexual panic useful. In *Between Men: English Literature and Male Homosocial Desire* (1985) and *Epistemology of the Closet* (1990), literary scholar Eve Kosofsky Sedgwick borrowed the term but historicized and depathologized it, transforming it into a tool for the critical analysis of modern gender and sexual politics. While the clinical concept was designed to diagnose a distinct group of latent homosexuals suffering from mental illness, Sedgwick used the term to identify "a structural principle applicable to the definitional work of an entire gender, hence an entire culture."[20] Sedgwick argued that because "the paths of male entitlement, especially in the nineteenth century, required certain intense male bonds that were not readily distinguishable from the most reprobated bonds, an endemic and ineradicable state of [what she calls] male homosexual panic became the normal condition of male heterosexual entitlement" (186). In other words, those looking to ascend to a position of male privilege found themselves in a double bind. On the one hand, access to male entitlement encouraged and even demanded new kinds of homosocial relationships and desires (e.g., "male friendship, mentorship, admiring identification, bureaucratic subordination, and heterosexual rivalry") (186). On the other hand, male privilege was structured by the exclusion and denunciation of homosexual relationships and desires.

According to Sedgwick, however, the line that separated acceptable homo*sociality* from unacceptable homo*sexuality* was unstable and shifted historically. It was arbitrary and self-contradictory, resulting in a "male definitional crisis" that placed western men (with the exception of self-accepting homosexuals) in a state of constant "blackmailability" (20). Freud's theory of sexual development, for example, posited a universal bisexuality and the mutability of sexual desire—both of which undermined faith in the security of one's sexual identity. In a patriarchal culture where definitions of heterosexual masculinity were aggressively enforced yet constantly uncertain, non-homosexual men were always vulnerable to the very homophobia on which

their heterosexual male privilege was founded. As a result, male homosexual panic served as an unsettling disciplinary mechanism—one that worked to regulate male gender and sexual identity. The constant fear of one's own latent homosexuality necessitated a constant vigilance (focused both inward and outward). And it fueled a virulent and violent homophobia that helped establish "the broad field of forces within which masculinity . . . could (can) at a particular moment construct itself."[21] Although Sedgwick's work was focused on tracing the ways this blackmailed masculinity can be read in the work of late nineteenth and early twentieth century writers like Henry James, she felt that male homosexual panic shaped gender and sexual politics in 1990 American culture—that straight men's identities and heterosexual society were still structured by a coercive terror experienced by/as a never entirely secure heterosexual masculinity.

Sedgwick's work helps reframe homosexual panic by insisting that we understand it as a social phenomenon. Although clinical and legal discourses describe it as a purely individual experience, homosexual panic also bespeaks a wider social anxiety—specifically that stirred up by the unstable boundary between categories of sexual identity. For a culture in which the moral, hierarchical line separating a sacrosanct heterosexuality from a socially abject homosexuality was absolute and instrumental in maintaining a historically specific social order, the ontological instability of sexuality would be particularly troubling. Clinical and legal notions of homosexual panic reveal this profound social anxiety while they simultaneously try to contain it. Kempf's clinical concept, grounded as it was in Freud's theory of sexual development, acknowledged that the barrier between homo- and heterosexuality was relatively porous. Poorly suppressed homosexual desires always threatened to bubble up and destroy one's sanity and sexual identity—a disquieting prospect. By identifying homosexual panic as an individual condition afflicting only a deviant few, however, the concept simultaneously worked to conceal its social etiology and to curb wider panic about the unstable nature of sexual identity categories. The homosexual panic defense works even harder to fortify the boundary between gay and straight. By so often omitting any reference to latent same-sex desires and insisting on the defendant's heterosexuality, the legal concept insists that the line between gay and straight is (or at least *ought to be*) stable. After all, gay panic is ostensibly caused by the perverse cravings of the homosexual other, not the defendant's internally conflicted sexual desires or the inherent mutability of sexuality. Moreover, the legal strategy argues that the physical/moral/sexual boundary between gay and straight is so fundamental that defending it against a gay advance justifies murder. Of course, one must ask how stable and secure male heterosexual identity is if the mere suggestion of a homosexual encounter is enough to throw an otherwise rational straight man into a psychotic rage. Despite its

constant protests otherwise, the gay panic defense ends up revealing a profound and violent anxiety over the nature of the line between gay and straight and an almost obsessive preoccupation with maintaining it. Sedgwick, of course, argues that the inherently unstable boundary is exploited by a patriarchal social system, generating an ever-present fear of being labeled homosexual which structures and disciplines normative gender and sexual identities.

Undoubtedly, homosexual panic continues to shape elements of American culture. As Sedgwick would predict, for example, the intense same-sex intimacy demanded by military life provides particularly fertile soil for homosexual panic (a fact made quite evident by the resistance to Clinton's efforts to allow gays and lesbians to serve openly). In describing an "inherent contradiction in military psychology," Jose Zuniga, an Army sergeant who came out during the gays-in-the-military debate of 1993, succinctly laid bare the double bind that leads to male homosexual panic. "The Army requires fellow soldiers to form close bonds founded on caring and concern," he observes, "yet it forbids them from caring for one another too much."[22] As Sedgwick would predict, this contradiction is managed (but certainly not solved) through a virulent homophobia. The ban on gays and lesbians serving in the military and the strict code of conduct prohibiting sodomy are only the institutionally codified tip of the iceberg. Military culture and rituals, for example, often deflect the ever-present homoeroticism of sex-segregated environments with a barrage of fag jokes, and homophobia becomes a boot-camp training tool. Zuniga, for example, remembered his drill sergeant whipping his troop into shape with stinging antigay barbs. "I'm going to make men out of you little faggots," he promised them.[23] Although everyone was implicated in such comments, Zuniga remembered that one soldier was singled out as the troop's weak link because of "some undefinable characteristic the drill sergeant directly attributed to homosexuality." The sergeant rode him mercilessly in an attempt to build unit cohesion and manipulate the remaining troop members. In hindsight, at least, Zuniga saw the strategy with painful clarity. "We would bond by purging one of our own," he confessed. Apparently it worked, as "the rest of the group dutifully focused [its] hatred and venom on him." The young man was eventually discharged for failure to adapt, but his expulsion didn't mark the end to the homosexual threat. In fact, it would only be the beginning. The drill sergeant's decision to target the young recruit seemed random. He wasn't stereotypically gay and often outperformed many of his troop-mates, but such facts didn't seem to matter. This arbitrariness, however, had a purpose. It placed everyone on notice: no one was secure. As Sedgwick might put it, each recruit found himself and his heterosexual masculinity in a constant state of blackmailability. What better tactic to keep soldiers in line? "As for us," Zuniga admitted, "we simply redoubled our efforts not to fall behind."[24]

STRAIGHT PANIC

Looking back on the 1990s, one wonders whether homosexual panic continued to shape mainstream American culture and heterosexual masculinity as deeply as it once had. Sedgwick implies that it did, suggesting that although the intense, same-sex environments of military life may have heightened homophobic anxiety, male homosexual panic structured the rest of society in similar ways. That is undoubtedly true, to some degree. *Newsweek*'s investigation into Matthew Shepard's sexual past, Stephen Bright's successful defense, and the military's intense resistance to lifting the ban clearly demonstrate the persistence of gay panic. But I would argue that by the 1990s, the cultural logic behind male homosexual panic was increasingly giving way to—or at least joined by—straight panic, a decidedly different set of anxieties that emerged unevenly within American society.

What is the difference between (male) homosexual panic and straight panic? If male homosexual panic held sway in a culture unsure about the ontology of sexuality but utterly convinced of homosexuality's depravity, then straight panic arises in a culture not only uncertain about the ontology of sexual identity but also uncertain about heterosexuality's moral authority. More simply put, male homosexual panic describes what happens when heterosexual men, insecure about the boundary between gay and straight, confront the threatening specter of a socially prohibited homosexuality. Straight panic describes what happens when heterosexual men and women, still insecure about the boundary between gay and straight, confront an increasingly accepted homosexuality.

A confluence of interrelated social changes helped fuel straight panic in the 1990s. Most directly, the gay and lesbian civil rights movement and the unprecedented visibility of gayness in popular culture, including on primetime television, magnified and shifted attitudes and discourses about sexual identity. The opposition to and public debate over the military ban and the failure of gay panic pleas, for example, indicate that the social stigma once firmly attached to homosexuality was weakening—or, at the very least, was open to negotiation in certain parts of the social formation. The challenge to the long-standing social hierarchies governing sexual identity and gender undermined homosexual panic's coercive power over heterosexual masculinity and laid the groundwork for straight panic. But straight panic and shifting discourses about sexual identity were also imbricated within broader historical developments—most notably multiculturalism and an emerging politics of social difference that reflected the impact of second-wave feminism, African American civil rights, and other movements for social equality. Such changes, I argue, altered the culture's structure of feeling. By the early 1990s, widespread discourses about the reality and value of cultural diversity drew into question the taken-for-granted authority of the center over the margins, the

privileged over the subordinated, the normal over the deviant, and the straight over the gay.

As the discussion above suggests, another distinction between homosexual panic and straight panic involves their different intersections with gender politics. Historians and theorists of sexuality have established the intricate relationships between categories of sexual identity and constructions of gender—a point well made by Sedgwick's argument linking male homosexual panic to normative masculinity and the maintenance of male privilege. However, I have consciously chosen the term straight panic, rather than straight *male* panic, not because I believe gender is irrelevant to the contemporary politics of sexual identity or to the anxieties I analyze, but in order to reflect the fact that key anxieties arose over the distinction between gay people and straight people. It is this socio-cultural fault line that is of primary interest here. At various points, however, I will address the ways gender works to complicate the operation of straight panic. Given that straight panic was fueled by the center's *perceived* loss of moral, political, and cultural authority over the margins and that privilege and subordination operate through the intersection of multiple axes of difference, it isn't surprising that straight panic would be most often and perhaps most powerfully expressed through the experiences of and narratives about straight, white men. Nevertheless, gay-themed TV narratives and debates over gay rights point to a set of anxieties stirred up when straight men and women were confronted by gay men, lesbians and other non-straight people. Increasingly, Straight America(ns) faced a world where being gay wasn't so bad, where being straight wasn't so effortless, and where social identities in general and sexual identities in particular were increasingly relevant even as the line between them became ever more indeterminate. Dealing with these new circumstances could, as my straight classmates discovered on Jeans Day, be a disquieting experience for both heterosexuals and mainstream American culture.

While the bulk of this book focuses more narrowly on the shifting politics of sexual identity and the role they played in fueling straight panic, I first want to situate straight panic in a broader context. Below, I discuss the political pressures multiculturalism placed on mainstream American culture and the psychic pressures it placed on members of the majority, because these pressures help explain the wider social climate within which the politics of sexual identity took place. As the social differences that separated Americans seemed to proliferate and solidify in the early 1990s, the lines separating the majority from the minority, the center from the margin, began to weaken. Although straight panic, when most narrowly defined, refers to the anxieties experienced by a heterosexual culture and heterosexuals unsure about the categorical and moral lines separating gay from straight, straight panic can also be used to identify a broader social anxiety

experienced by a once naïve mainstream confronting the politics of social identity and difference.

THE POLITICS OF SOCIAL
DIFFERENCE IN THE 1990S

In the early 1990s, America was obsessed with social difference. While multiculturalists celebrated it, conservative critics on both the New Right and Old Left warned us about it. In 1995 sociologist Todd Gitlin suggested that "American culture in the late twentieth century is a very stewpot of separate identities. Not only blacks and feminists and gays declare that their dignity rests on their distinctiveness, but so in various ways do white Southern Baptists, Florida Jews, Oregon skinheads, Louisiana Cajuns, Brooklyn Lubavitchers, California Sikhs, Wyoming ranchers, the residents of gated communities in Orange County, and the 'militias' at war with the U.S. government."[25] Gitlin would go on to conclude that this proliferation of identities and the politics of difference that fueled them undermined leftist political goals. His complaints indicate how troubling the politics of social difference could be for those forced to think about difference and identity differently. Yet his observations about American culture also reflected the fact that certain discourses about difference had in fact changed and that people were organizing their lives through their identifications as members of distinct social groups in new ways. American legal, political, and popular culture often valued and accentuated the axes of cultural difference, and locating oneself by one's affiliation with a racial, gender, sexual, geographic, or some other culturally distinct subculture seemed a prerequisite for social recognition and participation. Cindy Patton, for example, has argued that "identity increasingly became the currency of post-1960s political participation."[26] This proliferation of identities reflected and precipitated anxieties about the stability of American identity, its common cultural values, and the hierarchical relationship between a democracy's normative majority and it social minorities.

America, founded as it was on colonialism, immigration, and slavery, had always been confronted with the cultural cleavages brought about by such various differences, yet contemporary observers argued that the preoccupation with social difference was deeper, more widespread, and more unyielding in the 1990s.[27] Within a dominant historical narrative, the miracle of the American experience—its very foundational concept, in fact—had been its ability to integrate a diverse populace into a unified nation and culture. Ostensibly, millions of immigrants were successfully assimilated because American identity, founded on abstract principles laid out in the Constitution, not in ethnic, religious, racial, or tribal ties, was uniquely elastic. Despite the racial, ethnic, class, and geographic differences that separated Americans, the logic went, they were all invested in the nation's founding ideals of

universal freedom, human rights, and equality of opportunity—what sociologist Gunnar Myrdahl called the American Creed. In this story of American universalism, the decades after World War II marked the height of national unity. As had fascism during WWII, the threat of communism to national security and the American way of life mobilized the nation and curbed the public expression of internal conflicts. Meanwhile, postwar prosperity and political ideology promised middle-class status to all Americans—a promise reinforced by the homogenizing forces of suburbanization, national transportation networks and the consolidation of mass marketing, mass media, and mass consumption. By the early 1990s, however, faith in the American Creed and in the viability of a common American identity were challenged as discourses about social difference became more prominent and social identities proliferated.

Efforts to explain this shift usually trace its origins to a variety of interrelated factors rooted in the late 1960s—specifically in organized resistance to the hegemonic center's refusal to incorporate America's diversity into its notion of American identity. Despite it assimilationist goals, for example, the civil rights movement advanced legal recognition of minority rights and judicial notions of minority status (including affirmative action), exposed the consistent failure of the American Creed to make good on its ideals, and kindled desire for a separatist Black identity and culture. It also enabled and inspired other identity-based civil rights movements. In the 1970s, identity politics became an integral part of American culture as feminists, Native Americans, Chicanos, gays and lesbians, and the disabled fought to get their personal experiences recognized as politically shaped. Critiques of a homogenized American identity were also fueled by disillusionment over Watergate, American involvement in Vietnam, and an economic recession. Meanwhile, the Immigration Act of 1965, which lifted discriminatory provisions based on national origin, opened the door to immigrants from Asia and Latin America—groups whose racial, linguistic, religious, and cultural differences deepened the diversity of the U.S. population. Even more so than previous immigrants, these groups were highly concentrated in ethnic enclaves, lessening the need to assimilate.[28] Against this backdrop, as I outline in chapter 3, consumer capitalism and niche-oriented media exploited and solidified these various identity barriers rather than bridged them, targeting niche rather than mass audiences. And finally, new intellectual currents were shaped by and in turn helped legitimate people's growing investments in subcultural identities. Sociology, for example, helped popularize concepts like "identity" and "ethnicity" and leftist academics, especially in the humanities, increasingly dismissed universalism as essentialism, advancing theories that examined how one's race, sex, gender, and so forth shaped one's values and perspectives

(witness the growth of women's studies, African American studies, and eventually lesbian, gay, and bisexual studies as programs in academia).

Although gaining steam for decades, these developments came to a head in the early 1990s. With the end of the Cold War and of America's ideological Other, a common American identity and culture seemed less pertinent. The differences among Americans appeared starker and more relevant than ever—not surprising after a decade in which Reagan-era policies only widened and fortified the economic and cultural barriers among social groups. For those who remained blind to such growing schisms during the 1980s, events like the Los Angeles riots/uprising and the Anita Hill-Clarence Thomas hearings made it impossible to ignore them. Discourses about America's growing diversity were reinforced by the widely reported 1990 U.S. census figures that painted the demographic picture of a white majority losing ground to the swelling number of racial and ethnic minorities. In fact, census projections predicted that by 2050 non-Hispanic white Americans would no longer be a majority.[29] Widespread media reporting of this multicultural future seemed to distort American perceptions of the present. According to a 1990 Gallup poll, for example, the average American believed that 32 percent of the U.S. population was black and 21 percent was Hispanic. (The real figures were 12 percent and 9 percent respectively.)[30] Such statistics and perceptions drew into question the viability of mainstream culture and complicated the relationship between the center and the margins—between the majority and its minorities. As *American Demographics* magazine put it, "In the future, the white Western majority will have to do some assimilation of its own."[31]

Debates over what came to be called multiculturalism preoccupied an American culture trying to respond to these changes. In drafting the Civil Rights Act of 1991, for example, Congress battled over how or even whether to extend discrimination protections to new identity categories, to legislate minority status, and to sanction affirmative action policies. School boards and PTAs from California to Florida weighed the pros and cons of adopting revised textbooks that recognized the contributions and cultures of subordinated groups to American history and that exposed the cruel legacy of Anglo-American colonialism and slavery. Films like *Do the Right Thing* (1989), *Dances with Wolves* (1990), *Grand Canyon* (1991), and *Thelma and Louise* (1991) explored narratives about the politics of social identity. *Time* magazine offered readers such cover stories as "The Fraying of America: A Scorching Look at Political Correctness, Social Breakdown, and the Culture of Complaint" in 1992 and "The New Face of America: How Immigrants Are Shaping the World's First Multicultural Society" in 1993.[32] In fact, bestseller lists and op-ed pages were swamped with thought pieces weighing in on debates about hot-button multicultural topics like bilingual education, Afrocentrism, and

college curricula. Advocates of multiculturalism argued that America needed to confront the reality of a diverse population. Respecting the differences among us rather than imposing a normative sameness that privileged the values of the majority, they maintained, would actually enrich and strengthen the nation and help it live up to the ideals of constitutional liberalism. Critics from both the New Right and the Old Left, however, warned that the proliferation of identities threatened the stability of American democracy. In his widely cited 1991 book *The Disuniting of America*, one-time Kennedy liberal Arthur Schlesinger, Jr. decried the "cult of ethnicity" and predicted that "if separatist tendencies go unchecked, the result can only be the fragmentation, resegregation, and tribalization of American life."[33] In a decade marked by the balkanization of the Balkans, ethnic cleansing in Rwanda, and Canada's Quebecquois separatist movement, many saw multiculturalism's challenge to traditional American identity as particularly threatening. Neoconservatives, in fact, believed America to be embroiled in an all out war. "There is a religious war going on in this country for the soul of America," right-wing warrior and old-fashioned nativist Pat Buchanan declared at the 1992 Republican convention. "It is a cultural war as critical to the kind of nation we shall be as the Cold War itself."[34]

At the heart of the culture wars (as battles over multicultural issues like bilingualism, quotas, and gay rights came to be called) was what conservative pundit Charles Krauthammer disparagingly described as "the vast social project of moral leveling."[35] Time and again in the early 1990s, conservatives decried the loss of traditional values, the rise of cultural relativism, and the moral deregulation of American culture. For them, it had become a full-blown crisis. While I strongly disagree with their reactionary condemnation of such changes and their nostalgic invocation of Judeo-Christian values, conservatives were accurate in linking the proliferation of identities and the multicultural politics of social difference it produced to the erosion of traditional moral hierarchies. By finding greater meaning in the particularity of their social identities and cultures, minority groups made it clear that a common American identity and culture often failed to reflect their values and experiences. Despite mainstream culture's claims to commonality, minorities saw it as normalizing the socially-specific values of whites, men, heterosexuals, Christians, the able-bodied, etc. Spurred on by an investment in their subcultural identities, minority groups and women understandably fought for equality, civil rights protections, and increased cultural visibility. By doing so, they muddied the clarity and challenged the legitimacy of social hierarchies that regulated taste, morality, and cultural authority. By de-legitimizing certain ways of living, such hierarchies had worked to suppress social difference. When the lines separating Americans from each other by race, religion, gender, and sexuality *strengthened*, the lines differentiating the normal from the

deviant, the moral from the immoral, and the margin from the center *weakened*—and vice versa.[36]

Such changes, of course, were also extremely unsettling to members of a majority no longer able to easily delude themselves into believing that its way of life was the only or even the best way. "Normal Americans" (as Newt Gingrich so tellingly dubbed those who ostensibly comprised the social center) faced the growing exposure of and challenge to their authority. As a result, they experienced what legal scholar J.M. Balkin calls "status anxiety"—the panic experienced by those "who fear a loss of status, either due to competition from other groups or general social and economic changes."[37] One obvious and popular response to this growing nervousness was to confront the creeping cultural relativism head on and try to reassert traditional hierarchies by explicitly justifying them. William Bennett's nomination speech for Dan Quayle at the 1992 Republican convention did just that: "Within very broad limits people may live as they wish," he conceded. "And yet we believe that some ways of living are better than others—better because they bring more meaning to our lives; to the lives of others; and to our fragile human condition."[38] However, in a legal, political, and cultural context where social differences mattered more and more, whites, men, heterosexuals, and Christians also faced pressure to adapt. Forced to come to terms with the particularity of their own social identity, for example, members of formerly unmarked social categories experienced what Todd Gitlin calls an "identity panic" and scrambled to adopt their own identity consciousness.

Several scholars, for example, have pointed to the emergence of a specifically white identity panic. Michael Omi argues that before civil rights challenges, "white identity, whiteness, was 'transparent,' its meaning unproblematic." However, in a post–civil rights era marked by affirmative action, calls for racial reconciliation, and the growth of minority groups as a percentage of the U.S. population, whites have been increasingly racialized, leading to what Omi calls a "crisis in white identity."[39] Part of this crisis was realizing, often for the first time, that one was white and thinking about what that meant. In conversations with white college students about their sense of racial identification, sociologist Charles A. Gallagher found a growing awareness of racial identity. "I mean now I really have to think about it," one respondent remarked. "Like now I feel white. I feel white."[40] More and more people began to feel white, however, just as whites faced mounting criticism for a history of social domination—criticism that shaped how people experienced their whiteness. One white University of California student told the Berkeley Diversity Project (an early 1990s study investigating racial stereotyping), "Asians are the smart people, the blacks are great athletes. What is white? We're just the oppressors of the nation. At Berkeley, being white is having to constantly be on my toes about not offending other races, not saying

something to be construed as, 'I am continuing to be the oppressor of America.'"[41] According to Linda Martin Alcoff, cultural narratives about white superiority, which had offered an "almost invisible support structure" for "the collective self-esteem" of whites, started to breakdown with psychological consequences for whites. "As whites lose their psychic social status, and as processes of positive identity construction are derailed," Alcoff argues, "intense anxiety, hysteria, and depression can result."[42] While cases of clinical mental illness of the kind suggested by Alcoff may have been rare, an unsettling mix of defensiveness and confusion seemed common among whites in the post–civil rights era.

Needless to say, whites responded to this psychic threat in complex and varied ways.[43] One response was to wholeheartedly embrace one's whiteness—a move taken to its most extreme by white supremacist organizations whose calls for racial solidarity and separatism perverted multiculturalist rhetoric. Others more begrudgingly accepted their white identity, seeing it as the only way to get fair treatment in a culture they bitterly believed was increasingly founded on tribal claims and victim status. On college campuses, for example, white students called for the formation of white student organizations to match those serving the interests of other racial groups, and snide editorials asked why whites didn't have a white history month when blacks get one. A discourse of white victimization (mixed with male resentment) entered the media spotlight in 1993 when the Michael Douglas film *Falling Down* and a *Newsweek* cover story entitled "White Male Paranoia" examined the growing anger of white men who felt buffeted by feminists on one side and racial minorities on the other.[44] Backlash politics, however, were joined by other, less reactionary though no less complicated, responses. Despite the currency of multiculturalism, liberal discourses insisting that race doesn't matter continued to shape mainstream white attitudes about racial difference. Color blindness, as it has been called, gave whites a way to evade both their white identity and charges of racism. In contrast, some whites did try to come to terms with the social privilege offered by their whiteness—an effort taken to its most extreme by new abolitionists who, as the journal *Race Traitor* states, believe that the "key to solving the social problems of our age is to abolish the white race."[45] Meanwhile, white guilt and political correctness offered perhaps less radical options for progressive whites. Finally, David Roediger, Mike Hill, and others have described an ultimately reactionary move in which whites embraced racial difference and white's impending minority status to the point of making racial difference (and thus white privilege) *seem* irrelevant.[46]

Another response among whites (as well as everyone else forced to confront the emerging politics of social difference) was an increasing investment in new categories of identity. By the 1990s the mainstream seemed to be fol-

lowing the identity-politics path blazed by minority groups and feminists, making sense of themselves as members of distinct subcultural groups. As early as the 1970s, for example, sociologists identified a growing interest among whites in rediscovering their ethnic roots. Asserting one's Irish-American, Polish-American, or Italian-American background seemed to offer an alternative to an either unmarked or maligned whiteness. If such ethnic identities seemed less relevant by the 1990s, there was certainly no lack of other groups around which one could organize one's life. The Christian Right, for example, emerged as a de facto identity politics movement, with its own cable network, lobbying groups, bookstores, and tourist destinations. Afrocentrists were joined by environmentalists, riot grrrls, the men's movement, and the Christian Identity movement. People identified themselves as vegetarians, trekkers, soccer moms, or rednecks. You could be a member of the gay community, the S&M community, the deaf community, the Harley community, or smaller subgroup communities defined along multiple lines (e.g., gay and deaf community). As Gitlin both observed and complained, American culture expressed itself as "a very stewpot of social identities."

A 1991 *Time* cover spoke directly to America's growing identity crisis. The issue on stands that Fourth of July highlighted the nation's growing sense of disunity in the face of "new multicultural perspectives."[47] One in-depth article entitled "Whose America?" discussed the efforts to revise American history in order to acknowledge the nation's multicultural heritage. Like so much coverage of the politics of social difference, the article painted a picture of an American culture in which the promotion of "racial and ethnic pride" came at "the expense of social cohesion."[48] As is so often true of glossy, weekly newsmagazines, however, it was the cover that succinctly captured and amplified mainstream social anxieties. In the spirit of Independence Day, the cover illustration featured a colonial-era fife and drum team updated to better reflect America's racial and ethnic diversity (and presumably comment upon contemporary investments in racial and ethnic identities). A white man playing a snare drum marches side by side with a Native American man playing a flute and an African American woman playing a tribal drum. They are followed by what appears to be an Asian American woman and a Hispanic man. While the image challenged America's de-racialized (whitened) founding myth, the cover's headline revealed the crisis of identity such a challenge posed to mainstream America. In huge, bold print, the headline asked: "Who Are We?"

Straight Panic and Nervous Heterosexuals

In a climate where identity, history, and values based on the previously unchallenged assumptions of privileged groups were questioned, America was particularly sensitive to the tensions between the rights of a gay minority and

the normative power of a straight majority. In fact, that struggle became one of the defining political and cultural issues of the decade. For a culture uneasy about the loss of moral consensus and struggling to deal with the proliferation of social identities, gays and lesbians' demands for social recognition and equal treatment pushed a lot of buttons. Like whites in a post–civil rights era, heterosexuals in the gay 1990s experienced something of an identity crisis. In the next chapter I will analyze how specific gay civil rights debates intensified Straight America's anxieties over sexual identity, and in chapter 6, I will explore how much of the decade's gay-themed television programming negotiated these anxieties in specific narratives. Shaped as they were by people's particular locations within the social formation, individual responses to the shifting politics of sexual identity inevitably varied widely. To conclude this chapter, though, I briefly point to two broad responses—two divergent symptoms of the era's straight panic. A conservative backlash worked hard to reestablish heterosexual privilege by explicitly justifying and reinscribing traditional moral hierarchies that defined gays and lesbians as deviant. Meanwhile, gay-friendly liberals worked hard to accept and adapt to the new sexual politics by trying to figure out how to be straight (especially a straight man) without the despised homosexual Other as one's point of reference.

To conservatives, especially the increasingly well-organized and politicized Religious Right, the growing acceptance of homosexuality was nothing short of a social catastrophe. "We're at a crossroads," Martin Mawyer of the Christian Action Network declared amid the gays-in-the-military debate. "If they win, it will feed their strength. Eventually this will tear down the fiber of American society."[49] Pat Robertson declared that "the acceptance of homosexuality was the last step in the decline of Gentile civilization" and warned that hurricanes could hit Orlando because of Disney's gay-friendly policies.[50] Such fire-and-brimstone rhetoric found a more mainstream (though no less anxious) accent in the family-values debate that peaked during the 1992 presidential race. According to Dan Quayle, "the traditional values of middle America" were under attack by moral relativists whose permissive attitudes and destructive policies had created a social climate in which homosexuality (as well as single motherhood and welfare dependency) were accepted as normal. "When family values are undermined, our country suffers," he declared at the Republican National Convention. "Americans try to raise their children to understand right and wrong, only to be told that every so-called 'lifestyle alternative' is morally equivalent. That is wrong."[51] Pat Buchanan echoed Quayle's sentiments: "we stand with [Bush] against the amoral idea that gay and lesbian couples should have the same standing in law as married men and women."[52] Of course conservatives found homosexuality itself condemnable, but as such statements indicate, their anxiety was really

fueled by the fact that the rest of society no longer seemed to agree with them.

Not surprisingly, cultural conservatives fought bitterly to shore up the eroding stigma attached to homosexuality. In 1992, for example, Christian conservatives placed antigay referenda on statewide ballots in Oregon and Colorado. They produced editorials, TV ads, billboards, and flyers that tried to convince voters that gays and lesbians were both powerful and sexually deviant and therefore didn't deserve to be included in antidiscrimination laws. Meanwhile, groups like the Christian Coalition, Focus on the Family, and the Traditional Values Coalition published books, commissioned "research," mailed out newsletters, and lobbied legislators across the country in an effort to expose the gravity of the gay menace.[53] A small, fundamentalist church in California released a slick twenty-minute video entitled *The Gay Agenda* in 1992. The video featured edited footage of the most outré elements of San Francisco's gay pride parade with voice-over commentary that told viewers that 17 percent of homosexuals eat human feces for erotic fun and that 28 percent engage in sodomy with over 1,000 partners. "Expert" doctors, psychologists, and self-described reformed homosexuals testified to the depravity of gay culture. Such behavior, the video went on to claim, is "just one part of an aggressive nationwide offensive aimed at every segment of society to force the acceptance and approval of their chosen lifestyle."[54] The tape wasn't simply shown in church basements. Over 25,000 copies were sent nationwide (including to Sam Nunn, the chairman of the Senate Armed Services Committee, who was looking for ammunition to use in the gays-in-the-military debate). Clips were also used in several 1992 antigay TV commercials in Oregon, Florida, and Kentucky and were shown on Pat Robertson's *The 700 Club* in 1993. The antigay propaganda blitz of the early 1990s is but one sign of a growing conservative response to straight panic.

Conservative anxieties about the gay civil rights movement were often discursively articulated in ways that echoed the gay panic defense while reframing it in telling ways. Where the gay panic discourse condemned the sexually deviant homosexual who threatens the physical security and psychological stability of an innocent straight man, a common conservative straight panic discourse warned society about a sexually deviant gay and lesbian community that threatens the security and stability of mainstream (heterosexual) culture. Conservatives often described the gay movement as dangerously powerful. Lon Mabon, leader of Oregon's antigay initiative, for example, claimed that the gay and lesbian community "is probably, pound for pound, the strongest political lobby in the nation."[55] In demanding antidiscrimination protection and social legitimacy, gay and lesbians were seen as *forcing* their way of life onto heterosexuals, *compelling* them to endorse their immoral

behavior. When asked why he supported Oregon's antigay Proposition 9, one Portland, Oregon, police officer made the link between sexual and political aggression explicit. "I think there are a lot of people who are sick and tired of having this homosexual-agenda stuff shoved down their throats," he stated. "Let's face it, homosexuals are militant and they are violent."[56] Even *Newsweek* used the language reminiscent of gay panic defense lawyers in discussing the backlash politics of 1992: "A well-coordinated counter offensive by the religious right is underway in the city halls, school boards and state legislatures to stymie—and even roll back—what its leaders regard as an intolerable *gay advance* out of the closet and into the mainstream" (italics added).[57] But perhaps Dr. Paul Cameron, a former psychologist whose Family Research Institute provided antigay advocates with shocking and discredited statistics about gay and lesbian sexual behavior, best captured the conservative straight panic generated by the prospect of a homosexuality no longer curbed by uniform social condemnation. "Untrammeled homosexuality can take over and destroy a social system," he warned. "If you isolate sexuality as something solely for one's own personal amusement and all you want is the most satisfying orgasm you can get—and that is what homosexuality seems to be—then homosexuality seems too powerful to resist. The evidence is that men do a better job on men, and women on women, if all you are looking for is orgasm."[58] As the moral distinctions that had once so clearly separated a normative heterosexuality from a stigmatized homosexuality weakened, anxieties over the unstable line between being straight and being gay intensified into full-blown straight panic.

Given its explicit rhetoric, Christian conservatives' straight panic is easy to spot, but they weren't alone in experiencing anxieties stirred up by the politics of sexual identity, and such backlash politics weren't the only way straight Americans responded. The "gay advance out of the closet and into the mainstream" affected how straight Americans across the political spectrum felt—how they felt about the gay minority, about their own sexual identity, and about the nature of the line between the two. A 1993 *Glamour* magazine essay self-critically entitled "I'm not a faggot!" offers a glimpse into the straight panic of one gay-friendly heterosexual.[59] The author identifies himself as "a liberal, politically correct kind of guy" who believes in "many of the ideals and agendas of the gay community" and has "several gay friends and neighbors" in his "largely gay neighborhood in New York." One night while walking home with his girlfriend, however, a group of men drove by in a car, screaming antigay epithets like "Hey Faggot! What's she doing with you, homo? We're gonna beat your ass, faggot!" He and his girlfriend ran into a store where they waited. The threats continued until the homophobic gang tired and drove off. Once the fear subsided, he recounts, he became enraged: "I imagined myself as Clint Eastwood, walking out to the curb with a loaded

.44 magnum, sticking it in the driver's ear and saying in my most gravelly voice, 'Who you calling faggot, pal?'" His instinctive response—the need to assert a rigidly defined masculinity—offers a perfect example of the coercive power of male homosexual panic as Sedgwick would describe it. His emotional reaction, however, is only the article's starting point. For the bulk of the essay, the author self-reflexively and with a clear sense of guilt analyzes why their taunts had made him so angry and why he had felt the need to set his "sexual record straight." The essay's confessional quality—his decision to confront and seemingly exorcise his homophobic discomfort—reveals a new set of anxieties facing a progressive straight man forced to experience the privilege of his heterosexuality and to figure out how to assert a gay-friendly straight masculinity.

One 1993 *New Republic* essay, entitled "Straight Answer," served as something of a gay-1990s advice column for heterosexual men anxious to escape male homosexual panic. Written at the height of the gays-in-the-military debate, when supporters of the ban repeatedly invoked classic homosexual-panic fears about sexually aggressive gays leering at fellow soldiers in group showers, the straight author tells his readers "how a straight man should respond to the various types of homosexual advances."[60] Using his experiences with unwanted gay admirers in the locker room of his Washington, D.C. YMCA, the author offers solutions to three scenarios: "The lustful gaze" (simply avert your eyes and he'll get the hint); "The stalker who talks" (realize his interest is "a bit flattering" and develop a "gentlemanly response" that "conveys a distaste for the thing proposed without conveying a distaste for the person who proposes the thing"; and "The full frontal assault" (admit such instances are rare, be calm, and politely ask the man to stop). Again, in this primer male homosexual panic becomes the problem, not the solution. Finding ways to appropriately negotiate one's fears about homosexuality becomes a concern for those men caught in a gay-friendly straight panic.

Such examples hint at the specific anxieties of progressive straight men trying to adapt to a culture where once-unquestioned hierarchy regulating sexuality (and structuring gender) was increasing questioned. If such self-conscious assessments of one's attitudes about homosexuality were a symptom of straight panic, the authors and readers of such articles had plenty of company. Polls surveying Americans' feelings about homosexuality were ubiquitous in mainstream press coverage of gay rights issues in the 1990s. It seemed as if every story about the gays-in-the-military debate, gay employment discrimination, or gay marriage had to be accompanied by bold-font, sidebar statistics revealing what the nation thought and encouraging readers to ponder her or his own positions. "Does anything about homosexuality make you uncomfortable? If so, what?" *Glamour* magazine asked its readers. *Newsweek* wanted to know "Is homosexuality an acceptable alternative lifestyle?" and "Are gay

rights a threat to the American family and its values?" A *New York Times/CBS News* poll asked respondents whether they thought people could change their sexual orientation. And *U.S. News & World Report* used a survey to find out how many Americans knew someone who was gay or lesbian and whether knowing some gay influenced how they felt about homosexuality.[61] The answers to these questions, of course, varied, but the incitement to analyze one's own feelings about the politics of sexual identity were everywhere.[62] As defined here, straight panic refers to the social anxieties that played out in mainstream media and American culture more generally at a time when the relationship between the majority and its minorities, the center and the margins, the normal and the abnormal were drawn into question. For a society perceived to be fraught with fragmentation and the erosion of a secure, unquestioned American identity, thinking about gay people could be particularly disquieting. In the next chapter, I will focus more narrowly on just how.

CHAPTER 2

Thinking about Gay People

CIVIL RIGHTS AND THE CONFUSION OVER SEXUAL IDENTITY

Taylor, I never thought I'd spend so much time thinking
about gay people as I have in the last two weeks.

—Bill Clinton, 1993

SHORTLY AFTER TAKING OFFICE in January 1993, Bill Clinton
privately confided to his old friend, civil rights historian Taylor Branch, that
his new job had already been unexpectedly thought provoking.[1] While
Clinton had planned to devote his first days in office to launching the eco-
nomic reforms on which he had successfully campaigned, his agenda for get-
ting Americans back to work would have to wait as he found himself quickly
mired in gay rights politics. His campaign promise to lift the ban on gays and
lesbians in the military became the first high profile and controversial issue for
the inexperienced president, dominating national headlines and press brief-
ings during his first weeks in the White House. If Clinton hoped the topic of
gay rights would quickly go away, he was to be disappointed. The gays-in-the-
military debate would drag on for months, only cooling down the following
fall when "don't ask, don't tell" was finally adopted. Even then, Clinton found
little respite as a newly energized gay rights movement and the aggressive
backlash politics of Christian conservatives kept him thinking about gay
people throughout his tenure. For example, Clinton would have to decide
whether to speak at the Gay and Lesbian March on Washington (he didn't);
whether to add discrimination protection for gay and lesbian federal employ-
ees (he did); whether to take sides publicly in the Supreme Court case involv-
ing the constitutionality of Colorado's antigay Amendment 2 (he didn't); and
whether to sign the Defense of Marriage Act (he did).

Of course, Clinton wasn't the only one forced to spend time thinking
about gay people. Gay rights emerged as the defining civil rights movement of
the early 1990s, and Americans watched while federal, state, and local govern-
ments debated a series of civil rights issues: gays in the military, same-sex

marriage, gay adoption, nondiscrimination legislation, and hate-crime laws. In fact, millions weighed in on such debates themselves by voting in local or state referenda, participating in opinion polls, or reading the flood of mainstream press coverage that dissected gay rights battles. In 1993 the *Atlantic Monthly* announced:"The issue of homosexuality has arrived at the forefront of American political consciousness."[2] And the *Los Angeles Times* declared that "like it or not, gays and lesbians are in the national agenda."[3] In such a context, Straight Americans were forced to think about gay people more than ever before. This chapter explores just how tremendously confusing doing so could be.

Battles over gay rights in the 1990s reflected what might be called the paradox of identity-based civil rights politics. In discussing the legal strategies used to protect minorities from discrimination, critical legal scholars Dan Danielsen and Karen Engle describe an inherent contradiction in civil rights legislation linked to social identity movements: "On one hand, lawyers and activists have sought to design legal remedies for broad classes of disadvantaged groups, focusing on generally drawn status categories to define these groups. On the other hand, these same group remedies have often sought to transcend these categories by making it unlawful to take them into account."[4] Gays and lesbians, for example, may have fought to be treated like everyone else, but they did so by asserting their social difference. And conversely, they demanded acceptance of their social difference in the name of universal human rights. In the 1990s, then, efforts to make categories of sexual identity irrelevant in terms of military service, housing, or employment often made those categories all the more relevant to government legislation, cultural discourse, and people's social identities.

As the most visible civil rights issue of the early 1990s—"*the* movement of the moment" as the *Nation* put it in 1993—gay rights channeled the confusion of an American culture trying to resolve the contradictions between its abiding faith in assimilationism and individual rights and a begrudging acceptance of the nation's deepening diversity and the stronghold of group identities. For a mainstream that had long treasured the idea of the great American melting pot and caught in, as Lauren Berlant puts it, "the antinomy between abstract universality and embodied particularity," equality was gained through conformity;[5] to be treated the same was conflated with being the same. In this context, the assertion of social difference and the demand for social equality was (and remains) difficult to reconcile. As debates over political correctness, multiculturalism, and social fragmentation indicate, America was highly sensitive to these tensions in the early 1990s—just as gay civil rights emerged as a hot political topic. Understandably, gay rights became a site where these contradictions were negotiated.

The paradox of gay civil rights legislation and the inevitable confusion that it generated deepened and in turn were deepened by broader discourses

about sexual identity that were similarly conflicted. Looking at American culture in the 1990s, one can identify two contradictory ways of thinking about the relationship between gay people and straight people.[6] On one hand, a variety of discourses worked to sharpen the social, scientific, and moral distinctions between being gay and being straight. After two decades of the gay and lesbian identity movement, for example, gays and lesbians had emerged as another quasi-ethnic group like Latinos or Blacks—complete with their own sensibility, community centers, and history month. Rainbow-flag paraphernalia identified which bars, cars, and people were gay. Advertisers targeted the gay market. Political analysts tracked the gay vote. In 1993 a *New Republic* cover that read "Straight America/Gay America" proclaimed that the nation itself could be divided into two distinct camps, while multicultural calls to respect social differences highlighted and fortified these boundaries. Meanwhile, the popular press widely reported efforts to find scientific evidence to prove that sexual identity was innate and immutable. Undoubtedly, such discourses reflected and shaped how people thought about sexual identity, helping to socially construct what Barbara Ehrenrich identified as "The Gap Between Gay and Straight." In the minds of most, she explained, "the human race consists of two types of people: there are heterosexuals and—on the other side of the great sexual dividing line—homosexuals."[7]

On the other hand, various discourses worked to blur the distinctions regulating this binary. Queer theorists and historians argued that identity categories like gay and straight were social constructs, not intrinsic essences. Although often highly academic, these critiques of identity gained wider circulation through queer activists who encouraged people to move beyond constrictive labels and through articles in the mainstream press that provided simplified primers on historically specific epistemologies of sexuality. At the other end of the political spectrum, Christian conservatives claimed that gays could become straight if they only tried hard enough and that straights could become gay if they were tempted enough. Despite headlines hyping evidence that sexual identity was biological, the fine print inevitably revealed that scientists still understood little about the nature of sexuality and could offer no guarantees that the etiological line separating homosexuality from heterosexuality was stable. Even though multiculturalism encouraged people to respect difference, assimilationist discourses insisting that gays and lesbians were just like everyone else intensified. Such discourses were made all the more powerful by the fact that sexual identity was uniquely hard to detect. Ostensibly defined by one's desires (not by comparatively obvious markers of difference like skin color, language, or sex), sexual identity could be hidden and imperceptible.

Gay rights debates and the policies, legislation, and court decisions that resulted from them exposed and intensified these two seemingly incongruous

perspectives on sexual identity, serving as sites where they intermingled in profoundly paradoxical ways. This chapter begins by mapping out two important contexts within which specific gay rights debates took place. First, I provide a brief overview of the shifting political context in which an increasingly visible gay rights movement advanced an agenda aimed at integrating gays and lesbians into the mainstream. I then describe new biological research into homosexuality that helped make questions about the nature of sexual identity front-page news. In the rest of the chapter, I analyze the legal logic behind and public discussion surrounding the two most prominent gay rights issues of the period: gays in the military and antidiscrimination legislation. Doing so will make clear just how confounding thinking about gay people was at the time. It will also help us better understand the context within which so much of the gay material on prime-time television circulated. Structured by the paradox of identity-based civil rights politics and by the scientific, political, and social confusion over the nature of sexual identity, these gay rights debates worked to simultaneously sharpen and blur the overlapping legal, moral, and ontological lines separating gay people and straight people. They forced America to repeatedly think about homosexuality, heterosexuality, and the boundary between them. And they articulated America's anxious insecurity about the relationship between the majority and the minority, between the normal and the deviant. In other words, these debates both revealed and contributed to a straight panic.[8]

THE 1992 ELECTION AND THE MAINSTREAMING OF GAY POLITICS

Contemporary observers consistently identified 1992 as a watershed moment for the gay and lesbian movement and its relationship to mainstream America. "Gay issues have emerged from the political closet to an unprecedented degree in this election year," the Los Angeles Times noted that September. "From local and state races to party platforms and the presidential race, gay men and lesbians are more visible than ever as players and as targets."[9] Such changes were perhaps most noticeable in the presidential race. All five Democratic presidential candidates courted the gay vote. At a well-publicized May 1992 fundraiser in Los Angeles, for example, Bill Clinton told an audience of gays and lesbians, "I have a vision of America and you're part of it."[10] During the Democratic convention in July, the entire party seemed to embrace gays and lesbians. AIDS/environmental activist Bob Hattoy and San Francisco supervisor Roberta Achtenberg were loudly cheered when they addressed the convention as openly gay and lesbian Democrats, and the party platform called for an end to the military ban, a proposal for a federal gay and lesbian civil rights bill, and increased resources to fight AIDS. The media seemed fascinated with the strong gay presence at the conference and covered it extensively.

Meanwhile, the Republican Party turned gay rights into a wedge issue. If Clinton was betting a pro-gay stance would appeal to key female and educated suburban swing voters, foregrounding an antigay agenda made demographic sense for Bush, who needed to target non-college-educated men and the South aggressively. Patrick Buchanan's primary challenge and the need to solidify Christian conservative constituents also forced Bush to take a more vocal stand against gay rights than he had earlier in his presidential term. By the time of their convention in August, Republicans made gays and lesbians their latest scare tactic. In 1988 the Republicans had tried to tap into white fears of black criminality in order to brand Michael Dukakis as soft on crime. In 1992, however, lingering memories of the Willie Horton ad scandal and the proximity of the Los Angeles riots made it harder for the Republicans to demonize blacks, leaving them searching for a new threat. The so-called gay rights agenda seemed to fit the bill, offering conservatives a way to paint Clinton as dangerously liberal, agitate resentment about special interest politics, and exploit fears about America's eroding morals. The Christian Action Network, for example, produced a thirty-second television commercial featuring footage of gay protest marches and a voice-over erroneously claiming "Bill Clinton's vision for a better America includes job quotas for homosexuals. Is this your vision for a better America?"[11] Such antigay politics led *Time* magazine to ask, "After Willie Horton Are Gays Next?"[12]

Even more so than the presidential race, intense local and statewide fights over antigay referenda across the country got people to think about gay rights. In such battles, both sides lined up the support of key public figures, went door-to-door with brochures and talking points, and organized extensive print and TV campaigns. In the months leading up to election day, many communities heatedly debated questions that lay at the heart of the gay rights movement: *What impact does the increasing acceptance of homosexuality have on society? Where do we draw the line when individual rights conflict with community values and threaten social unity? Should a government protect the rights of a minority or impose the will of a majority? Are gay rights human rights or special rights?* Given just how pertinent such questions were to the wider social anxieties underlying straight panic, it isn't surprising that such local battles became national news stories.

Election night appeared to signal a huge victory for gays and lesbians. While polling data indicated that the economy was the deciding factor for most voters, the election was also seen as a barometer of the nation's changing attitudes about homosexuality. Key independent voters seemed turned off by the Republicans' political gay bashing, finding it to be not only harshly intolerant but yet another sign of just how out-of-step Bush was with the realities of a changing American culture. In contrast, Clinton's gay-inclusive vision of America passed muster with enough voters to give him a plurality. Like Clinton's own victory, however, (he won 43 percent of the popular vote,

compared to Bush's 38 percent and Perot's 19 percent) the victory for gay rights was far from resounding, and conflicting signs indicated just how divided and ambivalent Americans were on the issue. Although pro-gay forces defeated Oregon's explicitly intolerant Measure 9 by a margin of 56 percent to 44 percent, Colorado's Amendment 2 (which was written to appear less openly hostile to gays) passed 53 percent to 47 percent. Regardless of just how patchy the support for gay rights were, one can't deny that gays and lesbians had achieved an unprecedented level of visibility in 1992.

The experience of 1992 transformed the gay and lesbian movement, shifting its tactics and its public image. The late 1980s had seen a dramatic revitalization of the movement as the gay community mobilized to fight the AIDS crisis, an apathetic administration, and an increase of antigay violence. Grassroots organizations like ACT UP (founded in 1987) and Queer Nation (spun off in 1990) mixed traditional civil disobedience, savvy media manipulation, guerilla theater, and a defiant attitude in an effort to shock Straight America out of its complacency.[13] To the mainstream, this new wave of gay activism was "militant," "angry," "destabilizing," and "in your face."[14] After 1992, however, such confrontational politics seemed to give way to what might be called a politics of access. "Direct action is dead," Torie Osborn, one-time head of the National Gay and Lesbian Task Force, announced.[15] Meanwhile, *Newsweek* declared: "gay power is going mainstream at lightening speed."[16]

While *Newsweek*'s assessment was perhaps an overstatement, it was clear that as gay rights got on the national agenda, new tactics and new leaders emerged. Clinton's victory, in particular, changed the game. Some in the gay movement no longer felt like outsiders shouting to be heard. As Urvashi Vaid, executive director of the National Gay & Lesbian Task Force optimistically declared amid the post-election euphoria, "For the first time in our history, we're going to be full and open partners in the Government."[17] The Clinton campaign, however, revealed that gay issues got attention when gay donors made big contributions. Access was expensive. Thus, with some in the gay movement looking to translate their support of Clinton into a larger presence inside the Beltway, more energy was spent raising money, lobbying Congress, and establishing legitimacy in the eyes of Washington power brokers. The fiery rhetoric and outsider activism of just two years earlier seemed suddenly out-of-date and counterproductive. Under such pressures, the public face of the gay movement began to change. "Fed up with ACT UP, many gay activists are turning away from radical tactics to more traditional ways of making their point," *USA Today* told readers. "Forget about 'outing' the famous, pelting California Gov. Pete Wilson with fruit, or blowing whistles during mass at St. Patrick's Cathedral. The way to be heard now, many insist, is to dash off a letter to a member of Congress."[18] Gay activists, as historian Martin Duberman put it, went from "radicalism to reformism."[19] Images of angry protesters chanting

"We're here! We're queer! Get used to it!" were replaced by photos of suit-clad gay leaders like David Mixner hobnobbing with the likes of Ted Kennedy. Meanwhile, de-centralized, grassroots groups were being pushed aside by national organizations headed by members of the emerging new gay power class—the Beltway "gayocracy" or the upscale "gayoisie," as some observers dubbed them.[20] The Human Rights Campaign, for example, had a multi-million-dollar budget, corporate-style Washington offices, and (by 1995) Apple, Inc.'s former chief litigator Elizabeth Birch as its executive director.

With the growing clout of such new leaders and the intoxicating appeal of the politics of access came changes in the movement's priorities. The gay movement had long been marked by a tension between those advocating a radical politics aimed at fundamentally changing mainstream society and those calling for an assimilationist politics focused on integrating gays and lesbians into the mainstream.[21] By the early 1990s, however, the latter had gained a distinct advantage. In 1997 sociologist Mary Bernstein observed that "the lesbian and gay movement has been altered from a movement for cultural transformation through sexual liberation to one that seeks achievement of political rights through a narrow, ethnic-like interest group politics."[22] Working within the system became more prevalent than working to uproot it. This development was made strikingly clear by the major gay rights battles of the 1990s—most notably gays in the military, same-sex marriage, and civil rights protections. Instead of challenging these institutions, gays and lesbians were fighting to be included in them.

Within the gay movement there was strong disagreement over this development. For some, the change simply reflected the attitudes of an expanding gay community whose rank-and-file members identified with mainstream social values rather than with the radical and separatist sensibilities of the 1970s or the angry, queer activism of the late 1980s. Bruce Bawer, one of a number of newly influential conservative gay critics, argued that those gay leaders who maintained that homosexuality was essentially connected to a radical, leftist politics were holding on to "an anachronistic politics that largely has ceased to have salience for gay Americans today."[23] Others, however, were far more critical of these developments. They argued that the gay movement was being driven by the political economy of national politics and that it increasingly advanced the agenda of those gays and lesbians most invested in the existing social system at the expense of issues pertinent to more marginalized members of the community—sexual and gender nonconformists, gay people of color, or working-class gays and lesbians. Queer activist/theorist Michael Warner claimed that the desire to gain access and respectability led to what he disparagingly called "the politics of normal."[24] Instead of challenging the sexual and gender norms that pathologized gay life, he and others claimed, the gay movement was reinforcing them.

As gays and lesbians increasingly demanded inclusion in rather than toleration by the mainstream, battles over civil rights raised issues as pertinent to the straight majority as to the gay minority. Many of its critics rightly observed that the assimilationist agenda abandoned the goal of overturning heteronormativity—of radically altering society by undoing the complex system of gendered relations and social institutions that privilege certain ways of living. Nevertheless, battles to gain access to mainstream institutions didn't leave the heterosexual mainstream unchanged. According to sociologists Amy Hequembourg and Jorge Arditi, assimilationist strategies "attempt to transform the very foundational field that marks them as others, to change the parameters of civic categories, to erase the differences between same and other by expanding the boundaries of 'same-ness.'"[25] The integration of gays and lesbians into mainstream American life, then, held consequences for what it meant to be gay and straight. In 1993, amid the gays-in-the-military debate and on the eve of the gay and lesbian march on Washington, the *Nation*'s Andrew Kopkind astutely pointed to these consequences. "[The] gay nineties is not only about civil rights, tolerance and legitimacy," he asserted. "What started tumbling out of the closet at the time of Stonewall is profoundly altering the way we live, form families, think about and act toward one another, manage our health and well-being and understand the very meaning of identity."[26]

Faced with a gay minority increasingly demanding that its difference be respected even as it tried to integrate into the mainstream, segments of Straight America resisted strongly, handing the gay movement several big losses. Although gays technically were allowed in the military, for example, "don't ask, don't tell" forced them to stay in the closet—deep in the closet. Despite several court rulings that declared the ban on same-sex marriage to be unconstitutional, the Defense of Marriage Act pushed the battle for same-sex marriage rights back for several years. Just months after the Supreme Court declared Colorado's antigay Amendment 2 unconstitutional in 1996, Congress voted against a law that would have given gays and lesbians federal protection against employment discrimination. Such losses, of course, don't mean that the battles themselves failed to alter the way people thought about sexual identity. On the contrary, the often anxious efforts to keep gays and lesbians at bay reveal just how disquieting gay rights were to Straight America. In the early 1990s, civil rights debates were made all the more unsettling and confusing by reports that raised questions about the nature of sexuality and desire.

UNDERSTANDING THE NATURE OF SEXUAL IDENTITY?

In March 1993, as gays and lesbians prepared to march on Washington, the *Atlantic Monthly* ran an in-depth article that promised: "An introduction to a muddled and sometimes contentious world of scientific research—one

whose findings, now as tentative as they are suggestive, may someday shed light on the sexual orientation of everyone."[27] In the early 1990s, new research into the biology of homosexuality and the growing visibility of gay rights issues helped make the nature of sexuality front-page news. It was something people read about in the pages of their morning newspaper, heard about on the evening news, and likely thought about more than ever before. The February 24, 1992, cover of *Newsweek*, for example, featured an extreme close-up of a newborn's face. The headline asked: "Is This Child Gay? Born or Bred: The Origins of Homosexuality."

At first glance, it seemed as though this new science of homosexuality might finally provide an explanation for what sexual orientation is. Unlike racial or sexual difference, sexual identity has no visible marker and can't be easily linked to identifiable genetic factors.[28] It's exasperatingly elusive, existing somewhere between desire, behavior, and identity—between how people feel, what they do, and who they are. Opinion polls repeatedly show that Americans hold widely differing views about the nature of homosexuality, heterosexuality, and the boundary between them. Some are convinced that people are born gay, others that people are raised gay, and still others that people choose to live a gay lifestyle. While many believe that gays and straights are effectively separate species, many others believe that gays can change their sexual orientation though therapy or prayer and that heterosexuals can be lured into same-sex behavior. And a few believe that we are all just a little bit bisexual.

Such differing views on the nature of sexual orientation, of course, have been shaped by a wide variety of long-standing discourses about homosexuality—religious doctrines (that claim that same-sex sex is willful sin), Freudian concepts (that claim that everyone is born bisexual), the Kinsey scale (that claims that sexuality exists on a continuum), personal testimony (that often claims that homosexual feelings are natural and involuntary), identity-politics rhetoric (that claims that being gay is as much beyond an individual's control as the color of his or her skin at birth), and social theories (that claim that categories of sexuality are social constructs). Together, such discourses produced extremely confusing and contradictory perspectives on the nature of sexual identity. If anyone hoped that the new science of homosexuality would clarify the matter, they must have been disappointed. While the hoopla over evidence of a gay gene may have gotten everyone talking about the nature of sexual orientation, the actual findings and the wave of media coverage that followed very likely only added to the confusion. In particular they produced contradictory discourses that simultaneously sharpened and blurred the boundary between homo- and heterosexuality.[29]

On September 9, 1991, all three of the nation's major weekly newsmagazines reported new research that identified a difference between the brains of heterosexual and homosexual men. *Time*'s headline asked, "What

Causes People to Be Gay?" Similarly, *U.S. News & World Report* wondered, "Are Some Men Born to Be Homosexual?" and *Newsweek* asked, "Are Gay Men Born That Way?" The study, headed by Simon LeVay, a neurobiologist at the Salk Institute and published in the technical journal *Science*, had studied the brains taken from forty-one cadavers—19 presumed to be from homosexual men, 16 from heterosexual men, and 6 from heterosexual women. LeVay found that a group of neurons in the hypothalamus, the part of the brain associated with sexual behavior, was more than two times larger in the straight men than in the gay men. Although often criticized for the limitations of its methodology, LeVay's report received widespread coverage because it represented a new way of studying sexual identity. Whereas previous research into the causes of homosexuality had been grounded in psychology and focused on early childhood development (e.g., over-protective mothers and emotionally distant fathers), LeVay claimed to uncover concrete physiological evidence of sexual orientation.

Over the next few years, various studies in neuroanatomy, psychoendocrinology, and genetics added to the growing body of evidence linking sexual identity to biology. Only months after LeVay's study, Michael Bailey and Richard Pillard published a study of gay men and their brothers that claimed to have found evidence that homosexuality was hereditary. When one brother was gay, researchers found, there was a 52 percent chance that an identical twin was gay as well. The probability was only 22 percent for fraternal twins and just 11 percent for an adopted brother. According to Bailey, such statistics follow "genetic logic" and suggest that nature, more than nurture, determines sexuality.[30] The prospect of discovering a so-called gay gene gained further prominence with the widely publicized findings of a July 1993 study headed by Dean Hamer at the National Cancer Institute's Laboratory of Biochemistry. Hamer's team examined the genes of forty pairs of gay brothers and, according to *U.S. News & World Report*, found evidence to suggest "with more than 99 percent certainty that the sexual orientation of the men was genetically influenced."[31]

In certain ways, such studies and the widespread media coverage of them helped to sharpen the line between homo- and heterosexuality. They did so, for example, by identifying observable and measurable physical differences between gay and straight people (or at least between gay and straight men, since women and lesbians were largely absent from these studies—although often not the popular interpretations of the studies). All three mainstream press articles on LeVay's findings, for example, included diagrams of the human brain with graphics pinpointing the exact location of the hypothalamus, helping the reader *see* just where gays and straights differed. When asked what the significance of LeVay's findings were, one expert answered: "The important [point] is that several independent studies have shown that various

brain structures are different between people of different sexual orientations."[32] Such evidence of embodied difference (even if it was only on the cellular level) was an important development in notions of sexual orientation—a social identity historically defined by desire and behavior (as opposed to visible markers of difference like skin color or sex-specific body parts). Science seemed to prove that gay men's brains at least were different than straight men's brains.

Perhaps even more importantly, such studies suggested that sexual orientation wasn't simply reflected in but was, in fact, caused by biology. In a context where many people believed that differences rooted in biology were more natural and immutable than those rooted in culture, widely reported evidence of a gay gene increased the gap between gay and straight people even more. According to this logic, being gay was a question of genetic destiny, not individual choice. With different DNA, gays (and presumably lesbians), it seemed, were an objective and separate category of humans. Testimony from some gay men and lesbians dovetailed neatly with this view of sexual orientation as biologically determined. "I don't honestly think I chose to be gay," Rich Gordon told *Time*. "I always believed that homosexuality was something I was born with."[33] As a 1992 article in the *Nation* pointed out, the ability of such findings to stabilize categories of sexual identity seemed to strike a cord. "Every major paper in the country headlined the discovery smack on the front page, along with more eminent news like the breakup of the Soviet Union," the author observed. "[W]hat was by far the most ecstatically reassuring—at least to many—was that what had sometimes seemed like a fuzzy line between gay and straight was now certified as biologically inviolable."[34]

In other ways, however, such studies and the media coverage they generated actually worked to blur the "inviolable" line between homo- and heterosexuality. Articles may have lured readers in with headlines and teasers that touted provocative evidence of biological determinism, but they always ended up raising more questions about the nature of sexual identity than answers—a fact signaled by the question marks attached to so many of the articles' titles (e.g. "Born Gay?" "Does DNA Make Some Men Gay?"). Once scrutinized, the findings proved far from conclusive. Although the fact that 52 percent of identical twin brothers were both gay suggested a genetic link, the fact that 48 percent of identical twins in the study had different sexual orientations made clear that genes weren't always destiny. In reviewing the findings, the *Atlantic Monthly* offered its readers a primer on "heritability"—a rating geneticists use to indicate "how much genes have to do with a given variation among people." While eye color is 100 percent determined by genes, height is only 90 percent genetic (the other 10 percent being influenced by nutrition). Calculations suggested that homosexuality was only 70 percent genetic.[35]

In other words, ostensibly straight people could be walking around with a gay gene that, for whatever reason, wasn't triggered. Such a theory could leave some straight people thinking about the nature of the line between their heterosexuality and what they had always assumed was someone else's homosexuality. As if to encourage just such a thought, *Newsweek* opened its in-depth cover story on the science of sexual orientation by describing the experience of Doug Barnett:

> Until the age of 28, Doug Barnett was a practicing heterosexual. He was vaguely attracted to men, but with nurturing parents, a lively interest in sports and appropriate relations with women, he had little reason to question his proclivities. Then an astonishing thing happened: his identical twin brother "came out" to him, revealing he was gay. Barnett, who believed sexual orientation is genetic, was bewildered. He recalls thinking, "If this is inherited and we're identical twins—what's going on here?" To find out, he thought he should try sex with men. When he did, he says, "The bells went off, for the first time. Those homosexual encounters were more fulfilling."[36]

Of course, Doug's story reinforces the idea that sexual orientation is, in the end, part of one's intrinsic make-up. That "bells went off" suggests that he had found his true identity—the one determined by his genes. Yet, the fact that he had been a relatively happy heterosexual man for almost thirty years draws into question the mutual exclusivity of straight and gay identity, and raises the idea of a hidden gay gene waiting to kick in—a genetically determined latent homosexuality.

Researchers themselves often acknowledged the tentative nature of their findings. Reports emphasized that most experts believed that sexual orientation was the product of a complex mix of biology and environment, of nature and nurture. Dean Hamer, for example, admitted, "I know it's not all genetics and biology but I don't know what the rest is, and no one else does either."[37] In fact, if media coverage of the new science of homosexuality did anything, it made clear that, despite all of their efforts, experts actually knew very little about the "mystery" of sexual identity.[38] In 1998 biologist Evan Balaban told *Newsweek*, "I think we're as much in the dark as we ever were."[39]

Many media reports, in fact, included evidence that, despite mounting research into a biological link, sexual orientation was actually highly mutable and more complex than a gay/straight binary would allow. After citing research that estimated that a third of American men had homosexual experiences as teenagers, for example, *Time* concluded, "Clearly, even if sexual orientation does have a biological basis in the brain, it is not necessarily fixed."[40] Similarly, a *Redbook* article took the fluidity of sexual orientation as a given,

stating, "Of course, sexuality isn't fixed, like eye color. It can change over time. *Anytime*."[41] Media coverage of bisexuality, in particular, challenged the clear distinctions between gay and straight. *USA Today*, for example, asked its readers to question their own assumptions about sexual identity: "After all, the prevailing '90s view is that we're all destined for one sexual orientation or another. A gene here, a prenatal hormone there, a soupçon of early childhood experience and voilà, you're a heterosexual or a homosexual. You know who you're attracted to and who might be attracted to you. But what if, for at least some people, sexual orientation is a fluid, changeable thing?"[42] Other articles seemed to ask readers to question their own sexual identity. A bold-font pull-quote in a *Newsweek* article entitled "Bisexuality: What Is It?" for example, declared: "Freud said that we're all bi; he thought that exclusive heterosexuality was 'a problem.'"[43] Similarly, *Time* claimed, "In truth, sexual identity is a complex weave spun of desire, fantasy, conduct, and belief. . . . Even defining one's own sexual orientation can be difficult."[44]

Media interest in the new science of homosexuality encouraged those with alternative views to get their opinions out there, making for an even more confusing discussion. Writing in magazines like *Commentary* and *National Review*, E.L. Pattullo, a retired Harvard psychologist, offered a con-servatively spun, Kinsey-inspired perspective that counters notions of bio-logical determinism by emphasizing the role that environment plays in the development of sexual identity. According to Pattullo, homo- and heterosexuality exist on a continuum. While some people are exclusively straight and some exclusively gay, Pattullo argues, "it is clear that many people have a capacity for becoming either straight or gay."[45] He refers to such people as "waverers." The fact "there is a bit of the waverer in so many of us," he asserts, explains why so many people, even "those who abhor the mistreatment" gays have suffered, continue to feel uncomfortable with homosexuals. "Often straights are threatened not because gays are so different, but because they are so similar," he states. "Some straights are quite conscious of having homosexual proclivities and are fearful of undermining their predominant heterosexuality. Others unconsciously share the same fear."[46]

A lengthy 1993 *U.S. News & World Report* article entitled "Intimate Friends" circulated ideas that problematized the new science of homosexuality by offering readers an introduction to the social constructionist view of sexual identity. "History shows that the lines between 'straight' and 'gay' sexuality are much more fluid than today's debate suggests," a teaser headline announced.[47] For many historians, the article explained, sexual identity is neither an intrinsic part of people's true selves nor a product of DNA or early childhood parenting. Instead, it is a concept that a specific culture constructs at a specific time that then shapes how people make sense of their world and themselves.

> Every era clings to the belief that the way it views the world reflects not
> the influence of culture and location but the way the world is. In the
> most intimate area of life, in questions of what behind bedroom doors is
> acceptable or frowned upon, of what sexuality means and how it is
> expressed, such convictions gain particular force. Yet historians ... do not
> see a fixed scene but a moving landscape, a shifting of boundaries and def-
> initions that defies contemporary labeling.[48]

The article went on to survey different ways in which same-sex sex and
amorous same-sex feelings were understood in different historical and cul-
tural contexts (e.g., the idea of "eros" in ancient Greece, intimate friendships
in nineteenth century America). It also described our current notions about
sexuality (i.e., that people have a built-in sexual identity, either homosexual
or heterosexual, that is part of their true essence) as a product of modern psy-
chiatry and civil rights movements. By suggesting that sexual identity is
merely a cultural illusion, such arguments further muddled the debate over
the nature of homosexuality, heterosexuality, and the boundary between
them.

Political battles over gay rights understandably involved epistemological
battles over homosexuality. Many, for example, believed that establishing the
biological etiology of sexual orientation would make more people feel com-
fortable supporting equal rights for gays and lesbians. "In the long run, I
believe science will be helpful overall, especially taking away the stigma that
being gay or lesbian is a choice," Simon LeVay stated. "The evidence is com-
ing in that this is not a choice. It's what one is given."[49] For others, the inde-
terminacy of sexual identity was a clear rationale for discriminatory policies
against gays. Pattullo, for example, argued that society should maintain legal
and social distinctions between heterosexuality and homosexuality in order to
dissuade waverers from slipping into homosexuality. At a time when gays and
lesbians were fighting to "to change the parameters of civic categories," find-
ing evidence of distinct and stable parameters in nature or the body offered a
certain compensatory reassurance that difference between straight people and
gay people remained. However, the ontological mystery about what sexual
identity was—the "ineffable nature of our psychosexual selves" as the *Atlantic
Monthly* put it—only deepened the anxious confusion prompted by efforts to
end discriminatory social policies that had long marked gays and lesbians as
different.[50] Furthermore, at a time when American culture was grappling
with multiculturalism, the politics of social difference, and the increasingly
problematic nature of the boundary between the majority and various
minorities, gay rights issues channeled and exacerbated America's growing
straight panic. In the next section, I will examine how the gays-in-the-
military debate in 1993 did just that.

GAYS IN THE MILITARY

In the closing weeks of 1992, Clinton, the U.S. military, and Congress were gearing up for a major battle—one that would last well into 1993. Even before he moved into the White House, Clinton's campaign pledge to repeal the military's ban on homosexuals with one stroke of the executive pen became his first real political skirmish. While the president-elect's transition team was reportedly busy drafting an executive order to repeal the ban, rumblings from the Pentagon made their way into the media, which widely quoted military personnel adamantly opposed to the proposed policy change. Pressure increased when, just days after the election, a U.S. District Court ordered the Navy to reinstate Keith Meinhold, a petty officer who had been discharged in August after having announced on television that he was gay. Meanwhile, supposed Clinton ally and Senate Armed Services Committee Chair Sam Nunn warned Clinton that his plan to change military policy would meet with strong resistance in Congress—even one controlled by his own party.

The fight really intensified, however, in the last two weeks of January 1993. With Clinton now empowered to sign his executive order, the debate was no longer academic. On January 25, congressional offices were deluged with phone calls voicing support for the ban, and veterans' groups organized a media campaign that predicted negative consequences if gays were allowed to serve openly in the military. Within days, congressional resistance broke out into an open revolt. Sensing voters' unease over the issue and anxious to undermine the authority of both the inexperienced president and the Democratic majority in Congress, Republicans threatened to push through legislation that would preempt Clinton's executive order by writing the military's ban on gays and lesbians into law. The opposition was particularly vehement. In a statement typical of Republican rhetoric, Senator Phil Gramm declared, "We're not going to let politics destroy the greatest Army in the world."[51]

Unfortunately for Clinton, enough conservative Democrats like Nunn opposed his plan that the Republican legislation had a real chance of passing. Such a defeat in the opening weeks of his tenure would make the young president look ineffective. In order to avoid such embarrassment, Clinton struck a deal with conservative Democrats on the hill. On January 29, Clinton announced that he would postpone drafting an executive order until July 15—a six-month delay that would allow time for consultation with military and congressional leaders and concerned citizens and for further study to assess the so-called practical problems involved with lifting the ban. In exchange, the military would stop asking recruits about their sexual orientation and suspend discharge cases based solely on a service members' sexual orientation. While the six-month waiting period temporarily got Clinton out

of a political minefield, it extended the public debate in ways that magnified the cultural importance of the issue.

The gays-in-the-military debate became one of the highest profile political and social issues of 1993. It was the stuff of Sunday morning talk shows and late-night comedy monologues. *Nightline, Dateline,* and *60 Minutes* covered it. So did political cartoonists. It was the lead story on the evening news and the cover story in *Newsweek* and *National Review.* Over the course of six months, daily newspapers reported every twist and turn in a drawn-out process that generated no shortage of tie-in stories. On March 29, the Senate Armed Service Committee began hearings filled with impassioned testimony, acrimonious questioning, and plenty of media-ready sound bites. Senators even made photo-op-ready trips to military bases to hear directly from the troops. Not to be left behind, the House held its own hearings in May. Meanwhile, several decorated service members like army sergeant Jose Zuniga and marine sergeant Justin Elzie came out of their military closets in carefully planned media events. A navy investigation into the murder of Allen R. Schindler by shipmates who had believed he was gay made gripping headlines that spring. And throughout that process, people eager to comment on the debate filled the media. Gay activists, think-tank intellectuals, religious leaders, military historians, veterans, legal scholars, former military brass, and publicity-hungry politicians all jostled for camera time.

On July 19, Clinton tried to put this lengthy debate to rest when he announced an "honorable compromise" that allowed gays and lesbians to serve in the military as long as they remained in the closet. Dubbed "don't ask, don't tell," the policy stated "a person's sexual orientation is considered a personal and private matter and is not a bar to service unless manifested by homosexual conduct." In defending the compromise, Clinton argued that it marked a real improvement over the old directive, which had maintained that "homosexuality [was] incompatible with military service."[52] In line with this new attitude, military officials were not to ask recruits about their sexual orientation or engage in aggressive witch-hunts to ferret out closeted homosexuals. The policy would go on to define homosexual conduct so broadly, however, that it included not only engaging or attempting to engage in homosexual acts but also simply stating that one was homosexual. Meanwhile, the don't-ask provisions were extremely vague. Despite White House efforts to frame the policy as "don't ask, don't tell, don't pursue," procedural loopholes allowed commanding officers to continue to aggressively investigate service members' private lives in order to assess their sexual orientation. That September, Congress passed legislation that made the Defense Department policy federal law and added language more critical of the presence of gays in the armed forces. Clinton signed the measure with no fanfare and little public attention. The Pentagon, the White House, and Congress seemed satisfied and moved on.

Although the gays-in-the-military debate receded from the national spotlight by the end of the summer, the issue would linger throughout the 1990s. Gay activists worked hard to expose the continued harassment of gays and lesbians by a military that continued to both ask and pursue, and stories about the increase of old-fashioned witch hunts periodically appeared in the press. Meanwhile, the debate shifted to the courts, where several cases worked their way through the appellate system—each verdict reminding the nation that the issue wasn't fully settled. Court opinions were inconsistent. Some found that the policy violated both free-speech and equal-protection guarantees while others upheld the government's right to limit freedoms in the interest of national security. While never ruling definitively on the policy, the Supreme Court repeatedly rejected appeals that would have overturned it. The debate also shifted to the realm of popular culture where it became the stuff of made-for-TV movies. Like a *Seinfeld* catchphrase, "don't ask, don't tell" entered the cultural lexicon as something of a running joke—an apparently clever way to reference not only the cultural dynamics of the closet but also the general politics of denial.

While "don't ask, don't tell" may not have significantly changed the military's treatment of gays and lesbians, the debate over the policy did force the nation to stop and discuss gay rights in a way and to an extent it rarely had before. But just what was being said about gays and lesbians? What kinds of arguments did opponents and supporters of the ban make? And what did the final policy have to say about gay rights in America? In the next sections, I analyze the public discussion surrounding the gays-in-the-military debate in order to better understand how America thought about gays and lesbians, categories of sexual identity, and the politics of difference. On balance, the debate channeled the nation's emerging straight panic—its growing anxieties about multiculturalism, the threat of social fragmentation, and the contentious boundary between homosexuality and heterosexuality. Before I discuss the ways in which the gays-in-the-military debate exacerbated this straight panic, however, I want to start by addressing the ways in which it revealed the persistent power of male homosexual panic.

Homosexual Panic in the Military

Some of the most inflammatory rhetoric and sensational images of the gays-in-the-military debate tapped into homophobic ideas about homosexual deviancy, unwanted gay advances, and justifiable antigay violence. Resuscitating age-old discourses about homosexuality as a mental illness, some supporters of the ban described gays soldiers (usually though not strictly assumed to be male) as somehow defective. "Whatever the army makes right on gays, it won't be right for the grunt," a squad leader from the 82nd Airborne told *Newsweek*. "If a dude has a flaw, he'll fold."[53] More often, antigay conservatives

described gays as menacing perverts whose sexual desires threaten the safety of straight soldiers. One *Forbes'* essayist, for example, invoked the specter of predatory gay male soldiers cruising communal bathrooms. "When you can't even go to the toilet without being a witness to or target of homosexual activity," he argued, "we are no longer talking about how someone does his job."[54] A letter to the editor of the *Humanist* also tapped into fears about the gay advance, updating it in the process. "Mr. Miletich accuses servicemen of being 'afraid of homosexuals.' Why should they not be?" the author asks. "Most of the time nothing will happen, but I would not bet my life on the self-control of an 18-year old, especially when he is drunk or half asleep. The fear is not only of a traumatic, loathsome experience but, with AIDS prevalent, of death."[55] Meanwhile, reports claimed that military officials had shocking surveillance footage of soldiers having sex in a latrine at the Fort Hood army base—evidence to prove just what sex-hungry gay men would do.

News reports reinforced this discourse by describing what experts claimed to be the unavoidable realities of military life. Repeated coverage of the "the lack of privacy and forced intimacy" of army barracks and navy ships subtly and not so subtly painted a picture of environments where gay perverts could easily make unwanted advances on unsuspecting troop-mates.[56] "On the Land, 90 women share four showers and four toilets," the *New York Times* reported. "On the Montpelier, most of the all-male crew sleeps in triple bunks by a corridor two feet wide."[57] Making sure its readers got the point, *Newsweek* included a photograph of Senators John Warner and Sam Nunn touring the cramped sleeping quarters of a naval submarine.[58] The vulnerability of straight soldiers to homosexual attack was perhaps most effectively and most frequently conjured up by references to public showers. In fact, television newscasts at the time often wallpapered stories about the debate with stock video footage of naked soldiers filing into gang showers.

Not surprisingly, such discourses about the possibility of unwanted gay sexual advances were often accompanied by threats of antigay violence. Predictions about the likelihood of gay-bashings if the ban were lifted became a common element in coverage of the debate. John Kaiser, a twenty-two-year-old airman, for example, told the *New York Times*: "If they let gays in the military, there are going to be physical outbreaks."[59] Jason Puderbaugh, a twenty-one-year-old airman, echoed such sentiments, warning, "People are going to go after them [gays] physically."[60] Testifying before the Senate Armed Services Committee in early May, Marine Corps Colonel Fred Peck admitted that he would fight to keep his openly gay son from joining the military, because he knew the dangers his gay son would face. While such comments drew public attention to the likely possibility of homophobic fratricide, the sentencing hearing of Airman Apprentice Terry M. Helvey just two weeks after Peck's testimony drew attention to its reality. Widespread media cover-

age described the details of how Helvey had brutally murdered Seaman Allen R. Schindler the previous fall. It also quoted naval investigators who recounted Helvey's complete lack of remorse for murdering a shipmate he believed was gay. When interrogated, Helvy reportedly said that he was "disgusted by homosexuals" and that the victim "deserved it." "I don't regret it," he admitted, "I'd do it again."[61] Statements like Helvey's as well as those by the likes of Kaiser and Puderbaugh treated antigay violence as a matter of course—the logical and inexorable consequence of lifting the ban.

Discourses about the uncontrolled sexual desires of gay (usually male) soldiers and the uncontrollable violent responses of their straight troop-mates revealed a mind-set still caught up in male homosexual panic. Obviously, the ban on gays and lesbians was important to a military culture anxious to establish and police the fuzzy boundary between intimate male bonds and same-sex desires. In general, however, such discourses were often bracketed off in the national debate. As I will detail below, many official participants who supported the ban (e.g. Pentagon leaders, members of Congress) carefully distanced themselves from the most homophobic elements of the logic. Similarly, although mainstream press coverage often included quotes and images that reinforced such discourses, it usually emphasized how out-of-step the military's attitudes were with the mainstream or how unique the conditions of military life were. Nevertheless, such discourses likely reflected or reinforced many people's attitudes about gays and lesbians. For many, homosexuality remained something to be battled against, prohibited, and condemned at every turn.

Straight Panic and the Military

Clinton's proposal to lift the ban, however, produced another set of discourses that spoke to a different set of social anxieties. The lengthy, public discussion over "don't ask, don't tell" revealed and intensified American culture's emerging straight panic. Testimony on the need to balance the rights of gay and straight soldiers, warnings about the loss of unit cohesion, and the frantic effort to write a policy that simultaneously conflated and separated status and conduct focused and magnified Straight America's confusion about categories of sexual identity and its anxieties about the accelerating politics of social difference. As I argue below, this confusion was deepened and the stakes of the debate were raised by the perceived instability of sexual orientation and desire. First, though, I want to examine how the debate offered Straight America something of a politically-incorrect dream scenario. At a time when multiculturalism asked dominant social groups to fess up to and atone for various histories of discrimination, "don't ask, don't tell" gave Straight America the chance to acknowledge homophobic prejudice but refuse to do anything about it.

A key outcome of the gays-in-the-military debate was the recognition that straight soldiers carried at least some burden of responsibility for the ban. According to the Pentagon, gays and lesbians had always been barred from military service because something was wrong with them. Introduced during World War II, the ban was originally founded on sodomy laws, the belief that homosexuality was a mental disorder, and the assumption that gays were greater security risks. Stereotypes of gay male effeminacy and Cold War discourses linking homosexuality to communism and moral turpitude made the ban seem commonsensical. In 1981 the Pentagon drafted a new policy, which offered yet another rationale for barring gays and lesbians (i.e., they would be dangerously disruptive to unit cohesion and military effectiveness). "[H]omosexuality is incompatible with military service," the directive maintained. "The presence in the military of persons who engage in homosexual conduct seriously impairs the ability of the military services to maintain discipline, good order and morale."[62] By the mid-1980s, fears about AIDS-inflicted gay soldiers on battlefields, in foxholes, and in showers only worked to underscore the idea that gays and lesbians had no right being in the armed services.[63]

The intense public debate over the ban, however, forced America to think more carefully about just why gays and lesbians were barred from service— exactly what threat did they pose to military effectiveness? On balance, this process implicated straight as well as gay soldiers. Residual arguments about gays and lesbians being somehow innately unqualified for military service never really gained credibility in the mainstream discussion. Neither did warnings about a gay-fueled AIDS epidemic.[64] Although some military officials did describe homosexuality as a "moral virus" and gay soldiers as "walking depositories of disease," most major public figures had, by the early 1990s, come to appreciate the value of at least seeming to respect cultural diversity and distanced themselves from such blatantly intolerant statements.[65] Thus, supporters of the ban often acknowledged that there was nothing inherently wrong with gay people. During the Senate hearings on the issue, for example, Captain James Pledger testified, "I do not think there is any physical or mental or any other difference in [homosexual] capabilities compared with the heterosexual."[66]

Discourses about the dangers of gay service members' uncontrollable sexual behavior were more prevalent. However, the debate and the eventual policy drew those claims into question as well. No one on either side of the issue, for example, could deny that thousands of gays and lesbians had served honorably over the years. In fact, General Colin Powell, the chairman of the Joint Chiefs of Staff and an adamant supporter of the ban, told the House Armed Services Committee that gay and lesbian service members were "proud, brave, loyal, good Americans."[67] Such comments were reinforced by the widely publicized stories of decorated, gay military personnel discharged after years

of exemplary service. In newspaper profiles and television interviews, gay and lesbian service members like Colonel Margarethe Cammermeyer (a twenty-three-year veteran with a Silver Star) and Sergeant Jose Zuniga (the Sixth Army's Soldier of the Year in 1993) could not have better represented the well-disciplined soldier the Pentagon worked so hard to produce. By eventually agreeing to a policy that allowed closeted gays and lesbians to serve in the military, both the Pentagon and opponents in Congress indicated that gays and lesbians in and of themselves didn't pose a risk to straight soldiers or unit effectiveness. If gays and lesbians weren't dangerous deviants, where then did the problem lie?

The debate ended up turning the spotlight onto the armed forces' heterosexual members. With carefully crafted wording, the 1981 directive had worked hard to erase straight service members' accountability for any erosion of "discipline, good order, and morale" created by the presence of gay people. The 1993 debate, on the other hand, reframed the issue by highlighting the anxieties and prejudices of the heterosexual majority. In announcing the "don't ask, don't tell" policy, for example, Clinton pointed out a fact that news reports, congressional hearings, and the final compromise had made quite obvious—namely that "those who oppose lifting the ban are clearly focused not on the conduct of individual gay service members, but on how non-gay service members feel about gays in general and in particular those in the military service."[68] *Time* magazine nailed the point even more succinctly. "The military case against openly permitting homosexuals is, in essence, that they will cause discomfort to the heterosexual majority already in place."[69] Much of the discussion, then, focused not on what gays and lesbians did, but on how straight soldiers felt about what they did. It implicated their prejudice. "If a crew's morale suffers, who is to blame?" *U.S. News & World Report* asked, "The homosexual or the other members of the team who resent the homosexual?"[70] This shift—from unproblematicly blaming the stigmatized Other to considering the majority's liability in perpetuating social discrimination—raised the very kind of issues and anxieties the mainstream was forced to grapple with in the multiculturally aware 1990s.

The gays-in-the-military debate revealed a heterosexual majority that saw itself as the victim of minority gay activism and spoke to a wider American culture preoccupied with identity-based civil rights politics. Predictably, Clinton and his supporters argued that lifting the ban was simply a question of granting gays and lesbians their civil rights. Opponents, however, claimed that doing so would deny straight soldiers theirs. Testifying during the Senate hearings, for example, General H. Norman Schwarzkopf asked, "What about our troops' rights? Are we really ready to do this to the men and women of our Armed Forces . . . simply to force our servicemen and women to accept a lifestyle of a very well-organized, well-financed, and very vocal, but what

'DEAR MOM. WELL, HERE I AM IN THIS FOXHOLE WITH MY TWO BUDDIES, LURLENE
AND BRUCE. I DO NOT APPEAR TO BE IN ANY IMMEDIATE DANGER...'

1. This political cartoon from the June 26, 1993, issue of *The Economist* succinctly exposed the straight panic stirred up by the gays-in-the-military debate and the wider politics of difference by acknowledging and mocking the presumably straight, white soldier's anxiety as he finds himself in an integrated foxhole with his buddies—a presumably gay (white) man and a black woman (OLIPHANT©1992 UNIVERSAL PRESS SYNDICATE. Reprinted with Permission. All rights reserved).

turns out to be a very small minority?"[71] Pro-ban advocates identified a litany of rights—privacy, religious, free speech—that the heterosexual majority were being asked to forfeit. Testifying before the House Armed Services Committee, retired Marine Colonel John Ripley brought such backlash rights rhetoric to its illogical conclusion: "Does the normal person, the heterosexual person, the overwhelming majority, the 98 to 99 percent of the Americans in or out of military, do they have a right to normalcy?"[72] As *Time* observed, the military saw itself as "an embattled minority culture" misunderstood by the rest of society—a bastion of traditional, Christian values amid a culture increasingly dominated by cultural relativism and a loss of moral standards. The debate over the ban enabled straights to simultaneously demand majority rule and claim victim status.

It also served as a site where America's anxieties about social fragmentation and the loss of faith in the value of a unified American identity played out. The fundamental rationale behind "don't ask, don't tell" was that the presence of openly gay and lesbian service members would destroy unit cohesion—a term *Newsweek* defined as "the ability of men and women of sharply differing social backgrounds to live together and work together."[73] According

to the Pentagon, building unity was essential to military effectiveness. Soldiers had to subsume their individual and group identities and interests to those of the unit. "The most important thing we do with soldiers is try to bind the force together," a senior officer told *U.S. News & World Report.* "On the battlefield it's the commitment to the team that carries the day."[74] At a time when identity politics and multiculturalism were asking the rest of America to appreciate diversity, military officials insisted on the value of uni-culturalism and reframed difference as dangerous. Since so many straight service members were so intensely uncomfortable with homosexuality, the logic went, the presence of openly gay and lesbian troops would tear the team apart, put soldiers' lives at risk, and undermine national security. Officers repeatedly warned that lifting the ban would make it impossible to build trust and community. "[T]he introduction of an open homosexual into a small unit," Schwartzkopf testified, "immediately polarizes that unit and destroys the very bonding that is so important for the unit's survival in time of war."[75] Major Kathleen G. Bergeron agreed: "Heterosexual marines will choose not to live, socialize or recreate with homosexuals."[76] In the heat of the debate, in fact, many straight service members announced that they would leave the military if gays were allowed in, and some experts predicted that a gay-inclusive military would cripple recruitment efforts, perhaps making it necessary to reinstate the draft. In a period when they were being forced to adapt to a new world order, to smaller post–Cold War budgets, and to women in combat, the armed forces claimed to be at a breaking point. "How much change can one organization stand?" one senior officer asked. "Can we still hold the organization together, so that when the president wants to send troops to the next Somalia or Bosnia, we're trained and ready?"[77]

The rhetoric of unit cohesion declared that the rights of a gay minority were incompatible with the common good. "In short," *U.S. News & World Report* explained, "the battle is equality versus order, the rights of gays versus the rights of individual soldiers and the military as a whole."[78] The rhetoric proved effective. "Don't ask, don't tell" acknowledged that gays and lesbians could be valuable members of the armed services but only if they kept their identity a secret. The underlying logic, of course, sanctioned justifiable discrimination and directly contradicted the multiculturalist argument that embracing diversity strengthened a culture. Although the rhetoric of unit cohesion relied on the uniqueness of the military (i.e., the importance of its mission, the special conditions of military life), it most likely resonated powerfully with a mainstream American culture still highly ambivalent about multiculturalism and social fragmentation. Because of the privileged status of the armed forces, the gays-in-the-military debate legitimated antimulticultural discourses in a way that few debates in the early 1990s did. And by recognizing the straight majority's antigay prejudice and deferring to it, "don't

ask, don't tell" authorized the kind of blatant discrimination increasingly pro-
hibited in civilian life. Considering just how preoccupied American culture
was with the politics of social difference and the contentious and increasingly
unstable relationship between the majority and various minorities at the time,
it shouldn't be surprising that a debate over lifting the ban would become
such an emotionally charged issue and that the final "don't ask, don't tell"
policy would be so polarizing. For those resentful of multiculturalism and
what they saw as the loss of cohesive values and culture, the policy was a com-
pensatory victory. For those who supported a multicultural appreciation of
diversity, it seemed an illogical mess.

The Line Between Gay and Straight in the Military

Finally, I'm interested in how the gays-in-the-military debate exacerbated
America's confusion regarding categories of sexual identity—specifically the
relationship between homo- and heterosexuality. The highly public discussion
produced certain discourses that worked to sharpen the distinctions between
gay and straight, others that worked to blur it, and still others that simultane-
ously did both. The debate mediated the culture's conflicting ideas regarding
the nature of sexual identity. Contradictory beliefs about its causes and stabil-
ity fueled the gays-in-the-military debate and help explain why people on
both sides felt so intensely about the ban. For some, the ban was a social bul-
wark against a contagious homosexuality. For others, the ban was a blatant
denial of the equal rights of a insular minority. The assimilationist agenda of
those fighting for gay inclusion in the military, driven as it was by the para-
dox of identity-based civil rights politics, also contributed to the culture's
confusion. After all, gays and lesbians fought to be treated the same as hetero-
sexuals, but doing so wound up drawing even more attention to their social
difference. Was sexual identity fluid or fixed? Did one's sexual identity really
matter or not? Should service members be discharged on the grounds of their
status or their conduct? The gays-in-the-military debate would raise all of
these questions only to offer conflicting and confusing answers.

Like so many other gay rights battles in the 1990s, the gays-in-the-
military debate helped channel contradictory views on the nature of sexual
identity. At times, the debate circulated discourses that reinforced the idea that
sexual orientation was innate and immutable. Drawing an analogy between
antigay and racial discrimination became a common strategy. Clinton's sup-
porters often equated his promise to lift the military's ban to Truman's 1948
Executive Order to fully integrate the armed forces. In both cases, they noted,
the military justified its discriminatory policy on the grounds of morale and
discipline. With firm leadership, the military eventually became a model of
racial integration. If the Pentagon confronted antigay prejudice instead of
deferring to it, they argued, gays and lesbians would be similarly accepted.

Implicitly equating the nature of sexuality with that of race, the analogy linked sexual identity to dominant cultural discourses that maintained that people are either black or white, that they're born that way, have no choice in the matter, and can't do anything to change it.[79] Since, like blacks, gays and lesbians don't decide to be different from the majority, the logic went, the military shouldn't discriminate against them. Such historical comparisons helped sharpen the boundary between gay and straight by tapping into and reinforcing a view of sexual identity as natural and stable.

On the other hand, the debate produced different discourses that reinforced the idea that sexuality was mutable and the boundary between homo- and heterosexuality porous. The rhetoric of unit cohesion, for example, raised an obvious question: just why did the presence of gay soldiers make straight soldiers so nervous? At least one answer pointed to the intangibility and ambiguity of sexual desire. *Time*, for example, argued that the racial analogy fell apart on just that issue:

> But homosexuals are different [than African Americans], because sexuality is different. It can sometimes be a more deeply emotional part of identity than race—and a more ambiguous one. Most people identify with one race, while sexuality can be more complex. Many heterosexuals have some homosexual experience, frequently at the young-adult age of military recruits. . . . Some of the people who are most uncomfortable around open homosexuals worry that such impulses are part of their own nature. Moreover many young men think that having another man show sexual interest implies something unwelcome about their own sexuality.[80]

Writing in the *National Review*, E.L. Pattullo blurred the line between gay and straight even more profoundly, arguing, "In many individuals the urge to have sex with the opposite sex co-exists with a capacity to enjoy sex, also, with those of their own gender. The military, therefore, has reason to worry not only that gays will interact erotically among themselves, but that many men, primarily straight, will get amorously involved with comrades."[81]

Other articles drew particular attention to the intensely intimate same-sex relationships that often develop between soldiers forced to live with and rely on each other. In homosocial setting like military barracks and battlefield trenches, such articles suggested, the boundary between gay and straight could be particularly fuzzy. The *New York Times*, for example, quoted psychiatric literature from World War II that described the typical soldier's wartime relationship as one of "disguised and sublimated homosexuality."[82] According to *Newsweek*, such ambiguity was a by-product of the need for unit cohesion: "the male bonding so prized by military commanders—the willingness to die for one's buddies—can engender another kind of closeness as well."[83] The ban on gay soldiers, several articles contended, allowed ostensibly straight soldiers

to feel more comfortable with their homoerotic feelings. As the *New York Times* put it: "as long as no homosexuals were enlisted, soldiers could play at being lovers (and even consummate the roles) without ever having to acknowledge those feelings."[84] Published in the middle of the debate, Randy Shiltz' widely reviewed *Conduct Unbecoming* recounted not only the long history of gays and lesbians in the military, but also described consensual sexual encounters between gay and straight soldiers. Gay Vietnam vets Shiltz interviewed claimed that "the most sexually aggressive soldiers in the field were heterosexual." Shiltz paraphrased one gay soldier: "If there was any hint that a soldier really was gay, he was often subject to scores of advances. Straight guys would never say, 'Let's have sex,' of course. That would be queer. But if they believed somebody would be receptive, they might suggest something appropriately mechanical and impersonal, such as 'Let me put my d--- in your mouth.'"[85]

The idea that otherwise heterosexual soldiers might engage in homosexual sex has actually been reinforced by official military policy. A Department of Defense directive introduced in 1982 exempted putatively heterosexual soldiers who engage in homosexual conduct from being discharged. Nicknamed the "Queen for a Day" rule, the regulation stipulates that a service member caught having sex with a person of the same sex can be exonerated if it is found that the "member does not have a propensity or intent to engage in homosexual acts."[86] This seemingly illogical caveat reveals a profound incoherence regarding sexual orientation. On the one hand, it reinforces the idea of an essentialist sexual identity independent of behavior—one that can somehow be determined by a military inquiry. On the other hand, it simultaneously implies that otherwise straight men and women do have consensual sex with members of the same sex—or at least that they can. For a culture where one's sexual orientation was often defined by who one had sex with, reports of avowedly straight soldiers' same-sex sexual activity blurred the line between gay and straight even as they tried to maintain it.

Such contradictory messages about the nature of sexual orientation were not the only way in which the debate contributed to America's confused logic regarding the categorical distinction between gay and straight. The visual representations of gays and lesbians in the mainstream media, for example, sent highly contradictory messages about how noticeably different gays looked from straights. Since homosexuality has no "natural" visible markers of difference (like race and gender supposedly do), signifying gayness can take concerted editorial effort. For years, stock video footage of stereotypical-looking gay men walking hand-in-hand down the streets of San Francisco's Castro neighborhood served as a convenient visual aid for television news reports on gay issues. In the early 1990s, print coverage of gay rights issues often included photographs of gay men and lesbians that seemed

chosen and framed to visually convey gay difference through clothing, hair-styles, earrings, rainbow flags, and so forth. A two-page photo accompanying *Newsweek*'s February 1, 1993, cover story "Gays and the Military," for example, depicted a candlelight vigil for a murdered gay sailor. The photo's composition privileged two men—one clearly wearing an earring, the other a prominently positioned ACT UP button. Images also signified gay differ-ence by showing same-sex couples holding hands or in an intimate embrace. The photograph accompanying an April 26, 1993, *Time* article about the size of the gay community featured three men hugging, two of whom had highly visible earrings. By using such representational strategies to make identifying gays and lesbians easier, media coverage worked to sharpen the line between gay and straight.

The gays-in-the-military debate, however, simultaneously produced a noticeably different representational discourse. During the debate, several members of the armed forces who had been discharged for being gay fre-quently appeared in the media. Without exception, photographs of them were stripped of the conventional signs of gayness. They were almost always shown in their military uniforms and never shown in any sort of same-sex embrace. *Newsweek*'s February 1 cover, for example, featured a close up of Keith Meinhold in his navy uniform with an American flag as the background. Sim-ilarly, a *New York Times Magazine* profile on Jose Zuniga included a group photograph of him and his unit in Saudi Arabia. Dressed in the same army fatigues as everyone else, Zuniga is indistinguishable from his troop-mates.[87] With standard-issue military haircuts, no earrings, and at-attention poses, gay soldiers looked exactly like straight ones. Of course that was likely the editors' point—one reinforced by accompanying copy that often stressed gay and les-bian soldiers' exemplary service histories and described them as sharing the same values and personality characteristics (e.g., tradition-minded, drawn to authority) as straight soldiers. "For the most part," *Time* reported, "gays seek to serve for the same patriotic and pragmatic reasons that heterosexuals do."[88] Both the photos and the stories of gays and lesbians who had successfully served in the military, sometimes for years, without anyone knowing they were gay reinforced the idea that gays and straights weren't all that different.

Finally, the "don't ask, don't tell" policy itself generated widely contra-dictory discourses about the categorical line between gay and straight. By granting straight people the right to serve in the military and barring gay people from it, the original policy had helped sharpen and fortify the legal and cultural distinctions between the two groups. Although the Pentagon and key congressional conservatives wanted to keep the ban on gays and lesbians fully intact, Clinton worked hard to distinguish status (one's sexual identity) from conduct (one's sexual behavior) and to draft a policy that excluded people based on the latter not the former. "I don't think [sexual] status alone,

in the absence of some destructive behavior, should disqualify people," Clinton explained.[89] Discharging people based on what they do rather than who they are, Clinton's proposed policy would theoretically weaken the boundary between gay and straight by redrawing the lines regulating sexuality in the military and changing the "parameters of civic categories."[90] Instead of distinguishing gay people from straight people as the old policy had, the new policy would distinguish well-disciplined soldiers from undisciplined soldiers. "I strongly believe that our military, like our society," Clinton argued, "needs the talents of every person who wants to make a contribution and who is ready to live by the rules."[91] Clinton further dulled the taxonomic distinction between gay and straight by framing the matter as a question of individual rights: "For me, and this is very important," Clinton stated, "this issue has never been one of group rights, but rather of individual ones, of the individual opportunity to serve and the individual responsibility to conform to the high standards of military conduct."[92]

As the paradox of identity-based civil rights politics would predict, however, the issue was a bit more complicated than Clinton's disclaimer would have it. While he anxiously wanted to frame the debate as a question of individual rights (human rights or citizen rights as opposed to gay rights), the fact remained that the right those individuals were demanding was framed as the right to assert their social group identity while serving in the military. Lifting the ban on gays and lesbians would have blurred the distinction between gay and straight by treating everyone the same vis-a-vis access to the military. As far as military leaders were concerned, however, lifting the ban would have simultaneously sharpened the distinction between gay and straight soldiers by enabling gays and lesbians to announce their difference (whether through word or deed). According to the military's logic, of course, doing so would destroy unit cohesion. Although it's easy to dismiss such claims as homophobic and alarmist, the presence of openly gay soldiers would likely have been unsettling. After all, the presence of gay soldiers would not only draw attention to the social distinctions between gay and straight but also to the fact that the intense homosociality of military life existed uncomfortably somewhere between homosexuality and heterosexuality. Thus, thinking about gay soldiers made straight soldiers have to ponder the nature of their own heterosexuality—not always a comfortable task for a rigidly patriarchal institution and for those male soldiers whose definitions of masculinity continued to be structured by male homosexual panic.

In the end, however, the military and its supporters made sure that gays and lesbians wouldn't be able to serve openly in the military. Ostensibly, Clinton succeeded in drafting a policy that discriminated on the basis of conduct, not status. After all, "don't ask, don't tell" did state that "Sexual orienta-

tion is considered a personal and private matter, and homosexual orientation is not a bar to service entry or continued service unless manifested by homosexual conduct."[93] The devil, however, lay in the details. In theory, prohibited conduct could have been defined by those behaviors already outlined in the Uniform Code of Military Justice (e.g., sodomy, sexual assault, rape)—regulations that already pertained to all service members. Such was not the case, though. The policy constructed a specific class of "homosexual" conduct and defined it so broadly as to make the distinction between status and conduct almost inconsequential: "Homosexual conduct is a homosexual act, a statement by the applicant that demonstrates a propensity or intent to engage in homosexual acts, or a homosexual marriage or attempted marriage." In other words, any behavior that would lead a "reasonable person" to assume that a person would like to sleep with someone of the same sex (including saying that one was gay) constituted homosexual conduct.[94]

The policy had a convoluted logic of its own regarding the categorical distinctions between gay and straight. It basically said that gays could serve in the military like straights do—exactly like straights, in fact. Instead of being treated like everyone else (despite their difference), gays were forced to pretend to be like everyone else (and hide their difference). Their social identities were simultaneously legitimated and outlawed. Although "don't ask, don't tell" seemed to be out of step with mainstream attitudes toward homosexuality, this underlying contradiction was actually symptomatic of an American culture trying to balance its faith in individualism and American identity with the politics of social difference. Diane Helene Miller identifies the seemingly contradictory liberal attitude towards social difference—one that accepts difference as long as it is assimilated away. In analyzing the rhetoric surrounding two specific lesbian rights battles in the early 1990s, Miller argues that "there is no protection here for difference unless it can be successfully recuperated as sameness: a difference that makes no difference."[95] As *Newsweek* put it, "Polls about gays suggest that Americans are most tolerant of sexual differences when they don't have to confront them."[96] By allowing gays in the military as long they maintained a straight identity, "don't ask, don't tell" took this confusing logic to its extreme.

In the end, "don't ask, don't tell" was understandably seen as a highly visible loss for the gay and lesbian movement—a stunning indication that 1992 wasn't the sea change many in the LGBT community and its allies had hoped for. Nevertheless, as perhaps the most controversial social issue of 1993, the gays-in-the-military debate made a lot of people think about homosexuality, heterosexuality, and the line between them in new ways. In the next section, I will analyze a civil rights fight that would come to be seen as the greatest victory for the gay and lesbian movement in the 1990s.

SUSPECT CLASSIFICATION
AND ANTIDISCRIMINATION

Fighting for antidiscrimination legislation was the most common, at times most contentious, and arguably most successful gay civil rights tactics in the 1990s. At the beginning of the decade, a mere twenty million Americans lived in communities with ordinances banning discrimination based on sexual orientation in employment, housing, and other public services. Only Wisconsin and Massachusetts had statewide laws protecting gays and lesbians from discrimination in housing and employment. While gay activists campaigned vigorously to expand such protections on the local, state, and federal levels, antigay activists campaigned hard to defeat them. They also tried, sometimes quite successfully, to repeal existing gay rights ordinances and pass antigay initiatives. In 1996, for example, Congress failed to pass the Employment Nondiscrimination Act, and in 1998, voters in Maine repealed that state's gay rights law. On balance, though, pro-gay forces seemed to win the war. By the end of the decade, nine more states had passed statewide gay rights laws (Hawaii, Connecticut, New Jersey, Vermont, California, Minnesota, Rhode Island, Nevada, and New Hampshire), and almost 150 municipalities had some kind of anti-bias law that covered sexual orientation. In 1996 the Supreme Court declared laws that prohibited government bodies from including sexual orientation in antidiscrimination ordinances to be unconstitutional. In the private sector, roughly 50 percent of Fortune 500 companies added sexual orientation to their own corporate nondiscrimination policies. By 2000, 103 million Americans were protected from discrimination based on their sexual orientation.

Like the gays-in-the-military debate, battles over antidiscrimination legislation revealed and exacerbated America's growing straight panic. Laws that ban discrimination against gays and lesbians epitomize the paradox of identity-based civil rights politics. They simultaneously foreground the social distinctions that separate gay and straight people, only to insist that those distinctions be ignored. Legal concepts like "suspect class" and "protected status" work to construct gays as a fixed and identifiable social group, while principles of human rights and constitutional liberties work to displace the differences between gays and straights by constituting everyone as members in a unified community of individuals. By trying to manage the relationship between a heterosexual majority and a homosexual minority, such antidiscrimination legislation also stirred up wider anxieties about multiculturalism, social fragmentation, and the rights of the majority to determine the line between normal and deviant, right and wrong, us and them. The four-year-long battle over Colorado's Amendment 2, for example, made clear just how intensely disquieting gay rights and the politics of social difference were at the time.

As a liberal democracy, American political and legal culture struggles with an inherent contradiction between its ideals and its reality. On the one hand, liberalism promotes the notion of individual rights, protected by the constitution and grounded in our common humanity and our shared experiences as citizens of the nation. Liberalism encourages us to understand that beneath our difference, "We the People" are all the same and deserve to be treated the same. This ideal has been a powerful discourse in American culture and serves as the underlying justification for equal rights and antidiscrimination legislation. In the early 1990s, as America's diversity seemed to deepen and the politics of social identity intensify, the principle became all the more salient. In his acceptance speech at the 1992 Democratic convention, for example, Bill Clinton tapped into this ideal, declaring, "So we will say to every American: Look beyond the stereotypes that blind us. We need each other. For too long politicians told most of us that what's wrong with America is the rest of us. Them. Them the minorities. Them the liberals. Them, them, them. But there is no them; there's only us. One nation, under God, indivisible, with liberty and justice for all."[97] On the other hand, as Clinton's rhetoric suggests, liberalism also acknowledges that despite our shared humanity, social differences and group identities do divide people. According to Didi Herman, legal liberalism "assumes a series of truths: society is pluralistic, there are majorities and minorities, true democracy necessitates the protection of minorities from the tyranny of majorities."[98] Prejudice born out of group differences, then, can lead to discrimination and inequality. Antidiscrimination laws and constitutional notions of equal protection help ensure that such prejudice doesn't infringe on people's individual rights.

Although such legislation and judicial oversight aim to make social differences irrelevant, scholars have frequently pointed out how they paradoxically foreground and reify social categories by writing them into law. According to critical legal scholar Jane Schacter, "one of the hallmarks of antidiscrimination statutes is their codification of identity categories."[99] Most anti-bias laws use neutral language that prohibits discrimination based on a characteristic (e.g., race, class, gender, ethnicity, religion, skin color), not membership in a specific a group. As Schacter points out, however, ostensibly neutral categories like race, gender, ethnicity, and sexual orientation "come to be associated with those systematically disadvantaged because of those categories; complex social processes serve to naturalize the dominant sexual orientation, race, and gender in ways that can make it appear that heterosexuals have no sexual orientation, whites no race, and men no gender."[100] The fact that laws prohibiting discrimination based on sexual orientation are almost unanimously described as gay rights legislation underscores Schacter's point.

By using the legal system to gain equality, gays and lesbians are forced to adopt legal concepts that not only reflect but also shape how we think about

what it means to be gay and straight. Diane Helene Miller, for example, argues that, "the extension of existing liberal categories to new identities not only recognizes, but regulates, contains, and constitutes them."[101] In the case of gay rights, the pursuit of antidiscrimination legislation works to reinforce the idea that sexual identities are stable and fixed. Miller asserts that, "The legal arguments that emerge from a guiding civil rights agenda seek to protect gays and lesbians by fortifying the boundaries that divide human beings into distinct, inflexible classifications based on sexual orientation."[102] In a legal culture where arguments are made through precedent, minority groups seeking civil rights protections are forced to show how they are like already protected groups, most notably African Americans and other racial minorities. According to political scientist Paisley Currah, "Because race has served as a foundational category of civil rights discourse in general, and of antidiscrimination law in particular, both the popular and legal discourses on these are always mediated, either directly or indirectly, through an analogy with race—and in the popular and legal vernacular of rights discourse it is a truism that race is an immutable characteristic."[103] Such was the case, of course, in popular debates around gays in the military.

The legal concept of suspect class becomes particularly important in this regard. The courts have recognized that members of certain social groups (suspect classes) have been historically denied rights granted to all citizens and that laws that disadvantage members of such groups will receive a higher level of judicial scrutiny. The concept comes from a footnote in the 1938 Supreme Court ruling *United States v. Carolene Products Co.* that states, "prejudice against discrete and insular minorities may be a special condition which tends seriously to curtail the operation of those political processes ordinarily to be relied upon to protect minorities, and . . . may call for a correspondingly more searching judicial inquiry."[104] In other words, if a law disadvantages members of a suspect class, the court will apply "strict scrutiny" and the state must show a "compelling interest" to justify the discriminatory law. For groups that don't receive suspect classification, the state is held to a much lower standard and must simply demonstrate that the discriminatory law is "rationally related" to a legitimate goal (historically, a relatively easy task).[105] Thus, for minority groups looking to overturn laws that discriminate against them, gaining suspect class standing makes the task substantially easier. For the courts to recognize a group as a suspect class, however, they must satisfy a number of criteria that have been established through precedent. The characteristic used to single out the group, for example, must be "obvious, immutable, or distinguishing." The importance of race—and taken-for-granted perceptions of race as obvious, immutable, and distinguishing—to the concept of suspect classes has subsequently determined the tactics of gay and lesbian activists seeking civil rights protections.

The pursuit of suspect class standing became an increasingly important strategy for gays and lesbians in the wake of the 1986 Supreme Court ruling in *Bowers v. Hardwick*. In that case, gay activists had argued that Georgia's sodomy law was unconstitutional because it infringed upon the fundamental right to privacy. The court, however, ruled that homosexual conduct (sodomy) can be discriminated against by a community that deems certain behavior immoral. Forced to find a way to circumvent *Bowers v. Hardwick*, gay civil rights activists have since pursued cases on equal protection grounds and have argued that laws unfairly discriminate against them as a class defined by their sexual orientation (as opposed to their conduct). Although the courts have never granted gays and lesbians suspect class standing, the concept of immutability and the doctrine of protected group status have shaped gay legal activism, including antidiscrimination legislation, as well as popular discourses about sexual identity.[106]

The pursuit of civil rights protections has often been criticized by various segments of the gay and lesbian movement who believe the boundaries such legislation draws are counterproductive. Traditional liberals like Andrew Sullivan have argued that by pursuing such an agenda gays and lesbians risk embracing a victim status and mentality that ultimately will hinder the struggle for individual rights. By codifying identity categories, the logic goes, antidiscrimination undermines the universal values of human rights; it illogically draws lines between people in the name of equality. Queer activists like Michael Warner, Lisa Duggan, and Janet Halley launch a related but strikingly different criticism. By promoting a gay identity as a distinct and immutable minority identity, they argue, civil rights legislation works to naturalize the boundary between gay and straight; creates a monolithic gay identity that erases the differences among gay men, lesbians, and bisexuals; closes off opportunities for building alliances with non-normative straights; and leaves in place a social hierarchy in which the heterosexual majority agrees to tolerate a homosexual minority. They argue that identity categories work to reinforce dominant power relations and inequality and that activists should expose how both heterosexuality and homosexuality are socially constructed.[107]

Amendment 2 and Ballot Measure 9

Not surprisingly, however, the most vocal resistance to gay rights ordinances came from antigay conservatives, especially those from the Christian Right. In fact, in the months leading up to the 1992 election, battles over antigay initiatives made national headlines as voters in Colorado and Oregon, as well as cities like Tampa Bay and Portland, Maine, prepared to vote on initiatives that would prohibit government institutions from including sexual orientation in antidiscrimination legislation. Activists on both sides waged

impassioned, bitter, and at times violent campaigns in what were often described as the frontlines of the nation's culture wars.

The statewide battles in Colorado and Oregon in which antigay forces campaigned to amend those state's constitutions to prohibit gay rights legislation understandably attracted the most national attention. Initially, the debate over Ballot Measure 9 in Oregon—what the *Washington Post* called "ground zero" in the "emotionally charged battle over gays' civil rights and their place in American society"—provided the most explosive confrontations.[108] The Oregon Citizens Alliance (OCA), an offshoot of Pat Robertson's Christian Coalition, spearheaded the effort to get the measure on the ballot and headed the campaign to get it passed. Not only did the measure make it illegal for any government institution in the state to "recognize any categorical provision such as 'sexual orientation,' 'sexual preference,' and similar phrases that include homosexuality," but it also required such institutions to "assist in setting a standard for Oregon's youth that recognizes homosexuality, pedophilia, sadism and masochism as abnormal, wrong, unnatural, and perverse and that these behaviors are to be discouraged and avoided."[109] In line with the initiative's harsh language, Measure 9 backers used intensely homophobic rhetoric. OCA founder Lon Mabon warned Oregonians of a "militant homosexual agenda,"[110] and the organization's newsletter included headlines like "Homosexual Leader Confesses Tactics Drawn from Hitler" and "Homosexual Behavior Causes AIDS Crisis."[111]

By comparison, Colorado's Amendment 2 seemed significantly more reasonable, its language free of the openly homophobic judgment of Measure 9. The proposed amendment read:

> No Protected Status Based on Homosexual, Lesbian, or Bisexual Orientation. Neither the State of Colorado, through any of its branches or departments, nor any of its agencies, political subdivisions, municipalities or school districts, shall enact, adopt or enforce any statute, regulation, ordinance or policy whereby homosexual, lesbian or bisexual orientation, conduct, practices or relationships shall constitute or otherwise be the basis of or entitle any person or class of persons to have or claim any minority status, quota preferences, protected status or claim of discrimination.[112]

Amendment 2 was drafted by the Coalition for Family Values (CFV), a Christian conservative organization founded to repeal gay-inclusive, antidiscrimination ordinances in force in Aspen, Boulder, and Denver and to prohibit any further extension of gay rights in the state. In contrast to the heated and bitter statewide war in Oregon, the debate over Amendment 2 was relatively low-key, if no less antigay.

Antigay forces clearly wanted to counteract the logic that gays and lesbians should be protected from discrimination because they are the same as

everyone else. An important element of both the OCA's and CFV's campaign strategy was to convince voters that gays and lesbians were, in fact, very different. Campaign literature, for example, included bogus research about gay sexual practices. One OCA voter pamphlet claimed that "Studies by leading researchers show that the following practices are regularly engaged in by homosexuals: fellatio 100%, fisting 41% (inserting fist and forearm into the rectum), rimming 92% (licking rectum), water sports 29% (defecating on partner), sado-masochism 37% (beating, piercing, another person for sexual pleasure), public sex 66% (public restrooms, bathhouses, parks), pedophilia 46% (sex with minors)."[113] Such statistics seemed validated by *The Gay Agenda*, which featured footage of the most radical elements (e.g., North American Man/Boy Love Association [NAMBLA], leather fetishists, mock-masturbation) of a San Francisco gay pride parade. CFV activists showed the tape every chance they could. When asked about such tactics, Will Perkins, the leader of CFV, maintained that no matter how terrible it was, getting such information to people was important in order "to offset the claims of homosexuals that they are just like the rest of us, because they're not!"[114] OCA's Lon Mabon agreed, declaring that, "homosexuality is not a civil right. It's an aberration."[115] On these grounds, antigay forces argued that gays and lesbians deserved to be discriminated against.

In response, gay rights supporters emphasized the ways in which gays and lesbians were the same as everyone else. Their campaign literature stressed the fact that gays and lesbians paid taxes, went to work, and raised families just like straight Coloradans did. In fact, Equal Protection (the largest organization working to defeat Amendment 2) was accused of marginalizing those segments of the gay community that they feared veered too far away from normative heterosexual lifestyles and worked hard to present a public image that would be acceptable and identifiable to the straight majority.[116]

In both states, though particularly so in Colorado, openly homophobic rhetoric about gay sexual deviancy was accompanied by a seemingly gentler tactic. Antigay activists repeatedly claimed that antidiscrimination legislation didn't simply give gays and lesbians the same rights as everyone else, but in fact gave them "special rights." This ingenious argument of inversion clearly targeted the anxieties and resentment of those voters who felt civil rights laws gave minorities a privileged status in the eyes of the law that members of the majority didn't have. The special-rights rhetoric also elided the difference between antidiscrimination provisions and affirmative action and quotas, feeding into fears about reverse discrimination and the growing influence of minority groups. OCA's director Scott Lively, for example, claimed that gays and lesbians were seeking "affirmative action based on how they have sex."[117] Just a year earlier, such fears had been vigorously stirred up in the national debate over the Civil Rights Act of 1991, which opponents claimed

"strip[ped] white males of equality before the law."[118] The special-rights arguments seemed tailor-made to win over voters anxiously fearful of what all of the talk about America's deepening diversity, multiculturalism, and social fragmentation meant for them.

Through careful execution, special-rights rhetoric enabled antigay activists to tap into such anxieties while simultaneously appearing to support civil rights laws—an important move when more moderate voters were needed to pass the initiative. CFV, for example, argued that antidiscrimination laws that protected gays and lesbians would undermine efforts to protect the rights of the supposedly truly disadvantaged—racial and ethnic minorities, the handicapped, or women. "If having sex becomes all it takes to be considered 'ethnic,'" one CFV flyer announced, "then the concept of ethnicity, as well as legitimate minorities' hard-won gains, will have lost nearly all their meaning and value."[119] In an effort to differentiate gay rights from civil rights, antigay forces exploited the epistemological confusion about sexual orientation, (i.e., is it simply a behavior people choose to do or an identity/status they are born with?). Antigay activists argued the former. While treating someone differently for who they are is bad, the logic went, treating them differently for something they do—especially when (as in the case of gays and lesbians) the majority of people believe the behavior is abnormal, immoral, and dangerous—is justifiable.

The apparent success of the special-rights argument suggests how difficult it was for many people to reconcile social differences with the idea of social equality. Antidiscrimination legislation likely reinforced this perception. When asked about gays and lesbians' effort to get civil rights protections, for example, Lisa Lanier, a nineteen-year-old single mother, told the *Washington Post*, "They don't want to be equal with us. They want to be a little bit better."[120] Gay rights supporters repeatedly countered the special-rights claims by rightly pointing out that antidiscrimination protection simply ensures gays and lesbians the same rights as everyone else (i.e., equal treatment in housing, employment, education, public accommodations, health care, etc.). Nevertheless, as Didi Herman notes, listing sexual orientation in anti-bias laws (alongside race, ethnicity, age, sex, religion) *explicitly* establishes it as a characteristic that people cannot discriminate against—something not granted to any number of other characteristics (e.g., welfare status, body weight).[121] In this regard, it was easy for antigay forces to frame gay-inclusive anti-bias laws as part of a wider affirmative-action agenda. In a culture where equality and sameness were so strongly linked, demanding to be both equal and different made it look like gays and lesbians wanted special treatment.

If observers were looking to Oregon and Colorado for evidence of exactly where the nation stood on gay rights, November 3 offered only mixed signals. Voters in Oregon rejected Ballot Measure 9 by a margin of 56 percent

to 44 percent. Given the intensely homophobic language and openly intoler-
ant tone of the initiative, few were surprised it went down. In Colorado, how-
ever, the electorate passed Amendment 2 with a 53 percent to 47 percent
vote. Many on both sides of the issue were surprised. Amendment 2's base of
support certainly came from those who strongly opposed homosexuality on
religious grounds. But many others seemed to have been swayed less by sta-
tistics about homosexuals' supposed moral deviancy than by fears about the
divisive nature of civil rights legislation. Arguing that many Coloradans voted
for Amendment 2 "explicitly to protest the fracturing of ordinary politics into
more and more victim groups, all demanding customized protections," *U.S.
News & World Report's* John Leo framed the vote as a straight-panic backlash
to the politics of social difference.[122]

Romer v. Evans

In the month leading up to the election, the nation's attention had been
focused on the tremendously bitter fight in Oregon. Once the votes were
counted, though, Colorado, where the battle over Amendment 2 was only
heating up, would move center stage. A Denver-based group organized
Boycott Colorado—a campaign that drew national attention when Barbara
Streisand announced her support. "We must now say clearly that the moral cli-
mate in Colorado is no longer acceptable," she declared two weeks after the
vote, "and if we're asked to, we must refuse to play where they discriminate."[123]
Several organizations (including the National Conference of Mayors) and
businesses decided to go elsewhere, and some people cancelled ski vacations to
what some had started calling the Hate State. Conservatives, however, saw the
victory as a sign to export their strategy to other states. In 1993 and 1994, anti-
gay rights initiatives were started from Washington to Florida and many places
in between.

As with "don't ask, don't tell," the battle quickly moved to the courts. The
cities of Denver, Aspen, and Boulder (whose existing gay rights laws were
overturned by the amendment), along with six gay and lesbian Colorado res-
idents, challenged the constitutionality of the amendment. The case, *Romer v.
Evans*, was initially heard by Judge Bayless in the Colorado District Court.
The state offered a number of reasons why Amendment 2 (and the will of the
majority) should stand: it promoted uniformity among municipal laws and
reduced factionalism; it recognized the power of the people to make laws
through initiatives; it ensured that state resources wouldn't be spent protect-
ing non-suspect class minorities; it protected the privacy rights of people
opposed to homosexuality; it made sure the state wouldn't subsidize the goals
of a special interest group; and it protected children. The plaintiffs, on the
other hand, argued that gays and lesbians should be considered a suspect class,
assuming that if they were, the amendment would most certainly be

overturned. Bayless refused to grant gays and lesbians suspect status. Instead, he decided that the amendment was unconstitutional because it infringed upon a fundamental right—namely the right to participate in the political process. As in the case of laws that discriminate against suspect classes, laws that deny citizens a fundamental right are held up to the highest level of scrutiny, and the state must provide not just a rationale but rather a compelling reason for why the law is needed. Bayless rejected all of the state's arguments. The state appealed the ruling to the Colorado Supreme Court, which upheld Bayless's verdict. Colorado then appealed to the U.S. Supreme Court, which agreed to hear the case in 1995.

On October 10, 1995, the Supreme Court heard arguments in what *U.S. News & World Report* declared was "the most heralded case ever involving gay rights to make it to the top court."[124] As a major civil rights case and the first gay rights case in a decade, *Romer v. Evans* was among the most discussed Supreme Court cases of the 1990s. At its heart, the case was about the conflict between two constitutional principles: the right of majority rule versus the right of oppressed minorities to be protected from majority tyranny. According to the *New York Review* the fundamental question for the Court was: "May a 'moral majority' limit the liberty of other citizens on no better ground than that it disapproves of the personal choices they make?"[125] Coming as it did at a time when gay rights were so divisive, and multiculturalism and the nation's deepening diversity seemed so threatening, a case that focused on the constitutional principles underlying plebiscitary democracy understandably stirred up tremendous interest. The court, for example, received over twenty friend-of-the-court briefs (amicus curia) from nearly 100 government bodies, organizations, and individuals that wanted to weigh in on the debate. (A brief from the Clinton administration was noticeably absent). Arguments on both sides echoed many of those made during the original debate and trials. In particular, the lawyers representing Colorado, along with Justices Scalia and Rehnquist, characterized the amendment as simply reflecting the majority's desire to prohibit gays and lesbians from gaining special legal protections. Justices Stevens and others, on the other hand, seemed unconvinced and repeatedly asked what rational reason the state had to single out gays and lesbians for discrimination.

The court handed down its decision on May 20, 1996. In a 6–3 ruling (Scalia, Thomas, and Rehnquist dissented), the court upheld the Colorado Supreme Court decision and declared the amendment constitutionally invalid. In what was often described as a bold and sweeping opinion, Justice Kennedy declared that the state, even if acting on behalf of the will of a majority of its citizens, can't single out a group of people and discriminate against them simply because of who they are. Kennedy linked the verdict and gay rights to the nation's long and uneven history of discrimination by draw-

ing upon the sole dissenting opinion in *Plessy v. Ferguson*, the 1896 Court decision that had sanctioned racial segregation. "One century ago," Kennedy wrote in his opening sentence, "the first Justice Harlan admonished this Court that the Constitution 'neither knows nor tolerates classes among citizens.'" The Court argued that Colorado's Amendment 2 did just that. In fact, Kennedy argued that Colorado's attempt to disqualify gays and lesbians "from the right to seek specific protection from the law [was] unprecedented."[126]

In deciding that the law was not only unprecedented but also unconstitutional, the Court followed a different rationale than Judge Bayless and the Colorado Supreme Court had. Like Bayless, Kennedy quickly dismissed the special-rights argument, asserting that far from depriving gays and lesbians of special rights, the amendment actually "impose[d] a special disability upon those persons alone."[127] Unlike the Colorado courts (which had overturned Amendment 2 because they found that it burdened a fundamental right without a compelling reason), the Supreme Court found that Colorado failed to satisfy the lowest level of judicial scrutiny. In other words, Colorado could not demonstrate that Amendment 2 bore even a "rational relation" to a valid governmental goal. Instead, Kennedy argued, the amendment seemed motivated by nothing but "animus" towards gays and lesbians:

> We cannot say that Amendment 2 is directed to any identifiable legitimate purpose or discrete objective. It is a status-based enactment divorced from any factual context from which we could discern a relationship to legitimate state interests; it is a classification of persons undertaken for its own sake, something the Equal Protection Clause does not permit. . . . We must conclude that Amendment 2 classifies homosexuals not to further a proper legislative end but to make them unequal to everyone else. This Colorado cannot do.[128]

In essence, then, Kennedy argued that a majority cannot create a law that singles out and limits the freedom of a minority group simply because it disapproves of their lifestyle, behavior, or choices.

In a scathing dissenting opinion, Justice Scalia admonished the Court for abandoning judicial neutrality in favor of judicial activism. In particular, he refuted Kennedy's claim that the amendment bore no rational relation to a legitimate government purpose. What Kennedy dismissed as animus, Scalia characterized as "a modest attempt by seemingly tolerant Coloradans to preserve traditional sexual mores against the efforts of a politically powerful minority to revise those mores through use of laws."[129] Scalia most strongly criticized the Court for disregarding its own precedent, specifically the 1986 ruling in *Bowers v. Harwick* that upheld Georgia's antisodomy law. In *Bowers*, the Court declared that the "presumed belief of a majority of the electorate of Georgia that homosexual sodomy [was] immoral and unacceptable"

served as an adequate justification for a law that disadvantaged gays and lesbians.[130] In other words, the Court declared that as long as the state demonstrated that a law reflected the will of the majority to condemn a behavior it believed was immoral, the law would pass conventional (as opposed to heightened) judicial scrutiny. By invalidating Amendment 2 because it was motivated by nothing but "animus toward the class," *Romer* contradicted this precedent. In this regard, Scalia argued, the Court had ignored the constitutional principle underlying both the democratic process and the relationship between majority will and minority rights. In his opinion, the Court interjected itself into the kind of political debate that is supposed to be solved through the legislative process. "This Court has no business imposing upon all Americans the resolution favored by the elite class from which the Members of this institution are selected, pronouncing that 'animosity' toward homosexuality . . . is evil."[131]

The debate over antidiscrimination laws revealed and contributed to America's straight panic, putting the gay minority, the straight majority and the legal relationship between them under the spotlight of judicial scrutiny. Like the scientific discourse about the ontology of sexual orientation, legal discourses about civil rights simultaneously sharpened and blurred the distinctions between gay and straight in ways that made thinking about gay people (and straight people) highly confusing and disquieting. On the one hand, such legal discourses affirmed the idea that beneath our social differences we all share a common humanity. The principle of equal protection demands that our laws reflect that commonality, and antidiscrimination ordinances offer the hope that they can promote it. On the other hand, people talked about gay rights and special rights as much or more than they did equal rights or human rights, and the legacy of civil rights law helped bolster the idea that gays are as distinct from straights as blacks are from whites.

Romer v. Evans only added to this confusion. In her brief to the Supreme Court, Colorado Attorney General Gail Norton defended Amendment 2 by stating that "discrimination . . . once divested of its emotional connotation, simply means to distinguish or to draw a line."[132] According to *Romer*, however, the government didn't have the right to draw such a line between gay people and straight people simply because the majority wanted to. Paradoxically, by reinstating antidiscrimination laws in Aspen, Denver, and Boulder, the ruling likely made it easier and safer for gays and lesbians there and across the nation to assert their social difference. And more broadly speaking, by limiting the power of the majority to impose its values at will, *Romer* (like multiculturalism, political correctness, and reports on America's deepening diversity) helped unsettle the boundary between the majority and minority and between right and wrong.

In other words, *Romer v. Evans* and gay civil rights in general were examples of "affirmative action." Although antigay forces frequently used the term to tap into majority resentment of job quotas, the discourse really expressed the fear that gay rights were blurring the moral line between normal and deviant by forcing Straight America to affirm, promote, and endorse homosexuality as the moral equivalent of heterosexuality, not simply tolerate it as an inferior way of life. In this regard, it's not surprising that Straight America panicked. After all, if heterosexuality didn't have a distinct and morally reprobate homosexual Other against which to define itself, what did it mean to be heterosexual? Like the straight students on Jeans Day, straight Americans confronted with gay civil rights debates were forced not only to think about gay people but also straight identity.

CONCLUSION

Battles over "don't ask, don't tell" and Colorado Amendment 2 were only two of the most high-profile gay rights issues in the 1990s. Other political and cultural debates revealed and contributed to the confused logic regarding sexual identity. Just months after *Romer v. Evans*, for example, Congress debated the Employment Nondiscrimination Act, which would have added sexual orientation to federal nondiscrimination laws. Again, supporters of the act framed it as an issue of equality while opponents complained that the law would add to political fragmentation by granting yet another minority group special rights.[133] Reports of a "gayby boom" focused attention on gay and lesbian families, which, as a *People* profile of four gay-headed households put it, are "So Different, So Much the Same."[134] In 1998 the murder of Matthew Shepard reignited the debate over hate-crime legislation and a debate over whether crimes should be treated differently if they were motivated by animosity toward specific groups. That same year, an advertising campaign touting the success of reparative therapy made the ex-gay movement front-page news and raised questions about the immutability of sexual orientation all over again.[135] Meanwhile, some gay journalists started discussing the emergence of "The Post-Gay Man: He's not straight, though he isn't strictly homosexual, either, but then to call him bisexual wouldn't be exactly on the money."[136] As the assimilationist 1990s advanced, it seems, gays and lesbians were jumping into the melting pot—"Leaving the Gay Ghetto" and "Getting over being gay."[137] The battle over gay marriage, which picked up steam throughout the decade, served as the ultimate symbol of gay and lesbian integration and struck at the heart of Straight America's panic about the relationship between right and wrong, the majority and its minorities, and gay and straight. As we will see in the final chapter, the culture war over gay marriage that erupted in 2004 indicates the extent to which such anxieties remain powerful.

The prominence of such national debates over gay rights helps explain the increase of gay-themed television in the 1990s. Despite the networks' well-earned reputation for caution when it comes to controversy, they often do tap into hot-button political issues in order to lend an air of realism and topicality to their programming. Thus, as gay rights debates captured more headlines, they also captured the attention of more producers and executives looking for fresh story ideas and a dose of social relevance. In the opening season of *Melrose Place* (1992–1993), for example, Matt Fielding pursues an antidiscrimination lawsuit after losing his job as a social worker because he's gay. Similarly, on a 1993 episode of *Picket Fences*, a gay dentist sues the town when he is fired because he is HIV-positive. In 1995, less than two years after "don't ask, don't tell" became official government policy, NBC aired *Serving in Silence*, a high-profile made-for-TV movie starring Glenn Close as the true-life army nurse fighting to be reinstated after being discharged for coming out of the closet. And in 1996, lesbian love and marriage were in the air on *Friends* as Ross and the gang attend Susan and Carol's same-sex wedding. Gay rights issues, like so many controversial social topics before, were almost always smoothed over and watered down by the economic constraints and genre conventions of network TV. Nevertheless, network television did periodically deal explicitly with gay rights debates.

Such self-consciously political episodes, however, account for only a small percentage of the gay material that proliferated on prime time in the 1990s. The vast majority of gay-themed television kept civil rights politics offscreen, focusing instead on the personal stories of gays and straights in a world seemingly oblivious to the mainstream gay rights movement, landmark Supreme Court decisions, or contentious ballot initiatives. On *Party of Five*, for example, Claudia's preteen crush on her violin teacher Ross ends when she finds out he's gay (1994). On *ER*, Doug counsels a teenage boy confused about his sexual orientation (1996). And on *Cosby*, Hilton unwittingly joins a softball league for older gay men (1997). Even more so than watered-down social-issue narratives, of course, domesticated treatments like these (and countless others) gave skittish network executives a way to exploit the cultural prominence of gays and lesbians without having to tackle contentious political questions explicitly. Despite their emphasis on private encounters with gayness, such narratives were shaped by contemporary gay rights debates as well. Much of the gay material on 1990s television, as we will see in chapter 6, reflected and likely helped reinforce profound contradictions regarding categories of sexual identity—contradictions that civil rights debates both deepened and made people think about in ways they probably never had before. Suggesting that gay-themed programming became one of the most striking programming phenomena of the decade because increasingly visible gay rights debates gave the topic pulled-from-the-headlines topicality, how-

ever, is far too simplistic. After all, the L.A. riots/uprising certainly put America's race relations on the front burner, yet race-themed programming didn't become a prime-time programming trend. In fact, network television would become increasingly white and segregated over the course of the 1990s. The next two chapters help explain why by focusing on the changing dynamics of the industry that produced such programming and the discourses the likely shaped the political values of certain viewers who seemed drawn to gay-themed television.

CHAPTER 3

Network Narrowcasting and
the Slumpy Demographic

Everything's a scramble for demographics now. . . . Now it's "kids don't sell," so you've got to be young, hip, urban, professional.

In 1995 Matt Williams, co-creator of the ABC family sit-com *Home Improvement*, bemoaned one of the most notable developments in network television during the 1990s: the increasing importance of demographic numbers in general, and an obsession with a narrow segment of the 18-to-49 audience in particular.[1] Although demographics had played a part in the business of network television for years, their influence soared in the mid-1990s as the principles of narrowcasting challenged traditional broadcasting practices. Gone were the days of the mass audience when household ratings figures served as the gold standard by which ad rates were set and program success was judged. Audiences now broken down by race, class, gender, and especially age became the new currency for the economy of network television, and the audience most in demand by advertisers was upscale adults 18-to-49. As a result, the face of prime time changed. By the mid-1990s, programs designed to appeal to a broad audience (family sitcoms like *Home Improvement* and *Full House*) or that tended to skew older (*Murder, She Wrote, Matlock, Diagnosis Murder*) were out of fashion. Edgy, ironic shows geared to specific adult tastes—shows that pushed the envelope of TV content and style—got all the buzz, dominated the networks' development seasons, and won plum schedule positions. Such changes were symptomatic of large-scale transformations in the business of network television.

This chapter examines the dramatic increase of gay material in the context of such transformations—changes that both reflected and exacerbated America's emerging straight panic. The interconnected growth of niche marketing and cable competition in the 1970s and 1980s drastically changed the context within which ABC, NBC, and CBS operated in the 1990s. The value of their historical strength—namely their ability to offer advertisers access to a mass and undifferentiated audience of consumers—was seemingly

undermined by a social climate where differences among Americans appeared more relevant to their lives and to marketers. Faced with dramatic audience erosion and shifting advertiser goals, the Big 3 networks were forced to revise their strategies in order to maintain a competitive edge in these changing social and media environments. In this chapter, I focus on one such revision—the networks' changing conceptions of their quality audience. I argue that, in the increasingly competitive era of 1990s narrowcasting, network executives incorporated gay and lesbian material into their prime-time lineups in order to attract an audience of upscale, college-educated and socially liberal adults. Aggressively targeting what I call the *slumpy* demographic (socially liberal, urban-minded professionals) made sense for the Big 3, who faced mounting pressure to improve the demographic profiles of their audience base in order to impress advertisers eager to reach their core consumer niche.

The gay material's use-value as a narrowcasting-age tool to woo the slumpy audience was linked to wider social factors. By 1993 homosexuality was actually becoming chic in certain circles. As I argued in chapter 2, highly visible political battles over same-sex marriage, employment discrimination, and military service gave homosexuality a pulled-from-the-headlines relevancy. As I will detail in chapter 4, these gay rights debates also gave homosexuality a cutting-edge allure dulled just enough by their assimilationist goals to appeal to a relatively broad base. At the same time, gays and lesbians became a hot target for marketers looking to uncover new ways to sell goods and services. In chapter 4 I will also examine trade-press discourses that constructed the gay and lesbian community as an ideal niche market—one filled with disproportionately affluent, loyal, and active consumers. The growing circulation of such discourses helped make gay-themed programming more palatable to sponsors and network programmers always looking to create consumption-friendly media environments.

Mass-Market TV and Network Dominance in the 1970s

During the 1970s, television was a mass medium dominated by the Big 3 networks. Mass marketing, the efficient promotion of consumption to a relatively undifferentiated national audience, was an indispensable component of an economy like that of midcentury America—namely one based on the mass production of consumer goods. The nation's manufacturers, retailers, and service companies needed cost-effective ways to reach huge segments of the population with commercial messages. Television filled the bill. With its dramatic growth in the postwar years, network television quickly replaced national-circulation magazines like *Look* and *Ladies Home Journal* as well as network radio to become the premier advertising vehicle used to reach the mass audience. Over 97 percent of American homes had television sets by the

late 1970s, and millions tuned in nightly to watch. To the benefit of the net-
works, viewing options and industry competition were limited. Government
policy and broadcasting technology restricted the number of channels most
Americans received to a mere handful—usually the three networks' local
affiliates, perhaps one or two independent channels, and sometimes a PBS
station.[2] With favorable FCC regulations and enormously advantageous
economies of scale, NBC, ABC, and CBS maintained oligopolistic control and
dominated the few competitors they faced.

Network share of the television audience, for example, was remarkable
and profitable. During the 1978–1979 and 1979–1980 seasons, 90 percent of
people watching prime-time television were watching one of the Big 3 net-
works; their sitcoms, dramas, and action adventure shows reached an extraor-
dinarily large percentage of Americans. Top-rated programs like *Dallas*,
Laverne & Shirley, and *Three's Company* were routinely watched in 30 percent
of American households every week, and even shows with only moderate
success were seen in 20 percent. There was no other place a national adver-
tiser could reach so many consumers at one time. Consequently, the networks
were able to auction off commercial spots at exorbitant prices. Companies
like Procter & Gamble, McDonald's, and Sears, all anxious to reach network
TV's mass audience, spent billions of dollars rushing to outbid each other for
valuable sponsorship slots. As a result, the networks drew a disproportionate
share of TV ad dollars. Although there were over 700 commercial broadcast
stations in the United States at the time, the networks and the fifteen stations
they owned and operated accounted for over 44 percent of the television
industry's total advertising revenue. By the late 1970s, network television had
matured into a safe and highly lucrative business, with the Big 3's average
profit margins climbing as high as an unheard of 258.8 percent.[3]

The Big 3, then, were the unchallenged masters of a fully mature and
profitable industry in the 1970s, and the face of prime time reflected it. Look-
ing to rationalize their activities, networks embraced the stability of homo-
geneity and formulaic programming practices. According to historian J. Fred
McDonald, "Like so much else in U.S. commerce—from automobiles to
shopping malls to franchised hamburger stands—national TV offered the same
products to everyone everywhere: everything worked, looked, and tasted the
same."[4] Since the Big 3 faced no serious competition, program diversification
and innovation weren't needed; in fact, they jeopardized the system's efficient
and predictable delivery of the mass audience to national advertisers. The net-
works had little incentive to target the interests of smaller demographic
groups by experimenting with highly risky kinds of programming. In fact,
they anxiously avoided differences in taste, values, or interests that might
splinter their audience. As McDonald points out, one of the main program-
ming philosophies that guided network executives in the 1970s was the prac-

tice of least objectionable programming.[5] Carefully finding ways to offend no one was a virtue. If this approach failed to produce programs that struck at the inner core of viewers' desires, the networks didn't seem particularly concerned. Profit margins and audience share had never been higher, and viewers didn't really have anywhere else to turn in a network-dominated TV universe.

Even as the networks were riding high in the late 1970s, the winds of fortune slowly began to turn against them. Two interrelated developments emerged which in the course of time greatly undermined the networks' control of the mass audience and of advertiser dollars. On the one hand, the networks found themselves in a changing advertising world—one in which marketers seemed to care more about audience niches than the mass audience. At the same time, the growth of cable and independent broadcast stations loosened the Big 3's stranglehold on the channels of TV distribution. During the 1980s and 1990s these changes would transform the business of television, eroding the networks' power and forcing them to develop new tactics—tactics that would include the use of gay material.

The Rise of the Niche-Marketing Revolution

In the late 1970s the business world was beginning to change its approach to marketing. For decades, mass marketing had been the principle philosophy guiding the nation's advertising executives and their clients. The efficiency of the assembly line and of continual-flow production was matched by the efficiency of mass marketing campaigns that pitched the same, undifferentiated messages to a national market believed to be made up of relatively undifferentiated consumers. Reaching as broad an audience as possible was the primary concern for the nation's wealthiest companies, their ad agencies, and the mass media companies used to reach customers. By the end of the 1970s, however, the primacy of mass marketing was gradually giving way to target or niche marketing—a philosophy that emphasizes audience segmentation. Instead of homogenizing consumers into a uniform mass, target marketers sort them into different demographic groups by age, race, income, gender, and location. Target marketing wasn't entirely new in the late 1970s. Efforts to segment the mass audience had been evident throughout the twentieth century, but targeting remained a marginal practice in comparison to mass marketing—that is, until the scales began to shift in the 1970s. By the early 1980s, niche marketing was hot; audience segmentation was cutting-edge, and more and more advertising agencies tied their clients' campaigns to the targeting bandwagon. Products, advertising messages, and the media were increasingly shaped so as to appeal to the perceived interests of specific consumer niches. Instead of trying to avoid or smooth over any differences that

may have existed among people with different social experiences, target marketing exploited them in order to forge more intense connections between a product and its consumer.

Joseph Turow and Lizabeth Cohen have traced the multiple and often mutually reinforcing determinants that helped propel target marketing from the margins of advertising philosophy to the center of America's consumer industry and media.[6] Key to this shift, for example, was a change in advertisers' perceptions of American culture and consumers. In the decades immediately following World War II, advertisers believed Americans were united behind shared goals and values—a perfect foundation for mass marketing's broad address. By the 1970s, however, the cultural landscape looked different to ad executives. The turmoil of the late 60s seemed to splinter America's common purpose; Vietnam, hippie culture, and the identity politics of black power, second wave feminism, Chicano nationalism, and gay rights seemed to fracture the nation along numerous lines. Turow argues that advertisers believed such fractures grew in the 1980s as Reagan-era economics and attitudes created a widening gap between rich and poor and promoted a self-indulgent "me-ism." From advertisers' perspectives, American consumers were more frenetic and less predictable; they were increasingly suspicious of institutions and centralized authority and sought out friendship and community in increasingly narrow circles of people just like themselves.[7] In such a fragmented culture, advertisers reasoned, uniform messages would be less effective; targeting came to the rescue.

This new vision of a fragmented American culture fueled and, in turn, was fueled by a flood of new research into consumers' habits and values—research touted by an advertising industry interested in establishing its value to clients. By the end of the 1970s, information about the American consumer seemed woefully out of date and marketers called for more and more data to help them successfully navigate this supposedly new, segmented American landscape. Such information tautologically confirmed marketers' perspectives about social and, hence, market schism. As Cohen argues, "The consumer purchase became both the objective of and the evidence for the social-class segmentation."[8] The subsequent deluge of surveys, graphs, and reports was different not just in quantity but also quality. Computerization enabled researchers to gather and juggle data in unprecedented ways. By the 1980s, influential market research tools like VALS (Values and Life Styles), Acorn, the Yankelovitch Monitor, and Cluster Plus dissected and analyzed every aspect of Americans' buying habits and correlated them with demographic variables like age, income, occupation, gender, location, and race, as well as psychological variables like attitude and personality type. The Claritas Corporation's PRIZM (Potential Rating Index for Zip Markets), for example, cross-linked the U.S. Postal Zip Code map with U.S. census data and

consumer behavior information in order to classify each zip-code neighbor-hood into one of forty lifestyle categories. Supposedly capturing the essence of each zip code's typical consumer resident, these categories included such relatively self-explanatory titles as Shotguns and Pickup Trucks, Blue Blood Estates, and Furs and Station Wagons.[9] Buzzwords coined to supposedly bet-ter describe real consumers seemed to enter the ad-world lexicon every day, while new concepts like "demographic break-down," "lifestyle," "psycho-graphic profile," and "primary media community" influenced the ways adver-tisers talked about and conceived of the audience for their messages. Such inquiries into the varied habits and psyches of American consumers, what Robin Murray has called the "new anthropology of consumption," reinforced advertisers' assumptions about the fragmentation of American culture and the problems of mass marketing.[10]

The shift towards targeting niches instead of solely mass markets was also motivated by fluid conditions at the point of production and sales. An eco-nomic downturn in the early 70s, increasing competition within maturing industries, and the development of computerized technology encouraged both manufacturers and retailers to alter traditional business practices. In western economies like that of the United States, some experts claimed, Fordism was giving way to Post-Fordism—a new stage of capitalist produc-tion marked by, among other things, a new-found flexibility in production and distribution.[11] Computerization and other technological advancements helped loosen up the rigidly standardized assembly lines that had long been the backbone of Fordist mass production. The profit margins once made pos-sible only through the economies of scale achieved by the production of huge batches of a uniform product could now be maintained with the production of much smaller lots. Instead of churning out endless copies of the same sweater, chair, or teapot, for example, a factory could produce numerous ver-sions—different in color, size, style, or material. A corresponding flexibility also transformed the world of retail where the computerization of inventories and distribution systems made it possible for retailers to stock an increasing variety of items without sacrificing profitability. Consequently, store shelves swelled with new products, multiple variations, and seemingly limitless choices for consumers. Flexible production capabilities, combined with increasingly intense competition, encouraged manufacturers to design and sell products with market segments, not an undifferentiated mass of consumers, in mind. Doing so could help a product break into a competitive market, uncover completely new markets, intensify the product-consumer relation-ship, and boost customer loyalty.

Yet one more factor driving the fragmentation of consumption and the shift to niche marketing was self-interest on the part of various media in-dustries. As early as the late 1950s, radio and national magazines, once the

dominant forms of mass media, were forced to reinvent themselves as network television eroded their shares of the mass audience and mass marketing dollars. In response, they developed specialized formats that appealed to the distinct interests of narrower audience segments and tried to attract advertisers by promoting the unique qualities of their audience demographics. Such trends accelerated significantly in the 1980s and 1990s. Cable technology, as detailed below, changed the dynamics of television—the last bastion of mass marketing. Channels like CNN, MTV, and Lifetime came online just as advertisers and their ad agencies were looking to exploit perceived fissures fracturing the American social landscape and to sell the profusion of new specialized products they were able to produce. As an upstart industry, cable was anxious to attract marketers' money, and the narrow formats many cable channels developed capitalized on the general shift to target marketing taking place around them. At the same time, however, cable also accelerated that shift. Cable viewing patterns strengthened advertisers' assumptions about consumer fragmentation. Trade press comments by Doug McCormick, executive VP/sales manager for Lifetime, suggest how hard cable channel executives worked to reinforce the logic of niche-marketing principles and link cable to them. "Marketing strategies that let go of the mass appeal with all the waste and re-direct themselves into a target-specified audience are strategies that are going to bear fruit," he claimed. "There's been a quiet revolution in the marketplace that has cable taking its rightful place in media buys."[12] The rise of home computers, the Internet, direct broadcast satellites, and computerized printing technologies in the 1990s intensified competition for audiences and ad dollars across the entire media landscape and encouraged media outlets to find even narrower audience segments.

By the 1990s, then, the world of advertising was dramatically different than it had been just twenty years earlier when the Big 3 networks reaped the rewards for being the most effective media vehicles for reaching the much sought-after mass market. Consumers, broken into demographic and psychographic units, were now the center of attention and the currency of exchange among advertisers, ad agencies, and media outlets. A slew of new concepts like "tailoring," "signaling," "versioning," and "customized media materials" guided the way products were marketed and media outlets designed. Cost-conscious advertisers, for example, became increasingly interested in the demographic purity of the audiences they were paying to reach. Magazines, cable networks, and TV shows were tailored not only to appeal to those in a targeted demographic group but also to send clear signals to unwanted eyes that certain media products weren't meant for them. Rarely wanting to dissuade anyone from purchasing a product, advertisers used versioning—the practice of editing, casting, or customizing an advertising campaign in different ways in order to appeal to different kinds of audiences and to run in

different niche-oriented media outlets.[13] Niche-marketing tactics reached new highs in the 1990s as computerization made truly personalized advertising and media possible. Mass customization in computer printing made it possible to publish numerous versions of a magazine with articles and ads selected according to readers' lifestyle profiles. Direct marketing mailings sent custom-designed offers to targeted zip codes or households. And Web services would eventually provide news coverage edited to an individual's particular interests. The Big 3 networks were relatively unprepared for this world of target marketing. Their general approach to broadcasting was increasingly out-of-sync with many of the hottest trends in advertising.[14] As I argue below, the networks were forced to adapt, and one such adaptation was a growing appreciation for what gay material could do for them as they tried to tailor their programs in this era of audience segmentation and niche marketing.

THE END OF THE BIG 3 NETWORKS' MONOPOLY

At the same time the networks saw interest in the mass market—their long-standing stock in trade—cool, their oligopolistic control of the television industry was threatened. While helping to fuel the ad world's growing interest in targeting narrower audiences, the growth of cable also cut at the core of the Big 3's stranglehold on programming distribution and audience share. Cable—along with developments in independent and network broadcasting—dramatically increased the avenues by which television programming and consequently advertisers reached audiences. By 1989 the once cozy world of network-dominated broadcasting seemed like a wide-open free-for-all—an industry marked by, in the words of former FCC chairman Dennis Patrick, "ferocious competition that was unimaginable 10 years ago."[15] Such dramatic changes in the television landscape become most evident in the much-discussed erosion of network audience shares that started in the early 1980s. After reaching all-time highs in the 1979–1980 season in which ABC, CBS, and NBC together captured a 56.5 rating and 90 percent of prime-time audiences, network ratings and market share steadily dropped year by year. Between 1980 and 1990, the networks' portion of the prime-time audience dropped 28 percent to a 39.7 rating and a 65 share. By the end of the 1990s, the Big 3's share of prime-time viewers was half of what it had been at the end of the 1970s (27.0/43).[16] No longer did network programs reach huge segments of consumers.

Much of the erosion, of course, can be directly attributed to the expansion of the cable industry. In 1970 only 7.6 percent of U.S. homes received television programming via cable. By 1980 that number had jumped to 20 percent and climbed steadily throughout the decade to reach 57 percent in 1990. By 1996, 98 percent of the country was wired for cable and 72 percent

of Americans subscribed. Over the same period, the number of cable chan-
nels bringing programming to American homes grew exponentially. Pay-
cable pioneers HBO and Showtime were joined in the early 1980s by such
cable icons as CNN, MTV, and USA Network. By the early 1990s, a second
generation of even more narrowly targeted channels like The Food Network,
Home and Garden TV, and The Golf Channel came on line, raising the num-
ber of channels many Americans received to more than fifty. And although no
individual cable channel could come near the ratings figures the Big 3 still
got, by the early 1990s cable as a whole was drawing over 20 percent of tele-
vision viewers.[17]

Cable, however, wasn't the only segment of the TV industry to pose new
challenges to network domination. Independent broadcasting, for example,
experienced unprecedented growth. The number of nonaffiliated stations in
the United States tripled in the 1980s, rising to well over 300.[18] Such new
competition seriously weakened the networks' monopoly of the airwaves. In
1980, 84 percent of the nation's 734 stations were affiliated with one of the Big
3. In contrast, by 1987 there were nearly 1,000 licensed stations of which only
61 percent were linked to ABC, CBS, or NBC. The growth of independent
broadcasting was a boon for first-run syndicators (TV producers who side-step
the networks and sell their programs directly to stations.) By 1993, in fact, syn-
dicators replaced the networks as the industry's biggest suppliers of television
series programming.[19] In 1986, 100 of these independent stations joined
Rupert Murdoch's upstart Fox network. The formation of a fourth broadcast
network had been utterly unthinkable just a few years earlier when network
monopoly was at its peak. The once unassailable networks, however, were now
being challenged at their own game. Competition intensified further in 1994
when the WB and UPN emerged as the fifth and sixth broadcast networks. As
with cable, these new competitors chipped away at the Big 3's control of the
audience. By 1990 Fox consistently got a 6.5 rating and 11 share; shortly after
their launches, the WB and UPN earned combined ratings/shares around
5.9/9. By the 1990s this new landscape was further complicated by the emer-
gence of increasingly cost-effective and practical direct-broadcast satellite tech-
nology that beamed not just dozens but rather hundreds of channels of
programming into subscribers' homes. The result of such developments was
increased options for viewers. In 1976 only 27 percent of households received
more than ten channels of programming. In 1989, by contrast, 64 percent of
homes received at least fifteen and 45 percent received at least thirty, and those
averages would continue to rise in the 1990s. Clearly, the Big 3 were no longer
lords of an exclusive broadcasting universe; their government-supported
oligopoly over program distribution was disappearing.[20]

Things looked bad enough for the networks at the end of the 1980s, but
they would get worse in the early 1990s. While market domination fell

throughout the 1980s, advertising revenue remained strong. The Big 3 certainly received a smaller percentage of the money advertisers earmarked for TV as cable, Fox, independent stations, and syndicators took larger pieces of the pie than they had previously. However, the size of that ad revenue pie had grown enough to offset any losses. In 1980 advertisers spent $8 billion on television advertising, of which 60 percent went to the networks. In 1987, in contrast, only 50 percent of TV-targeted ad money went to the Big 3, but television ad budgets had more than doubled to $18 million.[21] A critical mass of advertisers was still willing to buy network commercial spots despite shrinking audiences. Consequently, the networks continued to see their ad revenue rise by as much as 15 percent per year. Rising ad rates were fueled by a seller's market in which dozens of frenzied buyers raced to outbid each other in a game still controlled mainly by the networks.[22] Such success helped blunt the impact of increased competition on network attitudes, and for the most part, the networks continued building prime-time line ups with only a few changes.[23]

In the early 1990s, though, such trends reversed. The economic recession that cost George Bush the 1992 election cost the Big 3 millions of dollars in ad revenue. Faced with a weak economy and low consumer confidence, marketers cut advertising budgets in favor of direct marketing and promotions in an effort to boost short-term sales. In the first half of 1991, for example, advertising spending by the 200 largest consumer-goods manufacturers dropped 6.2 percent.[24] Historically, the Big 3 had been amazingly recession proof, but by the 1990s they found themselves vulnerable.[25] The sellers' market was gone; power shifted to advertisers. A consolidation of ad agencies' media-buying operations in the late 1980s had reduced the number of buyers looking to purchase commercial spots.[26] At the same time, cable and Fox had matured into legitimate media outlets in the minds of national advertisers, raising the number of viable sellers of TV airtime. Combined, these developments transformed the dynamics of TV ad sales just in time for the recession. In what had increasingly become a buyer's market, the networks slashed prices as they fought for limited ad dollars.[27] In 1991 network TV ad revenues fell 6.7 percent and overall TV broadcast revenues declined for only the second time since 1960.[28] The soft ad market, which began in 1990 and deepened in 1991, lingered through the 1992–1993 season. According to *Electronic Media*, "Rarely [had] there been a time when the stability of commercial television's major revenue sources [were] so threatened."[29] By 1991 industry insiders started to suggest that one of the networks might actually go under.

The Growing Importance of Demographics and Narrowcasting

While the Big 3 networks saw their ad revenues and sense of invulnerability decline, cable actually saw ad rates and revenues increase at double-digit

rates by the early 1990s. At the same time, the cable industry expanded its client base, drawing more of the nation's largest advertisers and attracting new ad categories. Much of this progress was attributed to cable channels' success in, as *Adweek* put it, "sharply defining their target audiences and stressing the importance of micro-marketing and target-audience delivery."[30] The same tight ad budgets and weak economic conditions that encouraged marketers to favor promotion over advertising also encouraged them to value cable's less expensive and highly targeted delivery system. Despite network erosion and recession-era deflation, network television ad rates were mammoth compared to cable's per unit costs. In 1990, for example, one 30-second commercial spot on a top-rated network program like *Roseanne* cost as much as $300,000, while an 8-spot package of 30-second commercials aired during original movies on TNT cost only $36,000.[31] Paying top dollar for network television's mass audience was, in the eyes of a growing number of advertisers, imprecise and wasteful, especially compared to the accurate targeting and bargain prices cable offered. In 1990, for example, when asked which sector of the TV industry offered the best return on the ad dollar, 49 percent of advertisers and agency executives surveyed named network television while only 16 percent said cable. Three years later, network television's approval rating dropped to 36 percent while cable's had risen to almost 22 percent.[32] Cable's strength with target audiences was luring more advertiser dollars away from the networks.

Granted, the trade in demographic figures wasn't entirely alien to the networks; they had long developed programming strategies and sold airtime to advertisers with different audience blocs in mind. Daypart segmentation and counter-programming, both important scheduling practices since the early days of radio, were predicated upon rough divisions of audience members by gender and age. Similarly, reaching the broad demographic of adults 18-to-49, those assumed to be the most active consumers, had been a priority for most national advertisers and consequently the networks as well.[33] At times the networks also took unusual steps to target narrower audience segments that proved to be particularly lucrative under different market conditions. In the early 1970s, CBS—concerned with the revenue of its urban-centered owned-and-operated stations—used so-called socially-relevant sitcoms like *All in the Family*, *Maude*, and *Mary Tyler Moore* to attract a distinctly urban adult demographic. In the 1980s, as changes in women's employment patterns forced them to reassess their programming strategies, the networks used shows like *Cagney & Lacey*, *Kate and Allie*, and *Designing Women* to target what Julie D'Acci calls a "quality audience" of working women.[34] Such targeting tactics, however, remained subordinate to traditional broadcasting approaches throughout the 1970s and 1980s, especially where prime time was concerned. Advertisers continued to see network tele-

vision as a tool for reaching the largest audience possible and network exec-utives programmed accordingly.[35] Efforts to reach urban adults or working women were more often than not exceptions to the broadcasting rule—sup-plements to prime-time schedules still designed to maximize total audience size. While a handful of shows like *Cagney & Lacey* or *Hill Street Blues* stayed on the air only because of the quality demographics they attracted, mass-oriented programs that brought in big numbers remained the goal for net-work programmers who refused to splinter their audience to the same extent as magazines, cable, and radio.[36]

Pressure to adhere to a traditional broadcasting approach continued dur-ing the 1990s. Despite the popularity of niche marketing, the network's rela-tively large audiences remained enormously valuable to many national advertisers, especially large packaged-goods manufacturers who were the ad world's biggest spenders. "Network has been the butt of every other medium's sales efforts," one network executive admitted (referring to the fashion of pro-moting high quality, targeted demos over mass audiences), "but it is still the gold standard everyone else is held up against."[37] Measuring network market share against cable's meager drawing power, for example, a director of media and marketing for Coors, did the math: "It's still better to get a 66 share divided three ways versus a 27 share divided 27 ways."[38] And as late as 1992, one marketer argued that for some advertisers a show that won its time slot with a mass audience was "more palatable" than a third-place show that had a higher concentration of the target audience.[39] In fact, cable's expansion in the 1990s actually helped to bolster some advertisers' appreciation of the Big 3. The emergence of digital cable, the 500-channel universe, and a slew of magazine-style cable services like the Sci-Fi Channel, Home & Garden TV, and Cable Health Club splintered television audiences even further. On the one hand, such developments exacerbated the decline of the networks' rat-ings. On the other hand, as continued fragmentation spread audiences more thinly across all media outlets, the importance of those outlets that could still attract a *relatively* sizeable audience grew significantly. Not surprisingly, many network executives were hesitant to embrace the narrowcasting mentality. Alan Wurtzel, ABC vice-president for research and marketing, argued that aggressively chasing narrow demographics would threaten the future of net-work stability: "Frankly, there are only three mainstream broad-spectrum net-works in existence," he argued. "That's something unique, a franchise that once given away can never be recaptured."[40] Similarly, a somewhat disdainful Leslie Moonves, CBS president in the mid-1990s, told one USA Network executive, "I don't think we've slumped to your level yet."[41]

Nevertheless, by the mid-1990s executives at ABC, CBS, and NBC faced increasing pressure to adapt to the cable and niche revolutions and deliver good demographics, not just big audiences. The recession accelerated cable's

emergence as a legitimate ad vehicle and in doing so magnified the impor-
tance of audience segmentation to the overall television ad market. Fox, for
example, quickly established itself as a legitimate fourth network by adopting
a cable-inspired narrowcasting, not broadcasting, approach. Instead of trying
to appeal to as wide an audience as possible, Fox deliberately used programs
like *21 Jump Street, The Simpsons, Roc,* and *Beverly Hills, 90210* to target a
narrow audience of teenagers, twentysomethings, and African Americans—
groups who hadn't been well-served by traditional network programming and
for whom a viable advertising market existed. As more and more advertisers
grew accustomed to negotiating ad rates and planning media buys in terms of
cable's and Fox's demographic breakdowns, the demographic stakes were
simultaneously raised for the Big 3. "I recently spoke to about 50 advertisers
for next season," ABC Entertainment President Robert Iger explained, "and
I didn't meet one that spoke of household numbers. They spoke of specific
demographics."[42] The networks' competitors were gaining ground with
viewers and advertisers by focusing on specific demographic groups; viewers
enjoyed programming targeted at their unique interests, and advertisers appre-
ciated the efficient precision with which they could reach desired consumer
niches.[43] Network sales executives, those faced with the task of selling net-
work airtime and negotiating specific ad rates for each show with media buy-
ers, pressured programming executives to schedule shows that drew in sellable
demographics. And as audience share dropped to 60 percent and the viability
of the networks came into question, the writing on the wall became clearer:
they evidently weren't pleasing everyone anymore, so why keep trying?

THE 18-TO-49-YEAR-OLD DEMOGRAPHIC

Eventually, all three networks, with a zealous NBC in the lead and an
irresolute CBS bringing up the rear, started to stray from their broadcasting
approach. Demographic breakdowns in general found a more prominent
place in network strategy by the mid-1990s. ABC's Robert Iger, for example,
explained that his network's daily ratings sheet had always reported ratings by
household and had buried demographics on page three. In 1992, however, the
format changed; household figures were bumped and demographics monop-
olized the entire first page.[44] Amid such increased interest in audience seg-
mentation, one relatively narrow group of viewers was pursued most ardently.
Ostensibly, this network-style niche audience was comprised of the same
demographic that had been important for decades: adults 18-to-49. In the
1990s, however, the networks pursued this audience with a newfound tunnel
vision and an urgency born out of the necessities of cable-era competition.
For one thing, the networks had previously targeted 18-to-49 year olds some-
what casually, scheduling programs geared for a broad audience and assuming
that adults under fifty, with few media alternatives, would tune in as well. Alan

Wurtzel, senior vice-president of research and marketing, explained broadcasting's least-objectionable-programming approach. "When we are really successful, we have programs that span the gamut of ages," he claimed. "We don't want to do programs that are so hip, so cutting edge, so arcane, that nobody over a particular age is going to be interested in them. That's not in our best interest."[45] The luxury of that strategy, however, had disappeared by the mid-1990s. If adults 18-to-49 didn't get programming targeted at their specific tastes, network executives feared they would turn to cable, home video, or (as the decade progressed) the Internet. As Jeff Bader, ABC vice-president for scheduling admitted, "You're not going to get anyone by default anymore."[46] Thus, the networks targeted young adult sensibilities much more aggressively, greenlighting shows that ran the risk of alienating younger and older audiences. As we will see, such risks would include incorporating gay material.

Aggressively targeting 18-to-49 year olds was a logical choice for the networks. After all, if they were going to have to get by with considerably smaller audiences, it made sense to battle as hard as possible to retain their most lucrative viewers. The auctioning of viewers in the TV ad market works much like any commodities exchange. Like investors picking a stock to buy, advertisers select the audience and then the programs they want to purchase based on various factors. Market-research data on purchasing patterns and income levels often mix with less scientific cultural assumptions, gut instincts, and industry fads to elevate a certain audience and the programs they watch to the hot list.[47] Prices are then set within the supply-and-demand realities of the market place. The core, adult demographic, 18-to-49 year olds, had unquestionably been the most desired consumer group for decades. Their market value, however, soared in the 1990s as the recession and audience segmentation sharpened many advertisers' focus. ABC's Robert Iger, for example, felt he understood perfectly what advertisers wanted: "We heard loud and clear throughout our scheduling process that the demographic in this economy was more critical than it has ever been."[48] What Internet stocks were to Wall Street in the 1990s, one could argue, 18-to-49 year olds were to Madison Avenue.

Certain marketing assumptions and realities bolstered the demographic's exchange value. Advertisers had long believed that those adult consumers were responsible for a majority of the economy's purchases, had the most disposable income, and, unlike older consumers, were less rigid in their buying patterns and more susceptible to advertising messages. ABC's Ted Harbert gives some insight into advertisers' working assumptions about age-specific consumer behavior: "My parents have disposable income. They spend it. But the point the advertising agencies continue to make is that [older viewers'] habits are made and what they want are the young adults that are still forming

their habits and [deciding] which detergents they're going to buy for the next 40 years . . . And they want you making that choice when you're 23, not when you're 63."[49] Core young adults were also more valuable to the networks because they watched considerably less television than their older counterparts.[50] According to one media buyer, "network shows over-deliver the 50-plus segment of the audience and under-deliver the under-50 audience. . . . That's just the nature of who watches television."[51] In the supply-and-demand economy of TV ad sales in the 1990s, the harder an audience was to reach (i.e. the less they watched) the more advertisers were willing to pay to reach them. Conversely the more they watched, the lower the asking price. Hence, advertisers rushed to outbid each other for commercial spots on those relatively few shows that were popular with younger adults, running up the ad rates tremendously. In 1994, for example, CBS's *Murder, She Wrote* and NBC's *seaQuest DSV* went head to head on Sunday nights. *Murder, She Wrote* won the overall ratings race, ranking seventh compared to *seaQuest's* sixtieth. On the strength of its better performance among 18-to-49 year olds, however, NBC won with advertisers who paid $101,000 per 30-second spot for *seaQuest* compared to only $75,000 for *Murder, She Wrote*.[52]

While such factors strengthened the appeal of 18-to-49 year olds overall, the 18-to-34 segment of the demographic was singled out as particularly appealing in the early 1990s. Not only did they watch even less television than 35-to-49 year olds, but they were also considered to be cultural trendsetters. "They set the tone for what's hot and what's not," one advertising executive explained. "If you can get on their good side, you get the momentum from a sales perspective."[53] In addition, they were believed to have the kind of disposable income and spending patterns a wide range of advertisers lusted after. Although their elders may have higher incomes, these twentysomethings, popular reasoning maintained, had less money tied up in mortgages, children's college funds, and 401(k)s. Jumping on the bandwagon, advertisers soon became fixated on reaching these so-called "young viewers" and trade press articles obsessed over how to reach the hard-to-reach post-baby-boom generation.[54]

TARGETING SOCIALLY LIBERAL, URBAN-MINDED PROFESSIONALS

In 1993 Paul Isacsson, vice president of communication services for Young & Rubicam, identified an important shift in the business behind media production. "Programming," he noted, "is moving away from an age to a lifestyle focus."[55] While advertisers' and thus networks' official target audience was 18-to-49 year olds, competition and niche-marketing trends encouraged the networks to pay special attention to an even more narrowly defined segment of the adult audience—*upscale* 18-to-49 year olds. The category "upscale" emerged out of the lifestyle marketing research of the 1980s and

referred not just to the "genuinely affluent" but also the "selectively afflu-ent."[56] Computer-assisted data analysis allowed researchers to correlate income with other lifestyle variables, which in turn helped them identify consumers whose income levels weren't necessarily indicative of their true consumer behavior. Thus, upper-middle-class consumers without families could have as much disposable income as the truly affluent, and middle-class consumers who focused their spending on certain lifestyle areas could make purchases as though they were rich. Since there was no clear figure establish-ing the income of upscale consumers, the category expanded to cover a rela-tively broad segment of generally well-educated, upwardly mobile Americans. While these upscale adults had certainly been the center of attention for years, marketers and network executives, in response to inevitable genera-tional shifts, had to update their conception of the upscale adult market for the 1990s. Aging yet still socially progressive baby boomers, for example, dis-placed the more conservative generation that had preceded them. At the same time, Generation X-ers, believed to be critical individualists and cynical lib-ertarians with seen-it-all attitudes, drastically reshaped the 18-to-34 market segment. In an era when marketers used lifestyle and attitudinal research to compile complex psychographic consumer profiles, I am arguing, the net-works imagined this 1990s era upscale market to be comprised not simply of generic upscale adults. Instead, they envisioned this audience to be "hip," "sophisticated," urban-minded, white, and college-educated 18-to-49 year olds (perhaps even 18-to-34) with liberal attitudes, disposable income, and a distinctively edgy and ironic sensibility. Although neither market researchers nor the networks themselves labeled the members of this new psychographic market, it remained a centrally operative, if somewhat nebulous, category. Consequently, I have dubbed them *slumpies*: socially liberal, urban-minded professionals. Descriptors like "hip" and "upscale" sidestepped sensitive politi-cal issues a word like "liberal" might bring up, and it's not surprising that net-work executives wouldn't talk about their target viewers in such terms. I do, however, in chapter 4, for example, I will detail the political discourses at play behind notions of "hipness." For the rest of this chapter, though, I want to focus on why and how the networks pursued this psychographic group.[57]

Although this audience was extremely appealing for the networks, it was more difficult for them to reach. First, the Big 3 had lost much of its popu-larity among younger adults. In the late 1980s, Fox and cable had successfully targeted the so-called MTV generation, and as those 1980s-era teenagers matured into 1990s-era twentysomethings, the Big 3's hold on the 18-to-34 segment was in serious jeopardy. By 1992 when the median U.S. age was thirty-three, the average Fox viewer was only twenty-seven; the average viewer of the Big 3, by contrast, was forty-three.[58] Second, research had shown that highly educated and upscale viewers tended to watch less

television than their lower-income counterparts, and when they did watch television, they were increasingly switching to cable channels.[59] In the 1980s the cable industry had promoted itself by touting the disproportionate afflu-ence of its subscribers. According to the president of the Cable Advertising Bureau, cable's audience "represents the cream of America's consumers: view-ers with upper-bracket incomes, better education and greater buying power."[60] Such claims were backed up by demographic research that showed cable subscribers to be 18 percent more likely to have incomes over $50,000 and 19 percent more likely to have executive, managerial, or administrative jobs.[61] In fact, the very concept of an "upscale" TV audience first arose in conjunction with cable, as cable executives exploited the new term's cachet and its inherent ambiguity to paint an appealing profile of their subscriber base. Amid such trends, the networks' audiences seemed unappealingly old and increasingly downscale.

Although the networks fought such perceptions, Fox and cable gained reputations as the first choice for young and upscale adult viewers. In a 1989 Roper poll of viewer preferences, for example, cable dramatically outper-formed "regular TV" in such categories as educational, cultural, and enter-tainment programming. The survey's largest margins of difference, however, involved questions of mature content; respondents clearly believed that cable programming offered viewers more sex (71 percent to 6 percent), more vio-lence (58 percent to 11 percent), and more profanity (69 percent to 7 per-cent).[62] While exposing cable to censure from critics concerned about the medium's dangerous influence on children, such numbers also made clear that, in the minds of most viewers, cable offered the kind of adult program-ming traditional networks didn't. Even CBS Entertainment president Jeff Sagansky admitted that cable was commonly felt to be "the young, hip kind of medium."[63] Fox pushed the envelope as well. Programs like *Married . . . with Children*, *In Living Color*, and *American Chronicles* raised the ire of conser-vatives and successfully differentiated Fox from its broadcasting rivals.

As cable and Fox broke taboos, network schedules remained tied to "pat, formulaic television."[64] Reviewing the 1989–1990 fall line ups, for example, *USA Today*'s TV critic announced that "Network executives seem ready to play the nervous wardens over a fall television schedule where creativity, originality and individuality are prime-time crimes."[65] Although risky, adult-targeted programs like *Twin Peaks*, *thirtysomething*, and *Cop Rock* dotted prime time, network schedules continued to be dominated by conservative, family-friendly shows like *Family Matters*, *Matlock*, *America's Funniest People*, *Major Dad*, *Hardball*, *Sister Kate*, *Parenthood*, *Island Son*, and *Carol & Company*. As the 1990s progressed, cable raised the stakes further, investing heavily in high quality, risqué original programs. According to *Brandweek*, 1993 marked "the year when cable programming came of age."[66] HBO's *The Larry Sanders Show*

became one of the most talked-about programs on TV, while original made-for-cable movies dominated the Emmy awards. Bringing young, upscale adults back to network TV was going to require a conscious effort.

1992–1993: NBC's TURN
TO THE YOUNG AND THE HIP

NBC, looking to gain a competitive advantage over its rivals, made the first decisive move to aggressively target the slumpy audience. Its efforts demonstrate the extent to which the growing importance of demographics, the slumpy audience, and gay material were linked not only to macro-trends like niche marketing and cable, but also to the micro-politics of network competition. By the 1991–1992 season, the complete ratings dominance NBC had enjoyed since 1985 came to an end as the once proud Peacock Network found itself battling for second place; with many aging shows running out of steam, things looked even more dismal for the upcoming year. NBC realized it needed to develop a new strategy for the 1990s. Meanwhile, CBS, relying on a prime-time lineup effective at attracting a broad audience but particularly strong with older viewers, had leapt from third to first place and was poised for a successful 1992–1993 season. In CBS's older-skewing lineup, however, NBC saw its opportunity. When NBC announced its prime-time schedule for the 1992–1993 season, several successful but older-skewing shows of its own had been cancelled in what some advertisers called "granny dumping."[67] *Matlock* and *In the Heat of the Night* ranked in the top ten among viewers over fifty, but failed to crack the top fifty with 18-to-49 year olds. Both shows, along with over-fifty favorite *The Golden Girls*, disappeared from NBC's fall schedule.[68] In their place NBC picked up programs clearly targeted at the 18-to-49 demographic—most notably *Mad About You, Homicide: Life on the Street, Here and Now, Rhythm & Booms,* and *The Round Table.*

NBC simultaneously announced that, starting in September 1993, it would downplay its household ratings and foreground the demographic performance of its shows in all public reports and industry analysis. As we have seen, demographic breakdowns had been integral to the negotiation of ad sales for years, but the basic ratings unit in network broadcasting had always been the television household. Until the late 1980s, ratings measurement technology could only measure which channel the television sets in selected households were tuned to. To get more specific demographic information about which members of the household had been watching which programs, everyone had to wait for the participants' handwritten diaries to trickle in weeks later. Thus, the instantaneous household ratings numbers functioned prominently in industry ratings discourse, shaped popular and trade judgements about the success of different programs, and very likely delayed the insurgence of targeting in network television. Not surprisingly, advertisers and

cable executives demanded a better system for the niche-marketing age. In 1987 A.C. Nielsen introduced the People Meter, which finally provided overnight demographic data. The networks, however, strongly resented the new ratings system. First, the People Meter added significantly to the erosion of Big 3 audience shares, suggesting that the old system had overestimated the size of the networks' audiences. In the 1987–1988 season, the Big 3 saw their market share drop five percentage points (75 to 70) and experienced their largest-ever single-year drop in ratings (47.6 to 43.5). Second, the networks had little to gain at that time by promoting demographics, the stock-in-trade of their rivals. Thus, they continued to emphasize household ratings figures in internal analysis and public reports. When NBC broke ranks with its announcement, however, it explained that it was simply responding to the changing reality of ad sales. NBC was certainly not entirely disingenuous on this point. The continued prominence of household numbers flew in the face of advertisers' indifference to them. "The household ratings are an anachron- ism," one media buyer claimed. "I mean, really, who cares? Nobody advertises to households. . . . We don't even look at household ratings when we make media buys. I don't know one advertiser who does."[69] Nevertheless, NBC undoubtedly also hoped to undermine the strength of CBS and bolster its chances by complicating the public's and perhaps even advertisers' perspec- tives on what being the number-one-rated network meant in the 1990s.

Overall, NBC's move was a logical response to the economic realities it faced in the early 1990s. As the number-one network with the biggest total audiences, CBS could force advertisers to pay top dollar, even for less desir- able older viewers. NBC, on the other hand, was plummeting to third place. It faced a rapidly shrinking audience share and a buyer's ad market hit hard by recession-era belt tightening. It had no such leverage. "With *Matlock* and *Heat of the Night*," one NBC sales executive explained, "we were paying for programming that wasn't producing an audience we can sell."[70] NBC, then, more than any Big 3 network had before felt the pressure to abandon tradi- tional broadcasting tactics in favor of targeting valuable demographics. Rem- iniscent of CBS's so-called "turn to relevance" in the early 1970s, NBC's shift in strategy in the early 1990s marked the beginning of a general turn to the "young, hip, urban, professional" audience that *Home Improvement*'s Matt Williams seemed so resentful of—the slumpy audience.

"EDGY" PROGRAMMING

While NBC may have been the first of the Big 3 to make such a bold move, between 1992 and 1996 all three networks took certain steps to "tailor" their products to the tastes of this all-important audience.[71] Among the most noticeable trends was the use of sex, nudity, violence, risqué language, and cutting-edge visual style to make a program "edgy"—one of the buzzwords

of the era. If cable was luring away 18-to-49 year olds with R-rated content, the argument went, the networks had no choice but to follow suit.[72] ABC's introduction of Steven Bochco's gritty, urban cop drama *NYPD Blue* in September 1993 was perhaps the loudest shot in the battle to make prime time more adult-friendly. The program pushed the envelope with levels of adult language and nudity unprecedented for network television. Long before its actual debut, the show was the center of a war over television standards. Despite edits and the inclusion of a parental advisory warning included on the demand of nervous ABC affiliates, fifty-seven stations still refused to air the controversial premier episode. Bochco and ABC defended the show's edginess with an explanation that wove together the necessities of free market competition in the niche era, claims to artistic freedom, and television's duty to reflect a changing reality. Bochco, for example, argued that "In 1993, when you're doing a cop show, you're competing with cable. . . . I don't think we can at 10 o'clock with our hour dramas effectively compete any longer unless we paint with some of the same color that you can paint with when you make a movie."[73] ABC chief Robert Iger agreed, asserting that network censorship practices needed to keep up with changing social reality. "The standards and practices are, in my opinion, things that have to change with a changing world." He stated. "You have to adapt to a new audience."[74] ABC's refusal to bow to intense pressure from affiliates and protest groups suggests a new narrowcasting mentality in which not offending viewers was less important than appealing to a desired demographic.

By the mid-1990s a slew of decidedly adult-oriented dramas appeared on all three networks. Despite the controversy, or perhaps because of it, *NYPD Blue* proved to be "a demographic bull's-eye."[75] Its debut won a 31 share of adults 18-to-49. Seeming to satisfy the slumpy audience's desire for mature television, the program quickly became a top-ten favorite with them. Of the program, one critic wrote: "The camera work is cutting-edge sophisticated and hip; the big-city ambiance perfectly captures the massive, sudden loneliness, and metaphysical finality of Urb Americana."[76] A *TV Guide* advertisement for the series indicates how ABC tried to capitalize upon the controversy (fig. 2). Terms like "hip," "sophisticated," and "edgy" were commonly used to describe a number of dramas which, like *NYPD Blue*, mixed realistic dialogue, a frank treatment of sex, a highly unusual cinematic style, gritty urban settings, and socially relevant narratives. NBC's *Homicide: Life on the Street* incorporated fast-paced, unconventional editing with handheld video aesthetics to convey the disorder of urban Baltimore. NBC's *ER* redefined the staid hospital-drama genre with a no-holds-barred approach to depicting the blood and guts of an urban emergency room. ABC's *Murder One* followed a single court case over the course of an entire season. *Cracker, Nothing Sacred, The X-Files, New York Undercover,* and *My So-Called Life* all

2. *TV Guide* advertisement for *NYPD Blue*.

risked turning off older or younger viewers in order to offer core adults a reason to tune in.

The campaign to target the slumpy audience, however, wasn't limited to the 10:00 p.m. drama-dominated timeslot. An equally significant development of the mid 1990s was the proliferation of what might be called the adult-oriented, slumpy sitcom and the demise of the Family Viewing Hour—a demise brought about as the new breed of sitcoms pushed out more kid-friendly fare. In 1975 the networks, their affiliated stations and the FCC had tried to quiet public concern over increased violence and sex on television by instituting the Family Hour policy in which all agreed to air wholesome programming during the first hour of prime time. Although a federal judge struck it down a year later, the Family Hour remained a de facto policy, guiding network scheduling practices. While the policy had helped the Big 3 appear concerned about protecting America's children, it also dovetailed well with their broadcasting strategies. Scheduling shows with kid appeal during the early evening hours, the logic went, would attract children who, in turn, would bring the parents (the networks' real target audience) as the family watched TV together. By the 1993–1994 season, CBS was still number one with households, but ABC had taken over the lead in the core adult demographics, partially on the strong performance of family sitcoms like *Full House, Home Improvement, Step by Step, Thunder Alley, Phenom,* and *Family Matters.* While shows with strong kid appeal helped ABC capture first place among core adults, NBC gained ground by abandoning the family-hour strategy and blatantly going after 18-to-49 year olds—especially the young, hip, urban, professional segment.

This strategic move was encouraged by a number of factors. First, Fox's aggressive efforts to target 18-to-34 year olds in the early evening hours with risqué programs like *In Living Color, The Simpsons, Beverly Hills, 90210,* and *Melrose Place* increased pressure on the Big 3 networks to follow suit. Second, network executives perceived a change in television viewing practices. According to ABC's Ted Harbert, "Seventy percent of households now have more than one TV set. . . . You now have parents putting their kids in one room to watch their show and they can go in the other room and watch a more adult show designed for them."[77] Multiple-set ownership, combined with the success of kid-oriented cable networks like Nickelodeon, a rapidly expanding children's home video market, and Nintendo-style video games, seemed to alter the way families with children used television. It became increasingly evident to the networks that if they were going to successfully compete, they would have to put on programming more narrowly targeted at kids' interests—a move which would, most likely, turn off adult viewers in the process. In general, the networks decided not to pursue children; on its own, the kid demographic wasn't worth it. There simply weren't enough advertisers

interested in paying prime-time prices to reach them. Between 1993 and 1998, Nickelodeon quadrupled the size of its kid audience at 8:00 p.m., while network viewing by kids age two to eleven dropped 40 percent.[78]

By the mid-1990s, then, most prime-time sitcoms were hardly a family affair as all three networks packed their schedules with adult-oriented shows. With little to lose, a floundering NBC again took the lead—this time taking the first steps to abandon television's youngest viewers. Unconcerned with kid appeal, NBC was able to target its key upscale adult demographic more efficiently with programs like *Seinfeld, Frasier, The John Larroquette Show, Newsradio, Madman of the People*, and *Hope & Gloria*—programs that almost always eschewed cute toddlers, moralistic endings, and the stifling restraints of modesty. Their assault on the kid-held fortress of the early evening timeslot began in 1993 when they moved *Mad About You* and *Wings* to the 8:00–9:00 timeslot. The unprecedented success of *Friends* in the 8:30 slot a year later put the final nail in the coffin of the Family Viewing Hour, which would be officially pronounced dead the following year.[79] By the end of the 1994–1995 season, such programs had helped NBC climb out of the ratings basement, and with some of the best demographic figures, the network was poised to take over in the next season.

1995–1996: THE HEIGHT OF THE SLUMPY MARKET

By the 1995–1996 season, the other networks scrambled to copy NBC's success, resulting in an unmistakable programming trend. It seemed as though every prime-time show from 8:00–on was targeted to the perceived interests of a hip, cosmopolitan, professional, adult audience. During the preceding development season, for example, ABC made an about-face on the issue of family programming. As Ted Harbert explained, "Last year at this time, we made just nine comedy pilots and six of them were what we call kid-driven, where the kids were causing the problems in the show and the parents reacted. This year we're making 17 comedy pilots and zero kid-driven. . . . The focus of the show is more on the adults."[80] That fall ABC cancelled old-fashioned family-hour shows like *Thunder Alley* and long-time icon of wholesomeness *Full House*, moved shows considered to have more adult appeal such as *Roseanne* and *Ellen* to earlier time slots, and added *The Naked Truth, The Drew Carey Show, Hudson Street, The Faculty, Maybe This Time*, and *Murder One*. CBS's turnabout was even more dramatic. In the 1994–1995 season, it plummeted from first to third in household ratings and was a distant fourth, behind even Fox, in the key 18-to-49 demographic. CBS's numbers were dragged down by a schedule dominated by older-skewing shows like *Murder She Wrote, In the Heat of the Night, Chicago Hope, Touched by an Angel*, and *Diagnosis Murder*.[81] In a well-publicized effort to go younger, CBS pulled older-skewing shows like *Burke's Law* and *Christy* and banished *Murder, She Wrote* to the

ratings wasteland, putting it up against NBC's "Must See TV" juggernaut. It then promoted or added a slew of shows designed to bring in younger, hipper viewers—shows like *Cybill, Almost Perfect, Can't Hurry Love, If Not For You, Bless This House, New York News, Central Park West, John Grisham's The Client,* and *Courthouse.* Even Fox got in the game, picking up shows like *The Crew, Partners, Ned and Stacey,* and *Too Something* in an effort to expand its strong but narrow base among 18-to-34 year olds to include more thirty- and fortysomethings. Meanwhile, NBC placed *Caroline in the City, The Single Guy, Boston Common,* and *In the Pursuit of Happiness* onto a schedule already heavy with similar, slumpy-targeted programs.

As these new shows flooded the fall schedule, prime time was filled with programs about the lives of childless, often single, almost exclusively urban, white, upscale twenty and thirty year olds. Characters usually lived in big-city apartments and worked as often directionless yet still well-off professionals whose lives revolved around their close circle of like-minded friends and the trials of urban living, dating, and sex. For example, Jerry Seinfeld and his gang held a contest of wills to determine who could go the longest without masturbating. Frasier and Niles Crane opened their own French restaurant, battled to become the cork master of their wine club, and dashed each other's dreams of joining Seattle's most exclusive gentleman's club. Meanwhile Ellen Morgan aimed to get hip when her twentysomething boyfriend took her to L.A.'s hottest club, and she later strove for upscale sophistication when Martha Stewart attended her "autumn-bounty dinner." And all the while, edgy dramas like *NYPD Blue, ER,* and *Homicide: Life on the Street* told compelling stories about gang warfare, transvestite hookers, and the AIDS epidemic—all placed within the unmistakable landscape of "Urb Americana," all offering up cathartic nightmares for the slumpy viewer.

This preoccupation with the slumpy audience ignored the interests not only of viewers both younger and older than the target market, but also of rural-minded and/or socially-conservative adults—the slumpies' psychographic counterparts.[82] By 1995 there seemed to be little room on network TV for sentimentality, wholesomeness, or heartwarming narratives about the American family living in the heartland. Domestic dramas and family sitcoms were out of fashion and squeezed to the margins. "In the lexicon of television, there is a derogatory term for family shows: 'soft,'" one *Los Angeles Times* writer observed at the time. "Shows that are hip, shows that are racy, shows that are bound to become instant hits and sell ads, those shows have 'edge.'"[83] The short run of CBS's acclaimed but "soft" period family drama *Christy* makes clear just how disenfranchised the interests of certain viewers were at the time. Set in 1912 Appalachia, the show followed an idealistic young teacher as she struggled to make a difference for the children in a remote mountain community. During its spring 1994 run, the program performed

well, sometimes even winning its highly competitive Thursday 8:00 p.m. slot opposite *Mad About You* and *The Simpsons*. Its viewers were absolutely passionate about the show, flooding CBS with over 100,000 letters that applauded *Christy's* wholesome depiction of religious faith and small-town values (fig. 3). While it found an ardent and even sizeable audience, it never found a secure place on CBS's schedule. After less than envious timeslots and erratic runs in the 1994 and 1995 summer seasons, the network canceled the show. The problem: *Christy* played well in Omaha and Abilene but horribly in New York and L.A.—the supposed stomping grounds of the lucrative upscale adult. In an advertising market fixated on young, hip, urban professionals, viewers perceived to be too old, too young, too rural, or too conservative didn't seem to bring in the big bucks a network like CBS wanted at the time.

While there was little room on network television for Christy or her Smoky Mountain neighbors, there was an unprecedented amount of room in prime time for gay and lesbian characters. By the mid-1990s the number of gay characters as well as gay-themed episodes and references to homosexuality skyrocketed. With the exception of *In Living Color's* flamboyantly gay Blaine Edwards and Antoine Merriweather, there were no openly gay or lesbian characters on prime-time network television in early 1991. By the 1994–1995 season, however, the tally had risen to seventeen and one year later reached twenty-eight. Over the course of the 1996–1997 season, thirty-three different queer characters were scattered across twenty-four different prime-time network programs. At the same time, the number of subplots, jokes, and innuendoes dependent on homosexuality increased exponentially (see figs. 8 and 9). With children, as well as older and more conservative viewers increasingly out of the loop, writers, producers, network executives, and advertisers all took greater risks with what was previously taboo material. In fact, gay material's risqué reputation made it all the more appealing, giving it just the kind of edge that the Big 3 believed their target audience was looking for. Like *Homicide's* avant-garde editing style, *Seinfeld's* cynicism, *NYPD Blue's* nudity, and *Frasier's* urbane sophistication, gay material became a narrowcasting-age tool used to draw in the slumpy audience. In chapter 5, I will more carefully trace how specific gay material assumed that role.

WELCOME HOME: THE SLUMPY CRAZE COOLS OFF

As so often happens in the cyclical nature of network television, the fixation upon the slumpy audience that reached its apex in the fall of 1995 eventually waned, and it seemed as though the fascination with gay material might as well. CBS's decision to give itself a demographic facelift failed miserably. None of its new shows succeeded and its 1995–1996 season ratings and share dropped to an all-time low for the Big 3 (9.6/16). Not surprisingly, CBS abandoned its strategy and decided that its best bet would be to stick with

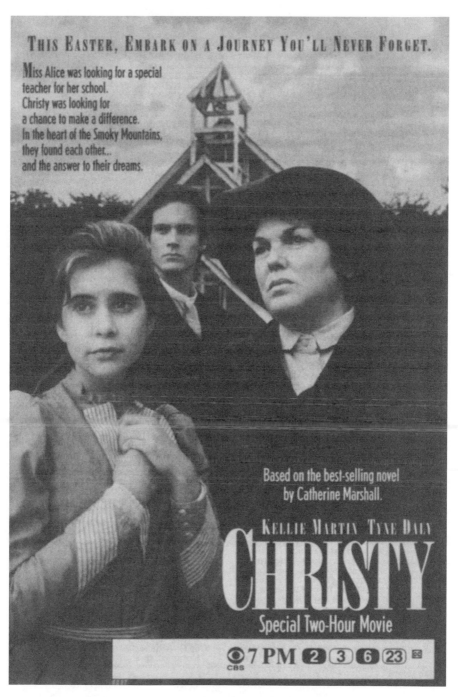

3. *TV Guide* advertisement for *Christy*.

what they knew—namely older viewers—and try to convince advertisers that the over-fifty demographic was indeed worth paying for. In the 1996–1997 season, CBS retreated from its 1995–1996 attempt to match NBC's slumpy-oriented strategy by developing a decidedly un-hip identity. The network's "Welcome Home" campaign unveiled in September 1996 sent a clear message that CBS was the network for the *Christy*-demographic—those older, more rural, more conservative viewers turned off by the New York sensibilities of slumpy TV. For the rest of the 1990s, CBS was known for shows like *Cosby, Promised Land, JAG, Walker, Texas Ranger, George & Leo, King of Queens, Kids Say the Darndest Things, Maggie Winters, Pearl, Nash Bridges,* and *Martial Law*—programs heavy on aging stars, down-home values, and tried-and-true formulas. ABC didn't fare much better in 1995–1996, seeing its ratings plummet to 10.6—the second lowest Big 3 rating in history. ABC's response, however, was less decisive. Spurred on by low ratings but also by its 1996 merger with Disney, there was a tremendous amount of discussion in the trade press that ABC would return to a family strategy. In 1997 it did revive the family-targeted *Wonderful World of Disney* for Sunday night. Despite the talk, though, ABC remained onboard the slumpy bandwagon, picking up typical slumpy shows like *Spin City, Dharma & Greg, Nothing Sacred, Cracker, Two Guys, a Girl, and a Pizza Place, The Practice, Hiller and Diller, Sports Night, Secret Lives of Men, It's Like You Know . . . , Wasteland,* and *Oh, Grow Up* between 1997 and 1999. Most notable, of course, was ABC's decision to allow Ellen Degeneres to out her character in the spring of 1997. ABC's strategy, however, seemed driven less by a firm faith than by a lack of vision; they didn't seem to have any other options. By the end of the 1999–2000 season, however, ABC seemed to have discovered a new tactic. With a lineup dominated by shows like *Who Wants to Be a Millionaire, Whose Line Is It Anyway?, 20/20,* and *20/20 Downtown,* ABC was more focused on cost-effective programming than on targeting a specific audience.

With such changes, it looked as though the trend of gay-themed TV would go the way of the western, the variety show, and the socially relevant sitcom. By 1998 the market seemed saturated with gay material. The failure of *Ellen* during the 1997–1998 season created concern about the viability of gay-themed programming. By the 1998–1999 season, the number of gay-themed episodes on the Big 3 network dropped noticeably as did the number of gay and lesbian recurring characters. In the long run, however, gay-themed programming would survive this saturation cycle and find a more secure place on prime-time schedules and in the conventions of TV's sitcoms and dramas. Despite the decline in the overall number of gay and lesbian characters and one-off gay-themed episodes, gay characters were, in fact, featured more prominently in the shows where they were included. The success of NBC's hit sitcom *Will & Grace,* which debuted strongly in the Fall 1998

season, undoubtedly helped revive gay-themed TV's stock, and in the following years short-lived shows like ABC's *Oh, Grow Up* (1999), Fox's *Normal, Ohio* (2000), and CBS's *Some of My Best Friends* (2001) featured gay leads. More importantly, perhaps, are successful series like *Buffy the Vampire Slayer* (1997–2003), *Dark Angel* (2000–2003), *Dawson's Creek* (1998–2003), and *ER* (1994–) which either introduced new gay characters or outed long-time characters. This chapter's goal was to situate the increase of such gay material within larger network developments and strategies,. In chapter 5, I will trace the emergence of the gay-themed programming phenomenon and industry discourse about specific episodes in a season-by-season chronicle.

The changing dynamics brought about by the niche-marketing revolution, audience erosion, and inter-network competition help explain why the networks became interested in more narrowly targeting a lucrative demographic like upscale 18-to-49 year olds and why they were willing to take greater risks to do so. However, they don't tell us why gay material seemed to be such a valuable narrowcasting tool for network executives looking to target slumpy viewers. The answer to that lies in the intersection between network assumptions and viewers' lived experiences. Earlier, I argued that the networks envisioned their upscale, well-educated target demographic to be "sophisticated" and "hip" with an "edgy" sensibility. Such terms are certainly imprecise, but I use them here because marketers, network executives, and media observers at the time employed them so frequently. They found them useful, I argue, because such adjectives offered a veiled way to talk about a relatively broad group of viewers who tended to have somewhat socially liberal attitudes. Including gay material in their lineups, network executives reasoned, might give such "hip," "sophisticated" viewers an added reason to tune in. The general success of gay-inclusive programming and the popular discourse surrounding it, I claim, suggests that by the mid-1990s a certain segment of the population did, in fact, find a gay twist with their prime-time TV not only acceptable but also appealing. Why? The next chapter describes an emerging social class whose sensibility found gay-themed programming particularly appealing.

CHAPTER 4

The Affordable, Multicultural
Politics of Gay Chic

Sometimes, I just gotta have my gays around me.
—Openly straight comedian Kathy Griffin on her HBO
comedy special, 1996

IN THIS CHAPTER I augment the industry-focused analysis
offered in chapter 3 by asking why certain straight viewers might have found
gay-themed television appealing. Gay material wasn't only useful for network
executives, I argue, but also for many viewers for whom watching prime-time
TV with a gay twist spoke to specific political values and offered some a con-
venient way to establish a "hip" identity. It was convenient because, as a cul-
tural category, homosexuality fit so comfortably with the socially liberal,
fiscally conservative politics many "sophisticated," well-educated, and upscale
Americans found resonant in the neoliberal political climate of the 1990s. It
is certainly important not to conflate the industry's conception of its slumpy
audience with the lived experiences of real viewers; such conceptions are (in
the case of U.S. network television) shaped by the economic imperatives of
an advertising-based medium, vague assumptions by marketers and media
executives, and an imprecise ratings system. Nevertheless, such notions do
change in response to social change, and network executives' notion of a
"hip" 18-to-49 target demographic did, if in distorted ways, reflect the shift-
ing attitudes and identities of many Americans.[1] More precisely, it reflected
the sensibilities of many of the upscale and upwardly mobile baby boomers
and Generation Xers whose centrist politics built Clinton's moderate middle,
whose unprecedented levels of college education drove the postindustrial
information economy, and whose incomes helped fuel everything from the
bull market to the popularity of L.A. Eyeworks. Throughout much of the
1990s, then, network executives were interested in creating programs that
would appeal to such viewers.[2]

Below, I map out the intersection of various discourses (about multicul-
turalism, the gay market, fiscal conservatism, and racial politics) in order to
theorize why some viewers may have enjoyed gay-themed television in the

1990s.[3] Doing so will help us better understand how some straight Americans likely experienced and responded to straight panic. As argued earlier, social conservatives, the Christian Right, and the Pentagon reacted to growing fears about the seemingly unstable line between the majority and its minorities, right and wrong, and straight and gay with a reactionary nativism, the reassertion of Judeo-Christian values, and "don't ask, don't tell." Social liberals, on the other hand, were encouraged to celebrate the very politics of difference and sexual identity that could be so unsettling to their majoritarian naïveté and privilege. Trying to find a way to be straight in a culture where being gay wasn't bad wasn't simple. The emergence of gay and lesbian chic and the increase of gay-themed programming serve as entry points for conceptualizing the political sensibilities and cultural tastes of cosmopolitan, gay-friendly Straight America—a category that is no doubt related to but can never simply be equated with the "hip," upscale professionals networks had in mind. In turn, exploring the dynamics of such attitudes can help us theorize the meanings and pleasure some viewers may have experienced in watching prime-time television in the gay 1990s.

I first conceptualized the shifting cultural politics of certain Americans in the mid-1990s when gay-themed television first became an identifiable programming trend. By the end of the decade, some observers began to herald the emergence of a new social class. Conservative cultural satirist David Brooks and regional planner Richard Florida, each working from different perspectives and towards very different ends described a group that would certainly dovetail well with the "hip," young, urban, professionals the networks targeted with much of their programming in the 1990s. Brooks' and Florida's observations provide a helpful context for theorizing the sensibilities and social mores of some of gay-themed TV's target audience. I then augment that broad portrait by examining how multiculturalism and the political correctness debates of the early 1990s dovetailed smoothly with the decade's strengthening neoliberalism and, in doing so, laid the groundwork for what I argue is a hallmark of what could be called a slumpy sensibility—a socially liberal, fiscally conservative political position. As multiculturalist discourses gained wider circulation in corporate boardrooms, on college campuses, and across popular culture, maintaining an appearance, at least, of social tolerance became de rigeur for those who wanted to be "hip" and "sophisticated." For many, however, this newfound multicultural tolerance seemed comfortable only when accompanied by the security of a fiscal conservatism that demanded a status-quo economic policy. As it came to be articulated in the 1990s, homosexuality fit conveniently into this delicate balance. Highly visible political battles over gay rights and Christian conservative invasions into gay bedrooms gave homosexuality a cutting-edge allure dulled just enough by its assimilationist goals to appeal to a relatively broad base of

straight neoliberals. Although victims of political discrimination, gays and les-
bians, it seems, were also economically self-sufficient. Reported to be affluent
and well educated with a disproportionate amount of disposable income, gays
and lesbians were something of a model minority. For those looking for an
affordable politics of social tolerance, I argue, supporting gays and lesbians fit
the bill, and consuming gay-inclusive cultural representations offered socially
liberal straight viewers a convenient way to affirm their open-mindedness.

SLUMPIES, BOBOS, AND THE CREATIVE CLASS

In a high-profile 2000 pop-culture book, conservative cultural observer
David Brooks satirized the social codes and lifestyle trends of what he calls
Bobos—short for bourgeois bohemians. According to Brooks, Bobos consti-
tute a new and expanding educated class for the information age and, as the
name suggests, are distinguished by their unprecedented fusion of a bohemian
antiestablishment spirit with a bourgeois pursuit of material security through
a solid work ethic. Brooks links the rise of the Bobo class to the dramatic
expansion and democratization of the nation's colleges and universities
between 1960 and 1975 and to the millions of working- and middle-class
baby boomers who streamed out of them. By the 1990s those well-educated,
upwardly mobile baby boomers had apparently matured, not only supplant-
ing their elders as the nation's business leaders and cultural trendsetters but
also reconciling their hippie idealism with their yuppie self-absorption. "Most
people, at least among the college-educated set, seemed to have rebel attitudes
and social-climbing attitudes all scrambled together," Brooks remarks. "Defy-
ing expectations and maybe logic, people seemed to have combined the
counter-cultural sixties and the achieving eighties into one social ethos."[4] The
old cultural lines that had separated black-clad, Kafka-reading, cappuccino-
drinking, urbane intellectuals from gray-clad, *Wall-Street-Journal*-reading,
scotch-drinking, suburban stockbrokers have all but disappeared.

Brooks provides an impressionistic portrait of the ethos of the Bobo class.
Unlike their educated-elite predecessors of the 50s and 60s who built an
aristocratic, Ivy-League world of WASPy exclusion, Brooks' Bobos are thor-
oughly meritocratic; they value good brains over good breeding. They are
also, by definition, reconcilers. At the core of the bourgeois-bohemian ethos
lie the seemingly inevitable tensions that result from the attempt to wed
incongruous value systems. "Those who want to win educated-class
approval," Brooks asserts, "must confront the anxieties of abundance: how to
show—not least to themselves—that even while climbing toward the top of
the ladder they have not become all the things they still profess to hold in
contempt. How to navigate the shoals between their affluence and their self-
respect. How to reconcile . . . their elite status with their egalitarian ideals"
(40). Brooks points to a range of cultural practices that illustrate the Bobos'

approach to resolving these contradictions. Casual Fridays, for example, help make workoholism seem less Dickensian, while eco-adventure vacations make time off seem productive. Paying outrageous prices for needless luxuries like French antiques would be vulgar, but paying outrageous prices for staples ("water at $5 a bottle . . . a bar of soap at $12") is conspicuous in a down-to-earth sort of way (97). Buying overpriced soap from socially conscious retailers like The Body Shop is even better, and buying corporate-made Nikes isn't so bad as long as the ad features a gritty rendition of the Beatles' "Revolution" or some Nick Drake song. "It's not that we're hypocrites." Brooks points out. "It's just that we're seeking balance. Affluent, we're trying not to become materialistic" (96).

Although dripping with a conservative snarkiness, Brooks' impressionistic profile of the Bobo actually dovetails well with economist Richard Florida's analysis of what he calls the Creative Class. While Florida, like Brooks, examines the social mores of this new social class, he grounds his discussion in labor statistics and census data. Amid the decades-long shift towards a postindustrial economy, Florida and others have identified the increasingly central role of information and creativity as the basic drivers of economic growth. Typified by the hi-tech sector, America's new economy is "explicitly designed to foster and harness human creativity" and "has given rise to a new dominant class."[5] Rooted in such structural economic changes, Florida's Creative Class is defined by occupational function. Relying on U.S. Bureau of Labor Statistics and various occupational classification systems, Florida argues that the Creative Class includes roughly 38 million Americans (30 percent of all employed people). This includes a Super-Creative Core of 15 million Americans—scientists, engineers, writers, artists, educators, architects—whose "economic function is to create new ideas, new technology, and/or new creative content" (8). Around this core, Florida also identifies 23 million "creative professionals"—problem-solving workers in knowledge-intensive industries like high-tech, healthcare, financial services, and business management, where high education and creative thinking are important. Florida's Creative Class, defined as it is by specific types of creativity activity, differs significantly from popular concepts of white-collar workers or the professional-managerial class.[6]

Although the Creative Class grew steadily since the 1950s, its ranks swelled during the 1980s and 1990s in conjunction with the rise of the postindustrial economy, leading to what Florida calls a "tectonic shift in the U.S. class structure" (76). The Creative Class has doubled in size since 1980 when it numbered less than 19 million and constituted only 20 percent of the workforce. Such gains coincided with the decline of the industrial economy and the once-dominant Working Class, which accounted for roughly 40 percent of the workforce in the 1950s but constituted only 26 percent by 1990.

Conversely, the same period saw the dramatic expansion of the Service Class which, by 1999, included 55 million workers (43 percent of the workforce)— a growth rate Florida attributes to an expanding Creative Class increasingly outsourcing work once done by the family. While the Creative Class grew in sheer numbers, its cultural and economic power grew even more dramatically. Relative to the increasingly de-unionized Working Class and the un-unionized Service Class, members of the Creative Class saw their incomes soar, resulting in a growing gap in terms of both economic and social capital.[7] The Service Class, emerging as the dominant group in sheer numbers, has failed to play the kind of social functions the Working Class did in the 1950s when they were the largest single class. Instead, Florida argues, the Creative Class has come to "represent a new mainstream setting the norms and pace for much of society" (211).

Florida also describes the shared sensibility that helps unite this new social group. Members of the Creative Class, he claims, tend to hold what political scientists call "postmaterialist" values; their economic security often translates into progressive attitudes towards sex, gender equality, and the environment, as well as an overall interest in lifestyle issues. Like Brooks, Florida identifies a fusion of bourgeois and bohemian value systems and, relying on interviews and focus groups, argues that members of the Creative Class tend to value individuality, creativity, merit, and diversity. They like to imagine themselves as nonconformists and seek out environments where ability and effort (not conformity to the norm) are rewarded. Seeing themselves as outsiders, they want to live in communities and work in companies where difference is appreciated. Several of the Creative Class members Florida interviewed, for example, told him that at job interviews they often ask if the company offers same-sex partner benefits, even when they themselves were straight, because gay-friendly policies signaled an unusually tolerant climate.[8] In fact, Florida notes that the Creative Class has segregated itself into those cities they find compatible with their lifestyles and values.[9] Cities with reputations for being tolerant, diverse, and open to new ideas—cities like San Francisco, Austin, Madison, and Burlington, to name a few—became magnets for well-educated, creative professionals. Analyzing decennial U.S. Census data, Florida discovered a positive and statistically significant correlation between cities with high concentrations of the Creative Class and those with high concentrations of gay households, foreign-born residents, and artistically creative people such as singers, actors, painters, sculptors, and dancers.[10]

Bobos, the Creative Class, and the networks' conception of their target audience all point to a specific segment of America's educated class whose political values and cultural practices shifted during the 1990s. Following Florida's lead, then, one could assume that the attitudes that drew many viewers to gay-themed programming was linked to the dynamics of the post-

industrial economy. In the complex processes behind the formation of social identities, however, nothing is cut and dried. Our position in the economic structure is but one of many factors shaping our sense of self. Although I'd argue that the attitudes of most creative professionals likely corresponded well with the sensibility I describe below, not all did. Conversely, many whose incomes, occupations, or geographic locations put them outside narrowly drawn boundaries of the postindustrial educated elite could still have held the political positions and cultural identity I outline. In fleshing out a specific 1990s formulation of a socially liberal politics and how it helps explain the success of gay-inclusive television, I start by examining the prominence of multiculturalist discourses in the early 1990s.

MULTICULTURALISM AND POLITICAL CORRECTNESS

In the early 1990s, American culture seemed unusually preoccupied with difference, specifically cultural difference. No longer something to be ignored or eradicated, difference was confronted and celebrated, marketed and consumed, managed and leveraged. Multiculturalism, tolerance, and diversity gained a new currency among a growing number of Americans focused on the changing dynamics of a seemingly fragmenting society. The metaphor of the American Melting Pot and notions of the American Character or the American Way of Life were giving way to what Stanley Fish has called "an ideology of difference."[11] The same changes that encouraged advertisers to adopt niche-marketing strategies led many universities and Fortune 500 corporations to make dealing with difference a key priority. In the process, broad segments of the population were increasingly exposed to traditionally marginalized voices, notions of cultural sensitivity, and mandates to appreciate diversity. The intensity of the debates about multiculturalism and its pop-culture offspring, political correctness, foregrounded issues of cultural diversity in unprecedented ways. Such discourses, I argue, likely helped transform yuppies into slumpies by rekindling the youthful ideals many boomers had seemed to outgrow in the 80s.

American colleges and universities served as one important springboard from which discourses of multiculturalism and tolerance entered wider circulation in the early 1990s. Inspired by and sometimes emerging from the various identity-politics movements of the 1970s and 1980s, a new generation of college administrators and academics stressed issues of difference. Despite having often-conflicting theoretical perspectives and political agendas, they shared a broad, underlying commitment: to reveal how notions of a unified American culture and identity (the proverbial melting pot in which gender, racial, ethnic, and other group differences were supposedly erased) actually worked to privilege the values and culture of privileged groups and, in doing so, reinforced their hold on economic and political power. As many

proponents of multiculturalism argued, this inequity was often achieved by ignoring, trivializing, or misrepresenting the histories, cultures, and identities of different minorities. Acknowledging those differences, they reasoned, might offer a way to foster greater social equality. According to one college professor, "we should be encouraging encounters that focus on how the ways we represent our differences affect the way we value each other and the access each of us has to social and economic opportunities."[12] Such ideas permeated higher-education discourse in the period, shaping the way administrators, educators, and students thought about difference—especially the representation of difference.

While the interest in multiculturalism had a profound and tremendously wide-ranging influence on academic scholarship, its most conspicuous impact involved changes in course curricula and institutional policies aimed at exposing students to cultural diversity. Some universities, for example, established new programs devoted to minority experiences such as Women's Studies, Chicano Studies, and African American Studies. Traditional disciplines like English and History slowly opened up their canons and course syllabi to the literature and historical experiences of those who had long been marginalized by both society and academics. Across various fields within the Humanities, analyzing texts and topics through the lens of race, class, gender, and ethnicity became common. Meanwhile, many college administrators strove to create a campus and student body sensitive to difference by initiating policies designed to foster diversity and tolerance. Many schools instituted affirmative action programs to help equalize gender and racial imbalances within faculty and student populations. Thousands of students took required ethnic studies courses created to underscore the importance of multicultural awareness to a liberal education. Speech and conduct codes, designed to foster an atmosphere where all students and faculty felt safe and welcomed, became commonplace. Students were encouraged to use culturally sensitive language: African American, not black; spokesperson, not spokesman; Asian American, not Oriental. The University of Connecticut banned "inappropriately directed laughter" and "conspicuous exclusion of students from conversations."[13] For a growing number of colleges, promoting tolerance and social equality by educating and sensitizing students to cultural difference had become an important and avowed part of their mission.

Multiculturalism, reframed to fit a corporate rationale, also made significant inroads into the human resource divisions of many multinational companies. Although the business sector had grappled with diversity issues for years, there was a growing sense of urgency around the topic in the late 1980s.[14] In 1987, for example, W.B. Johnston and A. H. Packard's influential *Workforce 2000: Work and Workers for the 21st Century* stressed how demographic trends and increased globalization were creating a diverse and fragmented society.[15]

In this new context, one expert claimed, a successful organization would be one that tried to "capitalize on the advantages of its diversity—rather than attempting to stifle or ignore the diversity—and to minimize the barriers that can develop as a result of people's having different backgrounds, attitudes, values, behavior styles, and concerns."[16] By embracing the diversity of its employees and encouraging employees to accept each other, the logic went, an organization would more effectively attract and retain highly qualified minority workers in a changing labor market; improve employee productivity; and create a less rigid corporate culture that could better adapt to the changing demographics of the marketplace.[17]

In the early 1990s, many corporations rushed to update their human resource divisions. Policies developed and implemented in the 1960s and 1970s to foster corporate cultures in which everyone was treated the same were abandoned in favor of management techniques designed to tap into the differences that existed among employees.[18] According to one diversity management expert, "To have ignored cultural differences as we always have in this country as a way of pretending that we are equal is another form of discrimination caused by and leading to ethnocentrism. What we really need is more knowledge about cultural differences in order to understand different people, manage different people and value their differences."[19] To that end, corporations like Digital Equipment, Kellogg, and MCI spent millions developing diversity training programs. Many brought in outside consultants to conduct "culture audits," and both employees and managers were increasingly required to attend diversity awareness training. Workshops, seminars, role-playing games, instructional videos, and discussion groups exposed participants to the diverse values and experiences of various cultural backgrounds and encouraged them to appreciate the ways those differences could enhance the workplace. A popular, seven-part video series entitled *Valuing Diversity* included interviews with senior executives who explained why they championed diversity, tips for managers looking to better motivate minority employees, a discussion of how stereotypes limit employee productivity, and dramatized workplace scenarios where cultural differences lead to miscommunication.[20]

By the early 1990s, multicultural rhetoric about inclusion and the acceptance of difference echoed across the political and cultural landscape. During the 1992 presidential campaign, for example, Bill Clinton frequently tapped into the diversity agenda, vowing in one widely-reported campaign promise: "If you vote for me, I will give you an administration that looks like America." Press coverage of Clinton's initial appointments—which included the nomination of five women, four African Americans, and two Hispanics to his cabinet, the creation of a White House liaison to the gay and lesbian community, and the selection of openly lesbian Roberta Achtenberg to a key position in the Department of Housing and Urban Development—overtly

connected his selection process to contemporary debates over multicultural-ism, quotas, and the value of diversity.[21] Meanwhile, in the realm of cable TV programming, the producers of MTV's *The Real World* (which debuted in the summer of 1992) carefully cast their show with a similar strategy of inclusion in mind. In what producer Mary-Ellis Bunim called "a little social engineer-ing," the reality-based soap repeatedly picked a set of stock multicultural char-acters—including the seemingly obligatory African American, Hispanic, and queer housemates—"to live in a house and have their lives taped to find out what happens when people stop being polite and start getting real."[22] For participants and viewers, the show functioned much like a four-month-long diversity-training seminar. In reflecting on her relationship with her white housemate John, for example, African American L.A. cast member Tami Akbar admitted: "[At first] I said 'OK, he's from Kentucky. He's wearing a cowboy hat, he yells heehaw at the top of his lungs—he's a racist. . . . Over time, [though,] I learned he's not anything like I envisioned him to be, and he learned the same about me."[23] In fact, the program's primary narrative arcs usually followed sheltered white characters like New York's Julie, L.A.'s John, San Francisco's Cory, and New Orleans' Julie as they learned to value the dif-ferences of their various housemates, especially their black and gay ones.

Adults weren't the only targets of the multicultural revolution. Elsewhere, multiculturalism became a hot topic for school boards and PTAs, as textbooks and lesson plans were revised to provide a more inclusive approach to teach-ing history, science, art, and literature. Disney even hopped on the multicul-tural bandwagon with films like *Pocahontas* (1995) that offered viewers both young and old a revised version of American colonial history—one in which Native Americans were the noble heroes and English settlers the greedy villains.[24] Its hit song "Colors of the Wind" provided a critique of euro-centrism and lyrics that could serve as a fitting slogan for any diversity-training workshop: "You think the only people who are people/Are the people who look and think like you/But if you walk the footsteps of a stranger/You'll learn things you never knew you never knew." From Latino History Month programs in public libraries to Kwanzaa displays at city halls, from debates over New World colonization and the 500th anniversary of Columbus' arrival in the Americas to battles over racist high school mascots, exhortations to acknowledge and celebrate cultural difference pervaded American society.

Such changes certainly didn't go unchallenged, and the subsequent debate propelled issues of multicultural tolerance from college campuses to national headlines. As Ellen Willis points out, conservatives "knew that it mat-tered what went on in universities, especially the elite kind. Decisions about what went on there—what counted as bona fide knowledge—resonated through the educational system as well as the culture as a whole."[25] For

cultural conservatives, the promotion of diversity was dangerously divisive—nothing less than an attack on the Western ideals and values upon which American society was founded and by which it continued to function. Although conservatives within academia had resisted multiculturalism's growing influence throughout the 1980s, the battle wasn't joined in earnest and on a national scale until the end of 1990. In a barrage of articles, cultural conservatives viciously decried so-called political correctness—the term they appropriated in their battle against the varied efforts to acknowledge/promote diversity. For them, political correctness was a new McCarthyism—a totalitarian orthodoxy in which anyone who didn't conform to the multicultural groupthink or use approved jargon was supposedly vilified as a racist, sexist, homophobic oppressor. With mass-market books like Roger Kimball's *Tenured Radicals* (1990) and Dinesh D'Souza's *Illiberal Education* (1991), the Right took their anti-PC battle to the mainstream and helped make the diversity agenda a national issue. By the spring of 1991, millions of Americans had read countless op-ed pieces and feature stories in relatively high-brow magazines like *Atlantic Monthly*, *Forbes*, and *New Republic* as well as in the *New York Times*, *Newsweek*, and *Time*.[26] By May of 1991, George Bush weighed in with an address to University of Michigan students condemning so-called politically correct speech codes. In the following weeks, pundits from both sides appeared everywhere from *Good Morning America* to *Nightline*. As one observer commented, "Within the span of a few months, PC went from an obscure phrase spoken by campus conservatives to a nationally recognized sound bite."[27]

THE CURRENCY OF A HIP, POLITICALLY CORRECT SENSIBILITY

In this environment, "politically correct," or PC for short, was a ubiquitous adjective—a convenient buzzword used to identify someone or something perceived to be sensitive (often overly so) to multicultural sensitivity and specific positions on issues like abortion, environmentalism, and gun control. In the syndicated cartoons of Jeff Shosel, for example, "Politically Correct Person," a new superhero for the 1990s, fought the dangerous influence of his archenemy, "Insensitive Man." Meanwhile, *New York* magazine asked its readers; "Are You Politically Correct? [Are you] Misogynistic, Patriarchal, Gynophobic, Phallocentric, Logocentric? [Are you] guilty of racism, sexism, classism? Do [you] say 'Indian' instead of 'Native American'? 'Pet' instead of 'Animal Companion'?"[28] In the realm of popular opinion, political correctness and by extension multicultural notions of tolerance seemed to take it on the chin. By 1993 *Time* identified a "pop-culture backlash against p.c."[29] Best selling books like *The Official Politically Correct Dictionary and Handbook* (1993), *Politically Correct Bedtime Stories* (1994), and *Once Upon a*

More Enlightened Time (1995) lampooned PC jargon and revisionism. Television shows like *Murphy Brown* and *Seinfeld* satirized earnest PC zealots. And comics like Jackie Mason and Bill Maher found success being "politically incorrect." The backlash against political correctness indicated a frustration with some diversity advocates' perceived stridency and channeled a conservative, often white and/or male voice. However, it also indicated that multicultural notions of cultural sensitivity were becoming increasingly hegemonic.

The fact that, in the parlance of the early 1990s, one could *be* politically correct makes clear just what was at stake in the battle over multiculturalism—namely, people's political values and social identities. The political correctness debates were so intense in part because critics on the right believed that the ultimate goal of many college administrators—by way of ethnic studies requirements, speech codes, and sensitivity seminars—was to change the way students thought. "There is an experiment of sorts taking place in American colleges," *Newsweek* reported. "Or more accurately, hundreds of experiments at different campuses, directed at changing the consciousness of this entire generation of university students."[30] While discounting conservatives' incendiary attempts to characterize such "experiments" as a nefarious plot to brainwash America's impressionable youth, I would argue that one of multiculturalism's objectives was to transform students' attitudes and behavior. In this, college administrators were not alone; by requiring employees to attend diversity workshops, human resource mangers had similar goals. As Pushkala Prasad and Albert J. Mills point out, "Diversity programs consequently attempt to facilitate transformations by altering organization members' beliefs, values, and ideologies in dealing with difference at the workplace."[31] Like feminists in the 1970s, then, diversity advocates in the 1990s sought to raise the multicultural consciousness of Americans.

Such consciousness raising efforts, I'd argue, influenced the emerging ethos of America's newly expanding educated class. Even though multicultural discourses seemed to be everywhere in the early 1990s, they circulated most intensely and carried the greatest weight at major colleges and multinational corporations. As a result, "celebrate diversity" rhetoric likely shaped the sensibilities of creative professionals more significantly than (or at least in ways distinct from) those of other demographic segments.[32] For many well-educated and upwardly mobile Americans, then, being politically correct was symptomatic of a liberal value system and could help forge an identity as open-minded, both in their own eyes and the eyes of others. Voting for the Latina city-council candidate over the white man, using phrases like African American instead of black, and expressing one's moral indignation over the ban against gays and lesbians in the military were marks of distinction—signals that helped identify one's educational level, class standing, and cultural identity.

In the thoroughly consumer culture of 1990s America, careful shopping offered those looking to reconcile their liberal ideals with their bourgeois materialism a way to communicate one's socially liberal values as well. Marketers quickly realized that multicultural difference could be profitably commodified, packaged, and sold.[33] Although black, Asian, and Hispanic versions of its hugely successful Barbie doll existed for years, for example, toy giant Mattel decided to "go ethnic" in its marketing in 1990, featuring ethnic dolls in network TV commercials and placing ads in minority publications.[34] The move more effectively tapped into minority niche markets, but it might also have been an attempt to make the venerable doll seem more relevant to baby-boomer parents concerned about the multicultural values of their echo-boom children. By 1992 "commercial correctness," "cause-related marketing," and "point-of-purchase politics" had become new buzzwords in an ad industry looking to target the growing number of upscale consumers seemingly attuned to political correctness. For the first time, major corporations like Benetton, Ben & Jerry's, and The Body Shop advocated specific social issues in ads that consciously blurred the line between product promotion and public service announcement.[35] It's not entirely clear whether the following copy from a 1993 Timberland ad, for example, was trying to sell footwear or promote PC activism: "Give the boot to racism. This message is from Timberland, but when it comes to racism and hatred it doesn't matter to us who makes your boots. Just put them on, join hands with City Year and stand up to racial intolerance. As partners with City Year, the urban peace corps, we believe one voice can make a difference. Theirs, Ours, Yours."[36] No company, however, was more successful or drew more attention for its overt appeals to the multicultural value system than Benetton. Starting in 1989, the global, Italy-based clothier put difference front and center in billboard and print ads that featured a virtual rainbow of human diversity. Racially and ethnically diverse models, dressed in the rainbow of Benetton color options, were pictured hugging and smiling. In 1991 Benetton unveiled a new, more controversial campaign that tried to expose the persistence of taboos, prejudices, and social injustice that surrounded cultural differences. Images of multicultural group hugs were replaced with photos of a dying AIDS patient, a suffering African refugee, a black woman breast-feeding a white baby, and a black Queen Elizabeth II. The campaign also addressed an array of other politically correct issues like environmentalism, safe sex education, and child labor practices.[37] Thus, people's political values could be expressed and reinforced through niche-market consumption. By buying a Native American dream catcher for a colleague's baby shower or taking friends to the most authentic Indian restaurant in town, by getting your child an African American Barbie or shopping at stores like Benetton, by attending a drag show or watching gay-inclusive television, socially liberal baby boomers and Gen-Xers could

distance themselves from the perceived self-centered greed and shallow mate-
rialism often associated with yuppies.

Of course consuming cultural difference commodified for one's conven-
ience and being repeatedly encouraged to celebrate diversity didn't guarantee
that one's consciousness was thoroughly transformed. Responding to multi-
cultural education initiatives was likely a complicated process of negotiation
for many—one marked by mixed motivations and a deep ambivalence. Diver-
sity rhetoric, after all, urged people to acknowledge and celebrate the same
social differences that had long been socially disavowed or vilified—a difficult
task even for the most sincere. With its emphasis on tolerance and equality,
multiculturalism appealed to people's sense of morality and fairness. Institu-
tions that championed diversity, however, also tried to legislate it. Ethnic
studies courses and sensitivity training were frequently compulsory, deroga-
tory speech was prohibited, and other rules (both spoken and not) created
environments where valuing difference was rewarded. For some, certainly,
multiculturalism corresponded with deeply held commitments to social
equality, and for others, being—or at least appearing to be—politically cor-
rect was a matter of expediency, not moral principle. For most, however, self-
interest and moral rectitude were surely intricately intertwined. Adopting the
right attitude not only made it easier to fit in at work, in school, and with
friends, but also to feel good about one's moral character. Celebrating the dif-
ference of the marginal was valued as a marker of one's open-minded nature
as well as one's social position as a highly educated, upscale (or at least
upwardly mobile) cosmopolitan who wasn't about to be mistaken for an old-
fashioned moralist or right-wing bigot. Assuming any social position involves
negotiating an odd fit, and people's relationships to this post-multicultural
sensibility were likely no exception; being politically correct could be a
highly ambivalent activity. Aspirations to embrace difference could exist side-
by-side with persistent fears and prejudices, and a sincere desire to "do the
right thing" could often chafe under institutional mandates requiring com-
pliance. As a result, within even the most well-intentioned, a dissonance likely
remained—a dissonance between the illiberal attitudes reinforced by a social
order still structured by classism, racism, sexism, and homophobia and the
politically correct sensibility they held. Not surprisingly, then, a sensibility
shaped by such discourses could be tremendously ambivalent and its tolerance
of diversity highly circumscribed.[38]

For those surrounded by multicultural rhetoric, consuming cultural
difference held out a closely related promise: the allure of marginality. Post-
colonial and critical race scholars have long pointed out that encountering
the socially marginal—those whose differences from the mainstream disem-
power them and identify them as Other—is often seen as a transformative
experience, what bell hooks calls "eating the other." For hooks, contemporary

culture capitalizes on the promise of encountering difference: "Commodity culture in the United States exploits conventional thinking about race, gender, and sexual desire by 'working' both the idea that racial difference marks one as Other and the assumption that sexual agency expressed within the context of racialized sexual encounter is a conversion experience that alters one's place and participation in contemporary cultural politics."[39] Although hooks focuses on racial difference and sexual desire, her point can be extended. At a time when multicultural discourses valued, commodified, politicized, and perhaps even fetishized difference and identity, being marginalized on almost any axis enjoyed a cultural caché with certain socially enlightened members of the educated class; from a politically correct perspective, being black, Latino, gay, or disabled seemed to offer one an inherent edginess forged from social oppression. On the other hand, within the economy of political correctness (though certainly not the economy of social power), being white, straight, middle-class, or male was, at the very least, dull and, at times, condemnable. Ex-nomination has been a powerful strategy of the dominant, allowing whiteness, patriarchy, and heterosexuality to serve as the naturalized norms against which all subordinated others are judged. This strategy has some limitations, however, in a social context where markers of difference are valued, at least culturally. Talking specifically about whiteness, George Yudice argues: "Multiculturalism and identity politics have not constructed an imaginary for whites who want to participate in the extension of citizenship to all."[40] The same could be said for heterosexuals. Like Brooks' Bobos confronted by the "anxieties of abundance," some socially liberal, well educated cosmopolitans likely confronted the anxieties produced by their white, straight, and/or patriarchal privilege. Consuming cultural difference could offer the possibility of being transformed—or at least of reconciling one's social privilege with one's ideals of social equality.

NEOLIBERALISM AND THE SOCIALLY LIBERAL FISCAL CONSERVATIVE

If members of an expanding educated elite were surrounded by "celebrate diversity" rhetoric in the early 1990s, they were also inundated by neoliberal discourses valorizing personal responsibility and the therapeutic power of the free market. Despite Clinton's victory in 1992, Reaganist policies aimed at dismantling the liberal welfare state and their legitimating discourses continued to circulate, becoming what one critic called, "the new hegemonic ideology."[41] The decade's booming economy, market globalization, the collapse of the Eastern bloc, deregulation, free trade agreements, and the high-tech revolution helped bolster a resurgent belief in the unquestionable superiority of free market capitalism. This "market triumphalism," as Judith Goode and Jeff Maskovsky have called it, was particularly conspicuous

in the welfare reform movement.[42] With the passage of the Personal Responsibility and Work Opportunity Reconciliation Act in 1996, Contract-with-America Republicans and New Democrats "ended welfare as we knew it" by gutting Aid to Families with Dependent Children. Public support was fueled by media coverage, social science research, and conservative rhetoric that racialized and pathologized the poor by articulating "government handouts" to reports of inner-city drug use, black female promiscuity, welfare queens, school dropouts, and crime.[43] Originally conceived as a corrective to the inequities of a profit-driven market economy, welfare was now to blame for fostering a culture of poverty that failed to instill a sense of personal responsibility. The market was now the solution; its competitive environment would improve the moral fiber of the underclass, nurturing a "responsibilization of the self."[44] In a decade marked by Clinton's "New Covenant," the Million Man March, dot-com entrepreneurship, and *Oprah*, being self-reliant was an increasingly hegemonic virtue.

This neoliberal logic resonated well with the sensibilities of an expanding and upwardly mobile educated elite. An ostensibly counter-cultural fondness for being a maverick outsider dovetailed well with the economic individualism at the heart of the neoliberal enterprise, and a meritocratic belief that skill and effort should lead to success revealed a liberal blindness to structuring inequalities and echoed calls for personal responsibility. As they tracked the miraculous growth of their mutual funds, 401(k) plans and stock options, many socially liberal, urban-minded professionals found their boats lifted by the rising tide of the New Economy. Surrounded by such neoliberal discourses and with more to lose than ever, many members of the expanding educated elite seemed drawn to economic policies that promoted fiscal constraint, targeted tax cuts, and welfare reform.

By the mid-1990s, many Americans had established a new political position—one that reconciled their bohemian ideals of social equality and their bourgeois materialism. Being socially liberal and fiscally conservative, one could synthesize multicultural discourses that celebrated diversity and neoliberal discourses that celebrated the free market. The emergence of this political position, what Clinton called the "vital center," was symptomatic of what political scientists call the postmaterialist politics of a New Political Culture. With roots in the 1970s but a noticeably growing role in the political dynamics of postindustrial countries in the 1990s, this New Political Culture undermined the traditional class politics and left/right ideologies that had structured debate and social identities for much of the twentieth century. According to Terry Nicholas Clark and Ronald Inglehart, New Political Culture revived neoliberal faith in market individualism, distinguished social issues from fiscal issues, reassessed the welfare state, emphasized consumption and lifestyle issues more than workplace and job issues, and was supported by

younger, more educated, affluent citizens.[45] The growing currency of multi-cultural discourses among well-educated boomers and Generation Xers also fostered their socially liberal, fiscally conservative politics. Multiculturalism, if not in academic theory then most certainly in its corporate and popular incarnations, focused on the inequity of cultural representations without drawing the connections to economic and institutional structures of power or to the unequal distribution of wealth. As such, multiculturalism made it easier for a fiscal conservatism to exist side-by-side with socially (or perhaps more accurately, culturally) liberal ideas.

The socially liberal, fiscally conservative ethos reconfigured the political landscape in the 1990s.[46] On the one hand, certain voters were turned off by the Republican Party's close ties to Christian conservatives and its increas-ingly moralistic tone. Culture warrior Pat Buchanan, for example, laid bare the far right's socially conservative values in his infamous speech at the 1992 Republican convention:

> The agenda that [Bill] Clinton and [Hillary] Clinton would impose on America—abortion on demand, a litmus test for the Supreme Court, homosexual rights, discrimination against religious schools, women in combat units—that's change, all right. That's not the kind of change America needs. It's not the kind of change America wants. And it is not the kind of change we can abide in a nation that we still call God's country. . . . There is a religious war going on in this country for the soul of America. It is a cultural war as critical to the kind of nation we shall be as the Cold War itself, for this war is for the soul of America.[47]

To voters predisposed to socially liberal attitudes and increasingly surrounded by multicultural discourses, the Right's antiabortion, antigay, family-values agenda was far too blatantly intolerant. "After more than 12 years of signifi-cant influence in the Republican Party," one pundit observed after Bush's decisive loss in 1992, the Religious Right "finally scared the bejeezus out of suburban America."[48] Democrats, on the other hand, suffered from their asso-ciation with New Deal-style tax-and-spend policies that seemed to care more for pork-belly projects and welfare mothers than the supposedly hard-working middle class. Neither party's traditional platform satisfied this mod-erate middle. As one self-identified socially liberal, fiscally conservative poll respondent put it: "Religious groups are trying to ruin this country from the right, and the other side is intent on spending everyone else's money."[49] A Gen-X spokesperson put it even more succinctly: "We're not fond of deficits or bigots."[50]

In this political climate, members in both parties rushed to adapt. "New Republican" governors like New Jersey's Christine Todd Whitman, New York's George Pataki, Connecticut's John G. Rowland, and Massachusetts' Bill

Weld had enormous success among suburbanites in 1994 by running on the two T's: tax cuts and tolerance. Meanwhile, 1996 GOP presidential candidate Arlen Specter linked his New-Republican platform to old-fashioned Republican libertarianism: "I agree with former Arizona Sen. Barry Goldwater when he said we need to keep government out of our pocketbooks, off our backs and out of our bedrooms."[51] Later, George W. Bush would eventually make it from the Texas statehouse to the White House with his so-called compassionate conservatism. Democrats weren't about to be left behind. In 1992 presidential hopeful and Concord Coalition cofounder Paul Tsongas was among the first Democrats to the call for fiscal conservatism in the face of the mounting national deficit. By 1995 he was joined by Bill Bradley and Gary Hart among others in what came to be known as the Group of 8—a band of mainly moderate Democrats that abandoned the New Deal coalition and advocated a fiscally conservative, socially liberal, pro-environmentalist, pro-campaign finance reform, pro-free trade agenda. Finally, despite his early efforts to create universal health care and increase taxes, Bill Clinton soon came to epitomize these new politics. Under pressure from Federal Reserve Board Chairman Allen Greenspan, he strove for fiscal responsibility— balancing budgets while creating targeted middle-class tax cuts. He was a strong advocate for gay rights and abortion, appointed African Americans, Latinos and women to key administration positions, and attended a black church, yet he declared that the era of big government was over, reduced the federal payroll, and vowed to "end welfare as we know it."

THE CONSTRUCTION OF THE GAY MARKET

Just when a growing number of Americans were looking to reconcile their social liberality and their fiscal conservativism, changing discourses about homosexuality seemed to offer a convenient solution. In the early 1990s, social meanings about homosexuality were in flux. Long-standing discourses about homosexuality as a sin, disease, or crime (rearticulated and reinforced by the AIDS crisis) continued to construct gays and lesbians as a deviant minority—a risk group deserving scorn or pity. As I detailed in chapter 2, however, the mainstream gay and lesbian civil rights movement often represented gays and lesbians as American citizens wanting to be integrated into (read: conform to) mainstream institutions like the military and marriage, shifting many of the standard meanings surrounding homosexuality. In this section, though, I want to focus on the circulation of yet another important discourse—namely the construction of affluent gay consumers in market research and reports. Here, various strands of our broader discussion—the niche-marketing revolution, the proliferation of social identities, gay-inclusive network programming strategies, and the politics of post-multicultural cosmopolitans—converge. Looking at how marketers reframed gays and

lesbians will help us understand why gay material might have been so appealing to the sensibility of certain viewers. Moreover, it will also help explain the shifting attitude network executives and their sponsors had toward gay content, a shift that will be traced in detail in the next chapter.

In April 1994 over 150 consumer-products companies paid up to $1,500 each to put up booths at the Meadowlands Convention Center in Secaucus, New Jersey, in what was billed as the First National Gay and Lesbian Business Expo. The event, according to *New York Times* advertising columnist, Stuart Elliott, was yet one more "indication of one of the least expected business trends of the 1990's: the growing efforts by many mainstream marketers to reach consumers who are homosexuals."[52] Economic and social changes, self-serving promotion on the part of a new gay press and marketing firms, and coverage in the business press worked together to focus more and more of the business world's attention on what gay men and lesbians did with their money. In the process, they constructed the gay community as not only a viable and important market in the highly competitive business world of the 1990s, but also helped to make gays and lesbian more palatable to advertisers, network executives, and certain post-multicultural sensibilities.

The interest in gay and lesbian consumers was intricately linked to the growing interest in niche marketing. As I outlined in chapter 3, by the early 1990s, marketers were focused on demographic breakdowns. They worked hard to segregate consumers by their supposed lifestyle profiles in order to develop marketing strategies aimed at their specific interests. As Ray Mulryan, a partner in the Mulryan/Nash advertising agency explained, "the mass market just doesn't exist. . . . If you want to reach America, you've got to identify them by group—and then you have to talk to them."[53] Amid increasingly intense competition to discover and dominate untapped markets, more companies specialized their sales pitches to appeal to ever-narrower groups. Stuart Elliott asserted that such economic incentives led mainstream companies to look to new markets previously ignored: "The need to attract dollars from consumers has become so overwhelming that they're willing to target messages to consumers that they might not have been willing to talk to in previous years."[54] As the 1994 expo illustrates, one such segment was the gay and lesbian community.

Marketers' willingness to target the gay market in the early 1990s was also encouraged by wider discursive shifts. In the late 1970s and early 1980s, numerous companies had started to pitch campaigns to the gay market. With the emergence of AIDS and the social stigma generated around the gay community, however, marketers retreated. By the early 1990s, companies like Johnnie Walker and K Mart gradually made guarded overtures to gay consumers with ambiguous ads.[55] Nevertheless, in 1990 one media analyst was still warning retailers to "be careful with niche segmentation, so you don't

offend some old customers who . . . might think, 'That's where the gays shop.'"[56] Yet as one observer pointed out four years later, such caution "was pre-Clinton, -gays-in-the-military, -Colorado-legislation headlines."[57] By the 1992 election, presidential candidate Clinton actually hired an advertising and PR firm specializing in reaching the gay and lesbian community to help him get the gay vote. As new discourses reframed gay men and women, moving them closer to the mainstream, more and more advertisers decided to follow Clinton's example and turned to the gay market. In a mutually reinforcing cycle, advertiser interest in gay consumers in turn moved gays and lesbians even closer to the mainstream.

If a new discursive context made the gay market viable, the emergence of new gay magazines, advertising agencies, and research firms made it attractive and practical. Traditionally comprised of local magazines produced on newsprint, focused on covering politics, and supported by locally gay-owned business and explicit sex ads, the gay and lesbian press saw a dramatic change in 1992. National magazines like *Out*, *Genre*, *Deneuve*, and *10 Percent* debuted on glossy paper and were filled with trendy layouts, full-color photos, and articles from nationally recognized writers. Faced with the new competition, the nation's oldest national gay magazine, *The Advocate*, followed suit, getting rid of its sexually explicit personals section and moving to glossy print. All these magazines needed to attract mainstream, national advertisers willing to pay the writers, designers, printing fees, and circulation overhead of a nation-wide periodical.[58] Consequently, these magazines rapidly began touting the attractive demographics of its readership, trying to convince Madison Avenue and its clients that buying space in their magazine was a smart investment.

The magazines quickly turned to research firms like Overlooked Opinions and advertising agencies like Mulryan/Nash and aka Communications—all of which specialized in promoting the gay and lesbian community—to provide the sterling demographics needed to woo national companies. A widely reported study by Overlooked Opinions claimed that America's estimated 18 million gays and lesbians were spending over $500 billion dollars annually.[59] Profiles of gay and lesbian consumers were almost always compared to data for average Americans. Data compiled by aka Communications from research by Simmons Market Research, the U.S. Census Bureau, and Overlooked Opinions claimed that 40 percent of lesbians and 47 percent of gay men held managerial jobs compared with 15 percent of women and 31 percent of men nationwide, that 27 percent of gay people were frequent fliers compared to a national average of 2 percent, and that 66 percent were overseas travelers compared to 14 percent nationwide.[60] According to a report by Mulryan/Nash, "61 percent of gay people have a four-year college degree, as opposed to 18 percent of average Americans. . . . 43 percent of gay people work out in a gym as opposed to 8 percent of average Americans. . . . 64 per-

cent of gay people drink sparkling water as opposed to 17 percent of Americans."[61] Other surveys in the early 1990s claimed that a typical gay male couple earned $51,600 a year, while the average straight couple earned only $37,900. The average lesbian couple reportedly earned $42,800.[62] According to aka Communications in 1992, 18 percent of gay households had incomes over $100,000.[63] Not only did gay men and lesbians have all this income, these reports suggested, they also tended not to have children. Without the worries of braces, college tuition, and medical bills, gay men and women's disposable income was even greater than their straight counterparts.

As if such stellar statistics weren't enough to convince blue-chip firms, many reports claimed that gays and lesbians were amazingly loyal to businesses that openly courted their patronage. According to a poll of its readers, *The Blade*, a Washington, D.C., gay weekly, found that 80 percent of its readers claimed to be loyal to *Blade* advertisers and that 70 percent said they would change their shopping habits if a retailer advertised in the paper.[64] According to *American Demographics*, "gay men and lesbians show their gratitude to marketers who have the courage to serve them. In return for what they see as acceptance and respect, gay consumers will go out of their way to patronize these companies. Furthermore, they will actively spread the word through an amazingly efficient network that circulates not only through word of mouth, but through 200 electronic bulletin boards."[65] Finally, other reported but less tangible qualities of the gay community make it a particularly important demographic segment. According to the report by Mulryan/Nash, because of their prominent position in the fields of fashion, design, media, and the arts, gay people "occupy a special sphere of influence and shape national consumer tastes. Gay men have been credited with popularizing blow-dryers, painter's pants, the gentrification of urban neighborhoods, disco music, Absolut Vodka, Levi's 501 jeans, Doc Martin boots, and Santa Fe home-style furnishings."[66] What better target market could a profit-hungry company have wanted?

Madison Avenue and its clients seemed to be convinced. When Hirman Walker & Sons was marketing its Tuaca liqueur, according to Laurie Acosta, group product manager, they wanted to reach young, hip consumers, "and by definition, that includes the gay and lesbian market."[67] BMG Records and RCA Victor began selling gay-targeted classical compilations like *Out Music* and *Out Classics*, and Atlantic Records established a department dedicated to marketing music to gay audiences. Articles informed banks, booksellers, radio stations, travel agents, and retail stores on the importance of tapping into the gay and lesbian demographic. In addition to the traditional ads from entertainment, clothing, and liquor companies, gay magazines were being filled with full-page ads promoting a wide array of products and services, including Apple computers, Naya spring water, Xerox copiers, Continental Airlines,

Swatch watches, and MCI long distance. The gay press was able to tap into the lucrative automotive market; Saab and Subaru both placed print ads in gay periodicals. A number of data lists of people assumed to be gay or lesbian—lists compiled from magazine subscriptions, gay-targeted credit-card holders, single-ticket buyers for plays like *Jeffrey*, and even lists of AIDS organization donors—were sold to companies interested in direct mailing.[68] IKEA, a Sweden-based furniture company, produced a now-famous television ad featuring a gay male couple shopping for a dining table. The 30-second spot aired in a number of big-city markets in 1994. When asked why their companies were targeting gays and lesbians, the responses of company spokespeople dramatically illustrated how widely accepted and influential the demographic picture of the gay market had become. A Virgin Atlantic Airlines ad executive asserted that, "They're an audience that we believe will give us a great return on our advertising investment." According to Benetton's director of communication, "Anyone who would pass over this market without giving it thorough analytical treatment is remiss and probably guilty of knee-jerk discrimination. . . . Ultimately it comes down to not minding the shop." Explaining why his company targeted gay consumers, Chris Auburn, marketing representative for Miller Brewing, put it succinctly: "The gay community has a lot of money."[69] Serving the self-interest of the marketing industry and produced by highly questionable research methods, such statistics grossly distorted the economic status of many gays and lesbians. Nevertheless, this discursive construction circulated widely in the 1990s, helping to paint an image of the gay community as being economically well off.

News of gays' and lesbians' supposed affluence wasn't limited to proprietary marketing research reports and the pages of trade magazines. Dovetailing well with persistent stereotypes of self-obsessed, fashion-conscious gay men, urban legends about gay-fueled gentrification, and assumptions about the disposable wealth of double-income, no-kids households, such discourses circulated much more widely. In political battles over gay civil rights legislation in states like Colorado and Oregon, for example, antigay forces promoted the same marketing research data in an effort to convince voters that gays didn't need protection from discrimination. As I outlined in chapter 2, the assimilationist politics of the mainstream gay rights movement, interested in convincing middle Americans that gays and lesbians were just like them, often presented a picture of a decidedly white, middle-class gay community. In popular culture, many of the most widely circulated cultural images of gay life—films like *Philadelphia* and *In and Out*; media coverage of out celebrities like k.d. lang, Melissa Etheridge, and Elton John; and television shows like *Seinfeld, Friends, Northern Exposure*, and *Frasier*—often reproduced discourses that exaggerated rather than problematized the discourse. And for many, personal experience very likely backed up cultural stereotypes. After all, a variety of forces

continued to make it easier for economically secure gays and lesbians to be out and more visible than their lower income counterparts.

THE AFFORDABLE POLITICS OF GAY CHIC

Specific cultural tastes and practices emerged as members of a newly expanded educated elite looked to balance its socially liberal identities as hip cosmopolitans with their fiscally conservative values as America's newest upwardly mobile elites. As it came to be constructed in the 1990s, homosexuality was a particularly pragmatic fit for those looking to find an affordable politics of multicultural tolerance. Gay issues, for example, were often included in multicultural educational discourse. Terms like "fag" and "dyke" were added to campus speech codes, and residence-hall diversity programs sensitized undergraduates to the problem of homophobia. Gay and Lesbian Studies programs and gay-themed courses appeared more frequently, and queer theory became fashionable in certain academic circles. Meanwhile, a growing number of major corporations like Apple, Boeing, and Coors added sexual orientation to their nondiscrimination policies, sponsored gay and lesbian employee groups, or offered same-sex partner health benefits. A prominent 1991 *Fortune* article entitled "Gay in Corporate America" informed its readers: "Odds are that there are almost as many gay employees in the workforce as there are blacks, but most of them will be invisible."[70] By the early 1990s, over 3,000 AT&T employees had attended homophobia workshops where they received "accurate information to replace myths they may have swallowed, such as that homosexuality is 'curable' or that gay men are sexual predators."[71]

Despite such multicultural discourses, supporting gays and lesbians was still a relatively exceptional marker of just how open-minded one was. In a post-PC environment, expressing public platitudes about the importance of antiracist attitudes, for example, had become obligatory in most social circles. Homosexuality, on the other hand, was still publicly condemnable for many. In the early 1990s, gay rights battles over "don't-ask-don't-tell," the Defense of Marriage Act, and antigay initiatives like Colorado's Amendment 2 and Oregon's Measure 9 generated viciously homophobic discourses that circulated widely as the media rushed to cover the hot-button issue of homosexuality. In an effort to "balance" their coverage of gay rights stories, mainstream media legitimized overtly antigay rhetoric in ways they no longer did in their coverage of most other civil rights movements. These heated debates and the numerous polls conducted to measure Americans' attitudes about homosexuality made it perfectly clear that many people still considered gays and lesbians to be immoral. In fact, a 1993 Gallup poll found that almost 50 percent of Americans did not favor the decriminalization of same-sex behavior.[72] In this context, expressing one's support for gays and lesbians still

held out the allure of marginalizing oneself; if postmaterialist politics and multicultural discourses made being intolerant in general declassé for some, being gay-friendly could be particularly hip.

Given the circulation of discourses about gay affluence in the 1990s, homosexuality fit conveniently into the delicate (and ambivalent) balance of the socially liberal, fiscally conservative agenda. Although clearly marking gays and lesbians as the victims of bigotry, many of the era's most visible gay rights issues—access to military service, adoption rights, hate crime laws—framed gays and lesbians as a minority ostensibly asking only for tolerance not downwardly redistributive social welfare policies. Amid widely circulating reports of gay affluence, homophobia was largely regarded as a cultural issue—not an economic one. Despite the importance of federal funding for research, for example, the AIDS battle was often framed less as a struggle for tax dollars than a battle against ignorance and fear. Even mainstream coverage of an economic-equity issue like domestic partnership benefits seemed to reinforce stereotypes of gay economic prosperity by drawing attention to white-collar corporate policies rather than issues facing the working poor. Moreover, marketers' interest in gay and lesbian consumers seemed to confirm the emancipatory power of free market capitalism and the validity of market liberalism. When defined as an issue of personal freedom in the face of an intrusive government trying to legislate values and private behavior, gay rights also suited the era's casual libertarianism.[73] The moralistic rhetoric of Christian conservatives like Pat Buchanan, Jerry Falwell, and Pat Robertson made gay rights an issue many social liberals could get behind. In the cultural logic of the 1990s, gays and lesbians were something of a model minority for the socially liberal, fiscally conservative-minded. They were victims of political discrimination and antiquated mores, but were apparently economically self-sufficient. Being gay-friendly, then, seemed to simply require celebrating cultural differences. In this regard, it offered an affordable politics of social tolerance.

Gay-friendly cosmopolitans' attitudes towards homosexuality were far from consistent. Opinion polls indicate that while a growing number of people believed that gays and lesbians shouldn't be discriminated against in housing and employment, attitudes towards gay marriage and adoption remained unchanged from the 1970s.[74] While many may have been proud of having gay friends and firmly believed that there was nothing wrong with homosexuality, fewer likely ever considered raising their children free of presumptive heterosexuality, and for most, attitudes about gay men and lesbians continued to be shaped by prescribed definitions of masculinity and femininity and by long-standing discourses linking homosexuality to deviancy, illegality, and sin. Such residual ambivalence about homosexuality, however, was likely part of the appeal. After all, being gay-friendly could give the socially

liberal and urban-minded the thrill of edginess precisely because it involved transgressing social norms; accepting homosexuality implied that there was something that needed to be accepted. Watching gay material on prime-time television, like going to a gay bar or having gay friends, was one way to be hip and demonstrate an edgy tolerance.

In the early 1990s, then, homosexuality crossed the often-fine line between being scorned and being chic as gays and lesbians suddenly acquired just the right kind of marginal allure for America's newest educated elites. According to a 1993 issue of the upscale, urban-targeted men's fashion magazine *Gentleman's Quarterly*: "gay chic has emerged from the underground and floated to the surface—it's not just for clubgoers anymore. Anyone, even your dad, can pick up a newspaper or turn on the television and see unvarnished gay product."[75] Movies like *Priscilla, Queen of the Desert, The Crying Game, In and Out*, and *Jeffrey* brought gay themes from the art house to the suburban multiplex. RuPaul took drag-queen divatude from Saturday nights at the local gay club to prime time on VH1, while *The New Republic* editor Andrew Sullivan and *Angels in America* scribe Tony Kushner were tapped to star in Gap ads. Calvin Klein underwear model Marky Mark stated publicly that it was cool "to suck dick" (even if he didn't do it), and red AIDS-awareness ribbons became a required black-tie accessory at Hollywood awards ceremonies.

Lesbians weren't left out of the trend either. In fact, lesbian chic became a genuine pop-culture phenomenon in its own right. From Madonna's much-discussed "Justify My Love" video to Banana Republic's "My Chosen Family" print ads, attractive women who had sex with attractive women seemed to be all the craze. Lesbianism made it onto *Rolling Stone's* hot list, while out comedian Lea DeLaria made it onto *Arsenio*. The trend reached its peak in the summer of 1993. ABC's newsmagazine show *20/20* aired a story on Northhampton, Massachusetts—"Lesbianville, USA". Mainstream magazines like *Newsweek, New York*, and *Vogue* ran prominent articles that translated lesbian lingo like "femme," "butch," and "lipstick lesbian" into terms their hip, straight readers could understand.[76] On the cover of *Vanity Fair's* August issue a scantily clad Cindy Crawford gave a highly androgynous k.d. lang what can only be described as an erotic, oldfashioned barbershop shave. And, of course, gay material became commonplace on network television. As Delaria put it during her 1993 *Arsenio* appearance, "it's the 90s, and it's hip to be queer."

If consuming "unvarnished gay product" was one increasingly convenient way to get a bit of the Other in the early 1990s, actually defecting from the banality of a straight identity became another. In 1993 the *Village Voice's* Ann Powers identified the emergence of "the Queer Straight, that testy love child of identity politics and shifting sexual norms."[77] Out of the mix of multiculturalism, a rejuvenated gay and lesbian activism, and poststructural theory

à la Judith Butler and Eve Kosofksy Sedgwick, straight academic and/or bohemian twentysomethings looking to renounce their oppressive heterosexuality forged a new category of sexual identity for themselves. These new "Queer Straights" continued to have heterosexual sex in the bedroom but cultivated a public image of gender and sexual ambiguity: "queer in the streets, straight in the sheets," in the lingo of the time. As one of Powers' Queer-Straight friends said of her relationship with her boyfriend, "We're the perfect couple. Everyone thinks I'm a lesbian and everyone thinks Jake's gay." GQ's David Kamp noticed the same trend and saw in it a reiteration of the 1950s' "White Negro": "Madonna, with her pantomime lesbianism and strong identification with the gay community, is a latter-day version of [the white-negro]: the straight homo. Like the earnest, clove cigarette-smoking Barnard undergraduates of the beatnik era who wanted to be black, Madonna and her ilk want to be part of the gay culture, expatriates from the straight world."[78] Although the Queer-Straight sensibility may have been a relatively small subcultural phenomenon, figures such as Madonna, Sandra Bernhard, Sharon Stone, and Kurt Cobain created a relatively mainstream counterpart. Stone, for example, seemed proud to admit that she had gone on a date with a woman, while grunge guru Kurt Cobain claimed he "was gay in spirit" and "an advocate for fagdom."[79] Even those less willing to flirt with the idea of being gay found a caveat to a straight identity in the pithy bumper-sticker slogan: Straight But Not Narrow. Whether it was a self-identified queer-straight NYU undergraduate who cultivated the image of transgressive sexuality or a heterosexual couple in Kearny, Nebraska that organized a party for the coming-out episode of Ellen, embracing gay culture in and of itself seemed to save one from the un-hip suburbs of straightsville.

In sharp contrast and as a point of comparison, the economic position and social construction of African Americans were particularly disquieting to the socially liberal, fiscally conservative sensibility.[80] In the reality of a post-Reagan economy which saw a decline in real wages among lower income groups, a reduction in federal support to urban communities, and the evacuation of highly paid manufacturing jobs from the inner cities, the gap between rich and poor widened tremendously, and a disproportionate percentage of black America found itself on the losing end of the deal. By the early 1990s, as poverty rates among black families rose significantly, America's long history of racialized economic inequality intensified.[81] Meanwhile, in the imagination of many white, middle-class suburbanites, black poverty became an unmanageable and threatening epidemic—one closely connected to excessive criminality, violence, and a poverty of values. The stereotype of the "Black welfare queen" exploiting middle-class taxpayers' largess, for example, was widely circulated in the early 1990s and served as the racialized subtext in Dan Quayle's 1992 condemnation of fictional single-mother

Murphy Brown.[82] That same year, the interconnected problems of inner-city poverty and racial injustice exploded on the streets of Los Angeles and were brought into white America's living rooms via 24-hour news coverage of burning buildings, unchecked looting, and a police force seemingly rendered ineffectual in the face of black rage. Sparked by the Rodney King verdict, the L.A. riots/uprising exposed the deep resentment of those black Americans who were utterly disenfranchised from the Reagan/Cosby-era American Dream. As one young black man told Oprah Winfrey and her television audience on an episode that aired shortly after the uprising: "Brothers and sisters don't have it like the so-called people who go out and work everyday and get in their nice cars and get in their nice houses; we come from the streets, we live in hell, we go through the trials and tribulations of all types of things, and when a situation happens like this, and people want to get theirs, and when they work hard and they still can't get groceries, and they see the place burning up, what you gonna do. . . ."[83] Such economic realities and social discourses that linked blackness to criminality and violence made it difficult to ignore the fact that race relations in the United States were intricately linked to the unequal distribution of wealth.

For cosmopolitan whites looking for an affordable politics of social tolerance, blackness would likely have been far less expedient than homosexuality; supporting affirmative action, reparations for slavery, or progressive welfare reform didn't dovetail neatly with the era's entrenched neoliberalism. They certainly would profess to hold antiracist attitudes, but gays and lesbians proved to be a more easily digestible Other in the arena of cultural consumption. In fact, if their fiscal conservatism (epitomized by quiet support of welfare reform) masked deep frustration with the intractability of race relations, hip, well-educated whites' support of gays could be seen as a compensating move—a way to shore up their identities as social liberals in the face of their fiscal conservatism.[84] While Florida's Creative Class professionals would often judge the appeal of a corporation by asking about its policy on same-sex partnership benefits, Florida found a negative correlation between high concentrations of black residents in a city and high concentrations of the kind of high-tech industries to which educated elites flocked.[85] In the realm of cultural consumption, the rise of gay material on prime-time network television coincided with the growing invisibility of black characters—a development so striking that it led the NAACP to threaten to boycott the industry in 1999. The few black characters that made it on to prime time were increasingly segregated into black-oriented programming blocks that attracted virtually all-black audiences. This segregation was often explained as the inevitable result of narrowcasting or the racist politics of TV production, and both forces certainly played a role. Yet the fact that many viewers looking for hip and edgy programming seemed to have found gay-inclusive TV more

appealing than black-inclusive TV tells us something, I think, about their politics of cultural consumption.

CONCLUSION

Mapping out this web of intersecting discourses about multicultural tolerance, difference, and homosexuality and examining the politics of a socially liberal, fiscally conservative neoliberalism reveals deep ambivalence. Pretensions to tolerance, of course, weren't always free from illiberal attitudes about class, race, gender, or homosexuality, and social imperatives to be politically correct could complicate the motivation of even the most earnest and sincere. Using politically correct terms like African American or Latino or condemning racial profiling and the exploitation of migrant workers could exist alongside the beliefs that blacks could be innately lazy and illegal immigrants were a debilitating drain on the economy. For the fiscally conservative cosmopolitan who wanted to be tolerant but who still believed in free market capitalism and the power of the individual to determine his/her own destiny, celebrating cultural difference was undoubtedly easier than facing the economic and structural inequities of a capitalist system grounded in inequality. And confronted with multicultural discourses that announce the evils of hierarchies of power, some probably looked for ways to evade his/her class, race, gender, and/or sexual privilege. In contemporary America's consumer culture, celebrating difference through the products one bought, the movies one saw, or the television one watched offered a passive way to establish one's credentials—an alibi against bigotry.

In the early 1990s, the cultural logic of multiculturalism and shifting discourses surrounding homosexuality intersected with the economics of niche marketing and network narrowcasting to make gay-themed TV not only a possibility, but also one of the most noticeable network programming trends of the era. Such interconnected forces, of course, also helped shape the ways gay characters and issues were actually incorporated into the narratives of prime time's sitcoms and dramas. In discussing the ways ethnic Others are encouraged to perform difference, post-colonial critic Sabrina Sawhney claims that "the members of subordinated groups are constantly buffeted by the desire of the 'well-meaning' members of the dominant group to stage their 'exoticism' such that their peculiarities may be easily understood and the dominant members may be granted an opportunity to make a ritualized gesture of piety toward cultural difference."[86] While gays and lesbians often find themselves staging their homosexuality for the benefit of their straight friends, I'd argue that gay characters and by extension gayness itself was forced to play the same role in much of 1990s network programming. Of course when such representations are produced by a collaborative and commercial

medium, they are also "buffeted" by a range of other desires and agendas. Chapter 6 will explore the ways gay material was staged for the benefit of straight characters and viewers. The next chapter, however, will describe exactly when and how gay material became a prime-time programming phenomenon.

CHAPTER 5

Gay Material and Prime-Time
Network Television in the 1990s

This award really indicates a whole new meaning to the phrase "acceptance speech."
—Max Mutchnick, September 2002

AT THE 2000 EMMY AWARDS, *Will & Grace* was a surprise winner, beating out *Friends, Frasier, Everybody Loves Raymond*, and *Sex and the City* for best comedy series. In accepting the award, series cocreator Max Mutchnick implied that the show's victory said as much about the television industry's attitude toward the program's gay content as it did about the quality of its scripts, direction, or acting. At the start of the 2000–2001 season, *Will & Grace* was one of the biggest hits on television. Besides winning the Emmy, the show consistently ranked in the top ten (and even higher among 18-to-49 year olds), and had just settled into one of prime time's highest profile timeslots—the all-important 9:00 p.m. tentpole position on NBC's Thursday night schedule long held by *Seinfeld*. Making *Will & Grace* the lynchpin in its most lucrative evening of programming indicated just how confident NBC executives were in the gay-themed sitcom's ability to draw both advertisers and viewers. The program with an openly gay male lead had become prime time's new "it" show. *Will & Grace*'s success in 2000 marked the end of a remarkable change in prime-time network television. Just ten years earlier, gay material was among the issues network executives had dreaded most. Yet in the fall of 2000, *Will & Grace* was among television's most lauded and watched programs.

In this chapter and the next, I turn to the emergence of gay-themed television as a programming trend and as a site where America's straight panic was fueled and exposed. In chapter 6, I will address specific narrative tropes through which Straight America's anxieties about homosexuality, heterosexuality, and the distinctions between them played out. In this chapter, however, I carefully chronicle gay-themed programming's rise season by season from 1989 to 1999. To some extent, this chapter is intended to provide a historical record of gay material's changing presence and function on prime-time net-

work television. To that end, I focus on specific episodes that I believe played particularly important roles in either reinforcing or shifting the industry's perceptions about gay material. I look at trade and popular press discourses surrounding such gay-themed programming and create a catalogue of prime time's recurring lesbian, gay, and bisexual characters and gay-themed episodes. Although the amount of gay content increased dramatically, the range of gay representations remained limited—often by the very same factors that helped get gay material on the air in the first place. Thus, I conclude by highlighting some of the major ways the depictions of gay characters were circumscribed.

Network schedules have an internal logic of their own. Programmers often learn from others' failures and copy their successes. An innovative series, character, or narrative device that bombs quickly becomes a cautionary tale— a warning to programming executives not to go down certain paths. On the other hand, an innovative hit can quickly transform a worn-out genre, a verboten topic, or an experimental visual style into a prime-time staple and cultural phenomenon as everyone tries to imitate its success. Of course imitation can sometimes lead to saturation, subsequent failures, and the demise of an entire trend. Over the course of the 1990s, gay material was caught up in both cycles. Between 1989 and 1993, a number of conspicuous failures made gay content the kind of programming networks didn't want to get anywhere near. Between 1992 and 1995, however, a series of innovative episodes helped shift how executives, advertisers, and producers felt about gay characters and gay-themed narratives. Between 1995 and 1998, gay-themed programming became a prime-time phenomenon as the number of gay-themed episodes and series with openly gay characters surged. Although the high profile failure of *Ellen* in 1998 led many to fear the trend was over, the subsequent success of *Will & Grace* and the continued presence of gay characters suggests that gay content (when safely within certain boundaries) had found a relatively secure place in prime-time programming.

While network programming practices have their own internal dynamics, they are always intricately connected to wider social and industry forces. The innovation-imitation-saturation cycle gay material was caught up in during the 1990s was fueled by the various interrelated factors I have described throughout this project (e.g., the politics of social difference; the mainstreaming of the gay rights movement; the growing interest in niche markets; the Big 3 networks' efforts to target the slumpy viewer; viewers' socially liberal, fiscally conservative political sensibilities). In other words, the trend I chronicle below can't be understood in isolation. Conversely, the dynamics of network television—its tendency to quickly turn a hit into a trend, a taboo into a formula, a political deliberation into a pop-culture preoccupation—fueled America's straight panic. After all, the proliferation of gay material on prime time didn't simply reflect the era's anxieties about the relationship between

the majority and its minorities, the normal and abnormal, the center and margin. It no doubt contributed to them—not only because millions of people watched these programs but also because millions more talked about them. Prime time's growing interest in gay material made headlines. It was the topic of call-in talk shows and political boycotts. It was part of the gay moment.

1989–1992: AD-REVENUE POISON

On November 7, 1989, ABC aired an episode of *thirtysomething* in which two gay men were shown in bed the morning after a casual sexual encounter. Titled "Strangers," the episode (or more specifically advertisers' reactions to it) would quickly become part of industry lore—a cautionary illustration of broadcast television's troubled relationship with gay content at the beginning of the 1990s. In a scene critics described as "tasteful," "somewhat tame," and "delicately" handled, the two men casually shared a smoke, discussed their morning routines, and talked about friends who had died of AIDS.[1] The men were bare-chested, but there was no post-coital kiss or intimate embrace—just a friendly hand on the shoulder (figs. 4 and 5). According to Peter O'Fallon, the episode's director, he and the cast went out of their way "to rehearse it in a normal way, to not make it too provocative or, honestly, too sexual."[2] As such timid care suggests, producers were aware that the scene's explicit acknowledgement (as opposed to depiction) of gay male sex was breaking prime-time barriers.

The episode created no real public outcry before it aired. Just one week later, however, industry insiders reported that the gay bedroom scene had, in fact, been a huge deal for *thirtysomething*'s advertisers. ABC lost as much as $1.5 million in ad revenue when five of the series' ten regular sponsors pulled their ads. The network also received approximately 400 phone calls about the episode—90 percent of them negative.[3] Although, as one might expect, both ABC and the producers, Marshall Herskovitz and Ed Zwick, insisted that the reaction from advertisers wouldn't keep the show from bringing the gay characters back in the future. Beneath the network-line spin, however, Herskovitz recognized that *thirtysomething*'s ability to include gay material was constrained by the network's commercial imperative. "Unfortunately, the skittishness of advertisers to certain story lines is the soft underbelly of television," he admitted. "Over-the-air TV exists to sell products, and advertisers aren't interested in artistic expression. It's dangerous that they have that power, but that's how the system works."[4] Concerns about advertiser influence and network censorship heated up again the following summer when ABC, fearful of losing another $1 million, refused to rerun the episode. The controversy surrounding "Strangers" became an important reference point for trade and popular press coverage of gay-themed programming throughout the 1990s, at first serving to frame gay material as an economic suicide and later helping to

4, 5. Two gay men wake up together after a casual sexual encounter. "Strangers," *thirtysomething*, originally aired November 7, 1989 (© MGM/UA Television Production Group, Inc., 1989).

measure just how much network television's attitude toward gay material had changed.

While television had never really welcomed gay material, gay-themed programming seemed to be particularly troubling for the networks at the beginning of the 1990s. Throughout much of the 1980s, homosexuality was firmly linked to the dominant discourses surrounding the AIDS epidemic (to disease, death, and promiscuity), and a renewed conservative climate fanned the flames of antigay rhetoric. Advertisers and network executives had good reason to consider it a highly divisive issue—something to be carefully avoided in an era still dominated by broadcasting principles. Yet while no one would point to 1980s television as particularly gay-inclusive, there had been signs that the networks were becoming more tolerant of gay content. In 1988, series like *Hill Street Blues*, *Hotel* and *St. Elsewhere* tackled gay issues in episodes that had earned the praise of gay and lesbian critics. That year, three other prime-time series—*Dynasty*, *Heartbeat*, and *Hooperman*—included gay or lesbian recurring characters. One year later, however, all three of these series were cancelled, and the controversy surrounding *thirtysomething* in both the fall of 1989 and the following summer signaled a renewed resistance to gay material.

Such retrenched opposition to gay-themed programming was fueled by increasingly skittish advertisers. By 1990 there was a perception among both producers and network executives that their sponsors had grown more sensitive to program content that might conflict with their corporate images or turn off certain consumers. "I think advertisers are definitely more frightened now than they were a year ago," Marshall Herskovitz observed in 1989. According to him, sponsors were also "more willing to take action."[5] ABC, for example, announced that it had lost $14 million during the 1989–1990 season because of advertiser defections. "It's a sorry state of affairs when advertisers are acting as skittish as they are," Robert Iger, ABC Entertainment President at the time, declared.[6] Sponsors reportedly fled from a variety of topics, including teen drinking, neo-Nazism, and violence. Along with abortion, however, homosexuality was the issue that scared advertisers most and generated the most widely reported controversies.

A variety of factors help explain why advertisers and by extension network executives were increasingly sensitive to gay content in the early 1990s. By 1988 all three networks found themselves under new management whose top priorities were to streamline operations and improve the bottom line. In the process, the budgets for network standards and practices divisions were cut significantly, leading to far less network oversight of program production and undermining advertisers' confidence in quality control. "Instead of having two people look at a program prior to airing, there's one person looking at it," Alfred Schneider, ABC vice-president of standards, admitted. "Instead of

watching it at rehearsal or watching the daily, you put your effort into the rough cut. You increase your margin of error."[7] At ABC, less than forty people were assigned to do the job eighty people used to do, and at CBS, only the pilot and first five episodes of a series were reviewed by Program Practices.[8] Meanwhile, special interest groups concerned about what they saw as dangerous content became increasingly active, pressuring advertisers by organizing boycotts of companies that sponsored offending programs. Michigan housewife Terry Rakolta's campaign against Fox's *Married . . . with Children*, for example, may not have forced the show off the air, but it gained national attention and put advertisers on edge. Organized opposition to gay material was most often spearheaded by Mississippi-based minister Donald Wildmon. As president of the American Family Association, Wildmon conscientiously alerted advertisers about programs that "promoted homosexuality," targeted networks with letter-writing and call-in campaigns, and organized boycotts. Network executives almost always claimed to be unmoved by protest groups. The growing number of sponsor defections, however, indicates such efforts did make certain advertisers, especially the nation's largest packaged-goods manufacturers, more skittish about controversial content and the bad publicity it might bring. "This appears to be a case of companies reacting to protect their interests," one ad agency executive said when asked about the flap over *thirtysomething*. "They are fearful of losing their market."[9] The 1991–1992 recession only made the threat of such boycotts more effective. In a tight economic environment, advertisers became even more fearful of alienating consumers and networks became more fearful of alienating advertisers.

In such a climate, homosexuality became notoriously problematic for the networks. Between 1990 and 1992, advertisers balked over several high-profile gay-themed episodes. In the fall of 1990, an episode of the NBC medical drama *Lifestories* in which a gay news reporter tested positive for HIV had trouble getting on the air at all. It went unscheduled for months amid rumors that NBC was afraid of it. After getting "battered in the press," NBC finally decided to air it on December 18.[10] While it finally made it on the schedule, the program had difficulty finding advertisers and was predicted to make $500,000 less than the *Law & Order* rerun it preempted. That same month, ABC reportedly lost $500,000 when advertisers pulled out of an episode of *thirtysomething* in which Peter and Russell, the two gay men from "Strangers," met for the first time after their sexual encounter. Similar defections occurred in conjunction with a much-hyped February 1991 episode of *LA Law* in which bisexual C.J. Lamb kissed a female coworker and an April 1991 episode of *thirtysomething* in which Peter discovers he's HIV-positive. As evidence of how nervous executives were about gay material at the time, one critic reported that when she called MGA-UA (the studio that produced *thirtysomething*) and asked for "the gay episode" (referring to the April 1991

episode), the studio's publicists "rather feverishly panted, 'We don't call it that.'"[11]

Intense controversy also surrounded the January 15, 1992, episode of NBC's sci-fi drama *Quantum Leap* in which the show's time-traveling protagonist Sam (Scott Bakula) leaps into the body of Tommy, a cadet at a 1964 naval prep academy. Sam's mission is to save the life of his former roommate Phillip who is gay and (Sam thinks) soon to be killed by a gang of homophobic students. Sam, however, discovers that Phillip is actually planning to commit suicide and frame his tormentors. With the help of the academy's closeted track coach, Sam stops Phillip and helps him start coping with his shame and anger.[12] News of trouble first surfaced while the episode was still in production. In September 1991, the *Los Angeles Times* reported that "NBC, in a move that pointedly illustrates the new financial reality in Hollywood, is seeking financial relief from the producers of the hit TV series 'Quantum Leap' because of possible advertiser pullouts over a controversial upcoming episode about a gay teen-ager."[13] The story immediately drew strong criticism from those who believed NBC was censoring the episode simply because it dealt with homosexuality. The Gay & Lesbian Alliance Against Defamation (GLAAD) threatened a boycott on NBC, charging that "NBC is sending a message that gay characters, even gay teen-agers who exist in our society who are persecuted, are not wanted on NBC."[14] NBC, however, claimed that it had never asked Universal to pay for advertiser fallout. According to NBC, Universal began production on the episode before NBC had signed off on the script, and the network refused to pay the production costs for an unapproved script. In fact, Rosalyn Weiman, vice president for Program Standards and Community Relations, said that NBC "didn't believe [the episode] was properly balanced in that it presented a negative gay portrayal."[15] After consulting with NBC, GLAAD was convinced and backed the network's position. Don Bellisario, the show's producer, however, felt NBC was being disingenuous and maintained that the network had known about the gay episode for months. "What this comes down to is this is an episode where they're looking for reasons not to accept the script because it deals with homosexuality," Bellisario said. "The problem is with the sales department, not standards and practices."[16] Eventually, the producers and NBC negotiated certain changes, which included presenting the cadets as being in their twenties rather than teens. While NBC presumably paid Universal its license fees after the changes, Bellisario maintained that the changes wouldn't have any effect on nervous advertisers. "Changing the script in any manner is not going to change [the network's] problem," he said. "Because it deals with homosexuality, advertisers will pull out. It does not really matter where you come down on the matter. Advertisers just won't touch the shows."[17]

In the end, Bellisario might have been right. By the time the episode aired, the controversy had been widely chronicled everywhere from the *New York Times* to *Entertainment Weekly*. For its part, NBC seemed anxious to downplay the episode's supposedly hot-button subject matter. The teaser that ran before the episode, for example, seemed to describe an entirely different plot: "Sam's life hangs in the balance when he's accused of betraying his country." Reviews on the actual quality of the program were mixed. GLAAD thought the episode was "great," but the *Los Angeles Times*' Howard Rosenberg felt "the hour was not as well executed as it was well intentioned." The ending, in which the track coach comes out and Sam's holographic sidekick (who had voiced several homophobic comments throughout the episode) realizes he had been wrong, "contributed to one of those familiar, pat TV endings in which the truth loses out to tidiness."[18] As far as industry observers were concerned, however, the real story was that once again a gay-themed episode proved costly. After a number of advertisers pulled their sponsorship, NBC scrambled to fill the open spots at minimum prices. Although all but one of the spots was eventually filled, NBC lost around $500,000.

Such incidents helped to create a sense in Hollywood that gay material was a money loser. Consequently, few executives greenlit gay-themed programming.[19] CBS, for example, had been developing a sitcom for the 1991–1992 season starring Harvey Fierstein as the openly gay leading character. They dropped the show, however, reportedly because Fierstein refused to tone down the gay content. Longtime TV producer Barney Rosenzweig met similar rejection when he pitched an idea to the networks for a made-for-TV movie based on the true story of a policeman who, because he's rumored to be gay, is harassed by other cops and is eventually forced to quit. "I loved that story," Rosenzweig said. "It was a slam dunk. But we couldn't sell it."[20] Although executives told him that the story simply lacked ratings potential, Rosenzweig was certain that the network simply didn't want to produce a movie with a gay lead. "If he had been a black cop (experiencing similar discrimination)," Rosenzweig argued, "it would have been a sure-fire sale. Automatic. But we couldn't sell that picture. It was outrageous."[21] Meanwhile, NBC considered producing a made-for-TV movie based on Randy Shilts' *And the Band Played On*, an in-depth historical account of the AIDS epidemic, but eventually rejected what would have been the first high-profile network TV special to deal with the AIDS crisis and the gay community since 1985's *An Early Frost*. Given such attitudes among network executives, it isn't surprising that with the exception of *In Living Color*'s flamboyantly gay sketch comedy characters Blaine Edwards and Antoine Merriweather, there were no recurring openly gay, lesbian, or bisexual characters on prime-time network television at the start of February 1991.

By caving into advertiser fears and special interest group pressure, some critics argued, the networks were compromising artistic freedom and failing their mandate to serve the public interest. TV critics described network television's treatment of homosexuality as "obstinately cautious" and "timid."[22] "Homosexuality still is rarely broached and gingerly handled," one critic observed in 1991. "The topic is so sensitive that some usually loquacious TV-industry and advertising-business sources declined to be interviewed."[23] Fed up, GLAAD took out ads that decried the lack of positive gay and lesbian characters. "It's time for the television industry to realize that 25 million lesbians and gay men in America, along with our families and friends, make up a significant share of the viewing audience," the ad declared. "Over 7,000 hate crimes against lesbians and gay men were reported last year. We believe the time has come for television to stop promoting bigotry by marginalizing and denigrating lesbian and gay lives."[24] In response, network executives like ABC's Robert Iger claimed that their hands were tied by unavoidable economic realities. "I am running a division that has a fiscal responsibility as well as a creative and social responsibility," he tried to explain, "and to maintain a balance between those two responsibilities is sometimes very difficult."[25] Barney Rosenzweig, however, argued the issue on the networks' own terms, claiming that their timid approach was actually fiscally shortsighted. "What the networks need to do more than ever is to be at the forefront [of timely issues like homosexuality], to compete with cable," he asserted. "They are being hamstrung by this fear."[26] As if to drive home Rosenzweig's point, HBO eventually produced *And the Band Played On*. The movie was a huge success, winning an Emmy for best made-for-TV movie and helping HBO to consolidate its reputation as a place discerning adults could find the programming network television was too fearful of.

The perception that gay material inevitably led to controversy and lost revenue had become so hegemonic at the time that GLAAD made a tactical move to counteract what it called "the myth of advertiser defection."[27] GLAAD had been among the most vocal in criticizing increasingly skittish sponsors and network executives, but in November of 1991, the organization tried to balance such criticism by drawing attention to a number of successful series that had included gay and lesbian characters without problems. Ellen Carton, executive director of GLAAD's New York branch, told the *Los Angeles Times* that while much of the coverage of advertiser pullouts had criticized the industry for its tentative treatment of homosexuality, such stories had become "damaging to the lesbian and gay community" by reinforcing the idea that gay material was inherently controversial.[28] By the summer of 1992, however, GLAAD launched a boycott of high-profile advertisers who had pulled ads from gay-themed episodes of *LA Law*, *Golden Girls*, *Dear John*, and *Sisters*. They specifically targeted General Motors, Gillette, and American

Home Products (maker of Anacin, Dimetapp, Dristan, Denorex, ChapStick, Chef Boyardee, and Jiffy Pop).[29]

Some controversial episodes and advertiser defections notwithstanding, a handful of gay-themed episodes and a few recurring gay characters appeared with little controversy during the 1991–1992 season. After the controversial kiss between the self-described "flexible" C.J. Lamb and the seemingly confused Abby in February 1991, *LA Law* dropped the storyline and made little reference to C.J.'s sexual identity for almost a year. The following season, however, the series had several gay-themed episodes, as did the NBC sitcom *Dear John*, CBS's quirky dramedy *Northern Exposure*, ABC's family sitcom *Coach*, and Fox's black-themed sitcom *Roc*.[30] Meanwhile, ABC's perennial top-rated family sitcom *Roseanne* had added a recurring gay character when it outed Roseanne's officious boss Leon Carp near the end of its third season ("Dances With Darlene," April 30, 1991).[31] During the 1991–1992 season, Leon remained a prominent character, appearing in nine of the season's twenty-four episodes. While his primary narrative function was to serve as the testy supervisor with whom Roseanne could trade sardonic barbs, Leon's gayness periodically became central to the storylines. When Roseanne invites Leon to her husband's poker night, for example, Dan and his buddies aren't quite sure how to act ("Why Jackie Becomes a Trucker," October 1, 1991). Later, when Rodbell's makes its employees take a lie detector test in order to find out who's been stealing supplies, Roseanne cracks and tells the corporate snoop that Leon is gay ("Lies," March 24, 1992).

By the end of the 1991–1992 season, industry and popular press assessments of network TV's record regarding homosexuality slowly began to shift. "There's been great progress with television," New York–based gay media critic Ann Northrop declared. "It's still atrocious, but it's getting better."[32] In a year marked by intense gay protests over films like *Basic Instinct*, *JFK*, and *Silence of the Lambs*, television suddenly seemed to be relatively gay friendly. "The incidence of gay characters in episodic television series is phenomenal," GLAAD's Chris Fowler stated. "There is a desperate need for positive images in the media, and television is definitely more willing to take a risk than movies."[33] Another critic went so far as to announce "the coming of age of gay TV."[34] In retrospect, such pronouncements seem premature and naïve and reveal just how far expectations had been lowered. After all, there was hardly a flood of gay material in 1992. At a time when gay material was so strongly perceived to be ad-revenue poison, the most meager increase was apparently reason for optimism.

Nevertheless, even this slight shift was the hesitant start of what would become a strong trend. The number of gay characters and gay-themed episodes would slowly grow over the next five years—following in the wake of the cultural prominence of gay rights politics. Yet throughout the 1990s,

the idea of gay material as somehow inherently controversial remained. No matter how common gay characters became, no matter how successful gay-themed episodes were, the notion that gay material was somehow taboo and risky lingered. Trade and popular press coverage would consistently frame network television's growing acceptance of gay material by contrasting it to the recent animosity toward it. Reciting what became a standard narrative, one critic writing in 1994 noted, "Outcasts only a few years ago because of network fears that they would alienate advertisers, gay television characters have made a resurgence in prime time."[35] In telling this story, observers frequently reminded readers of ABC's $1 million *thirtysomething* debacle—a reference point that helped calculate just how far the industry had come, but also paradoxically stigmatized gay material by repeatedly linking it to past controversies. Coverage also continued to represent antigay viewpoints, often including quotes from Christian conservatives, especially the American Family Association's Donald Wildmon who repeatedly denounced shows that advanced what he called a "prohomosexual agenda."[36] Although niche-marketing principles eroded the impact viewer protests had on advertisers and networks, the standard inclusion of antigay opinions in journalistic accounts of gay-themed TV helped frame it as controversial—a front in the culture wars. Furthermore, just when it seemed networks and advertisers had become blasé about gay material, yet another controversial, high-profile episode would stir up the same old reports of network interference and sponsor skittishness. Between 1992 and 1997, episodes of *Roseanne*, *Picket Fences*, and *Ellen* kept the "myth of advertiser defections" alive. Such episodes and press coverage of the trend helped gay material maintain its edge, even as it increasingly became an identifiable and ubiquitous television formula.

1992–1995: TRANSITION

If the first three years of the decade were marked by intense industry anxiety over gay material, the next three years were a transitional period in which network executives increasingly realized that gay material, if incorporated correctly, could be a valuable programming tool. As I argued in chapter 3, it was during these years that the networks began to appreciate how important it was to more aggressively target highly profitable slumpy viewers with edgy programs like *NYPD Blue* and *Seinfeld*—shows that helped the networks overcome their reputation for safe, banal, and family-friendly programming. That reputation, of course, had been reinforced by the common perception that, when faced with pressure from advertisers and conservative watchdogs, the networks had tried to avoid gay-themed programming. Ironically, when network priorities shifted in the mid-1990s, gay material's once taboo status made it all the more suitable for networks looking to spice up bland lineups. The emergence of gay material as one of the most remarkable programming

trends of the era wasn't without its fits and starts, of course, but between 1992 and 1995, the industry's attitude towards gay content slowly changed.

The 1992–1993 Season

When Fox's steamy prime-time soap *Melrose Place* debuted in summer of 1992, the ensemble cast of young, hip, twentysomething characters included Matt Fielding, an openly gay social worker. As the first prominent continuing gay character on prime time since *Heartbeat* and its lesbian nurse practitioner were cancelled in 1989, Matt's appearance seemed to signal a new attitude toward gay material. Fox, however, fearful of doing anything that might threaten the viability of the young series, was extremely cautious in developing Matt's character. Several proposed storylines, including one that focused on Matt coming out to his brother, were nixed, and Darren Star, the series' executive producer, admitted that the chilling effect from previous advertiser pullouts had made Fox nervous. For months both the network and the show's producers faced intense criticism for "keeping the private life of prime-time network television's only continuing gay character in the closet" and treating Matt as a "shadow figure" and "plot distraction."[37] After rejecting several ideas, Fox finally approved a four-episode story arc that aired in November 1992 in which Matt is gay-bashed, fired from his job, and involved in a wrongful termination lawsuit. *Melrose Place* faced no advertiser complaints over the high-profile episodes, a development that to some observers signaled a shift in attitude. According to Gene DeWitt, president of a prominent New York ad agency, sponsors weren't as skittish about gay material per se. "I think today people are much more sophisticated than they were two years ago, as are viewers," he claimed. "Advertisers are more likely to say, 'That will be fine. Just make sure my spots are not next to anything objectionable.' Because of that, it's not an enormous problem for the network."[38]

Melrose Place's experience with Matt Fielding underscored the fact that advertisers and executives were willing to tolerate gay characters and story-lines as long as they remained out of the bedroom (and on Fox). Although pro-gay critics acknowledged that gay bashing and discrimination were important issues and were glad to see Matt do more than be the supportive friend to his straight neighbors, many criticized the series' efforts to assiduously avoid Matt's sex life. On a show known for depicting its heterosexual characters having sex left and right, *Melrose Place*'s prudish treatment of Matt made the double standard particularly glaring. "Given the size of his role so far," one national TV critic wrote, "I get the feeling we won't be meeting any of Matt's lovers until Fox gets around to premiering its 21st Century show, 'Melrose Retirement Community.'"[39] For producers and executives looking to make their shows edgier, however, finding advertiser-friendly gay material was often a priority. In the early 1990s, for example, gay-bashing narratives

were a seemingly "safe" way for programs to address gay issues. In addition to *Melrose Place*, *21 Jump Street*, *LA Law*, *Civil Wars*, and *Life Goes On* all featured such plot lines. As I will discuss below, much of the gay-themed programming on 1990s television would similarly find ways to deal with homosexuality without having to tackle the problem of same-sex intimacy.

That isn't to say such issues were never addressed. Later that season, for example, David E. Kelley's quirky family drama *Picket Fences* raised network concern when it decided to explore the sexual identity of the family's sixteen-year-old daughter Kimberly. Although the series had touched on numerous hot-button issues (e.g., polygamy, fetal tissue transplants, animal cruelty) with little network interference, the opening scene of its April 29, 1993, episode "Sugar and Spice" raised red flags for CBS. In the original script, Kimberly's friend Lisa is sleeping over. As they get ready to go to sleep they talk about what it would be like to kiss another girl. Curious, they kiss on the lips. They part, look at each other, and kiss again more intensely. They part again, look at each other in surprise, and roll onto their backs. Citing fears of conservative affiliate backlash, CBS demanded revisions that led to detailed production negotiations. "The network did not want to be graphic about teenage girls kissing," Kelley told the *Los Angeles Times*. "We basically agreed to shoot the back of the heads so you wouldn't see touching lips. But they asked if we could fade out before the second (more intense) kiss so that viewers wouldn't see anything. We told them that if you fade to black before the kiss, you're not telling [the audience] where it ends." In turn, CBS suggested cutting to Kimberly's younger brother who could be eavesdropping on his sister. The producers resisted. When it finally aired, viewers saw the first tentative kiss, but when the girls decide "to do it for real" (as Lisa puts it), they pull down the shades and turn off the light, shrouding the second kiss in near total black (figs. 6, 7). The remainder of the episode deals with the aftermath. Lisa discovers she has a crush on Kimberly, while a "confused" Kimberly wonders whether she's gay. When both girls' parents find out, they "freak" and debate what they should do. After a clumsy nod to the nurture-versus-nature debate, a gloss on "elective lesbianism," and the parents' repeated expressions of liberal guilt over wanting their daughter to be straight, Kimberly finally decides that she's not into girls.

While *Melrose Place* and *Picket Fences* established that some gay material was still too edgy for the networks, the success of two other series during the 1992–1993 season established that gay material's edginess could be just what hip, upscale, young adult viewers wanted. When *Roseanne* debuted in 1988, the series was a blue-collar clone of *The Cosby Show*. Despite Roseanne's sardonic parenting style, the show's first two seasons were marked by many traditional, kid-friendly sitcom conventions. Outing Leon in 1991 moved the program away from such family-viewing-hour sentimentality. Although Leon

6, 7. In the top image, Kimberly and Lisa experiment with a same-sex peck on the lips. When they try it "for real," however, CBS turned the lights out. "Sugar and Spice," *Picket Fences*, originally aired April 29, 1993 (© Twentieth Century Fox Film Group, 1993).

would temporarily leave the series in May 1992, *Roseanne* wouldn't remain gay-free for long.[40] The following fall, Roseanne's good friend Nancy raises eyebrows when she introduces everyone to her new girlfriend Marla ("Ladies' Choice," November 10, 1992). The inclusion of openly gay/bisexual characters helped transform the series into a hip, slumpy favorite. Between October 1992 and January 1993 (the same period viewers learned Nancy was bisexual), *Roseanne*, with a rating of 26.8, became the top-rated prime-time show in $60,000+ households. That figure was up 13 percent compared with the previous year. In comparison, the more traditional and less edgy family sitcom *Home Improvement* under-performed in affluent households. Although it ranked fourth with total viewers, it only ranked sixth among households with incomes over $60,000.[41]

That same season, *Seinfeld* emerged as a break-out hit, paving the way for the kind of edgy programming that would soon open doors for gay material. During its first three seasons, *Seinfeld*'s ratings hadn't cracked the top thirty. With its unconventional story structure, cynical sensibility, urban milieu, and decidedly un-family-friendly plotlines, however, the show developed a cult following and would become the prototypical edgy sitcom. Early on, periodic references to homosexuality also helped make the show feel hip and distinguished it from the *Cosby*-era sitcoms that then still dominated. Elaine gets trapped in the subway on her way to be the best man at a lesbian wedding ("The Subway," January 8, 1992). Jerry's budding friendship with baseball player Keith Hernandez is satirically framed as a gay romance ("The Boyfriend 1 & 2," February 12, 1992). And George's girlfriend discovers secret love letters between her father and John Cheever ("The Cheever Letter," October 28, 1992). *Seinfeld* moved from the ratings and cultural margins to the spotlight, however, when NBC moved it to the plum Thursday night lineup in February 1993. The second episode that aired after the high-profile move, interestingly enough, was the soon-to-be famous "not-that-there's-anything-wrong-with-that" episode in which Jerry and George spend the entire time trying to establish their heterosexuality ("The Outing," February 11, 1993). Thus, as millions of viewers tuned in to *Seinfeld*, perhaps for the first time, they were entertained by a half-hour obsessed with homosexuality. By the end of the month, *Seinfeld* had become the hottest show on TV and the top-rated program among 18-to-49 year olds.

In network programming, success almost inevitably breeds imitation, and the success of *Roseanne* and *Seinfeld*, especially their clear appeal to the upscale adult demographic, most likely helped shift industry attitudes about some gay material. As the powerful star and producer of the most successful sitcom on television at the time, Roseanne Barr was able to demand the inclusion of gay characters on her show even at a time when resistance was strongest. *Roseanne*'s continued ratings success, however, demonstrated that viewers,

specifically the most valuable viewers, didn't have a problem watching a program with recurring gay characters, at least in supporting roles. As we will see, the number of series that included recurring gay characters would increase exponentially in subsequent seasons. *Seinfeld*'s use of gay material was similarly influential, foreshadowing the kind of references to homosexuality that would become common over the next few seasons. Although the series' only recurring queer character was Susan (George's one-time girlfriend who dated women after their breakup and returns as George's fiancé in the sixth season), Jerry and the gang were clearly gay savvy. They lived in a social world populated by gays and lesbians and shaped by the politics of sexual identity (and social difference). While the nuclear families that dominated *Cosby*-era sitcoms seemed thoroughly insulated from homosexuality, references to gayness and gay-themed episodes would became a de facto genre convention of the *Seinfeld*-era's hip sitcoms.

The 1992–1993 season also marked a turning point for the industry's attitude toward gay material, because, as we saw in chapter 2, it marked a turning point in the politics of gay rights and cultural visibility. Clinton's election in November, the gays-in-the-military debate in January, the March on Washington in April, and the lesbian-chic-moment in the spring of 1993 signaled a changing social climate and made straight people think about gay people more and in new ways. Although the AIDS crisis was far from over, different discourses about gays and lesbians circulated widely—discourses that didn't link homosexuality so strongly to the specter of a sexually transmitted disease and death. Appearing just as these political shifts were starting, *Roseanne*'s and *Seinfeld*'s gay-themed episodes tapped into the cultural zeitgeist in a way that helped secure (for both audiences and industry insiders) the idea that they were the shows of the moment—and therefore the shows to watch and clone. In turn, such gay-themed episodes became important sites where emerging discourses about gays and lesbians were circulated.

The 1993–1994 Season

Given the timelines of prime-time production, it would take the networks a while to respond to the gay cultural moment and to the other lessons of the 1992–1993 season.[42] As figures 8 and 9 indicate, for example, there was no appreciable increase in the number of gay characters or gay-themed episodes from the previous season. Over the next two seasons, however, gay material gradually became more common. Nevertheless, gay material wouldn't become an undeniable programming phenomenon until the 1995–1996 season.

Not only was there an increased number of gay-themed episodes in this period, but there was also a shift in the kinds of stories gay-themed episodes focused on. AIDS narratives and coming-out tales continued, but were increasingly joined by other tropes (e.g., gay weddings, mistaken-sexual-

8. This graph charts the increase of openly gay characters on prime-time network series from 1990–2000. The 1995–1996 and 1996–1997 seasons mark the peak. Although many of the characters included in those tallies were on short-lived series like *Pursuit of Happiness* (1995), *Public Morals* (1996), and *Lush Life* (1996), the chart underscores network executives' willingness to greenlight series with gay characters.

identity plots, adoption stories). On NBC's *The John Laroquette Show*, John wonders whether he's gay when an old Alcoholics Anonymous buddy makes amends for a sexual encounter John doesn't remember. On ABC's *The Commish*, Tony, who encourages a closeted gay cop to come out when he witnesses a gay bashing, is disappointed by the homophobic reaction of the squad. On CBS's *Murphy Brown*, Jim unwittingly becomes the owner of a gay bar. On Fox's *Roc*, Andrew is upset to find out that his gay brother is moving to Paris. NBC's domestic melodrama *Sisters* added a recurring lesbian character when Alex learns that her producer Norma is gay. Later that season Alex invites Norma's parents to town, not knowing that they think their daughter is married. *Northern Exposure*'s gay bed-and-breakfast owners Ron and Erick get

9. This graph charts the increase of gay-themed episodes identified by *TV Guide* program descriptions. Included in these tallies are all sitcom and drama episodes whose descriptions indicated gay material would be part of the program. In order to identify the increase of specifically gay-themed episodes (separate from the impact of recurring gay characters), I excluded episodes of series with recurring gay characters unless the program description foregrounded a gay-themed narrative—a decision prompted by entries for *Melrose Place*, which often only obliquely identified gay storylines by mentioning Matt's character. There were, of course, other gay-themed episodes during this period that weren't identified in *TV Guide*. If those were added to this tally, however, the general trend would hold. Finally, a number of factors help explain the drop in 1998–1999. That season was the first after *Ellen's* high-profile failure in 1997–1998, and there was some discussion among executives that the market may have become saturated with gay content. Although *Will & Grace* debuted in September 1998, the series (at least as promoted in *TV Guide*) played down the gay angle in favor of highlighting Will and Grace's friendship.

married in a wedding ceremony attended by the whole town.[43] And on *Melrose Place*, once-chaste Matt finally gets a boyfriend and a sex life, of sorts. (Nervous Fox executives, for example, demanded that the show cut away before viewers could see Matt actually lock lips with another man.)

Just when the controversy surrounding gay material seemed to be waning, however, a new scandal erupted. In early February 1994, *Roseanne*'s executive producer Tom Arnold claimed that ABC was refusing to air an episode in which Roseanne and Jackie go to a gay bar with their bisexual friend Nancy. Of particular concern, predictably, was a same-sex kiss between Roseanne and Nancy's girlfriend, played by Mariel Hemingway. According to Arnold, an ABC executive told him that they were pulling the episode because it included a scene that "is not a lifestyle that most people lead." Roseanne stirred the controversy further when she went on the late-night talk show circuit to complain about network censorship. ABC, who never publicly acknowledged that it had decided to pull the episode (entitled "Don't Ask, Don't Tell"), did air it on March 1, 1994—its originally scheduled night and the last night of the February sweeps period. ABC, however, included an advisory warning, and the same-sex kiss was shot in such a way that the viewer only saw the back of Hemingway's head and Roseanne's surprised reaction—not the women's lips touching (fig. 10). The publicity

10. Roseanne is surprised when Nancy's girlfriend gives her a kiss. "Don't Ask, Don't Tell," *Roseanne*, originally aired March 1, 1994 (© The Carsey-Werner Company, 1994).

generated the usual press discourse about nervous advertisers, affiliate defec-tions, and lost revenue. Despite or perhaps because of the controversy, how-ever, the episode drew strong ratings. Only 2 of ABC's 225 affiliates refused to carry the show, and as industry press accounts always pointed out, both were in small markets. The show earned an above-series-average 30 share, and ABC reported that its New York headquarters received only 100 calls, 75 per-cent of which were positive.[44]

"Don't Ask, Don't Tell" quickly entered industry lore, joining the in-famous 1989 *thirtysomething* episode as a much-referenced moment that sig-nified the industry's attitude toward gay material. The message from *Roseanne*'s lesbian smooch? Gay material, especially same-sex kissing, could arouse con-troversy and network nerves, but it and the scandal it might create could also draw huge ratings without serious economic consequences. The fact that two small-town affiliates refused to air the episode was of little consequence to ABC's bottom line. At a time when interest in the slumpy audience was build-ing, major-market ratings and adult demographics mattered most, and the show's performance proved that gay content, even a gay kiss, could draw in that demographic. Furthermore, it was increasingly clear that most advertisers were unfazed. For those that voiced concern about the episode, the problem wasn't the gay content (even the kiss), but rather the attention surrounding the very public struggle between ABC and the show's producers. Over time the episode's importance would grow and shift. Subsequent articles remem-bered the episode as both "a ratings smash" and "a baldfaced ploy for rat-ings."[45] Coming as it did on the heels of the cultural fascination with "lesbian chic" (which had peaked the previous summer) and scheduled during the high-pressure sweeps period, "Don't Ask, Don't Tell" seemed to be both exploiting and commenting on the culture's growing fascination with certain images of same-sex female sexuality and gay rights politics to boost its num-bers. For the most cynical observers, the struggle between Arnold and ABC was self-serving. Regardless of the motivation behind it, the controversy did help support what would eventually become a common belief about gay-themed programming—namely that producers and/or network executives used it as a stunt. Such a discourse was a far cry from the idea of gay content as ad revenue poison that dominated just two years earlier.

The 1994–1995 Season

Over the course of the 1994–1995 season, gay material would finally establish a relatively integrated and secure place on prime-time network tel-evision. The number of recurring and continuing gay and lesbian characters, for example, finally increased noticeably, fulfilling the expectations set by *Mel-rose Place* and *Roseanne* two years earlier. The cast of CBS's sitcom *Daddy's Girl*, for example, included Dennis Sinclair, an openly gay fashion designer played

by openly gay actor Harvey Fierstein (who only a few years earlier had repeatedly failed to get a sitcom deal, in part at least because of network skittishness about gay content).[46] Meanwhile, several other series would add continuing or recurring gay characters during the season. On ABC's *My So-Called Life*, Rickie's coming-out narrative eventually made him television's only teenager and Latino to be openly gay, and episodes focused on his unrequited crushes, attempts to date girls, and his decision to turn to a gay teacher for help. Fox's freshman domestic drama *Party of Five* revealed that Claudia's violin teacher Ross was gay. When UPN's *Married . . . with Children*-clone *Unhappily Ever After* debuted in January, it included openly gay comedian ANT as a decidedly fey high school student. The cast of WB's short-lived soap-spoof *Muscle* included Bronwyn Jones, a beautiful television news anchorwoman who eventually comes out of the closet on air when someone threatens to expose her. CBS's *Absolutely Fabulous*-clone *Cybill* included a recurring gay waiter at Cybill's favorite restaurant. And in March, ABC's *NYPD Blue* added John Irvin as the precinct's openly gay administrative assistant. Including Matt and his various boyfriends (*Melrose Place*), Norma (*Sisters*), Leon and Nancy (*Roseanne*), and the increasingly out Mr. Smithers (*The Simpsons*), there were fifteen gay, lesbian, or bisexual recurring or continuing characters on prime-time network television at some point during the 1993–1994 season—a striking increase that didn't go unnoticed. A *Los Angeles Times* headline, for example, drew readers' attention to the "Resurgence of Gay Roles on Television" and the *New York Times* announced, "On TV, a Heightened Gay Presence."[47]

The debut and quick success of NBC's *Friends* in 1994 further increased gay material's prime-time profile. From the beginning, the series depicted the kind of gay–savvy world *Seinfeld* had pioneered. David Crane, the series' openly gay cocreator and producer, frequently traced the show's origins to the experiences he and cocreator Marta Kaufman had had as twentysomething best friends living in New York. In fact, Chandler Bing, one of the six lead characters, had originally been written as a gay man. Although his sexual orientation was changed when Matthew Perry was cast (in order to better suit the actor's qualities, Crane asserts), the show didn't entirely straighten him out.[48] In one early episode, for example, Chandler is troubled when he discovers that people often assume he's gay ("The One Where Nana Dies Twice," November 10, 1994). Although Chandler and the other main characters were ostensibly straight, a key plot point in the pilot revealed that Ross's ex-wife Susan had left him for another woman. The premise created the opportunity for numerous references to homosexuality—references that established the gay-savvy credentials of the gang. None of their best friends were gay, but at least their best friend's ex-wife was. Susan and her lover Carol, in fact, became recurring characters, appearing in six first-season episodes

centered on the birth of Susan, Carol, and Ross's baby. As the most successful new show of the 1994–1995 season, *Friends* had the kind of buzz network executives craved and spawned numerous clones the following year—many of which incorporated a gay-savvy sensibility along with their trendy urban milieus.

Considering it was ahead of the curve in targeting the slumpy demographic, it's not surprising that NBC took the lead in promoting gay material. Perhaps the most successful gay-themed episode of the year was the October 10, 1994, episode of *Frasier* titled "The Matchmaker" in which Frasier Crane, in a classic sitcom series of misunderstandings, ends up on a date with his new gay boss. The episode was such a hit that NBC reran it in the November sweeps period accompanied by a large promotional campaign. NBC also aired the highest profile made-for-TV movie of the year—*Serving in Silence: The Margerethe Cammermeyer Story* (February 6, 1995). The film dramatized the legal battle between Cammermeyer (a highly decorated colonel whose twenty-six-year career as an army nurse ended when she was discharged for admitting that she was a lesbian) and the military. With her upright demeanor, devoted family, and exemplary record, Cammermeyer had become a poster woman during the 1993 gays-in-the-military debate and the movie promised to be network TV's most important response to the period's defining civil rights issue. With industry muscle like Barbara Streisand (executive producer) and A-list actress Glenn Close (star and producer) behind it, the biopic gained an aura of political and cultural importance. Reports of a same-sex kiss between Close and Judy Davis (who starred as Cammermeyer's lover) predictably led to protests from conservative groups like the Family Defense Council. NBC, however, refused to cut the scene, leading the Rev. Lou Sheldon to tell *TV Guide*, "The values of America are Adam and Eve, not Adam and Steve . . . or in this case, Eve and Stephanie. . . . If NBC wants to risk the consequences—what this will do to their image and their viewing audience—then that's their business."[49] Meanwhile, most critics praised *Serving in Silence*, describing it as "fittingly earnest," "absorbing, subtle, extraordinarily acted, non-preaching," a "quality, adult drama," and "a milestone in TV depictions of lesbians and gays."[50] The made-for-TV movie was also successful with advertisers. Despite the controversy over the kiss, ads sold at standard rates ($110,000 per 30-second spot), leading *Electronic Media* to ask "Does advertisers' support of . . . 'Serving in Silence: The Margerethe Cammermeyer Story' on NBC mean that Americans are becoming more accepting of homosexuality on TV?"[51] While ad support for the film says more about *advertisers' perceptions* of what Americans thought about homosexuality, the film did draw relatively strong ratings, winning its timeslot with a 13.4 rating and 21 share. As a high-profile TV event, *Serving in Silence* both reflected and fueled the industry's changing attitude toward gay material.

1995–1998: THE PEAK

The 1995–1996 Season

Between 1992 and 1995, the networks focused more and more energy on reaching slumpy viewers rather than mass audiences, gay rights became the movement of the moment, and gay material become more common and lost its reputation as ad-revenue poison. During the 1995–1996 season, however, it became a full-blown prime-time phenomenon—one of the defining characteristics of that television season. According to one critic, 1995–1996 was "the gayest TV season in memory."[52] A *Washington Times* headline declared that "Homosexuality Is 'In' On Prime-time Television."[53] And *USA Today* announced, "On TV, gays are coming out all over."[54] The increase of gay and lesbian characters, in particular, drew attention from critics who consistently underscored the sea change that was taking place. "This season is something of a watershed in network TV's handling of gay and lesbian characters," the *Star Tribune*'s Colin Covert reported. "More than a dozen prime-time shows feature gay cops and flight attendants, secretaries and judges, violin teachers and lawyers, in recurring roles."[55] The *Dayton Daily News*'s Tom Hopkins echoed that narrative: "Five years ago, homosexuality was barely acknowledged by the networks," he asserted. "In the new season, gay and lesbian characters will have a greater prime-time presence than ever."[56] And according to the *Pittsburgh Post-Gazette*, "On TV, It's a Prime Time for Gays; 1995 Was the Year Network Shows Embraced Homosexual Characters."[57]

As all four networks worked to reach the same "young, hip, urban, professional" audience in the fall of 1995, incorporating gay and lesbian characters and plot lines was a shrewd business decision. Network executives seemed convinced that this new quality audience of white, urban sophisticates was not only comfortable with, but was even drawn to, programming featuring gay material. Thus, including a gay neighbor, a lesbian sister, or some queer plot twist was not only possible but also lucrative for those networks and producers anxious to differentiate their product in a saturated market of *Friends* and *Seinfeld* imitators. With such a perspective, bringing controversial issues from current headlines could give a show the politically-correct and in-the-know quality helpful in attracting a hard-to-reach audience uninspired by warm-hearted family sitcoms and other standard network fare. No longer seen as a financial hardship for the networks, gay material was reframed as an effective programming tool. As was often reported, a record number of series debuted with continuing gay or lesbian characters:

> *Pursuit of Happiness* (NBC—sitcom): This typical slumpy sitcom didn't last long, but it did include Alex Chosek (Brad Garrett), a gruff ambulance-chasing lawyer who comes out to his law partner in the series' pilot (supporting role).

Courthouse (CBS—legal drama): This quality drama included Judge Rosetta Reide (Jennifer Lewis), a single mother who is involved in a lesbian relationship with her housekeeper (ensemble cast member).

High Society (CBS—sitcom): This short-lived *Absolutely Fabulous*-clone included Stephano (Luigi Amodeo), a chic, Italian gay assistant (supporting character).

The Crew (Fox—sitcom): This *Friends* clone included Paul Steadman (David Burke), whom Fox described as "a warm and utterly winning guy who dreams of finding love and settling down—if only he could find the right man" (main character).

Murder One (CBS—legal drama): This high-concept drama included Louis Heinsberger (John Fleck), the gay office manager (supporting ensemble character).

Matt Waters (CBS—high school drama): This short-lived, midseason replacement included Russ Achoa (Felix A. Pire), a gay high school student (supporting character).

Meanwhile, other series added or outed gay characters later in the season. UPN's newsroom-based drama *Live Shot* outed the sports anchor Lou Waller (Tom Byrd) in November ("Decisions, Decisions," November 28, 1995). In January, Paul's sister Debbie tells the family that she is gay and in love with a woman on NBC's decidedly slumpy sitcom *Mad About You* ("Ovulation Day," January 7, 1996). When combined with other returning characters, twenty-six different gay and lesbian characters appeared on prime time at some point during the season. Meanwhile, the number of gay-themed episodes and references to homosexuality also rose dramatically as all the networks rushed to copy the hip, edgy success of *Friends*, *Seinfeld*, and *ER*. One critic at the time observed, "Transvestites, homosexuality, bisexuals and gay bars are all the rage on network television."[58] As figure 9 indicates, the number of gay-themed episodes reached new highs in the 1995–1996 season and would continue to rise in 1996–1997 and 1997–1998. Although some of this increase can be accounted for by the launch of the WB and UPN, the number of gay-themed episodes on the major networks also increased. Between 1994 and 1997, over 40 percent of all prime-time network series had at least one gay-themed episode.

As their competitors looked to imitate their success, NBC executives seemed to work even harder to stay ahead of the curve when it came to gay-savvy programming. During the November 1995 sweeps period, for example, NBC promoted its Thursday-night Must-See-TV lineup (*Friends*, *The Single Guy*, *Seinfeld*, and *Caroline in the City*) with a gimmick called "Star-Crossed

11. While taking Ross' baby out for a walk, Chandler and Joey unwittingly pass as a gay couple. "The One with the Baby on the Bus," *Friends*, originally aired November 2, 1995 (© Warner Bros. Television, 1995).

Thursday," in which characters from each program made guest appearances on one of the other shows. The various sitcoms were also linked by the repeated appearance of gay material. When *Friends*' Joey and Chandler take Ross's baby out for a stroll, they happen to cross paths with *Caroline in the City*'s Lea Thompson who assumes they are a gay couple with an adopted baby (fig. 11). Mentioning that her gay brother and his partner have been looking to adopt, she asks Joey and Chandler what adoption agency they used. On *The Single Guy*, a temporarily homeless Jonathan has to spend the night at his gay neighbors' apartment where he runs into Ross from *Friends*. When the two later go to the theater, they each wrongly assume the other is gay and that they are on a date (fig. 12). Meanwhile, on *Seinfeld*, two gay thugs steal Elaine's new armoire. The seamlessness of these sitcom worlds—the fact that the characters could so easily move from one show to the next—underscored the homogenizing influence slumpy narrowcasting had on prime time. An ad for "Star-Crossed Thursday" visually underscores just how interchangeable the characters on NBC's lineup had become by 1995 (fig. 13). "Star-Crossed Thursday" also suggested that this slumpy world included gay people (or more frequently gay-savvy straight people). And finally, the high-

12. Ross and Jonathan arrange to go on a date. "Neighbors," *The Single Guy*, originally aired November 2, 1995 (© Castle Rock Entertainment and the National Broadcasting Company, Inc., 1995).

profile crossover stunt indicated that the lesson from Roseanne's lesbian kiss had been learned—gay material could be a useful tool for sweeps.

During the 1995–1996 season, gay material had become so common that the once too-hot-for-prime-time topic became almost mundane—just one more television formula. On the January 18, 1996, episode of *Friends* ("The One with the Lesbian Wedding"), for example, Ross's ex-wife Susan and her lover Carol get married in a ceremony officiated by gay activist Candice Gingrich, the sister of then House Speaker Newt Gingrich. "During any other television season, it would have been the same-sex wedding of the year," the *New York Times* noted. "This season it was more like the same-sex wedding of the month."[59] Just five weeks earlier, *Roseanne* had featured a same-sex marriage ceremony of its own, with Roseanne in charge of planning Leon and Scott's gay wedding. "The biggest news about the wedding on 'Friends' was that it was almost no news at all," the *New York Times* claimed. Actually, there was some news. Gingrich's appearance and the not-so-subtle commentary on Contract-with-America Republicans' antigay positions made headlines, and two of NBC's 220 affiliates (KJAC-TV in Port Arthur, Texas, and WLIO-TV in Lima, Ohio) refused to air "The One with the Lesbian Wedding." KJAC's

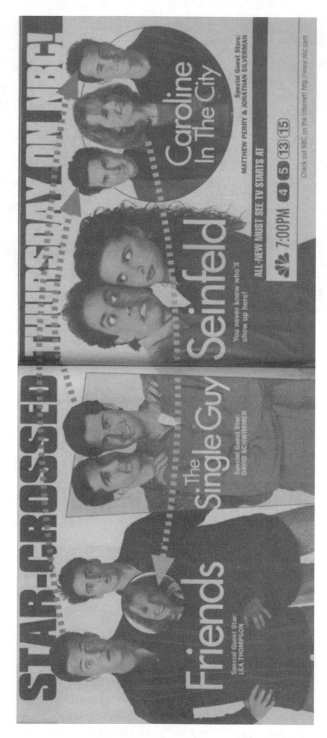

13. *TV Guide* advertisement for NBC's Thursday night lineup. (October 28–November 3, 1995).

general manager stated, "We don't believe the episode of 'Friends' meets prevailing standards of good taste in our community."[60] Their protest barely registered a blip in the press or at the network, however, suggesting how little sway two rural affiliates held with NBC and advertisers interested in hip, urban, sophisticated audiences. Once a major event feared by networks, covered by the press, and desperately sought-after by gay and lesbian viewers, gay-inclusive TV had become standard fare.

A May 1996 *Los Angeles* magazine cover story by gay journalist David Ehrenstein, in fact, argued that gay material was even more pervasive than the average viewer might have thought. "You may not have noticed, but your favorite sitcoms are written by gays and lesbians," a headline informed readers with a tongue-in-cheek nod to the idea of a gay-sitcom-writer mafia. "As outsiders in the mainstream, they're redefining prime time."[61] Most major sitcoms at the time (e.g., *Friends, Seinfeld, Murphy Brown, Roseanne, Mad About You, The Nanny, The Single Guy, Caroline in the City, Coach, High Society, The Crew,* and *Boston Common*) had openly gay and lesbian writers on staff. The presence of gay writers increasingly comfortable with being open at work certainly helps account for the increase of explicitly gay-themed episodes and gay characters. Ehrenstein, however, also argued that gay writers imbued the era's slumpy sitcoms with a decidedly gay sensibility. "Since current comedies are positively obsessed with the intimate sex lives of straight young singles, who better to write them than members of a minority famed for its sexual candor?" (63) Ehrenstein asked. Gay writers are also credited with giving the new breed of sitcoms a certain sophistication. *Frasier's* openly gay writer David Lee, for example, suggested "When you talk about a gay sensibility, you're starting to describe a very urban, very educated—" "—ironic, detached, iconoclastic attitude," added his openly gay writing partner, Joe Keenan (64).

Ehrenstein wasn't alone in linking gay material to sitcoms. Although most critics interested in affirmative images of gays and lesbians were pleased with the greater gay visibility on television, they were also understandably cautious. Many critics complained that representations of gays and gay life were more circumscribed than ever. Networks were greenlighting gay material, critics observed, as long as producers carefully avoided serious gay issues or images of same-sex intimacy. Such criticism was reinforced by the widespread sense that gay material was presented on sitcoms, whose genre conventions made it easier to treat gayness in less troubling ways. Although analytically limited, statistics both support and problematize assumptions about a gay-sitcom ghetto. On one hand, there were more recurring and continuing gay characters on dramas than on sitcoms. On the other hand, there were decidedly more gay-themed sitcom episodes than drama episodes. The higher number of gay-themed sitcom episodes, however, can be partially

explained by the fact that there were far more sitcoms on the air than dramas in this period, and most of the top-rated and highest-profile series were sit-coms.[62] While the percentage of dramas that had gay-themed episodes was actually greater than that of sitcoms, overall, a larger percentage of the gay material on prime time did appear in sitcoms.

The 1996–1997 Season

Regardless of the genre, all of the openly gay, prime-time characters in the 1995–1996 season were in either supporting roles or ensemble casts. In general their primary function was to create opportunities for the further development of the straight main characters, and despite the networks' interest in gay material, it didn't look like things would change any time soon. As GLAAD's Loren Javier observed in December 1995, "We've managed to become ensemble. The day when we have a gay lead character is not in the foreseeable future."[63] As the 1996–1997 season began, it looked as if that trend would continue. The number of gay and lesbian characters reached a record high. That fall six series debuted with recurring or continuing characters: *Spin City*, *Public Morals*, *Lush Life*, *Party Girl*, *Profiler*, and *Relativity*. Although only *Spin City* and *Profiler* stayed on air the whole season, the record number of freshman series with gay characters indicated that network executives were still interested in exploiting the trend.[64] Throughout the season, several other series added or outed gay characters: Doyle on *ER*, Bev on *Roseanne*, Stacey and Pepe on *Nash Bridges*, Abby on *NYPD Blue*, Pete on *Suddenly Susan*. And in March, NBC's midseason replacement *Fired Up* included an openly gay drag queen. As in previous seasons, all of these characters were in supporting roles. All in all, over thirty-three recurring gay and lesbian characters appeared on prime time at some point during the 1996–1997 season. As more gay and lesbian characters were integrated into the weekly worlds of more series, there was also an increase in the number of references and storylines about homosexuality

Although the increase of gay-themed programming continued to gain momentum, the main story of the 1996–1997 season without a doubt surrounded ABC's two-and-a-half-year-old sitcom *Ellen*. To many people's surprise, America didn't have to wait all that long to see a gay lead character on network TV. Rumors about the possible *Ellen* storyline broke on September 16, 1996, when an article in the *Hollywood Reporter* and a press release by *TV Guide* announced that producers were considering bringing Ellen Morgan out of the closet. Although ABC/Disney refused to comment, the story quickly became "the television season's hottest topic of conversation."[65] Everyone agreed that the decision to out a lead character, especially one viewers had come to know so well, would be unprecedented—"a landmark decision in the world of television."[66] Just when it seemed as though gay

material had become mundane, the reports ignited "a storm of controversy."[67] Christian conservative activists like Lou Sheldon, Donald Wildmon, and Pat Robertson reemerged as go-to talking heads for journalists anxious to frame the issue as a heated cultural debate. "Is America Ready for a TV sitcom where the leading character is a lesbian?" *Newsweek* asked, suggesting the fate of Ellen Morgan would serve as a national gut-test on gay issues.[68] Although the show dropped hints throughout the fall, the rumors weren't officially confirmed until the following spring, leading to months of speculation about what Disney would do, how advertisers would react, and whether viewers would approve.[69]

The desire to target the slumpy audience was most certainly a factor in Disney/ABC's eventual decision to allow Ellen Morgan out of the closet. *Ellen*'s history typifies network narrowcasting strategies in the 1990s. When it first appeared as *These Friends of Mine* in 1994, the program was seen as ABC's attempt to compete with NBC for the hip, urban, upscale adult audience. As one critic pointed out, "It was *Seinfeld* with women."[70] Observers, however, argued that the program never gained an identity of its own; it was always "following trends but never setting them (first it was a female *Seinfeld*, then a *Friends* clone)."[71] Throughout its short history, producers dramatically retooled the show in an attempt to attract the socially liberal, urban-minded, white, adult audience. In the 1995–1996 season, for example, producers decided to highlight the program's Los Angeles setting to better exploit the possibilities of its big-city surroundings. That same season saw the increased importance of two gay characters, Peter and Barrett, whose send up of traditional gay stereotypes tested the audience's hipness and progressive politics. Opening the closet door for the lead character was a logical step in revamping the program. As the immense media attention suggested, a gay Ellen Morgan would certainly distinguish the show not only from family sitcoms like *Step by Step* and *Home Improvement* but also from clones like *Caroline in the City* and *Suddenly Susan*. Many observers argued that the move would give the show the much-needed "identity" required to attract the target demographics. Paraphrasing a high-ranking studio executive, one media observer claimed that "Commercially, making Ellen Morgan a lesbian would give *Ellen* an edginess that might bring back its sophisticated *Seinfeld*-type viewers."[72]

ABC's announcement the following March that Ellen Morgan would, in fact, come out on April 30 was followed by an a month of intense scrutiny and publicity. The story was a major news item debated everywhere from CNN's *Crossfire* to the editorial pages of local newspapers.[73] DeGeneres herself came out on the cover of *Time* and was interviewed by Oprah Winfrey and Diane Sawyer. Gay activists heralded the episode as a cultural milestone, and GLAAD organized national "Come Out with Ellen" parties underwritten by Absolut Vodka. Conservatives saw it as yet one more example of the

networks pandering to "a very small, militant community in Hollywood" against the wishes of America's once-again abused moral majority.[74] The conservative Media Research Center took out a full-page ad in *Variety* (signed by Pat Robertson, Phyllis Schlafly, and Jerry Falwell) imploring ABC/Disney to rethink "this slap in the face to America's families."[75] Cynical observers saw it as a brazen, tedious, year-long ploy for ratings. "Is 'Ellen' an Opportunity— Or Just Opportunistic," one *Los Angeles Times* headline asked, and according to the *Washington Post*, "In the long history of network competition, there's never been a stunt like this one."[76] Still others saw it as a chance to take America's pulse. According to a *USA Today*/CNN/Gallup poll conducted just over a week before the episode aired, 46 percent of respondents felt there were too many gay characters on television (up from 37 percent two years earlier). A third of the respondents felt there was the right amount and 9 percent felt there were too few.[77] As the episode neared, some felt the hype might have gone too far. "Is *Ellen* opening the door or creating a backlash?" one observer asked.[78] As a *TV Guide* ad for the episode suggests, ABC exploited the buzz in its marketing efforts.

The coming-out episode had huge ratings and financial success. Of ABC's 225 affiliates only WBAM (serving Birmingham and Tuscaloosa) refused to air the program. Despite conservatives' threats to boycott advertisers that supported the episode, ABC had no problem finding sponsors. Anticipating that the unprecedented media buzz surrounding the show would draw a huge audience, companies were willing to pay as much as $330,000 for a 30-second spot—nearly twice what ABC had been charging for the series. When the Nielsen ratings came in, the episode had exceeded even the most optimistic projections, scoring a 23.4 rating, a 35 share, and ABC's best Wednesday-night performance among 18-to-49 year olds in three years. Over 42 million Americans watched the episode—164 percent more than its season average. Coming in to the coming-out episode, the show's average had been 9.6/16.[79] Although ratings for the season's two remaining episodes (in which Ellen comes out to her parents and her boss) predictably dropped off, they still scored higher than the series' season average and higher than its *Drew Carey* lead-in. How would the show handle its lead character's gay identity for an entire season, many asked, and how would viewers respond to a series whose title character—the person around whom most of the narratives were structured—was openly gay? Those questions would be answered the next season.

As sponsor support for *Ellen* underscored, most advertisers now sanctioned gay-themed programming. With only a few exceptions, major national sponsors offered little resistance to the proliferation of gay material on television in this period. Such changing attitudes were certainly the product of a variety of factors. First, many programs avoided controversy by carefully

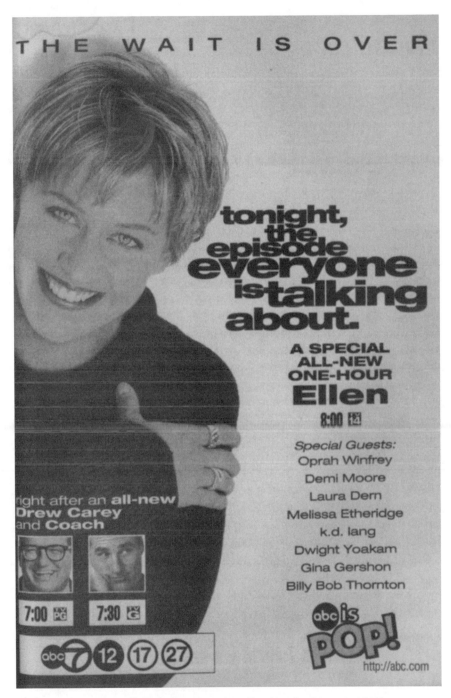

14. *TV Guide* advertisement for *Ellen* (April 26–May 2, 1997).

avoiding depictions of same-sex sexual intimacy. On-screen same-sex kisses and the public attention that tended to accompany them, for example, continued to alarm sponsors and networks well into the 1990s, but a producer could usually buy advertiser cooperation by keeping a low gay-sex profile.[80] Second, in the 500-channel universe, many advertisers reasoned, narrowcasting was presorting many viewers; in other words, intensely conservative viewers would most likely not be watching the edgy programs on which gay material usually appeared. Instead, they were presumably siphoned off by programs like *Touched by an Angel* and *Seventh Heaven* or by cable networks like CBN and the Family Channel. Thus, audience segmentation alleviated many advertisers' fears of controversial social issues that often divided consumers; although some companies pulled out of the coming-out episode of *Ellen*, many more were glad to take their place and to pay premium prices to reach the viewers who would likely be drawn to the high-profile episode. Of Volkswagen of America, Inc.'s decision to buy time on the episode, Tony Fouladpour, company spokesperson, explained "It's about advertising our products to a target audience of drivers, which matches the viewers of *Ellen* and which would include many different life styles."[81] Third, a new breed of prime time advertiser had emerged. High-tech companies quadrupled their prime time ad spending between 1992 and 1994.[82] With gay-friendly corporate cultures and upscale, well-educated target consumers in mind, companies like Intel, Apple, and Microsoft had no qualms sponsoring gay-inclusive programming. Rebecca Patton, senior vice president at E-Trade Group, an online brokerage firm who aired spots during the controversial episode of *Ellen*, felt the program would reach its desired audience: "We really appeal to people who think for themselves."[83] Fourth, as gay material became ubiquitous, even the most conservative packaged goods manufacturers, such as Procter & Gamble, became less fearful. When everyone seemed to be sponsoring gay-themed episodes, there was less chance of being singled out. This desensitization led to a snowball effect: the more gay material aired, the less nervous advertisers got, and the less nervous advertisers got, the more chances networks and producers were willing to take in using gay material to reach their target audience. Finally, as we saw in chapter 4, social discourses that increasingly linked gays and lesbians to trendy consumerism rather than to AIDS helped make gay content more palatable to sponsors.

The 1997–1998 Season

With the success of *Ellen*, the networks seemed prepared to continue opening prime-time doors to gay characters and exploit gay material at the start of the following season. That August, *Broadcasting & Cable* reported that "The 1997–1998 season is being called a banner year for gay roles."[84] Three new series debuted with openly gay continuing characters: *Head Over Heels*,

Total Security, and *413 Hope Street*. In addition, *Veronica's Closet* included Josh, a self-proclaimed straight man who everybody else knew was gay. According to a widely covered GLAAD report, a record thirty gay, lesbian, or bisexual characters were featured on prime time that fall—up 23 percent from the start of the previous season. Later in the season, *Homicide's* Tom Bayliss came out as bisexual, long-time regular Dr. Hancock came out on *Chicago Hope*, and mid-season replacement *Style and Substance* included Mr. John, an openly gay interior designer. Besides the various storylines involving series' regular gay cast members, there continued to be a consistently high number of one-off gay-themed episodes in both series with and without recurring gay characters. Furthermore, executives continued to use gay material to promote a show's hipness. NBC's oft-run 1997 promo spot for its supposedly hot, new sitcom *Working*, for example, prominently featured a gay joke in which Fred Savage's new boss offers him an attractive male secretary as a perk for a new job. While the episode had no other gay content, somebody at NBC apparently felt that foregrounding the gay bit was the best way to get viewers interested in the show.

Ellen, of course, was the highest-profile gay-themed program. *Ellen's* post-coming-out honeymoon with the network, advertisers, and viewers, however, didn't last long. The first sign of trouble came when ABC announced that, in addition to giving the series a TV-14 rating, it also planned to place a parental advisory warning before the series—a move that incensed gay activists who saw it as a homophobic double standard. ABC's decision came at a time when the television industry faced renewed pressure to curb sexual and violent programming and Disney/ABC faced the threat of a boycott from Southern Baptists unhappy with the corporation's gay-friendly policies—developments that signaled a conservative backlash to the era's slumpy programming and the limits of network narrowcasting. The warnings also seriously soured the relationship between the network and DeGeneres, who reportedly threatened to walk off the show and criticized executives publicly. Tensions only increased as producers developed the relationship between Ellen Morgan and her girlfriend over the course of the season. Meanwhile, some ABC affiliates, especially in the South, complained that it had become impossible to find local advertisers willing to buy spots on the series, forcing the network to fill them with national ads.

ABC would likely have dismissed conservative boycotts and rural affiliate complaints if the series' ratings had remained strong, but they didn't. In October, *Ellen* averaged 15.3 million viewers a week (losing just 14 percent of its lead-in *Drew Carey* audience). In early 1998, however, the series averaged only 10.6 million viewers a week (losing a much less respectable 35 percent of its lead-in audience). Such statistics sparked widespread speculation that ABC was going to cancel the show. There were several explanations for the ratings

decline. ABC executives and some critics felt that the series had betrayed its roots and its mainstream viewers when producers decided to focus almost exclusively on the character's lesbianism. "In short," one critic complained, "*Ellen* has been so busy acknowledging the sexual orientation of its lead character that it has forgotten how to be funny."[85] The show's producers, on the other hand, argued that ABC refused to promote the series. Executive director Tim Doyle claimed that ABC "mismanaged the public perception of the show" and that viewers "have been given permission to have the negative feelings they have about the series."[86] Looking to cut its losses, ABC put *Ellen* on hiatus in March, replacing it with the bland *Two Guys, a Girl, and a Pizza Place*. The series returned in May for a one-hour series finale.

1998–2002: FROM SLUMPY TREND TO LONG-TERM INTEGRATION

In the wake of *Ellen*'s perceived failure, it seemed as though network attitudes toward gay-themed programming had cooled. The 1997–1998 season had already seen some signs of a shift in network attitudes about gay material. When *Veronica's Closet* debuted in September 1997, for example, producers had planned to out Ronnie's gay-acting assistant Josh within a few months. According to executive producer David Crane, however, NBC chief Warren Littlefield told them to keep the character's sexual identity ambiguous. Prime time in general, and NBC in particular, Littlefield warned, had become swamped with gay material, and NBC executives were looking to curb that trend. A more dramatic and widely publicized sign came in the fall of 1998 when GLAAD's annual TV Scoreboard measured a 33 percent drop in the number of gay, lesbian, and bisexual characters on the network's new fall line-ups. The number dropped from thirty at the start of the 1997–1998 season to only twenty at the start of the 1998–1999 season—a statistic noted in many fall-preview articles. "Scared Straight; New Season to Debut with Fewer Gay Characters after 'Ellen' Fallout," one typical headline announced.[87] The 1998–1999 season also had the fewest number of gay-themed episodes of any season since 1995.

In September of 1998, conventional wisdom suggested that gay-themed programming might have run its course. Television history is filled with boom-bust cycles in which an innovative and hugely successful program gets copied so often that what was once novel eventually becomes formulaic and overexposed, and the trend eventually dies out (e.g., magical sitcoms in the 1960s, black-themed family sitcoms in the 80s). As we saw in chapter 3, the apparent success of *Seinfeld* and *Friends* among the slumpy demographic had spawned dozens of sitcoms focused on hip, urban, twenty- and thirtysomethings whose friends became their de facto families. Although gay material was not limited to such programs, these slumpy sitcoms certainly accounted

for much of prime time's gay content. Although traditionally gay-savvy shows like *Friends* and *Frasier* were still going strong, *Seinfeld* concluded the same month *Ellen* did, and the utter failure of NBC's *Friends* clones like *Jesse* and *Union Square* (despite the luxury of their coveted post-*Friends* time slot), suggested that the slumpy sitcom trend was nearing its end. Meanwhile observers began to notice the ratings growth of decidedly non-slumpy shows like *Everybody Loves Raymond* and *JAG*. Given such shifts and *Ellen's* high-profile failure, it isn't surprising that some would think the trend of gay-themed programming might also be nearing the end of its own innovation-imitation-saturation cycle.

In the long run, of course, gay material didn't fade away. In fact, by the following March, the *Washington Post*, noting a resurgence of gay content, reported that the networks "have given producers the go-ahead on the formerly taboo topic because it is attracting young viewers like a magnet and advertisers aren't fleeing. In fact, gay stories have this season become another standard sweeps stunt, along with weddings, baby birthings and lead-character shootings."[88] In December, Steve's mother came out of the closet on *Beverly Hills, 90210* ("I'm Back Because," December 2, 1998). During the following February sweeps period, the WB's teen drama *Dawson's Creek* brought series regular Jack McPhee out of the closet, making him television's only openly gay high-schooler. That same month, the WB's college drama *Felicity* outed the title character's boss, Javier. The Christian Action Network, a conservative "pro-family" organization, felt there was so much gay material on television, especially in programs ostensibly targeted to teenagers, that it called for the industry to add a new "HC" ratings category to warn viewers about homosexual content.[89]

Gay material would remain a standard component of prime-time programming well into the next decade. Several openly gay, lesbian, or bisexual characters would be added to prime-time rosters on both new and established series in 1999–2000 (*Action; Mission Hill; Oh, Grow Up; Wasteland; Popular; Buffy, the Vampire Slayer*), 2000–2001 (*Bette; Dark Angel; Grosse Pointe; Normal, Ohio; ER*), and 2001–2002 (*The Ellen Show; Some of My Best Friends; First Year; The 80s Show; Titus*). Although most of the characters continued to be limited to supporting or ensemble roles, three were in leading roles, and two series (*Normal, Ohio* and *The Ellen Show*) were built around openly gay characters. Typical of network series' high failure rates, most of these shows lasted only one season. A program's gay content, however, was rarely mentioned as a reason for failure, and the fact that network executives kept greenlighting gay-inclusive series indicates that gay characters were becoming just one more character-type used to create a well-rounded cast. Meanwhile, gays (and to a far lesser extent lesbians) were also included in network television's newest trend—reality television. Starting with Richard Hatch, the victor on

CBS's inaugural *Survivor* (2000), openly gay men frequently appeared on *Survivor, Big Brother, Amazing Race,* and *The Mole.* The number of gay-themed episodes and the kind of savvy references to homosexuality made popular by *Seinfeld, ER,* and other 1990s staples remained well above the level seen in the early 1990s.

The continued viability of gay-themed programming in the post-*Ellen* era was helped considerably by the success of *Will & Grace* (1998–). Like *Ellen,* the show had a title gay character. Unlike *Ellen,* however, protests were virtually nonexistent, and the show was a ratings hit, ranking as the number-one-watched program on Monday nights among 18-to-49 year olds.[90] *Will & Grace* was able to fly under the radar for several reasons. Rather than sensitizing conservative watchdogs, advertisers, and affiliates to gay content in general, the huge controversy surrounding *Ellen* had primarily focused the spotlight on itself. In the months leading up to the initial coming-out episode, for example, a rather provocative kiss on ABC's domestic drama *Relativity* had raised barely an eyebrow (despite the fact that ABC promoted it as "the episode everyone is talking about").[91] In some ways, then, *Ellen* drew the fire from antigay advocates and offered *Will & Grace* valuable cover.

Will & Grace's path was also made easier because it refused to go very far down the trail *Ellen* had blazed. By trying to develop an entire season around the coming-out experience of a well-known character, *Ellen* had shifted the terrain of struggle regarding gay representation much farther than any previous program. Although doing so accounts in part for the trouble it faced in its last season, the series did make it easier for more circumscribed gay-themed efforts that followed to go unnoticed. *Will & Grace* had a decidedly gay sensibility, two openly gay characters, and relatively explicit references to gay sex, but the series carefully avoided representing same-sex physical intimacy and overtly political storylines. Furthermore, the series' central premise, what NBC's promotional literature called "a kind of friendship that's possible between a man and a woman when sex doesn't get in the way," worked to if not heterosexualize, at least de-(homo)sexualize Will.[92] Comparing the episode descriptions provided to *TV Guide* for *Ellen*'s final season with *Will & Grace*'s first season reveals two very different promotional strategies. While nine of *Ellen*'s nineteen episode descriptions made clear that the plot would focus on gay issues, only four of *Will & Grace*'s twenty-two did.[93] NBC managed promotional efforts in ways that likely gave straight viewers more easy entry points. A *TV Guide* ad for NBC's Monday night comedy lineup (*Suddenly Susan, Conrad Bloom, Caroline in the City,* and *Will & Grace*), for example, included four photos featuring each series' primary male-female couple (see fig. 15). The accompanying text for the first three series exploited the underlying (hetero)sexual tension between the shows' main characters. Although

15. *TV Guide* advertisement for NBC's Monday night lineup. (September 26–October 2, 1998).

the text for *Will & Grace* simply quoted a critic praising the series' "appealing stars" and "snappy writing," the ad's overall layout worked to articulate Will with the other heterosexual men on NBC's line up. Downplaying rather than exploiting gay content marks a significant shift in promotional strategies and hints at a change in the role gay-themed programming played for NBC. Looking to capitalize on positive buzz and good ratings, NBC moved the freshman series to the highly visible post-*Friends* timeslot at the end of its first season—a sign that the network had tremendous confidence in the show. Coming as it did so quickly on the heels of *Ellen*'s cancellation, the success of *Will & Grace* helped counteract the negative perceptions of gay material *Ellen*'s troubled final season may have created among network executives, advertisers, and affiliates.

Although impossible to measure, it is worth considering what role the October 1998 murder of Matthew Shepard played in sustaining gay-themed programming in the immediate post-*Ellen* period. The brutal murder shocked the nation and generated widespread condemnations of antigay violence and rhetoric. For many writers and producers, both gay and straight, incorporating affirmative gay content became even more important in this context. Ryan Murphy, creator and executive producer of the WB's gay-inclusive teen dramedy *Popular* (which was picked up in development just months after Shepard's death) talked about using gay story lines in order "to save one person any amount of pain."[94] While such idealism was likely rare among bottom-line–focused executives, the incident and subsequent calls for tolerance might have made it more difficult for them to nonchalantly nix gay-themed programming. In the months immediately after Shepard's murder, for example, there were a number of storylines focused on gay teenagers on series like *ER*, *That 70s Show*, and *Dawson's Creek*.

I have argued that the networks' need to aggressively compete with cable for the lucrative upscale adult demographic in the early 1990s helps explain why gay material, once taboo, quickly emerged as a noticeable programming trend. By the end of the decade, however, programming strategies shifted when the networks realized that they couldn't all successfully compete for the same audience segment. Thus, while 18-to-49 year olds remained important, each network took certain steps to focus on a slightly different demographic. While NBC continued its slumpy-focused strategy, CBS tried to tout the value of its 25-to-54 audiences to advertisers. ABC eventually returned to family-oriented strategies, and the WB carved out its niche by appealing to teenagers. Gay material, however, remained and was incorporated and adapted into various types of programming targeting decidedly non-slumpy psychographic groups. It appeared in older-skewing shows like *Bette*, *The Ellen Show*, *JAG*, *Becker*, *The Guardian*, *Judging Amy*, and *Providence*; in young, male-oriented shows like *Action*, *Titus*, *King of the Hill*, *The Job*, and *Dark Angel*; on

teen-targeted shows like *Popular, Dawson's Creek, Young Americans, Grosse Pointe,* and *Buffy, the Vampire Slayer;* and even on edgier family shows like *My Wife and Kids, Grounded for Life, The Bernie Mac Show, The George Lopez Show, Malcolm in the Middle,* and *The Hughleys.* And, of course, gay material remained a standard convention in slumpy-targeted shows like *Ed, The Weber Show, West Wing,* and *Law & Order: Special Victims Unit.*

Gay content, then, no longer helped differentiate hip, sophisticated programs from their more bland, conservative competitors as effectively as it once had. By the end of the 1990s, gay material became a standard element of network television, rather than a just a trend. In the process, it began to lose its edge—the thing that had made it so appealing to the networks just a few years earlier. *Ellen's* high-profile failure in the 1997–1998 season exposed what had always been true: even as the networks exploited gay material's once taboo status in order to spice up their reputations, they placed definite limits on just what kind of gay material would make it onto prime time. Since 1998 there have been isolated examples of producers who tested those limits, but the vast majority of the gay-themed programming has stayed safely within the boundaries established between 1993 and 1997. Certain shows have made tentative steps to test the networks' tolerance for same-sex kisses, for example, yet no prime-time program, not even the hugely successful *Will & Grace,* has attempted to show to men in bed together like *thirtysomething* did in 1989.

Of course, since the late 1990s there have been television series that went where *Ellen* couldn't. *Oz* (HBO, 1997–2002), *Sex and the City* (HBO, 1998–2004), *Undressed* (MTV, 1999–2001), *Queer As Folk* (Showtime, 2000–2005), *Six Feet Under* (HBO, 2001–2005), and *The L-Word* (Showtime, 2004–) are only a few of the series to push the envelope regarding television's portrayal of gays and lesbians by including explicit depictions of nudity, same-sex intimacy, and gay sex, and often placing gay lives and friendship circles at the center of their narratives. Of course, all of these series appeared on basic or pay cable channels, not the networks. Although the networks had turned to gay material to help convince slumpy viewers that their programming wasn't too safe, bland, and family-friendly, cable networks responded by raising the bar on the edginess of their gay content higher than the networks could or would go. As their slogans make clear, HBO ("It's not television, it's HBO") and Showtime ("No Limits") implicitly construct network TV as limited, and the fact that edgy gay content is one way cable differentiates itself from the networks reveals much about the limits of network narrowcasting. Although they used gay material to more aggressively target a certain relatively narrow demographic (and marginalized the perceived interests of younger, older, conservative, or rural-minded viewers in the process), a host of reasons kept the networks from casting their nets as narrowly as their cable competitors.

The networks' limits regarding gay material underscores the fact that even in an era marked by niche marketing, broadcasting principles still held some sway as far as prime-time network programming was concerned. Although the television landscape had become so fractured, cultural associations that gave prime-time network TV the aura of the nation's shared living room remained, in part because of FCC regulations and persistent memories of an earlier era. And even though their audience shares were a fraction of what they had been in previous decades, the networks' prime-time lineups still provided advertisers access to the largest numbers of consumers—a fact that allowed the networks to continue to charge top dollar for ad time. It also kept them from programming material that would be seen as *too* narrow. In other words, the networks tried hard to find the right balance between narrowcasting and broadcasting. These economics account for the networks' use of gay material to appeal to a lucrative demographic of slumpy viewers—a lucrative niche audience that was still large enough to satisfy advertisers who wanted a relatively mass audience.

Such factors also account for the fact that the networks and advertisers didn't use gay material to target a gay audience. Discourses about the supposed affluence of the gay market undoubtedly influenced network television executives, but they did so in indirect ways. Considering how extensively reported the statistical profiles of gays and lesbians were in the early 1990s, it is hard to believe that the demographic-obsessed marketing, advertising, and programming executives at work behind the networks remained unaware of and unaffected by the numbers. In 1993, *Mediaweek*, a major trade journal, cited the same demographic figures, quoted the same gay-owned advertising firms, and included the same targeting-the-gay-market-is-smart-business advice circulating in other business magazines.[95] Reportedly loyal, highly-educated, and affluent with disposable incomes greater than the national average, gay men and women represented the perfect market for networks eager to deliver a quality audience to advertisers. In many ways, the reported demographics of gays and lesbians were strikingly similar to those of the upscale, "hip," urban, white, college-educated, liberal audience networks and advertisers were so anxious to reach; in fact, they seemed even better. Moreover, as network audience shares decreased and the imperatives of narrowcasting intensified, it might seem natural for network executives to have considered gay and lesbian viewers as a profitable niche audience. Narrowcasting principles, after all, often encouraged a network to discover markets currently being underserved by other outlets, and television programming's ubiquitous heterosexuality had certainly turned away many gay and lesbian viewers.

Nevertheless, network executives have never admitted to targeting gay and lesbian viewers, and considering the economics of network television, their silence is likely not disingenuous.[96] Targeting a gay audience would have

been politically difficult for the Big 3 networks given their historical role as the nation's last mass medium. Furthermore, despite the dramatic erosion of network audience shares, gays and lesbians, at least in the minds of network executives, remained too small a market segment to target specifically. Even in the age of narrowcasting, network broadcasting functioned on a different scale than more niche-oriented media like magazines, direct marketing, or even cable; network television's niche audiences remain significantly larger than those targeted by other media.[97] Moreover, A.C. Nielsen's television ratings reports don't breakdown audiences by sexual orientation, so no data was available about the viewing behavior of gays and lesbians, making it difficult, if not impossible, to sell and buy gay TV viewers in the network TV ad market. Granted, some producers consciously created programming to appeal to a gay and lesbian audience. However, such efforts were driven by a desire to serve rather than target gay viewers and don't completely account for the overall increase of gay-inclusive programming. More often than not, as I've argued, gay material was used to target a significantly larger audience of socially liberal, urban-minded professionals. The fact that it could also be particularly effective at appealing to a highly lucrative gay segment of that quality audience was a collateral and ultimately unmeasurable benefit.[98] If affluent gay viewers entered the equation at all, then, it was only in an auxiliary way.[99] Still, the widely circulating discourse of gay affluence did play a more direct role in the increase of gay material on prime time, primarily because it helped make it easier to integrate gay content into the kind of consumption-friendly media worlds with which sponsors felt most comfortable.

Network interest (or lack of interest) in specifically gay viewers, then, was intricately linked to the interests of advertisers. Although advertisers' opposition to gay material began to weaken in the 1990s, few if any sponsored gay-inclusive TV in order to target specifically gay and lesbian viewers. The economics of network broadcasting just didn't support such a marketing strategy. The high cost of a 30-second prime-time network ad spot determined its use. In order to get one's money's worth, marketers couldn't feasibly use prime-time network television to target a niche audience as small as gays and lesbians, even if they were supposedly disproportionately highly active and affluent consumers. Gay publications, direct marketing, and special event advertising were far more cost effective vehicles for reaching them than an episode of *Seinfeld* or *Ellen*. Even with a commercial like the gay-themed 1994 IKEA spot, the target audience was not merely—or even really—gay men. According to IKEA advertising executive Linda Sawyer, the gay-inclusive ad was meant to appeal to a group of consumers the agency dubbed "wanna-bes": basically, upwardly mobile consumers highly concerned about establishing a sense of style.[100] Surely, IKEA felt that gay men were part of that market, but more importantly IKEA and its ad agency felt that a gay

couple would be an effective tool to speak to the broader wanna-be market. Although IKEA's calculated exploitation of gay consumerism was exceptional, more and more advertisers warmed up to gay content on the shows they sponsored because gay men and lesbians were increasingly being articulated to a "lifestyle" defined by high disposable incomes and high consumption. Marketers, long concerned with "complimentary copy" and "adjacencies" (i.e., the compatibility of an ad with the media content that surrounds it), want to place ads in contexts that dovetail well with their commercial message. When social constructions of homosexuality were closely linked to immorality, illegality, and death, gay-themed content was an unacceptable adjacency. When it was increasingly articulated to active consumption, however, gay-inclusive feature articles or TV narratives became more palatable. Because neither advertisers nor network executives were primarily interested in reaching gay and lesbian viewers/consumers, they weren't motivated to push the boundaries in terms of depicting gay and lesbian life.

Limiting Gayness

Explaining Fox's decision to cut away from a same-sex kiss on *Melrose Place*, Fox Entertainment president Sandy Grushow admitted that gay material was caught up in the network's bottom line: "We're trying to explore the characters within the boundaries of making money."[101] Just what kinds of limits did the networks' money-making priorities place on prime-time depictions of gayness? How was homosexuality incorporated into these various programs? Most scholars looking at gay-themed programming have been concerned with evaluating television's circumscribed, distorted, and powerful discourses about gays and gay life. Increased cultural visibility, of course, does not necessarily mean a wider range of representations. Old stereotypes of gay men and lesbians usually persist, new ones often emerge, and dominant ways of thinking about gay people remained limited. As Suzanna Danuta Walters warns, "media saturation of a previously invisible group can perpetuate a new set of pernicious fictions, subduing dissent by touting visibility as the equivalence of knowledge."[102] Although a growing body of scholarly work has emerged on more recent high-profile series like *Ellen* and *Will & Grace*, less attention has been paid to the early and mid-1990s—the period I have argued was key for the networks' change of attitude regarding gay content. Although detailed analysis of such programs is beyond the scope of this project, I want to make a few observations about the ways gays and lesbians were or were not incorporated into prime-time programs, paying special attention to the connections between such representations and the larger industry and social contexts I have discussed so far.

We have already discussed what was perhaps the most obvious and most common complaint about the networks' limitations on gay, lesbian, bisexual,

and queer life—displays of same-sex intimacy. While the networks pushed boundaries in their depictions of heterosexual sex with frank dialogue and steamy sex scenes, the vast majority of gay and lesbian characters had no sex life—at least not one that viewers got to see. After the controversy surrounding the episode of *thirtysomething* and same-sex kisses on *Melrose Place*, *Picket Fences*, and *Roseanne*, most producers simply played it safe. So viewers got to see Carol and Susan wed on *Friends*, but they didn't get to see them kiss. And fans of *NYPD Blue* could hear male hustlers talk about their johns, but the only sex they got to see involved the precinct's straight cops—naked butts and all. Clearly, chastity was the price gay characters paid for admission to prime-time television in the 1990s.

Less frequently mentioned in mainstream press coverage was the age, general affluence, and urban sophistication of many of prime time's gays and lesbians. Used as textual selling points, gay and lesbian characters and their lives often resembled the demographic profile of the upscale, well-educated, urban 18-to-49 year old viewer networks and advertisers were most interested in reaching. In the process they also tended to mirror the demographic profile of the supposedly urbane, affluent gay consumer circulated in the marketing press at the time. Frasier's gay boss was an upwardly mobile radio station manager who moved to Seattle from London after a break-up over opera recordings. Paul's sister on *Mad About You* and her obstetrician partner were upscale professional Manhattanites who met while on a ski weekend. And Will Truman was a highly successful New York attorney with a two-bedroom, two-bath Manhattan apartment (complete with patio). There certainly were demographic exceptions. As the office mailguy, Pete was likely the lowest-paid and definitely least-hip character on *Suddenly Susan*. Gay characters on *Roseanne*, *Picket Fences*, and *Grace Under Fire* lived in relatively small towns in America's heartland. And shows like *ER* and *Homicide* included gay hustlers living on the street—part of those series' gritty urban milieus. Overall, however, gay and lesbian characters fit smoothly into the era's upscale, prime-time mise en scène. In this regard, they weren't all that different than their straight counterparts, which likely accounts for the fact that fewer journalistic media critics drew attention to the class and geographic bias than to the sexual double standard. As a commercial system, network television in general presents a class-skewed vision of American culture. The emerging construction of gays and lesbians as economically secure and asking for tolerance rather than economic equality helped explain the appeal of gay material to a certain 1990s political sensibility and marketing logic. The era's gay-themed programming both reflected and reinforced those constructions.

Given the overall face of prime-time programming, it isn't surprising that gay characters also tended to be disproportionately white. Of the 71 continuing and recurring gay, lesbian, and bisexual characters that appeared on

prime-time network series between the fall of 1992 and spring of 1999, 58 (82 percent) were white, 7 (10 percent) were Latino, 5 (7 percent) were African American, and 1 (1 percent) was Asian American.[103] Although I don't have similar statistics for guest stars or incidental characters, a survey of eighty-five gay-themed episodes that aired between 1992 and 1999 suggests an even greater percentage of those non-straight characters were white. Of the 13 recurring and continuing non-straight characters of color, most appeared in either narratively marginal recurring roles (Yosh Takata and Raul Melendez on *ER*, Pepe on *Nash Bridges*) or on extremely short-lived series (Troy King on *Cutters*, Rosetta Reide on *Courthouse*, Billy Sanchez on *The Brian Ben Ben Show*, Melvin Todd on *413 Hope Street*, Russ Achoa on *Matt Waters*). *Spin City*'s Carter Heywood was perhaps the clearest exception to this rule—a narratively central gay character of color on a long-running series. Yet Carter's racial identity was far less salient to his narrative function than his gayness. While the show's writers and Carter's coworkers seemed blind to his blackness, his homosexuality was a constant source of narrative development and jokes. Conversely, on the few occasions the series did explicitly deal with Carter's race, it didn't deal with his sexual identity. In other words, the series never addressed what the specific experiences of being a black gay man or a gay black man might have been. Carter was usually gay, sometimes black, but never really both at the same time. Although other series tackled such intersectional identity politics (e.g., Russ's experience coming out as a teenager in a Cuban American family on *Matt Waters*), on network television being gay was almost always equated with being white (an intersection that narratives never explicitly problematized either). In being disproportionately white, gay characters again resembled their straight, prime-time counterparts.

Not only were gay characters on 1990s network prime-time TV usually white, well-off, and urbane, they were frequently isolated—the only homosexuals in an otherwise heterosexual world. Like the black maid of 1950s-era sitcoms who took care of a white family all day only to disappear at night to a black family and black community that viewers never saw, queer characters usually appeared in exclusively straight worlds. Such tokenism, of course, placed enormous limits on how queer characters were represented, what kinds of issues were explored, and what kinds of resolutions narratives could have. It conveniently foreclosed the possibility of gay romance and sex, ignored the role of a gay community and activism in the lives of non-straight characters, and required most gay-themed storylines to focus on gay-straight relationships. As I will explore further in the next chapter, tokenism also tended to position a series' straight characters as the sole source of support for their gay counterparts. A few series (e.g., *Northern Exposure*, *Friends*, *Melrose Place*) included two gay or lesbian characters, making other narrative options possible (at least in theory). In just about every case, however, they were either

a committed couple or at least dating. The exceptions were *Will & Grace*, the final season of *Ellen*, and *Roseanne* (which by the end of its run had incorporated five queer characters—Leon and Scott, Bev and Joyce, and Sandra).

A larger LGBT community was periodically represented on prime time, but only on special gay-themed episodes and in ways that worked to distance the viewer from it. On legal and police dramas like *Law & Order, Homicide: Life on the Street*, and *NYPD Blue*, for example, cases sometimes brought investigators into contact with various elements of the gay community. Following traditional genre conventions, however, scenes almost always focused on straight cops questioning, intimidating, or helping a string of individual gay suspects, witnesses, or victims. If a larger group of gays was shown (usually in terms of an angry crowd of gay protestors or a dimly lit gay bar) the narrative emphasized the experiences of straight characters in such "exotic" situations. Every now and then, a program would deviate from this narrow range of representational options, providing an exception that highlighted the standard even more. A brief D-plot on an episode of *ER*, for example, included a white gay man in the last stages of AIDS. Not only was his lover at his side, so too was a presumably gay, HIV-positive friend and the patient's mother. Although such families-of-choice are familiar to many gay men and lesbians, the brief scene was striking because it was so unfamiliar to network television viewers (fig. 16).

16. A patient is surrounded by his gay friends. "Everything Old Is New Again," *ER*, originally aired May 18, 1995 (© Warner Bros. Television, 1995).

Given gay characters' typical token status, it isn't surprising that gay-themed programming consistently privileged the emotions, perspectives, and experiences of straight characters over their gay counterparts. This imbalance was particularly true on special gay-themed episodes where the conventions of episodic series meant that viewer identification and narrative structure would almost always be centered on the program's continuing heterosexual characters. In the standard coming-out episode, for example, a series regular finds out that a guest star—perhaps an old friend or a never-before-seen-and-never-to-be-seen-again coworker or neighbor—is gay. What matters, as the narrative progression, music, laugh track, and shot selection usually indicate, is how this discovery affects the heterosexual character fans have come to know because of weekly viewing. Supporting and recurring gay characters were usually subordinated in similar ways. One episode of *Party of Five* ("Ides of March," March 15, 1995), for example, wove a story focused on Bailey's attempt to deal with the death of his girlfriend with a story of Ross's attempt to adopt a baby. The series' foundational problematic focused on the Salinger siblings' attempt to adapt after the death of their parents. As a member of that family, Bailey's depression predictably occupied the A-plotline, while Ross (the openly gay violin instructor who had become a de facto parent to Bailey's younger sister) provided the C-plotline. Not only did Ross's adoption saga get less airtime, but the episode's conclusion worked to subordinate Ross's joy over being a new parent to Bailey's path through grief. In the final scene (at a restaurant where the Salinger family helps Ross celebrate the adoption), Bailey asks Ross if he can hold the baby. The episode's last close-up focuses on Bailey's smile as he looks at the infant (and presumably ponders the circle of life). The last shot pulls away from Bailey (still holding the baby) as he sits down at the booth with his brother and sisters (and Ross). While the shot implies that Ross had become part of the extended Salinger family, the shot's construction privileges Bailey and actually renders Ross invisible when he gets blocked by the back of the booth (figs. 17, 18). Although supporting and recurring gay characters like Ross helped make the worlds of prime time gay inclusive, they rarely made them less heterocentric.[104]

For the most part, gay characters, despite their increasing numbers, continued to exist solely for straight characters to react to. This strong heterocentric bias was overdetermined by an industry that used gay material to target an audience envisioned as straight; by textual conventions that privileged lead (i.e., heterosexual) characters; by straight viewers who seemingly demanded heterosexual entry points into gay-themed narratives; and by a political culture that continually and explicitly reaffirmed heterosexuality's centrality at a time when multiculturalism and gay rights threatened to dislodge it. Being forced to serve as heterosexuals' sounding boards placed perhaps the most significant limits on how gay and lesbian characters were

17, 18. Although Ross has just adopted a baby, Bailey and his happiness are the center of attention. "Ides of March," *Party of Five*, originally aired March 15, 1995 (© Columbia Pictures Television Inc., 1995).

represented. In her analysis of gay visibility in American popular culture, Suzanna Dunata Walters identifies two dominant modes of representation for gayness: gays as "an exotic but ultimately unthreatening 'other'" and gays "as really straight after all, the 'aren't we all just human beings' position."[105] On television, the sassy, gay male sidekick became a stock character on 1990s sitcoms (e.g., the waiter on *Cybill*, Stephano on *High Society*, Pepe on *Nash Bridges*, Ashley on *Fired Up*, Nelson on *Lush Life*, Derrick on *Party Girl*). Their effeminacy, trendiness, bitching bon mots, and/or same-sex innuendo clearly established their difference and served as a key source of humor, positioning them as exotic but safe. When *Ellen*'s not-openly-gay-yet-but-unmistakably-nelly-friend Peter meets Martha Stewart at a book signing, for example, his hysteria becomes the scene's central joke. After getting Martha to sign his book "To Peter, I see your face in every pan I use. All my love, Martha," Peter literally squeals with delight as he skips across the room. As Ellen and Martha watch, Ellen comments, "I bet his wife is going to love that." Peter's homosexual difference can't be missed and serves as the punchline for ostensibly straight characters (figure 19). Meanwhile, dramas often developed other ways to exoticize gay difference. Gay bars, for example, were

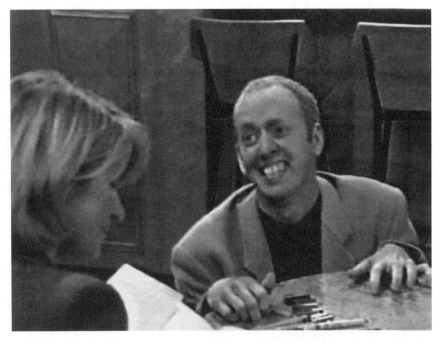

19. Peter can't control himself as he meets Martha Stewart. "Salad Days," *Ellen*, originally aired November 15, 1995 (© Touchstone Pictures and Television, 1995).

often filmed in ways that constructed them as alien places, and detectives often had to explore a strange gay world—one often framed as existing side-by-side but decidedly segregated from the straight world—in order to solve a crime.

On the other hand, numerous narratives turned on the very notion that gays and lesbians were indistinguishable from straight people. The most common gay-themed plot twist was the mistaken-sexual-identity narrative in which confusion and hilarity ensue when a gay character is assumed to be straight and/or vice versa. As we will see in the next chapter, such episodes spoke volumes about heterosexuality, reflecting and reinforcing the notion that the line between gay and straight was far from clear. This kind of narrative twist was also exploited for dramatic purposes. On an episode of *Beverly Hills, 90210*, for example, Kelly is told that the abandoned infant she had discovered was going to be adopted by a couple, Kyle and "Jean." At first she is pleased to meet Kyle, the father. When Gene walks in a few moments later holding the baby, however, Kelly and the viewer are surprised to discover that the couple is gay—a narrative twist that depends upon the presumption that Kyle is straight (figures 20–23). The discovery bothers Kelly, who questions the suitability of gay parents. By the end of the episode, however, Kelly comes to recognize that Kyle and Gene can be good parents, too. In so many of the era's gay-themed dramas and sitcoms, characters learn the same liberal lesson—not only is it hard to tell gays and straights apart, but when it comes down to what really matters, we all share the same humanity.

Like so many wider discourses about homosexuality at the time, then, prime-time network television circulated confusing messages about gay people. Gay characters and themes often reinforced the confounding contradictions at play beneath the era's multicultural liberalism. Through various manipulations of narrative, shot selections, casting, and acting styles, some shows worked to reinforce the assumption that gays and lesbians were identifiably different than straights, while others worked to reinforce the assumption that they were essentially the same. Few shows seemed able to reconcile gay difference with a shared humanity. According to Walters, however, "*Roseanne* has done what is seemingly simple but has proved to be close to impossible: to depict lesbians and gays as both same and different, as being part of both the dominant culture in which they emerged as well as the more marginalized culture which they inhabit by virtue of being gay."[106] The bulk of gay-themed programming, though, stubbornly reflected the perceived paradox of gay civil rights politics—the apparent conflict between the demand for equality and the simultaneous assertion of difference. In this regard, prime time's gay characters helped fuel Straight America's anxieties over the boundaries between straight and gay, the center and the margins, and right and wrong. Although—as other

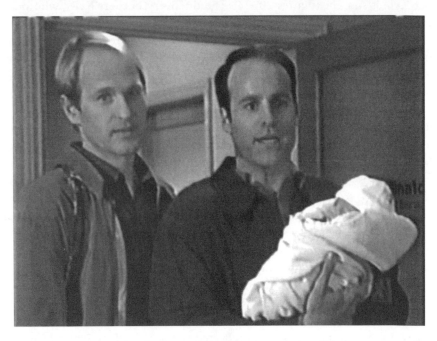

20, 21, 22, 23. [20, 21] Kelly doesn't have a problem with a father she assumes is straight until his partner enters the picture. [22, 23] Kelly gets concerned. Meanwhile, Brandon is surprised to find out he's dating a woman who isn't sure two gay men should be raising a baby. "The Nature of Nurture," *Beverly Hills, 90210*, originally aired March 18, 1998 (© Spelling Television, Inc., 1998).

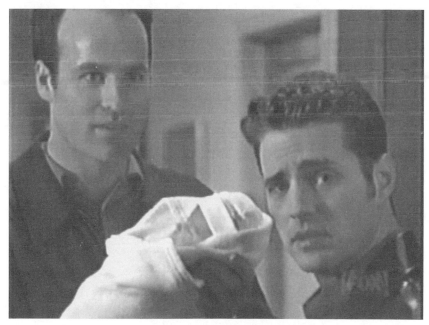

critics demonstrate—much more could be said about the circumscribed images of gay life offered on 1990s network television, I'd argue that gay-themed programming was (and still is) mostly about heterosexuality. After all, many of the era's gay-themed episodes didn't include a single gay or lesbian character. In the next chapter we will look more closely at what gay-themed programming had to say about straight panic and the negotiation of hetero-sexual identity in the 1990s.

CHAPTER 6

"We're Not Gay!"

HETEROSEXUALITY AND GAY-THEMED PROGRAMMING

We're not gay! Not that there's anything wrong with that.
—Jerry Seinfeld

JERRY SEINFELD AND GEORGE CONSTANZA were anxious to set the record straight on the February 11, 1993, episode of the hit NBC sit-com *Seinfeld*. Entitled "The Outing," the episode places sexuality—both homo and hetero—front and center in a plot structured around a 1990s twist on the age-old comedy convention of mistaken identity—in this case mistaken sexual identity. The trouble for Jerry and George starts when they sit down for lunch with gal pal Elaine Benes. As the gang blathers on about nothing, Elaine spies a woman at the next table eavesdropping on their conversation. Looking to spice up her day, she decides to give the woman an earful and motions to the guys to play along. "Just because you two are homo-sexual, so what?" she exhorts loudly, "I mean, you should just come out of the closet and be openly gay already." So the plot is set in motion. In typical sit-com fashion, coincidence and confusion ensue when the eavesdropper later shows up at Jerry's apartment to interview him for a newspaper profile. When her subsequent article reports that Jerry is gay and George is his longtime companion, the news spreads like wildfire. For the rest of the episode, the pair frantically attempts to reclaim their heterosexuality all the while trying not to appear homophobic. After all, Jerry explains, although he may not be gay, he definitely has "many gay friends" and firmly believes that being gay "is fine, if that's who you are." In fact, by the end of the episode, everyone from Kramer to Jerry's mom makes sure to temper their obvious shock and distress about the gay thing with a "not-that-there's-anything-wrong-with-that" tag line that comes to serve as the episode's mantra of straight, gay-friendly political correctness.

Like "The Outing," much of the era's gay-themed programming was as preoccupied with heterosexual anxiety and straight panic as with homo-sexuality. Confronted with gay characters, caught up in queer plot twists, and

surrounded by references to homosexuality, many of prime time's hetero-sexuals suddenly found themselves in narratives about the evils of homo-phobia and the hipness of homosexuals. As Jerry and George discovered, however, it wasn't always simple being straight in a world where being gay wasn't necessarily bad. In the 1990s, I argue, Straight America's anxieties about heterosexuality and the shifting boundary between gay and straight were often negotiated on prime-time television—and likely reflected the specific anxieties and ambivalence of those viewers to whom most gay material was targeted. Gay-themed programming consistently offered up narratives about gay-friendly heterosexuals adapting to an increasingly gay-inclusive world. In this chapter, I analyze some of most revealing of these narratives. After having studied eighty-five sitcom and drama episodes with gay material between 1992 and 1999, I have identified three common tropes: The Hip Hetero-sexual, The Helpful Heterosexual, and The Homosexual Heterosexual. While neither exhaustive nor entirely discrete, these three categories do reveal dif-ferent ways in which prime-time television expressed and sometimes tried to resolve America's growing straight panic.[1] Since most of prime time's gay material was used to target an audience of socially liberal, upscale, well-educated, mainly straight, white adults, it's not surprising to discover that many gay-themed narratives negotiated what it meant to be gay-friendly and straight in the 1990s.

THE HELPFUL HETEROSEXUAL

On the March 15, 1995, episode of *Party of Five* entitled "Ides of March," Ross Werkman is overjoyed when the adoption agency tells him that his dream of being a parent is about to come true. He rushes to the hospital to see the baby girl that will soon be his. He also rushes to tell Claudia, his pre-teen violin student, and her brothers and sister, who seem to be among his only friends. Ross's happy future comes into question a few days later, how-ever, when he tells the adoption agent that he's gay. Suddenly, unexpected problems arise, and the adoption is put on hold. Upset, Ross talks with Claudia about his fear of losing the daughter he has already come to love. As the camera pulls back, we see that Claudia's older brother Bailey is eaves-dropping on their conversation. Bailey knows the pain of such loss. His girl-friend had died from an apparent drug overdose just a few days earlier. Moved by Ross's plight, Bailey tracks the adoption agent down and tries to convince her to let Ross have the child. "He really loves this baby, so how can you say that that isn't good enough?" he asks her as tears well up in his eyes, his own grief fueling his plea. "How does being gay matter at all? I mean if someone is actually willing to love someone else. That isn't so easy to do. Its hard, and it doesn't happen that often, so. . . ." The fate of the adoption is left hanging until the end of the episode when we see Ross holding his new baby girl,

surrounded by the Salinger family. When Bailey walks up, Ross turns to him, and with heartfelt gratitude, says "Thank you."

As with Ross and his daughter, the narrative fate of many gay characters depended on the action of straight people, making what I call the helpful heterosexual a common trope in 1990s gay-themed programming. At a time when America's social center *seemed* to be eroding under the pressures of the nation's deepening diversity—when Straight America *seemed* to be pushed aside by angry queer activists, sassy drag queens, affluent gay couples, and a gay-chic sensibility—such gay-themed television programs offered stories where gay-friendly heterosexuals remained firmly in the center. In chapter 5, I referred to this episode of *Party of Five* to illustrate how the conventions of episodic series subordinated the emotions and perspectives of recurring gay characters. One noticeable outcome of that dynamic was the trope of the helpful heterosexual. *Party of Five*'s use of Bailey to resolve Ross's dilemma was predictable for an episodic melodrama focused on the Salinger family. It was certainly more narratively economical than having Ross turn to gay friends or a gay advocacy organization. Bailey's support for Ross simultaneously advanced the episode's A-plot about Bailey's grief. (It was likely cheaper as well, since it didn't require extra casting). The narrative, however, doesn't simply imply that Bailey's emotions are more important. It also grants him an agency that Ross doesn't have, enabling him to be the helpful heterosexual and leaving Ross with nothing to do but say "Thank you."

Like the liberal concept of tolerance, the trope of the helpful heterosexual offers a reassuring image of an empowered gay-friendly heterosexuality. The notion of tolerance reaffirms heterosexual privilege by positioning heterosexuals as agents and gays and lesbians as passive recipients of their largesse. Straights tolerate; gays are tolerated. Like tolerant straight people who shore up their social centrality in the face of multicultural difference by tolerating it, straight characters like Bailey confirm their dominance by ensuring the safety and happiness of the gays and lesbians around them. So on *ER*, Dr. Mark Green breaks the law in order to save a gay teen hustler from the dangers of juvenile hall, slipping the kid out the back door with medicine and $50. And on *NYPD Blue*, Detective Bobby Simone, like a heterosexual big brother, warns two homophobic cops to stop harassing John (the precinct's gay receptionist) and his boyfriend (a closeted cop who works with the homophobes). "You better understand me here," he says menacingly. "I know you did this. Anything more happens to this cop Caputo or his friend, I'm going to come looking for you."[2]

On a gay-themed episode of *The Commish* ("Keeping Secrets," January 22, 1994), suburban police commissioner Tony Scali not only captures a gang of serial gay-bashers, but also helps Hank, a gay cop on his force, come out of the closet. Early in the gay-bashing investigation, Hank tells Tony that he saw the

suspects flee the scene because he had been at a nearby gay bar. Tony urges him to file a report, but Hank is afraid it will ruin his career when the other cops discover he's gay. Tony, however, assures him, "I can't control what they think, but I can control what they do. And I will." Inevitably, Hank's fears are realized when most of the cops, including his partner, turn against him. At the narrative's nadir, Hank accuses his partner of intentionally letting the gay-bashers get away, and the once-close friends start to fight. Tony, however, literally gets between them. As other cops pull them apart, Tony stands in the middle. The scene ends with a high-angle crane shot that pulls away, visually underscoring Tony's narrative centrality and signaling that Tony is the one who must resolve the conflict (figure 24). For the rest of the episode, Tony divides his energy between solving the case and helping a newly outed Hank integrate into the squad. When Hank becomes a victim of the gay bashers, the plotlines merge, and Tony tries to resolve both by forcing Hank's partner to go undercover as a gay man in order to expose the suspects and teach him a lesson about tolerance. His plan works perfectly. In the episode's final scene, Hank and his partner reconcile, and the episode's closing shot is a close-up of a smiling Tony who realizes he has accomplished his mission (figure 25). The narrative, however, not only gives Tony the power to make things better for Hank, it also gives the straight white man the responsibility and ability to help his squad cope with diversity.

In a number of instances, the straight character who plays just such a pivotal narrative role is actually the person one would least expect to help. On an episode of *Beverly Hills, 90210* ("The Nature of Nurture," March 18, 1998), for example, Kelly surprises her gay-friendly boyfriend Brandon by questioning whether two gay men would be suitable parents for the baby she had rescued from a doorstep (figures 20–23). In fact, Kelly is partially responsible when the gay couple loses the chance at having their family because the baby's homophobic birth mother comes forward to reclaim her child. By the end of the episode, however, Kelly realizes that two gay men can be great parents and convinces the mother to let them adopt the baby. As with *Party of Five*, the episode ends with the gay characters thanking the helpful heterosexual who made their family possible.

Two of the era's most prominent same-sex wedding episodes followed a similar pattern. The night before Ron and Erick's wedding on *Northern Exposure* ("I Feel the Earth Move," May 2, 1994), Erick, like seemingly every other television groom, gets cold feet. Somewhat surprisingly, Erick decides to go to Maurice's for a place to hide out. Although Maurice is Ron and Erick's friend, he has made it perfectly clear that he doesn't approve of a same-sex wedding and, in fact, is the only citizen of Cicely not planning to attend the ceremony. During their conversation, however, Maurice helps Erick realize that he loves Ron and does want to marry him. In the process, Maurice convinces himself that he should attend the wedding. The same scenario occurs

24, 25. Tony gets in the center of the action when he has to keep peace in his police force. The last shot of the episode shows Tony pleased with a job well done. "Keeping Secrets," *The Commish*, originally aired January 22, 1994 (© a.k.a. Productions, Inc., 1993).

on *Friends* ("The One with the Lesbian Wedding," January 18, 1996). Monica, Chandler, Joey, Rachel, and Phoebe are excited to go to Susan and Carol's wedding (and in fact, they all spend the night making appetizers for the reception). Ross, on the other hand, is uncomfortable with the idea of attending his ex-wife's lesbian wedding and refuses to go. When Susan and Carol argue the night before their wedding, Susan rushes to Ross for advice. Despite his earlier misgivings, Ross plays the helpful heterosexual, convincing her not to let anything get in the way of her and Carol's love for each other. Not only does Ross save the wedding, he also attends and actually marches Susan down the aisle. The fact that these gay characters either turn to or are dependent upon otherwise unsympathetic straight people reinforces how often gay characters serve as conduits for heterosexual character development. In each of these examples, the helpful heterosexual gets to grow through the process of helping their fellow gay characters.[3] At the same time, the narrative reaffirms their sense of self-importance by underscoring the influence they wield.

In this regard, the trope of the helpful heterosexual offers reassuring narratives for those viewers who may have felt unsure about their social positions at a time when the relationship between the majority and its minorities seemed uncertain. As members of previously ex-nominated social majorities found themselves in a culture where social identities and difference mattered, such programs reaffirmed heterosexuals' agency and centrality. That that agency was used in the service of an oppressed minority was all the better for those viewers looking to reconcile their social privilege with their politically correct sensibility.

THE HIP HETEROSEXUAL

On the October 26, 1998, episode of *Suddenly Susan* ("A Funny Thing Happened on the Way to Susan's Party"), Susan's young-at-heart grandmother Nana makes Pete her project for Halloween. Although he's the series' only openly gay continuing character, Pete doesn't fit the stereotype of the trendy gay man at all. He's low-key, always wears flannel shirts, and couldn't be less sassy if he tried. When Nana discovers that Pete plans to go to Susan's Halloween party as a shoe salesman, complete with shoehorn and footsizer, she is dismayed (fig. 26). "Pete, this is Halloween," she tells him. "You of all people should let loose and fly. Be fabulous! Be exciting." To help him out, she takes him shopping. Later, we see the results when Nana stops the party to announce Pete's arrival: "Attention, presenting the new, improved Pete Mulligan Fontaine!" (fig. 27). With Nana beaming like a proud parent, Pete walks in dressed as a six-foot-two Liza Minnelli. His feather boa and high-heeled shoes, however, aren't enough. "I look fabulous, but I don't feel fabulous," he admits. "I feel stupid." Again Nana coaches him: "You're dressed like a diva! Act like one!" He takes her advice, and when the host asks if he'd like a caramel apple, he replies, in his sassiest voice, "Honey, if I want something sweet, I'll nibble on that hunk by the door" (fig. 28). Success at last. "That's my boy!" Nana exclaims.

26, 27, 28. Nana takes Pete, the nerdishly un-gay gay mail-room worker, under her wing on Halloween when she finds out he plans to go to Susan's party as a shoe salesman. "A Funny Thing Happened on the Way to Susan's Party," *Suddenly Susan*, originally aired October 26, 1998 (© Warner Bros. Television, 1998).

Pete's gay makeover by Susan's gray-haired grandma is perhaps the most extreme example of another common trope in gay-themed programming: the hip heterosexual. If the helpful heterosexual reaffirmed heterosexuality's social primacy by showing straight characters acting on behalf of gays, the trope of the hip heterosexual recuperated heterosexuality from banality by showing straight characters being cool with homosexuality. In chapter 4, I argued that, in certain circles, supporting gays and lesbians could establish one's hip credibility. With their transgressive sexuality, supposedly edgy sensibility, and minority-of-the-moment status, gays and lesbians had a certain marginal allure for those looking to distance themselves from a blandly in-the-center heterosexual identity. Having gay friends became a symbol of being cool— evidence that although you may be straight, you were definitely not narrow.

In line with this cultural logic, many of the gay characters on network television worked to establish the hipness of the regular straight characters simply by the virtue of their presence. On UPN's short-lived sitcom *Party Girl*, for example, the lead character's credibility as a cutting-edge New York trendsetter is partly established by the fact that her best friend is an openly gay fashion photographer. The cast of *Daddy's Girl* laughs at Harvey Fierstein's sarcastic barbs, Jerry Seinfeld has coffee with a gay wigmaster, the heroic doctors of *ER* don't bat an eye when a patient's gay lover comes in, and the entire town of Cicely attends Ron and Erick's commitment ceremony on *Northern Exposure*. Meanwhile some narratives pushed the trope further. On *Suddenly Susan*, Nana's so hip that she actually knows how to be a better gay man than the gay man. Similarly, on *Veronica's Closet*, everyone on the staff but Josh knows that Josh is gay. Not only are they all right with his sexuality, they repeatedly encourage him to come out, because, as Veronica herself tells him, "We just want you to be happy."[4]

In many cases, a heterosexual character's hip credibility is established by juxtaposing their gay-savvy-ness to someone else's lack of it. When Nancy introduces her girlfriend Marla (Morgan Fairchild) to Roseanne, Jackie, and their out-of-the-loop mother Bev, Roseanne scores hipness points at Bev's expense. Bev immediately recognizes Marla from the department store makeup counter. When Nancy admits that that's where she and Marla met, Roseanne chimes in, with a knowing look, "Yeah, but Nancy got the free gift," leaving a noticeably confused Bev to ask why she hadn't gotten a gift.[5] For both Roseanne and the audience, the humor comes from being in the know when Bev's so clearly out of it. Similarly, a running joke on the lesbian-wedding episode of *Friends* involves Rachel's mother (Marlo Thomas), who visits her daughter in Manhattan to tell her that she wants to leave her bland, suburban life and husband. Her naïve fascination with signifiers of urban hipness (e.g., the gang's trendy coffee shop, the naked next-door neighbor, the prospect of smoking pot) culminates in her reaction to the lesbian wedding

where she seems almost giddy over the prospect of flirting with women. Mrs. Green's isn't-this-all-strange-and-exciting attitude to the situation underscores the fact that Rachel and her twentysomething friends are taking the lesbian wedding in stride, like truly hip heterosexuals would.

The trope also appeared in dramas, although it was predictably framed quite differently than in sitcoms. On an episode of *Law & Order* ("Manhood, May 12, 1993), for example, a gay police officer is killed on the street when homophobic cops fail to back him up. Throughout the investigation and subsequent trial, the narrative puts the series' main protagonists and, by extension, the audience in the progay minority. The episode opens in the police dispatch center where we hear the gay cop's frantic call for help, the shots, and the silence that signals his death, encouraging the viewer to sympathize with the gay victim. When Detectives Logan and Brisco investigate the backup officers who they suspect purposefully left their gay partner hanging, they run into widespread resistance and homophobia in the police force. "Every cop in the city's against you," one precinct captain tells them. Eventually, the district attorney puts the homophobic cops on trial for second-degree murder. The defense suggests that hatred of gays is the norm, telling the jury that it would be wrong "to find these men guilty for upholding the very values of the society that they've sworn to protect." "Are their values really so different than your own?" he asks the jury. The narrative encourages the viewer to be incredulous, like series regulars Assistant D.A. Stone and D.A. Schiff are shown to be. The jury, however, finds the defendants not guilty in a verdict that clearly shocks Stone and Schiff and is intended to surprise the viewer. In the episode's powerful closing scene, the district attorneys discuss the verdict. "They used to ask, 'How could a man put a sheet on his head and lynch somebody,'" Schiff says. "Usually he can't, by himself, but when there's more than one. . . ." Stone: "Four cops let him die." Schiff: "And twelve citizens did it again." Stone: "And they voted their indifference." The unjust verdict and the analogy to the Klu Klux Klan reinforce that Stone and Schiff are members of an enlightened minority and encourages viewers to identify with their indignation.

While gay material often established a straight character as hip, *Roseanne's* "Don't Ask, Don't Tell" episode provides a sly critique of this trope (as well as the cultural politics of gay chic that supports it) by exposing the limits of Roseanne's hipness. From the beginning, the episode places Roseanne's cool quotient front and center when Nancy admits that she didn't invite Roseanne to a lesbian bar because she thought it might freak Roseanne out. Insulted, Roseanne forces Nancy to take her. The first act focuses on Roseanne and Jackie's visit to Lips. While Jackie is predictably nervous about being there, lest someone mistake her for being a lesbian, Roseanne seems to fit right in. She pretends she's Jackie's girlfriend, flirts with the bartender, and teaches

everyone to dance. "Can you believe Nancy doesn't think I'm cool enough for this place," Roseanne complains to Sharon, Nancy's girlfriend, when they pause for a drink. Sharon seems to think Roseanne is definitely cool enough and kisses her. The scene, however, ends with a close up of Roseanne's surprised and uneasy reaction (fig. 10).

In the second act we learn that the kiss had, in fact, bothered Roseanne. At work the next day, she repeatedly tries to deny it upset her, but Nancy (and the viewer) clearly sees through her bluff and accuses Roseanne of freaking out just like she predicted she would. The subsequent exchange exposes Roseanne's desperate desire and ultimate failure to be cool by being cool with homosexuality.

ROSEANNE: I'm not freaking out. Why would I freak out?

NANCY: Well, you know, maybe, maybe you liked the kiss just a little?

ROSEANNE: [taken aback] What? That is the most ridic . . . What? [audience laughter]

NANCY: Well, it's not that unusual. I mean . . . sexuality isn't all black and white. There's a whole gray area.

ROSEANNE: I know about the gray area. [audience laughter]

NANCY: And you're afraid that just one little tiny percent of you might have been turned on by a woman.

ROSEANNE: [pause, odd expression on her face] [audience laughter] That is the most ridiculous thing that I've ever heard. I'm not afraid of any small percent of my gayness inside. . . . You know what I mean . . . I . . . I am ah I am totally okay about whether I'm like 3 percent or 4 percent or lower.

NANCY: This is exactly why I didn't want to invite you in the first place Roseanne, because you are a total hypocrite.

ROSEANNE: [getting angry] I am not a hypocrite. A hypocrite doesn't go and teach forty gay people how to do the monkey.

NANCY: Oh, and we're supposed to admire you because you went to a gay bar. I'm supposed to think you're cool because you have gay friends.

ROSEANNE: I don't care if you think I'm cool at all, because I know that I am cool, baby. I'm probably the coolest chick you've met. And for your information, I have friends that are way gayer than you.

Roseanne eventually admits that she might not be as comfortable with the idea of homosexuality as she thought or as hip as she likes to think she is and apologizes to Nancy, but adds, "I'm still pretty cool, ya know, for a forty-one-year-old mother of three that lives in Lanford, Illinois. I like that Snoopy Dog Dog."

By mocking Roseanne's sense of herself as a hip heterosexual, this exchange exposes the hypocrisy beneath the cultural politics of gay chic. As Nancy points out, Roseanne may feel she's cool because she hangs with gay

people, but when it comes down to it, she's not all that comfortable with homosexuality. For the hip heterosexual, of course, homosexuality's trangressiveness was part of its appeal—its what made being gay-friendly edgy. Most hip-heterosexual narratives, however, either conveniently suppressed discourses about homosexuality's deviancy or projected such feelings onto other characters (e.g., one's naïve mother, a homophobic jury). In doing so, they offered up images of a relatively straightforward path to a hip-heterosexual identity. "Don't Ask, Don't Tell," on the other hand, acknowledged that Roseanne's feelings about homosexuality are far more ambivalent than she'd like to admit, implying that the hip heterosexual may not be all that hip after all. In this regard, "Don't Ask, Don't Tell" resembles *Seinfeld*'s "The Outing" and the trope of the homosexual heterosexual.

THE HOMOSEXUAL HETEROSEXUAL

FRASIER: Don't take this the wrong way, but it never even occurred to me that you might be gay.

TOM: Wow, it never even occurred to me that you might be straight.

FRASIER: [awkwardly] Thank you.

When Frasier meets his new boss Tom, he's intrigued ("The Matchmaker," October 10, 1994). By asking seemingly casual questions, he discovers that Tom loves the theater, appreciates well-tailored clothing, just moved back from London, has "a soft spot" for people who are "a bit eccentric," and is recovering from "a bad break-up." Frasier thinks he'd be the perfect date—for Daphne. Playing the secret matchmaker, he invites Tom over for dinner that evening. What Frasier doesn't know, but the viewer soon discovers, is that Tom is gay. Needless to say, confusion and hilarity ensue when Tom shows up for dinner assuming he's on a date with Frasier. Frasier works hard to connect Tom and Daphne. Daphne does her best to impress Tom. Tom thinks Frasier's dad Martin is hitting on him. And when Niles shows up and tries to get between Tom and Daphne, things get even more farcical as just about every comment becomes an opportunity for comedic misunderstanding. Eventually, the wires get uncrossed. Niles and Martin learn that Tom is gay, and (presumably like the viewer) they both find tremendous amusement in watching Frasier on his gay date. On his way out, Niles finally pulls Frasier into the hall to tell him that Tom is interested in him, not Daphne. Frasier returns to find Tom alone, sitting on the couch with a blatantly seductive look on his face (fig. 29). "So," he says expectantly. Clearly unsettled by this turn of events, Frasier paces anxiously. "You're cute when you're nervous," Tom tells him. "Well, I must be downright adorable now," Frasier replies with a nervous laugh. Frasier finally gathers the courage to be straight with Tom. "The truth is I'm entirely straight," he admits. The tension immediately subsides as the

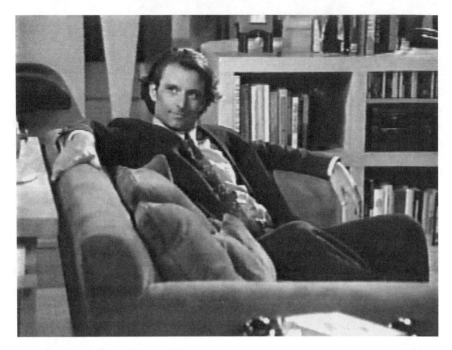

29. Frasier is met with a highly seductive look from the man he thought was interested in Daphne. "The Matchmaker," *Frasier*, originally aired October 4, 1994 (© Paramount Pictures, 1994).

two admit that it never occurred to them that they weren't on the same sexual page. Frasier's gay date ends as he shows Tom to the door, apologizing profusely for leading him on.

Frasier was not the only ostensibly straight character to be mistaken as a gay man on 1990s television—far from it. The mistaken sexual identity plot, in fact, became a formula for prime-time sitcoms, and such episodes form the basis of what I call the trope of the homosexual heterosexual. Of the eighty-five gay-themed episodes I studied, thirty-five included this trope as a major story element. On *The Single Guy*, two straight men become friends at a gay couples' dinner party. Misreading certain signs, each assumes the other is gay and interested in him. On *Caroline in the City*, Richard gets entered in a gay art show. On *The Drew Carey Show*, Oswald is surprised to find out that the coworker he thinks is just his new best friend is actually his boyfriend. *Hudson Street*, *The Secret Lives of Men*, *Third Rock From the Sun*, *Getting Personal*, *Holding the Baby*, *Ned and Stacey*, *Spin City*, *Wings*, and *For Your Love* are only some of the sitcoms that incorporated some variation of the homosexual heterosexual.

It is in these comedic narratives that America's straight panic became most visible. It's where its anxieties about homosexuality, heterosexuality, and the boundary between them were most clearly exposed and negotiated. As detailed in chapter 2, civil rights debates and increased gay cultural visibility made the distinctions between being gay and being straight more important and more paradoxical than ever before. On the one hand, gays and straights seemed like members of separate tribes. They were often subject to different laws and lived in different enclaves. Gays had their own parades, bars, and sensibilities, and some scientists found evidence suggesting that they had different DNA. On the other hand, no scientists could offer a definitive answer to how or when sexual identity is formed, leading some to believe that anyone could become gay (or straight). Activists argued that gays and straights were all just people and challenged the moral and legal lines that separated them. And many gays and lesbians looked just like straight people—their difference often impossible to detect. Straight Americans were increasingly forced to think about their own sexual identity amid this confusing discursive context. Once oblivious to its heterosexuality and naïve about the privileges that came with it, Straight America had to acknowledge both.

Most of these narratives focused on the mistaken sexual identities of ostensibly gay-friendly, straight men, a pattern that suggests that the trope of the homosexual heterosexual revealed the particular anxieties of liberal heterosexual masculinity.[6] This gender bias shouldn't be surprising, given the relationship between patriarchy and heteronormativity, between male privilege and straight privilege. Television narratives that channeled uncertainties stirred up by an increasingly visible gay minority, by discourses about multiculturalism and the nation's deepening diversity, and by the perception that the mainstream was losing its normative status would predictably center on straight (and usually white) male characters. After all, they were the ones least prepared to deal with a world where social difference was celebrated, where the line between the center and the margins was being undermined, and the moral distinctions between gay and straight were unclear. By eroding the definitional power of male homosexual panic, the weakening of cultural sanctions against homosexuality destabilized notions of normative heterosexual masculinity. As straight-panic narratives, then, the trope of the homosexual heterosexual focused on liberal straight men trying to figure out a way to assert their heterosexual masculinity in an era when gay men no longer served as their semiotic whipping boys.

Narratives about the homosexual heterosexual channeled the confusion and anxiety that such changes inevitably stirred up, especially for gay-friendly straight men. Like the straight college students on Jeans Day, many of prime time's heterosexuals suddenly found themselves in a carnivalesque world

where heterosexuality wasn't always the presumptive norm and the distinctions between gay and straight were loaded with meaning but impossible to pinpoint. Time after time, mistaken sexual identity plotlines and the trope of the homosexual heterosexual exposed the difficulty of navigating these new politics of sexual identity. Although such episodes often followed a certain narrative pattern, there were also numerous twists on the formula. Below I highlight the most notable conventions and a few telling variations in these episodes.

Crossed Wires

Since the trope of the homosexual heterosexual is always predicated upon mistaken identities, the narratives frequently include a moment when characters get their wires crossed. In such scenes, the jokes arise out of the mistaken assumptions characters make about each other's sexual identity. Frasier's gay dinner date, which takes up most of the second act, is perhaps the most elaborate and extended example. When the reporter interviews Jerry and George on Seinfeld's "The Outing," the humor arises out of the crossed-wire confusion between her questions ("How did you two meet?" "Do you live together?" "Do your parents know?") and their answers ("We met in gym class," "No, I have my own place," "My parents, they don't know what's going on"). Wings, Hudson Street, Working, and Holding the Baby included their own variations on this scene.

These comedic situations depend upon and, in the process, reinforce the notion that the distinctions between gay and straight are not easy to discern. For the jokes to work, viewers have to believe that the misunderstanding could really occur. To this end, stereotypical signifiers of gayness are often foregrounded only to be deconstructed. With their penchant for opera, fine sherry, and fussiness, Frasier and Niles made Tom's mistake understandable. Conversely, from Frasier's perspective, Tom's love of opera was a sign of refinement, not gayness. The tortured premise of Ned & Stacey—a successful, fussy, heterosexual ad executive needs a sham wife and marries a hapless straight woman looking to move out of her parents' house—predictably led to a homosexual-heterosexual episode on which an openly gay client assumes Ned is gay and Stacey is his beard. When Ned asks why anyone would think he's gay, his friend replies, "Well, well, lets see. An impeccably dressed thirty-five-year-old man in an arranged marriage who loves to cook, who frets over a balcony full of plants, he's meticulously neat and has never ever had a long term relationship with any woman. . . . Hmm?" Chandler faces a similar problem on Friends when a woman at work tries to set him up with a guy, and he discovers that lots of people think he's gay. "So, what is it about me?" he asks. "You have a quality," Monica replies, to which everyone agrees. "Great, I was afraid you were going to be vague," Chandler jokes in frustration. Such

episodes often acknowledge gay stereotypes only to insist that they are inadequate tools for determining who's gay and who's straight—an increasingly pressing issue at a time when unprecedented gay cultural visibility forced Straight America to realize that gay people were all around them. The illegibility of sexual identity could be emphasized through casting and acting direction. Although as mentioned in chapter 5, some characters (e.g., Peter on *Ellen* and Jack on *Will & Grace*) signaled gayness through stereotypical behaviors, actors could be selected, dressed, and directed to play upon a wide range of preconceived notions about gay versus straight mannerisms, speech patterns, or other markers of difference.

While such moments may have tapped into viewers' anxieties over the blurred boundaries between being straight and being gay, they also offered the viewer a privileged position from which they could more easily engage with those anxieties. As is often true in comedy, the humor in these scenes was based on the viewer having more information than the clueless characters caught up in the misunderstandings—a narrative detail that helps distance the viewer from the situation while simultaneously making them more in-the-know than the characters on view. In several cases, the text accentuates this distance by including other characters who, like the viewer, know what's going on and laugh at the confusion. On *Frasier*, for example, Roz discovers Frasier and Tom have crossed their wires immediately and could easily straighten things out. When Frasier makes her mad, however, she purposefully allows the farce to play its course and takes pleasure in the trick she is playing. Later, when Niles and Martin figure out what's been going on, they both laugh hysterically at the awkward situation Frasier finds himself in. As so often the case, comedy enables one to recognize and then disavow through laughter.

The Heterosexual Coming-Out Moment

The central moment in many homosexual-heterosexual narratives occurs when the straight character finally figures out that he has been mistaken for being gay—a realization that generates tremendous anxiety and the need to assert his heterosexuality. After learning that Tom is gay and interested in him, Frasier instantly becomes a nervous wreck, and when Jerry and George figure out the reporter assumes they're a couple, they panic (fig. 30). On *Friends*, Joey and Chandler's attempt to use Ross's baby as a chick magnet fails when the woman they try to hit on assumes they are a gay couple with a child. The next time they strike up a conversation with two beautiful women and one of them asks what they're doing out, a hyper-sensitive Joey anxious responds, "We're not out. No, no, no. We're just two heterosexual guys hanging with the son of our other heterosexual friend doing the usual straight guy stuff."

Such reactions and their narrative functions are far from straightforward. On the one hand, they reveal a deep-seated discomfort with homosexuality.

30. Jerry and George insist that they're not gay or homophobic. "The Outing,"
Seinfeld, originally aired February 11, 1993 (© Castle Rock Entertainment, 1993).

JERRY: Oh God! You're that girl from the coffee shop that was eavesdropping on us.
 I knew you looked familiar!
GEORGE : Oh no! Oh no!
REPORTER: I'd better get going.
JERRY: There's been a big mistake here.
GEORGE : Yeah, Yeah.
JERRY: We did all that for your benefit. We knew you were eavesdropping. That's
 why my friend said all that. It was on purpose. We're not gay! Not that's
 there's anything wrong with that.
GEORGE : No, of course not.
JERRY: I mean its fine if that's who you are.
GEORGE : Absolutely!
JERRY: I mean I have many gay friends.
GEORGE: My father's gay.

Frasier's sudden unease with Tom invokes the homosexual-panic discourse,
including its assumptions about gay male sexual aggression, the vulnerability
of heterosexual masculinity, and justified antigay violence. Despite their insis-
tence to the contrary, Jerry and George are clearly not "fine" with homosex-
uality either, and Joey and Chandler are desperate not to lose sexual access to
these women. On the other hand, even as these narratives rehearse such
homophobic anxieties, laugh-track cues, shot selection, and parodic dialogue

frame these nervous responses as ridiculous. Before the reporter leaves, for example, George insists she have sex with him right then to prove his heterosexuality. After Joey's insistent assertion of their straightness, Chandler impatiently and with a great deal of embarrassment asks him "Are you done?" In line with other straight-panic discourses (e.g., the advice column that gave straight men tips on gay-friendly locker-room etiquette, the attention paid to straight soldiers' homophobia in the gays-in-the-military debate), such scenes both cite and critique the nervous heterosexual man.[7]

While such scenes may reveal and critique these straight characters' fears of homosexuality, they also reveal their anxious discomfort with appearing homophobic. Despite his obvious unease, Frasier carefully phrases his statement so as not to offend Tom and then awkwardly thanks him for assuming he was gay. Meanwhile Jerry and George seem almost as concerned with convincing the reporter that they're not bigots as they are in convincing her they're not gay. Such heterosexual-coming-out moments suggest that asserting one's heterosexuality wasn't simple at a time when being gay wasn't necessarily bad. Gay-friendly heterosexuals were caught in a semiotic catch-22. How do you disavow homosexuality without implying that there's something wrong with it? And how do you establish your heterosexuality without disavowing the homosexual Other? While Straight America was trying to reconcile difference and equality, these straight characters struggled to come out of the straight closet without doing so at gay people's expense.

Although Frasier, Jerry, and many other prime-time characters were troubled by the realization that their sexual identities could so easily be "read" wrong, I'd argue that they were also unsettled by the discovery that their sexualities had to be read at all. The fact that these straight characters were forced to come out of a straight closet suggested that heterosexuality's ex-nominated privilege was in doubt. Such narratives offered viewers a peak at a culture where heterosexuality isn't the presumptive norm, where straight people had to think about being straight, and where the relationship between the center and its margins (the normal and the abnormal) could no longer be taken for granted. As far as these straight characters were concerned, such a thought seemed to engender a discomforting mix of lost naïveté, paranoia, and defensiveness —much as Jeans Day did for many of my straight classmates.

Gay Minstrelsy

Another common twist on the mistaken-sexual-identity narrative involved straight characters who pretend to be gay. In most cases, such plots start with the standard moment of mistaken identity. Rather than immediately asserting their heterosexuality, however, these homosexual heterosexuals decide to stay in the straight closet when they realize that doing so will be to their advantage. On *Ned & Stacey*, when a gay client misinterprets Ned's sham

marriage, Ned tries to come out to him as straight. The client, however, does-
n't believe Ned's story and refuses to work with someone who is closeted. To
save the account, Ned pretends that he and his brother-in-law are secretly in
love. On *The Naked Truth*, Dave and Nicky pretend to be gay to score basket-
ball tickets from their misinformed boss. On *Caroline in the City*, when Del
and Charlie's insurance agent mistakenly assumes they are life partners not
business partners, they pretend to be a gay couple for the cheap insurance. On
The Drew Carey Show, Drew and Oswald pretend to be gay in order to cover
up the fact that Drew tried to use his company's same-sex health benefits to
cover his dog's surgery.[8]

On the one hand, such narratives negotiate discourses about straight,
white male resentment over the idea that they were excluded from or even
disadvantaged by multiculturalism's celebration of diversity. By exploiting the
indeterminate signifiers of gayness for their own profit, these straight charac-
ters corrupt the logic of affirmative action and reverse the politics of the
closet. Most episodes, however, also undercut such discourses. On an episode
of *Caroline in the City* ("Caroline and the Gay Art Show," October 5, 1995),
for example, Richard's painting mistakenly gets included in a gallery that
exclusively sells work by gay male artists. When he discovers that the owner
believes he's gay, Richard announces that he has to drop out of the show, Car-
oline, however, tries to talk him out of it, suggesting, "maybe you being
straight can be our little secret." Richard's reply simultaneously references and
satirizes white male resentment: "Look, Caroline, I'm not ashamed of being
straight. In this day and age I should be able to walk into that gallery with a
woman on my arm and not feel like I'm being stared at and gawked at like
some sideshow freak."

When he discovers that his painting might fetch $20,000, however,
Richard stays in the closet and pretends to be gay. In doing so, he and other
homosexual heterosexuals regain control over how people read their sexual
identity. In many such narratives, the straight characters consciously perform
gayness by excessively citing gay stereotypes. When Charlie and Dell show up
at their gay insurance agent's party, for example, they wear white t-shirts and
tight jeans with bandannas in their back pockets (fig. 31). Ned and his
brother-in-law giggle like girls and say things like "You're terrible!" While
narratives, acting styles, and laugh tracks almost always encourage viewers to
read these excessive stereotypes ironically, such gay minstrelsy works to recu-
perate these characters' heterosexuality by distancing them from the gayness
they can consciously put on and take off. Unlike so many homosexual het-
erosexuals, Richard doesn't "stoop" to gay stereotypes. His heterosexuality,
however, is drawn into graphic relief by the presence of a "real" gay artist who
performs excessive gay stereotypes and complains "I just have no idea what to
do for Liza Minnelli's birthday."

31, 32. (top) Del and Charlie dress up as gay men to go to a gay party, but they end up standing out in the crowd anyway. "Caroline & the Little White Lies," *Caroline in the City*, originally aired April 6, 1998 (© CBS Worldwide Inc, 1998). (bottom) Ross tries to ask Jonathan whether his friend is gay without coming right out and asking. "Neighbors," *The Single Guy*, November 1, 1995 (© Castle Rock Entertainment and The National Broadcasting Company, 1995).

Invariably, the straight men's performances of gayness go beyond their comfort level, forcing them to come out of the closet. Their discomfort, however, usually arises not from a distaste for homosexuality. Predictably, such episodes do include jokes about the straight man's unease with performing gayness. In episodes where two straight characters pretend to be a gay couple, for example, one always pushes the other's same-sex comfort limits for laughs. In just about every case, though, those homosexual-panic anxieties quickly subside and the straight characters easily fall into their gay roles. In some episodes, the straight man is outed by his overpowering desire to hook up with an "ideal" woman (who invariably shows up at just the most inopportune time for the homosexual heterosexual). That he can't fight his overpowering heterosexual desire, of course, further establishes his heterosexuality but does so through an often comically excessive sexual desire for a woman rather than through a rejection of gay men. In other episodes, straight characters' social conscience (i.e., their straight panic, not their homosexual panic) does them in. Richard's painting, for example, sells and his long dream of being a professional artist is about to come true. As in all episodic sitcoms, however, Richard's life can't change that dramatically. As Richard celebrates, the gallery owner tells him how happy he and the buyers, Bob and Bob, are to help young gay artists. Unable to bear the thought of betraying these gay men's sense of community, Richard admits that he's not gay and loses his future. Similarly, Drew Carey, is just about to get away with his insurance scam, having convinced the board that he and Oswald are in fact a couple. When his boss suggests they pose for the company's upcoming gay outreach ad campaigns, however, Drew is forced to come out—not because he's afraid of everyone thinking he's gay but because he couldn't be "a role model" for a community he's not part of. In the end, Drew and Richard literally pay a price for being a gay-friendly heterosexual.

Some of the gay-minstrel narratives seem to offer a solution to gay-friendly heterosexuals' catch-22. Richard and Drew, in particular, find ways to assert their heterosexuality with very little nervous homophobia. They come out not to disavow homosexuality or to fend off a gay man's sexual advances. Instead, they come out to ensure that they don't profit at the expense of gay people's dignity and trust. The fact that the misunderstandings at the heart of homosexual-heterosexual narratives are straightened out by the end of the episode—that all of the characters' real sexual identities are established—also works to resolve anxieties about the instability of sexual identity in general. Homosexual-heterosexual episodes, however, didn't always clear things up neatly.

The Homosexual in the Heterosexual

In a historical context where the politics of sexuality were more central than ever—where more and more gay people were asserting their gayness and

more and more straight people were recognizing their straightness—mistaken-sexual-identity narratives predictably exposed and negotiated anxieties about the boundary between homosexuality and heterosexuality. Most such narratives exploited and reinforced the increasingly common notion that it was difficult to read people's sexual identities. The system of signification that helped people recognize who was gay and who was straight seemed to be breaking down just at the moment it was most needed. The anxieties such narratives exposed were also fueled by and, in turn, fueled a more profound fear—namely that sexual identity itself might be as unstable as the system of social signification used to make sense of it. Compared to racial and sexual difference, sexual identity seemed particularly mutable, its etiology elusive. Although anxieties about the indeterminate nature of sexual identity lurked behind most mistaken-identity narratives, a few acknowledged them explicitly.

Episodes from two of the most successful sitcoms of the era each raised questions about the stability of sexual identity. On *Roseanne*, as we have already seen, Nancy suggests that Sharon's kiss bothered Roseanne so much because she might have actually liked it. "[S]exuality isn't all black and white," she states. "There's a whole gray area." Although Roseanne claims to be fine with "any small percentage of [her] gayness inside," her delivery reveals her real unease over the prospect that her sexual identity might not be all that stable. Although Roseanne repeatedly asserts that she's not gay, the narrative remains vague on just why the kiss bothered her, leaving open the possibility that while Roseanne might not be gay, she might not be entirely straight either. Meanwhile, when Frasier Crane has a sexual dream about Gil Chesterton, the radio station's nelly food critic, he desperately marshals all of his psychiatric expertise in an effort to find an interpretation that will secure his heterosexuality. When his first attempts fail, Frasier ponders the possibility of his latent homosexual desires. Much to his relief, he seems to eventually crack the case; bored with his work, his subconscious apparently created the dream as an intellectual challenge. Just when Frasier thinks his sexual identity is secure, however, his final dream (in which Sigmund Freud hops into bed with him) keeps Frasier's sexuality comically up in the air ("The Impossible Dream," October 15, 1996).

Perhaps the most striking example, however, was an episode of *The John Laroquette Show*. The series focused on John, a notorious womanizer and recovering alcoholic who managed a seedy bus station. In "The Past Comes Back" (October 26, 1993), an old male drinking buddy visits to make amends to John for having seduced him one booze-filled night. Although John doesn't remember the incident, he admits he doesn't remember a lot from those days. For the bulk of the episode, John is forced to reconsider his sexual identity. He has a same-sex dream, attends a gay Alcoholics Anonymous meeting, and asks the local hooker for her insight. Couching the situation as a friend's problem, John tells her: "You know, it's not that my friend minds so much if

he's a homosexual. I guess if that's what he is that's what he is. Its just what if he has this whole other life that he doesn't know anything about." Eventually, John comes to terms with his past and decides that he's not gay, even if he did have sex with a man that one drunken night. John's sexual identity seems to be confirmed when his old friend returns to tell him he made a mistake. He ran into a third guy who had been drinking with them that night and who told him that although all three of them went to the hotel room, John passed out as soon as they got there. John is relieved to hear that. Just when his heterosexuality seems secure, however, his old friend tells him that although he didn't have gay sex, he did wake up and watch them. The news doesn't bother John, though, who walks out of his office whistling "The Trolley Song" and tells everyone "I got some great news. I'm not gay. I'm just curious."

"It shouldn't matter, but it does"

The trope of the homosexual heterosexual wasn't limited to sitcoms. On an episode of *Homicide: Life On the Street* ("Hate Crime," November 17, 1995), for example, the case of an antigay hate crime takes an unexpected turn when the detectives discover the victim might have been straight. At the start of the episode, detectives Tim Bayliss and Frank Pembleton investigate the murder of a man outside a gay bar and assume he was gay. Although the victim's father claims his son Zeke "wasn't queer," the detectives point out the facts: "Your son was killed outside a homosexual bar in a predominately homosexual neighborhood." They clearly believe the intensely homophobic father is in denial. The evidence very quickly leads to the arrest of two skinheads who had bragged about killing the "fag," and only half way through the episode, the case seems closed. At that point, however, a new line of investigation begins when Zeke's friends try to convince the cops their friend was straight. "Ultimately, it doesn't matter," Frank tells them. "It does to us," one of them replies, and urges them to talk to Zeke's fiancé. For the rest of the episode, Frank and Tim focus on determining Zeke's sexual identity. Only after talking to Zeke's fiancé and a lesbian friend of Zeke's mother (both of whom testify to Zeke's hetero-sexuality), do Frank and Tim change their presumption about Zeke's identity.

At the end of the episode, Tim and Frank discuss the case, trying to make sense of the straight man's gay-bashing death:

TIM: Look, a guy's, you know, he's just walking down the street, you know. Two other guys assume that he's gay and they beat and stab him to death. It makes no sense.

FRANK: Well Tim, if you, Tim Bayliss, were walking along Park and Read, not dressed like a cop as you are but let's say in that black leather jacket you sometimes fancy. You got a new haircut . . . I'm coming along . . . I might assume the same thing.

TIM: [incredulously amused] Me?

FRANK: Yeah, and that pisses me off, cuz here I am, I'm living my entire life with strangers making assumptions about who I am and I broke the first rule of being a detective. I assumed Zeke Lafeld was homosexual.

TIM: Well, it's what people do. It's human nature, Frank.

FRANK: [sarcastically] Yeah, it's human nature to kill someone simply because their sexual orientation is different.

TIM: People get afraid. That's right.

FRANK: People? That's you and me—grown ups. Why is it that children don't care about such things.

TIM: As adults, we get socialized. We learn to behave.

FRANK: We learn to hate. . . . Hetero, homo. What does it matter . . . he's dead.

TIM: That's the worst part. It shouldn't matter, but it does.

Zeke's death "makes no sense" because it underscores the paradoxical fact that hetero-homo difference simultaneously matters and doesn't. That gay people are different—that they have different desires, go to different bars, and live in different neighborhoods—mattered to the murderers (who hated gays' difference enough to kill because of it). It mattered deeply to Zeke's homophobic father (who couldn't mourn his death until Frank returned and told him that his son was straight). It also mattered to Zeke's friends (who asked the detectives to prove he was straight). Frank suggests that it also mattered to Tim when, at one point during the investigation, he accused him of not caring as much about solving a gay man's death. On the other hand, Zeke's *actual* sexual orientation didn't matter to the murderers. And in the end, it didn't matter to Zeke; his heterosexuality couldn't protect him.

In other words, the distinctions between being gay and being straight became all the more important just when they became harder to pinpoint. While *Frasier, Seinfeld,* and numerous other sitcoms played the anxiety created by this paradox for nervous laughs, *Homicide* framed it as a matter of life and death. A story about a heterosexual man mistakenly murdered by gay-bashers offers a complex coming-out narrative for gay-friendly heterosexuality—one that frames the enlightened straight man as a victim.[9] Although Zeke was straight, his murder might not simply have been a case of being in the wrong place at the wrong time. During Tim and Frank's conversation with the lesbian family friend, we not only learn that Zeke hadn't shared his father's bigotry, but also that he had been at her jewelry store the night he was murdered (to buy a gift for his girlfriend). Although not explicit, the narrative intimates that Zeke's friendship with the woman explains why he was in "a homosexual neighborhood" the night of his death. The post-mortem police investigation into his sexual identity (rather than his murder) allows Zeke to establish his heterosexuality without ever disavowing the homosexual Other. In fact, it makes clear that he was both straight and gay-friendly. Although Zeke's death

again underscores the illegibility of signifiers of sexual identity and indicates that that illegibility can be particularly dangerous to gay-friendly heterosexuals, Zeke's narrative offers some reassurance that in the end his sexual identity was just misread, not unstable.[10] Finally, Zeke's death literalizes the liberal platitude that everyone's hurt by bigotry, and Frank's commentary reinforces the belief that too much difference and fragmentation are dangerous.

CONCLUSION

Much of the era's gay-themed programming was fundamentally about being straight in an era when increased gay visibility and gay rights battles highlighted and challenged heterosexuality's ex-nominated privilege. Since, as I've argued, most gay-themed programming was used to appeal to an audience of socially liberal, upscale, white heterosexuals who prided themselves on being gay-friendly, it is not surprising that gay material got narrativized in ways that likely resonated with the anxieties of certain viewers. Episodes about helpful and hip heterosexuals offered gay-friendly straight viewers ways to resolve their ambivalence regarding their own heterosexual privilege at a time when being different or marginal held a certain allure. Such narratives provided images of heterosexuals who go out of their way to help, hang with, and be like gay people. Meanwhile, episodes about homosexual heterosexuals offered viewers the opportunity to safely explore anxieties about the indeterminate and paradoxical boundary between gay and straight. It isn't surprising that most such narratives appeared in sitcoms. The fears stirred up by the shifting politics of sexual identity and social difference could more easily be experienced and then disavowed in a genre where jokes dissipate the very anxieties they exploit. On *Friends*, Chandler's discovery that everyone seems to think he has a gay "quality" likely might have tapped into straight men's fears about the legibility (and perhaps even stability) of their own sexual identities. Framed by jokes and laugh track cues, however, Chandler's concerns become humorous. In what was a standard twist in such situations, the narrative deflects Chandler's anxiety by indicating that his indignation over the sexual-identity misunderstanding is trumped when he discovers that his coworker thinks Brian (the office hottie) is out of Chandler's league. "I could get Brian," Chandler insists. "Believe you me. I'm really hot." While this response deflects Chandler's heterosexual anxiety, Chandler's vanity hints at the ambiguity of sexual desire. Simultaneously, it lets Chandler turn his anxiety into a form of gay-friendliness that, while laughable, proclaims "I want gays to be attracted to me."

I would also argue that much of the era's gay-themed programming reflected the ambivalence certain viewers likely felt about both multiculturalism and homosexuality. As I argued in chapter 4, aspirations to celebrate diversity could often coincide with fears about the loss of one's privilege, and

a sincere desire to support gays and lesbians could exist side-by-side with lingering prejudices. Difference and equality could be as difficult to reconcile for individual viewers as for the American political system. Gay-themed programming often reflected such ambivalence, mixing homophobic stereotypes with gay-affirmative narratives. On *The Single Guy*, for example, Jonathan thinks his gay neighbors are the greatest, counts them as his friends, and doesn't want to offend them by telling them he's actually straight. "I don't want to make a big deal about this because it's not," he tells them. "It's not a big deal, and this is not a judgment here. I just want you guys to know that I'm straight." Although a bit overcautious, Jonathan is sincere. Elsewhere in the episode, Jonathan seems decidedly less gay sensitive. In the episode's coda, Jonathan and a friend (Ross from *Friends*) are talking to Jonathan's obnoxious (and straight) best friend Sam. After Sam leaves, Ross asks Jonathan, "So is he . . . ?" [with a swishy hand gesture]. Not catching Ross's drift, Jonathan asks, "What?" Ross responds with a full-body fey move (fig. 32). Finally getting it, Jonathan replies, "Sammy? Oh yeah, big time." Not only do Ross's hand and body gestures invoke a traditionally homophobic sign of gay difference, Jonathan's decision to let Ross think Sam is gay is, in context, clearly a way to punish him.

I want to conclude by briefly returning to the "not-that-there's-anything-wrong-with-that" episode of *Seinfeld*, for it exposed certain anxieties and internal conflicts as overtly as any program of the era. Satirizing politically correct straight affirmations of difference, "The Outing" plays a public homo-friendly facade against inner homo-phobic anxieties. Wrapped in *Seinfeld*'s typical cloak of ironic distance, the episode can claim to be slyly critiquing Jerry and George's heterosexual insecurities, exposing their unreflective PC lip service to gay tolerance as simply a thin veneer covering their unresolved prejudices. On the one hand, then, socially liberal viewers can laugh at Jerry and George's panic and in doing so feel multiculturally superior. On the other hand, the episode's humor repeatedly taps into the viewer's unresolved prejudices. Proving that it's a fine line between celebrating gayness and celebrating gay stereotypes, for example, much of the episode's humor centers on an ironic acknowledgement of cultural assumptions about gay men and gay male culture. But more importantly, I'd argue that Jerry and George's panicked reaction is funny, even to viewers, because on some level they might identify with their anxiety. The viewer's ambivalence toward homosexuality and the imperatives of both political correctness and heterosexuality fuel their nervous laughter.

Straight Panic in the 2000s

IN MARCH 2003 a colleague of mine struck up a conversation with a white, straight, twentysomething man sitting next to her on an airplane.[1] Their conversation eventually turned to 9/11 and the young man expressed the renewed sense of patriotism that came over him in the wake of the terrorist attacks. As a self-identified liberal undergraduate in the 1990s, he recalled, he had experienced a certain antipathy and even guilt about being white. Michael Omi may have argued that he was caught in a crisis of white identity; the young man seemed to feel that whiteness couldn't serve as a source of meaning or community for him. However, he went on to describe the powerful sense of belonging he experienced after 9/11. He was enraged that "those people did this to us." In discovering an "us" with which he identified and in which he could find meaning, the young man seemed to have overcome his white identity crisis through a reinvestment in a rehabilitated national identity.

The politics of social unity seemed to have made a sudden comeback in the immediate aftermath of 9/11. Like the Cold War, the War on Terrorism provided the kind of external threat that made a common identity more salient—especially for the socially privileged. Although I don't want to suggest that members of marginalized groups didn't feel a revived sense of American unity after 9/11, I'd argue that the attacks enabled mainstream culture to put the politics of social difference on the back burner in a way that many of those living on the losing end of those politics couldn't. As a result, the identity-based culture wars of the 1990s were declared to be dangerously divisive and petty. Cultural-war general Jerry Falwell, for example, found out how quickly the rules had supposedly changed. While appearing on Pat Robertson's *The 700 Club* just days after the attack, for example, Falwell launched the kind of attack he often had during the previous decade: "the pagans, and the abortionists, and the feminists, and the gays and the lesbians who are actively trying to make that an alternative lifestyle, the ACLU, People for the American Way, all of them who have tried to secularize America, I point the finger in their face and say, 'You helped this happen.'"[2] Falwell faced an immediate barrage of criticism. Just about everyone, including George W.

Bush, denounced his comments as utterly inappropriate, and Falwell quickly retreated, apologizing for his wrongheaded comments. In those times, its seemed, the politics of social difference were out and calls for unity were in.

The national tragedy of 9/11 also seemed to have offered straight, white, mainstream America its own sense of victimhood. The young man's anger over what "they" had done to "us," for example, not only constructed a unified national community into which his white identity could disappear, but it also created a righteous indignation over the injustice of what had happened. During the 1990s such feelings had largely been denied progressive whites, straights, men, and so forth by multiculturalist discourses and political correctness. While the angry, white men of 1993 seemed more bitter than beleaguered, the angry (white) Americans of 2001 were utterly validated in feeling unfairly abused by a less problematic evil Other— Islamic fundamentalists bent on destroying the American way of life. Such anger and resentment was patriotic, not bigoted.

In the aftermath of 9/11, I started to wonder whether America's straight panic was over. Had all of those anxieties about the boundary between the majority and minority, the normal and abnormal, the center and the margins been eased? Had they been repressed by a resurgent nationalism and a revived faith in American values? Had the politics of sexual identity become anachronistic? Had problematic questions about what it meant to be gay and what it meant to be straight been dropped by a nation that seemed certain about what it meant to be American? And had cultural narratives about homosexual heterosexuals been pushed aside by a reinvigorated American (heterosexual) masculinity riding tanks into Baghdad and declaring victory on the deck of an aircraft carrier? Even before I had the chance to sift the jingoistic bravado from seismic social shifts, the repressed returned full force. During the summer of 2003, the politics of social difference and sexual identity once again moved front and center, dominating American popular culture and political debates—perhaps more than ever before.

On June 26 the Supreme Court overturned Texas's antigay sodomy law with a 6-3 majority. Described as a "blockbuster ruling," "the most significant gay rights decision ever," and "maybe one of the two most important opinions of the last 100 years," Kennedy's ruling in *Lawrence v. Texas* ignited intense reactions from both supporters and opponents.[3] As *Romer v. Evans* had in 1996, *Lawrence* zeroed in on the relationship between majority rule and minority rights. As Kennedy's opinion put it: "The issue is whether the majority may use the power of the State to enforce these views [moral attitudes about homosexuality] on the whole society through operation of the criminal law."[4] By overturning sodomy laws, the Court declared that a majority can't use laws to regulate or stigmatize behavior simply because it deems that behavior immoral. If the liberty of gays and lesbians is to be compromised by

law in this way, *Lawrence* asserts, the state must provide a "legitimate state interest"(18). According to Lawrence, promoting the morality of a majority of Texans is not a legitimate state interest. Critics of the decision panicked. In a remarkably bitter dissent, Justice Anton Scalia claimed the Court's decision "effectively decrees the end of all morals legislation" and predicted that the ruling would lead to "a massive disruption of the current social order."[5] Following Scalia's lead, social conservatives warned that by placing the privacy rights of consenting adults ahead of the interests of a moral majority, the Court had delegitimized all state laws prohibiting bigamy, incest, prostitution, bestiality and obscenity and created a slippery slope down which America's morality would likely slide.

Not surprisingly, *Lawrence v. Texas* reignited Straight America's anxieties about the relationship between normal and abnormal, right and wrong, and the majority and minority. As debates over military service and antidiscrimination legislation had in the 1990s, the verdict reflected the paradox of identity-based civil rights politics. On the one hand, it reinforced the idea of gays and lesbians as a distinct minority. By acknowledging the liberty of "homosexual persons," the language and spirit of Kennedy's opinion recognized being gay or lesbian as a whole way of life—an identity, not simply a sexual behavior. On the other hand, antisodomy laws were a social mechanism that differentiated and hierarchized; they helped to distinguish being straight (and normal) from being gay (and abnormal). Kennedy points to antisodomy laws' discursive function: "The stigma this criminal statute imposes, moreover, is not trivial. The offense, to be sure, is but a class C misdemeanor, a minor offense in the Texas legal system. Still, it remains a criminal offense with all that imports for the dignity of the person charged."[6] Removing the regulatory mechanism that helped stigmatize gays and lesbians also undermined the line separating what it mean to be gay from straight, a fact social conservatives recognized immediately.

Scalia also warned that *Lawrence* would pave the way for same-sex marriage by dismantling "the structure of constitutional law that has permitted a distinction to be made between heterosexual and homosexual union."[7] The debate over same-sex marriage became a major news story that summer. *Newsweek*'s July 7 cover headline, for example, wondered: "Is Gay Marriage Next?" The fact that Canada was simultaneously moving to grant full marriage rights for same-sex couples and that the Massachusetts Supreme Court was expected to do the same later that summer made the possibility of gay marriage as concrete and pressing as it ever had been. Social conservatives quickly called for the passage of an amendment to the U.S. Constitution that would declare marriage to be between a man and a woman. Political pundits announced that the debate had emerged as the "first hot-button issue of the '04 campaign."[8] And by August the Vatican released a decree urging Catholic

politicians to defend the sanctity of marriage. Meanwhile, some public opinion polls signaled a wider backlash. When Americans were asked in May 2003 (the month before *Lawrence* overturned *Bowers*) whether same-sex relations between consenting adults should be legal, 60 percent of respondent said yes and 35 percent said no. In July, amidst intense public debate over same-sex marriage, only 48 percent said yes and 46 percent said no.[9]

The prospect of gay marriage was highly troubling for much of Straight America. Surveys have consistently suggested that a certain percentage of Americans who support gay rights regarding issues like employment discrimination, military service, and health-care benefits remained strongly opposed to gay marriage. Such intense resistance is not surprising, given marriage's relationship to religious tradition and a heteronormative romance culture. Nevertheless, the LGBT community and its progressive straight allies are often perplexed by the argument that gay marriage would undermine or belittle heterosexual marriages. Such attitudes, I'd argue, reveal profound status anxieties and straight panic. Some straight people accept giving certain rights to gays and lesbians as long as marriage still serves as a clear indicator that, no matter how socially integrated gays and lesbians become, straight life and love are fundamentally different and better than gay life and love. Marriage becomes the last line of difference for those uneasy about the unstable scientific, moral, and cultural distinctions between homo- and heterosexuality. Even for the sizeable percentage of straight Americans who support gay marriage, the debate must be thought provoking. Like the straight students on Jeans Day, the possibility of state-sanctioned gay weddings forces them to think about what it would mean to be straight in a society where gay couples could have the same standing in law as them.

The debate over gay marriage that ignited after *Lawrence v. Texas* had started at least ten years earlier. Clinton's victory and the assimilationist politics it advanced had helped put marriage on the neoliberal gay agenda in the early 1990s, and a 1993 Hawaiian Supreme Court ruling that many saw as the first judicial step in the legalization of same-sex marriage helped put it on the national agenda. By 1995, anticipation of Hawaii's decision stirred many into a paranoid frenzy. Calls for preemptive action against gay marriages invading the mainland were common. Politicians like Clinton and Dole rushed to denounce something that hadn't even occurred. Newt Gingrich, for example, announced that if his lesbian sister were to have a wedding, he wouldn't attend, leading *Time* to comment on the absurdity: "In other words, he publicly turned down an invitation he hadn't been sent to a hypothetical event that could not, at this point, legally take place."[10] For some conservatives, the legalization of gay marriage was the ultimate symbol of cultural relativism and epitomized the dangers of multiculturalism. Anticipating the rhetoric of 2003, they often framed it as the start of a slippery slope or the thin edge of the

wedge prying open the door to total moral and social chaos. *Time*'s Charles Krauthammer, for example, asked "If gay marriages are O.K., then what about polygamy? Or incest?"[11]

Since Straight America's monopoly on marriage (like its official monopoly on military service) was an important social policy that fortified the line between the majority and this minority, the normal and the deviant, and straight and gay, it isn't surprising that the prospect of opening the institution up to gays and lesbians would fuel America's straight panic. As with other identity-based civil rights issues, the battle over gay marriage exposed the culture's difficulty with reconciling difference and equality. Mainstream press articles often had clever titles that reframed familiar expressions in ways that linked gays and lesbians to marriage even as they exploited the seeming absurdity of that link (e.g., "You May Now Kiss the Groom," "Do You, Paul, Take Ralph . . . ," "The Unmarrying Kind").[12] A 1995 *Newsweek* story worked similarly. The article opened with the description of the dream wedding any young (well-off) woman might have: "Ninia Baehr has concocted elaborate plans for the wedding of her dreams. Why not? She's 35 and 'crazy in love.' She will rent a fabulous estate outside Honolulu and string lights in the trees. The reception will be a traditional Hawaiian luau. Breaking tradition, Baehr will wear a slinky black evening gown dotted with sequins. There is, however, another tradition waiting to be broken in this fantasy wedding. The person Baehr wants to marry is another woman."[13] That Baehr's every-woman wedding fantasy and her sexual identity could be juxtaposed for dramatic effect reveals and reinforces the perceived tension between gay difference and equal access to marriage. Many of the photographs that accompanied such articles offered visual versions of the seeming paradox of gay marriage. Photos of gay men in tuxedoes and lesbians in white dresses cited the ubiquitous imagery of heteronormative wedding photographs while simultaneously queering them, producing what was likely an unsettling mix of similarity and difference. Unsettling because, like the logic behind and coverage of gay rights issues in general, such photographs worked simultaneously to blur and sharpen the distinctions between gay people and straight people.

Given the perception that heterosexual marriage was the last arena of public life that could protect the stability of straightness by cordoning off gayness, it isn't surprising that politicians rushed to shore up Straight America's monopoly on marriage in the 1990s. Fearful that Hawaii's Supreme Court would legalize gay marriage and that the Constitution's full faith and credit clause would force them to recognize such marriages, at least sixteen state legislatures passed laws forbidding same-sex marriages. In September 1996, Congress joined the battle, passing the Defense of Marriage Act (DOMA), which prevented states from having to recognize the same-sex marriages of other states and defined marriage for federal purposes as between a man and a

woman. Although many argued that the law was unconstitutional, it passed with tremendous margins (85-14 in the Senate and 342-67 in the House). Anxious not to appear too liberal less than two months before the election, Clinton signed DOMA into law.

Once again, a gay civil rights debate produced highly contradictory messages about the line between gay and straight. Legislation like DOMA insisted that, as far as marriage was concerned, that line was secure. Yet the fact that marriage needed to be defended indicates just how insecure heterosexuals' monopoly on the institution was. While legislatures across the nation were anxiously reinforcing Straight America's exclusive access to marriage, companies like Starbucks Coffee and Xerox and cities like New York and Seattle were offering domestic partnership benefits (sometimes to both gay and straight couples), which created new legal categories that worked to blur the distinctions between gay and straight. In 1983, for example, New York gave many of the rights married couples had to unmarried hetero- and homosexual couples who signed up as domestic partners, including new-child leave for city employees, some visitation rights at municipal hospitals and city jails, and the same standing in qualifying for apartments and inheriting leases in buildings owned or overseen by city.[14] Meanwhile, coverage of gay commitment ceremonies circulated images and stories about "married" gay and lesbian couples that looked and acted a lot like their straight counterparts, and network television programs like *Northern Exposure, Friends,* and *Roseanne* presented narratives about gay weddings. By the end of the 1990s, newspapers like the *New York Times* ran same-sex wedding notices. The courts didn't let up either. Although Hawaii passed a constitutional amendment barring same-sex marriages in 1998, Vermont's Supreme Court forced the state to offer same-sex couples the same rights and responsibilities as married couples in 1999. Of course, the debate would reignite and recapture the nation's attention in the summer 2003 in the wake of *Lawrence v. Texas* and in advance of the Massachusetts Supreme Court's ruling.

The Gay Summer of 2003 was not limited to Supreme Court rulings; it also played out in popular culture. The fascination with the "metrosexual" and the unprecedented success of television programs like *Queer Eye for the Straight Guy* and *Boy Meets Boy* contributed to the perfect storm that formed around *Lawrence v. Texas.* On June 22, the *New York Times* reported that marketers were conducting focus group studies to learn more about metrosexuals—urban men who seemed to have adopted the supposed consumer habits and cultural tastes of their gay counterparts. Mark Simpson, an openly gay British cultural critic, had coined the term in 1994 to sarcastically describe "a new, narcissistic, media-saturated, self-conscious kind of masculinity . . . produced by Hollywood, advertising and glossy magazines to replace traditional, repressed, unreflexive, unmoisturized masculinity, which didn't go shopping enough."[15]

After the *New York Times* article that June, the term quickly became ubiquitous in the U.S.—the buzzword of the year according to wordplay.com (a website that tracks slang). According to one self-identified metrosexual in Cleveland, "We're men who love women, so much that we spend lots of money to make ourselves appealing to them. We understand fashion, have impeccable manners and appreciate comforts like facials and manicures. But most importantly, we don't resent it when someone takes us for gay; we thank them for noticing our sense of style."[16] Also known as PoMosexuals, SGSG (straight guys who seem gay), and hybrids, metrosexuals were symbols of a new masculinity, a marketer's dream demographic, and the latest incarnation of the homosexual heterosexual.

The metrosexual emerged out of the complex feedback loop between the lived experiences of real men and the efforts of marketers interested in selling more designer clothes, styling gel, and gym memberships. In this regard, the fascination with metrosexuality says a lot about American culture in the wake of the gay 1990s—about the intersection between the politics of social difference and the proliferation of social identities in late capitalist societies. Most of the discourse around the metrosexual treated it with a healthy dose of suspicion; after all, the term epitomized the kind of pop culture sociology that only admen really buy into. Yet the explosion of interest in this demographic category and the emergence of actual straight men who enthusiastically embraced certain cultural signifiers of an upscale gay masculinity suggest how the politics of sexual identity that played out in American culture in the 1990s had destabilized the categorical distinctions between gay and straight—here between gay and straight masculinity. The concept of the metrosexual provided marketers with a way to fuel/target consumer desire more efficiently. Meanwhile, the cultural politics of consumption that metrosexuality evoked offered certain (urban or urban-minded, perhaps progressive or at least gay-friendly, upscale or aspiring to that status) straight men the opportunity to draw a distinction between themselves and other kinds of straight men.

The discourse surrounding metrosexuality was ratcheted up following the July 15 debut of Bravo's *Queer Eye for the Straight Guy*. With critical praise and an unprecedented promotional push by its sister network NBC, the program became the breakout hit of the summer, earning record ratings for Bravo (2.8 million viewers for its fourth episode) and drawing 7 million viewers when NBC ran an abridged version after *Will & Grace* on July 24. In the show, five gay men, each experts in their own areas of fashionable living, used their gay sensibility and biting wit to transform hapless straight men into better-coiffed, fully moisturized, and sushi-eating versions of themselves. As a glorified infomercial, *Queer Eye* channeled both the celebration of male consumerism and the evocation of gay male stereotypes so central to the dis-

course of metrosexuality. As one review pointed out: "The Fab Five are your guide to the post-macho lifestyle, and who better to play that role than gay men who live for shopping and are willing to turn the Other chic."[17]

While the concept of metrosexuality revealed how categories of sexual identity and gender were being redrawn in a culture where being gay wasn't necessarily bad, *Queer Eye* made it clear that being a metrosexual was different than being homosexual. Much of the humor emerged out of the straight guy's awkward reactions to the gay men's innuendo and manhandling; the motivating force for the makeover was almost always the straight man's desire to please his female love interest; the Fab Five's performance of certain gay male stereotypes constantly underscored their difference; and the last segment of each episode segregated the Fab Five in their well-appointed urban loft watching via video while their now-metrosexual charge returned to his nearly always all-straight world. Although thoroughly heterosexual, these newly crafted metrosexuals are also thoroughly homo-friendly. In this regard, the makeover process offered these straight guys (and theoretically the few straight men who might have been watching the show) a way to establish a straight male identity but do so with the help of gay men, rather than at gay men's expense. Perhaps the most poignant moment in each episode is the scene in which the straight guy, sometimes with tears in his eyes, hugs the Fab Five, professing his gratitude for the impact they've had on his life. *Queer Eye*, then, provides a guide for escaping male homosexual panic and a solution for those straight panic anxieties about what it means to be straight in a culture where being gay was no longer unequivocally stigmatized.

The July 29 episode featuring the transformation of John Bargeman brought the discourse of metrosexuality and the debate over gay marriage together in what would become the most-seen *Queer Eye* installment to date. The Fab Five's mission was to transform John and help him engineer the perfect marriage proposal. They teach him to say "I love you" in Armenian (his girlfriend's second language), help him pick out his ring, design the perfect romantic setting, and choreograph the proposal minute by minute. John's response to his gay gurus would raise the bar for all the straight men that followed. He was so moved by his transformation and their help that he could barely speak. In tears, he thanked the guys and gave them a long hug. In the final segment, of course, the Fab Five watched via video while John nervously asked his girlfriend to marry him. When she finally says yes, they scream, cheer and hug each other, celebrating their successful mission (figs. 33–35). At a time when a constitutional amendment banning gay marriage was building steam, the irony of five gay men serving as midwives to a heterosexual marriage was striking. *Queer Eye* offers an interesting reversal of the trope of the helpful heterosexual, but whereas such narratives had offered straight characters agency and narrative centrality, the helpful homosexuals on *Queer Eye*

33, 34, 35. The Fab Five watch expectantly as John Barge-
man proposes to his girlfriend, and they jump with joy when
she says yes. "He's a Little Bit Country: John Bargeman,"
Queer Eye for the Straight Guy, originally aired July 29,
2003 (© Scout Productions, 2003).

become narratively central but (as far as marriage was concerned) remain socially marginal.

Bravo's other "hit" that summer, *Boy Meets Boy*, offered an even more remarkable reality-TV twist on the trope of the homosexual heterosexual. A gay version of the popular dating reality-TV show, *Boy Meets Boy* featured James (the "leading man") who tried to find a romantic connection with one of fifteen attractive men. What James didn't know until just before the final elimination round, however, was that some of the men were actually straight and pretending to be gay. If James selected a gay suitor, James would win the money and the gay couple would take a romantic trip. If he chose a straight suitor, James got nothing and the straight man got the cash. Most critics were appalled by the show and its "cruel" twist that exploited James' sincere pursuit of same-sex love for the voyeuristic pleasure of the audience. Since, as Bravo admitted, the primary target audience for the series was straight women 18-to-49, not gay men, it isn't surprising that producers would incorporate a twist that shifted the preferred pleasure away from identifying with James' romantic journey to playing a game of is-he-gay-or-is-he-straight.[18]

In the process, *Boy Meets Boy* offered remarkable evidence of Straight America's inability to reconcile gay difference and equality and its profound confusion about categories of sexual identity. The show paradoxically asserted that the difference between being gay and being straight was both inconsequential and important, inherently ambiguous yet utterly determinate. On the one hand, producers carefully edited and cast the show so as to keep viewers guessing about which suitors were gay and which were straight; that indeterminacy was key to sustaining viewer interest (at least according to the producer-crafted premise). The notion that one couldn't tell a gay guy from a straight guy was reinforced by obligatory post-elimination confessionals in which the straight suitors invariably noted what their experience on the show had taught them: that gays and straights look the same and are the same underneath it all. On the other hand, the fundamental difference between being gay and being straight was essential to the successful execution of the series' premise. After all, if there weren't significant differences between gay men and straight men, the twist would be culturally meaningless. If James picked a straight guy, for example, they weren't going to go on a romantic trip or get it on. Furthermore, the series may have played upon the fact that sexual orientation is difficult to read, but it simultaneously reinforced the idea that it is ontologically clear-cut. Although each suitor's sexuality remained illegible while they were still in the game, once James eliminated them, viewers immediately learned what their true sexual identity was by an on-screen caption that identified them as gay or straight. In the process, the series reified a gay/straight binary and relied on the erasure of any form of bisexuality.

At one point, for example, a suitor (who we later learn is "straight") slipped up by mentioning that he had dated a girl. Because of the premise of the show and the way it was edited, viewers were encouraged to see this as a sign of his real heterosexuality, rather than a sign of bisexuality or sexual confusion.

In the series' most tense moment, James confronts Franklin, the last straight suitor in the game, and expresses how hurt he is at having been deceived. Echoing comments made by most of the straight suitors, Franklin anxiously insists that he came on the show to fight antigay stereotypes. "I came here on your side," he tells James. "I'm not here to infiltrate. I'm not here to expose. I'm here to show we're all alike. . . . I'll leave here and never be the same." In an earlier direct-to-camera confessional, Franklin explained to viewers just what the experience had been like for him in a speech that reflects a perspective that suggests equality is established through understanding similarity not recognizing difference:

> The physical stuff on the show [the same-sex physical intimacy] was easy for me to convey, but the emotional stuff was so hard, because I had this daunting sense of guilt. There were so many times during the last two days that I almost said something. . . . I knew it was hard for homosexuals to come out of the closet. I didn't know to what degree until I did this show. I went to bed thinking about it. I woke up thinking about it. To have to go on for years on end where people have to keep closed to people they care about . . . I wanted to show them that this can be felt by a straight man, because we're all the same. And sexuality is like eye color. It's just a characteristic that each one of us has. I need to remember everything I've learned here and never forget it.

Like many of the homosexual-heterosexual narratives of 1990s television, *Boy Meets Boy* put straight men in the heterosexual closet and helped them establish a progressive straight male identity forged from the anxieties of straight guilt rather than the anxieties of male homosexual panic. Both *Queer Eye* and *Boy Meets Boy*, then, provided transformation narratives that lay a path by which progressive straight men can figure out a way to be straight in a culture where being gay isn't reprehensible.

As the summer of 2003 gave way to the civil disobedience of San Francisco's gay wedding week, to the election of 2004, and to a nation supposedly psychographicly divided into blue and red, it became clear that America's straight panic was far from history. *Lawrence v. Texas* and recent gay marriage debates reproduce the same paradox and stir up many of the same anxieties that the gays-in-the-military debate and *Romer v. Evans* had. Frasier Crane was metrosexual before Americans had a buzz word to describe it. And *Boy Meets Boy* updated the mistaken-sexual-identity narrative for the era of reality TV. In other words, the social anxieties revealed in and exacerbated by the

increase of gay-themed programming in the 1990s have continued to shape cultural politics in general and television programming in particular. This is not to say that today's crop of gay-themed television will negotiate those anxieties in the same way. The historically specific culture that shapes such programming, the television industry that produces it, and the audience that make it part of their daily lives change. NBC's quirky hospital drama *Scrubs*, for example, is as preoccupied by the anxieties of a once ex-nominated, normative identity confronted by the politics of social difference as any 1990s program. Yet unlike *Seinfeld* or *Friends*, *Scrubs'* straight, white protagonist J.D. is as self-conscious about the politics of race as he is of sexuality. On the other hand, new narrative tropes have emerged in which openly gay men are victims and closeted gay men are dangerous. Episodes of *Hack* ("Double Exposure," January 24, 2004) and *Law & Order: Special Victims Unit* ("Lowdown" April 6, 2004) presented narratives about gay-on-gay murder in which closeted gay men, tortured by their secret lives and desires, kill other gay men. As gay, lesbian, bisexual, and increasingly transgender and transsexual characters and themes become more firmly integrated into prime-time television, constant attention will need to be spent on tracing the complex processes, meanings, and politics that surround them. As we look to better understand the politics of contemporary gay-themed programming, however, it will also be useful to situate it within the broader history of America's straight panic.

Appendix A: Select Gay-Themed Network TV Episodes

Below is a list of selected gay-themed episodes from 1992–1998. There were certainly many more gay-themed episodes and others that included gay material. I list these, however, because they include the episodes that I systematically analyzed for chapter 6. In creating the list, I selected episodes that received significant popular press coverage or that played a particularly important role in shifting network attitudes about gay material as identified by my interviews and trade-press analysis. I then randomly selected the remaining episodes from a more complete list of gay-themed episodes from the era.

1992–1993

Roseanne (ABC sitcom) "Ladies' Choice," November 10, 1992: Roseanne and Jackie discover Nancy is a lesbian when she introduces them to her new girlfriend.

Jackie Thomas (CBS sitcom) "Forces of Nature," February 2, 1993: Jackie and Bobby stumble into a gay bar, leading to tabloid rumors about them.

Picket Fences (CBS drama) "The Body Politic," February 5, 1993: People try to run a gay dentist out of business when they find out he is HIV-positive.

Seinfeld (NBC sitcom) "The Outing," February 11, 1993: When Elaine 'outs' Jerry and George, word spreads that they are a couple.

Picket Fences (CBS drama) "Sugar and Spice," April 29, 1993: Kimberly and her friend wonder what it would be like to kiss another girl.

Law & Order (NBC cop/legal drama) "Manhood," May 12, 1993: A gay cop is killed waiting for backup that never comes because of his colleagues' homophobia.

1993–1994

The John Laroquette Show (NBC sitcom) "The Past Comes Back," October 26, 1993: John wonders about his sexuality when an old drinking buddy visits to make amends for a sexual encounter John doesn't remember.

Sisters (NBC drama) "Something in Common," November 6, 1993: Alex learns that her producer Norma is gay. Norma becomes an openly lesbian recurring character.

The Commish (ABC police drama) "Keeping Secrets," January 22, 1994: Tony helps a gay cop come out of the closet during a gay-bashing case.

Roseanne (ABC sitcom) "Don't Ask, Don't Tell," March 1, 1994: Roseanne freaks out when Marla's girlfriends kisses her when the gang goes to a lesbian bar.

Roc (Fox sitcom) "Brothers," April 5, 1994: Andrew is upset when his gay brother tells him he's moving to Paris.

Northern Exposure (CBS dramedy) "I Feel the Earth Move," May 2, 1994: The entire town celebrates when Erick and Ron get married.

1994–1995

Frasier (NBC sitcom) "The Matchmaker," October 10, 1994: Frasier unwittingly ends up on a date with the station's new (gay) manager.

Hearts Afire (CBS sitcom) "Birth of a Donation," October 22, 1994: Billy Bob can't believe that an old friend is gay.

Party of Five (Fox family drama) "Something Out of Nothing," November 7, 1994: Claudia discovers that Ross, her violin teacher, is gay.

Friends (NBC sitcom) "The One Where Nana Dies Twice," November 10, 1994: Chandler is bothered by the fact that a coworker thinks he's gay.

NYPD Blue (ABC police drama) "Don We Now Our Gay Apparel," January 3, 1995: A robbery-homicide at a gay bar leads to an arrest.

ER (NBC hospital drama) "Long Day's Journey," January 19, 1995: Ross helps a homeless teenage hustler with AIDS.

Muscle (WB drama) Episode #5, February 1, 1995: Bronwyn come out of the closet on the air when a tabloid threatens to out her.

The Nanny (CBS sitcom) "A Fine Friendship" February 6, 1995: Fran is surprised when her new male nanny friend turns out to be straight.

Party of Five (Fox family drama) "Ides of March," March 15, 1995: When Ross has difficulty adopting a baby, Bailey comes to the rescue.

NYPD Blue (ABC police drama) "The Bank Dick," May 16, 1995: John asks for Simone help when he and his police-officer boyfriend are victims of gay-bashing.

ER (NBC hospital drama) "Everything Old Is New Again," May 18, 1995: Benton treats a gay man with AIDS and helps his lover realize that it's time to let his partner go.

Law & Order (NBC police/legal drama) "Pride," May 24, 1995: The murder of an openly gay councilman implicates his roommate, a married man, and a homophobic politician.

1995–1996

Live Shot (UPN drama) "T.G.I.F.," September 9, 1995: Lou refuses to let an old teammate come out during an interview.

Caroline in the City (NBC sitcom) "Caroline & the Gay Art Show," October 5, 1995: When Richard's artwork is mistakenly accepted for a showing of gay artists, he pretends to be gay to get the exposure.

Pursuit of Happiness (NBC sitcom) "Wedding Dates," October 10, 1995: Steve reluctantly agrees to be Alex's date for a wedding.

Friends (NBC sitcom) "The One with Phoebe's Husband," October 12, 1995: Phoebe's secret husband returns to tell her that he's actually not gay and needs a divorce.

The Nanny (CBS sitcom) "Oy Vey, You're Gay," October 23, 1995: Maxwell is interested in his publicist, but she turns out to be gay.

Hudson Street (ABC sitcom) "The Man's Man," October 24, 1995: Melanie discovers that her ex-boyfriend dumped her because he was gay. When he and Tony hit it off, she assumes he has a thing for Tony.

Friends (NBC sitcom) "The One with the Baby on the Bus," November 2, 1995: When Chandler and Joey take Ben out for a walk, all the women they try to hit on think they're gay.

The Single Guy (NBC sitcom) "Neighbors," November 2, 1995: When Jonathan befriends a gay while staying with his gay neighbors, he fears the guy thinks they're dating.

Ellen (ABC sitcom) "Salad Days," November 15, 1995: When Ellen hosts a fancy Martha-Stewart-inspired dinner, Peter and Barrett make a romantic connection.

Homicide: Life on the Street (NBC police drama) "Hate Crimes," November 17, 1995: Bayliss and Pembleton investigate a gay hate crime only to discover that the victim was straight.

Grace Under Fire (ABC sitcom) "Emmett's Secret," December 6, 1995: Grace discovers that her father-in-law has a secret gay lover.

Picket Fences (CBS drama) "Witness for the Prosecution," December 8, 1995: A gay man is accused of killing his lover, and the pope becomes a witness.

Roseanne (ABC sitcom) "December Bride," December 12, 1995: Much to his dismay, Roseanne plans Leon's wedding to Scott—and goes overboard.

Wings (NBC sitcom) "Honey, We Broke the Kid," January 2, 1996: When his favorite TV star come to town and befriends him, Antonio is clueless that he's gay.

Mad About You (NBC sitcom) "Ovulation Day," January 7, 1996: Debbie tells her family that she's a lesbian.

Matt Waters (CBS drama) "Who?" January 17, 1996: Russ starts to acknowledge his sexual orientation.

Friends (NBC sitcom) "The One with the Lesbian Wedding," January 18, 1996: Susan and Carol get married.

ER (NBC hospital drama) "It's Not Easy Being Greene," February 2, 1996: Ross has trouble helping a teenage boy who thinks he might be gay.

Ned & Stacey (Fox sitcom) "The Gay Caballeros," February 19, 1996: When a gay client finds out that Ned and Stacey sleep in separate bedrooms, he assumes Ned is gay.

Living Single (Fox sitcom) "Woman to Woman," March 21, 1996: When Max throws a bridal shower for her old college roommate, she finds out her friend is marrying another woman.

Seinfeld (NBC sitcom) "The Wig Master," April 4, 1996: Jerry feels insulted when a gay man hits on a man he's sitting with.

Picket Fences (CBS drama) "Bye, Bye Bey Bey," April 24, 1996: The mayor reveals to the town that the father of her baby is her gay brother's lover.

1996–1997

Murphy Brown (CBS sitcom) "Comedy of Errors," September 30, 1996: When Murphy helps Frank stage his autobiographical play, she lets the director restage it as a gay love story.

Moesha (UPN sitcom) "Labels," October 1, 1996: Moesha goes on a date with Hekeem's cousin, who turns out to be gay.

Frasier (NBC sitcom) "The Impossible Dream," October 15, 1996: Frasier is bothered when he has a dream that suggests he may have repressed homosexual desires.

Spin City (ABC sitcom) "Grand Illusion," October 29, 1996: Carter protests the mayor's stand against gay marriage.

3rd Rock from the Sun (NBC sitcom) "World's Greatest Dick," November 10, 1996: Sally dates a man she met at a gay bar (who assumes she's a drag queen).

Caroline in the City (NBC sitcom) "Caroline and Victor/Victoria," November 19, 1996: When Annie pretends to be a man in order to prepare for an audition, she finds herself dating a lesbian.

The Drew Carey Show (ABC sitcom) "Drew's the Other Man," November 20, 1996: Oswald inadvertently starts dating a man.

The Naked Truth (NBC sitcom) "Women Gat Plastered, Star Gets Even," January 23, 1997: Dave and T.J. pretend to be a gay couple to ingratiate themselves with the boss.

The Simpsons (Fox sitcom) "Homer's Phobia," February 16, 1997: When the family starts hanging out with a gay man, Homer begins to fear Bart is gay.

The Drew Carey Show (ABC sitcom) "Man's Best Same-Sex Companion." March 5, 1997: Drew tries to get medical insurance for his dog by listing him as his same-sex partner.

Dr. Quinn, Medicine Woman (CBS-drama) "The Body Electric," April 5, 1997: When Walt Whitman comes to town, rumors about his sexual orientation start to circulate.

Suddenly Susan (NBC sitcom) "A Boy Like That," April 24, 1997: Luis's brother visits from Cuba to tell him that he is gay.

Married . . . with Children (Fox sitcom) "Lez Be Friends," April 28, 1997: Marcy becomes jealous when her lesbian cousin hits it off with everyone.

Ellen (ABC sitcom) "The Puppy Episode," April 30, 1997: Ellen comes out of the closet.

1997–1998

Alright Already (WB sitcom) "Again with the Laser Surgery," October 5, 1997: Vaughn pretends to be gay in order to attract a model.

Unhappily Ever After (UPN sitcom) "Sorority Girl," October 12, 1997: Ryan's popularity soars when he joins a gay fraternity.

Cosby (CBS sitcom) "Older and Out," October 13, 1997: Hilton unwittingly joins a softball team for older gay men.

Working (NBC sitcom) "Rumoring," December 10, 1997: Delaney lets Tim think Matt's gay and tricks him into going on a date with Tim's son.

Homicide: Life on the Street (NBC police drama) "Closet Cases," January 2, 1998: Bayliss and Pembleton catch a hustler who's killed several rich gay men.

Party of Five (Fox family drama) "Here and Now," January 28, 1998: Sarah's new boyfriend tells Bailey that he's gay and is attracted to him.

Just Shoot Me (NBC sitcom) "Pass the Salt," January 29, 1998: Finch's estranged father visits in order to make amends with his son and accept his sexual orientation.

Beverly Hills, 90210 (Fox drama) "The Nature of Nurture," March 18, 1998: Kelly struggles to accept that two gay men can be good parents to the abandoned baby she found.

Caroline in the City (NBC sitcom) "Caroline and the Little White Lies," April 6, 1998: Del and Charlie pretend to be gay to get cheaper health insurance.

Brooklyn South (CBS police drama) "Doggonit," April 13, 1998: A gay man asks for help when he thinks his boyfriend is going to go on a shooting rampage.

Spin City (ABC sitcom) "The Lady or the Tiger" and "Single White Male," May 6, 1998: Carter and Stuart open a bar together in a gay neighborhood.

Getting Personal (Fox sitcom) "Chasing Sammy," May 18, 1998: Milo pretends he's gay to court a client.

Holding the Baby (Fox sitcom) "The Gay Divorcee," September 27, 1998: Gordon's date thinks he's gay.

Nash Bridges (CBS police drama) "Imposters," October 2, 1998: Nash and Joe pose as gay private investigators on a case focused on a wig stolen from a Cher impersonator.

Guys Like Us (UPN sitcom) "In and Out," October 12, 1998: When a beautiful new woman moves in next door, she thinks the guys are gay, undermining Sean's efforts to impress her.

The Secret Lives of Men (ABC sitcom) "Dating Is Hell," October 14, 1998: Michael thinks a gay client is hitting on him.

Suddenly Susan (NBC sitcom) "A Funny Thing Happened on the Way to Susan's Party," October 26, 1998: Nana helps get Pete ready for Halloween.

Spin City (ABC sitcom) "An Officer and a Gentleman," November 3, 1998: Mike gets upset when his old Navy buddy (Lou Diamond Phillips) falls for Carter.

ER (NBC hospital drama) "Stuck on You," November 5, 1998: Greene risks his life to save a gay teen who is beaten and left for dead on the street.

For Your Love (WB sitcom) "House of Cards," November 19, 1998: Sheri tells Dean that her longtime male friend is gay to assuage his jealousy (only to find out that he really is gay).

That '70s Show (Fox sitcom) "Eric's Buddy," December 6, 1998: Eric's new lab partner (Joseph Gordon-Levitt) kisses him.

Norm (ABC sitcom) "Norm Dates Danny's Dad," April 7, 1999: When Danny's father visits, Norm discovers that he's gay—kind of.

Appendix B: List of Interviews

Greg Berlanti, interview by author, tape recording, Los Angeles, Calif., 16 March 2000.

David Crane, interview by author, tape recording, Los Angeles, Calif., 29 June 2000.

Scott Glaser, interview by author, tape recording, Los Angeles, Calif., 5 December 1999.

Sally Lapiduss, interview by author, tape recording, Los Angeles, Calif., 19 December 1999.

Maxine Lapiduss, interview by author, tape recording, Los Angeles, Calif., 12 December 1999.

Max Mutchnick, interview by author, tape recording, Los Angeles, Calif., 26 April 2000.

Kevin Williamson, interview by author, tape recording, Los Angeles, Calif., 9 February 2000.

Notes

INTRODUCTION: THE IMPORTANCE OF GAY-THEMED TV

1. The project's methodology is grounded in a critical cultural studies approach to media analysis. Cultural studies practitioners like Stuart Hall and Richard Johnson have encouraged media scholars to situate television's representations and industry practices within wider structures of domination and social relations and to acknowledge and theorize the relative autonomy of reception. Recent studies have applied such theoretical perspectives in an integrated approach which asserts that to understand television as a cultural practice more fully we need to examine the mutually determining relationships among specific programs, the industry that produces them, the audiences that view them, and the social contexts within which these activities take place. This integrated approach helps me to foreground the political implications of commercial television's Janus-faced nature as, in Eileen Meehan's terms, both a "culture industry" and "industrial culture"(563-572). At a time when both gay and lesbian politics and commercialized televised representations of homosexuality were so socially central, exploring the relationship between them becomes vitally important. Eileen R. Meehan, "Conceptualizing Culture as Commodity: The Problem of Television," in *Television: The Critical View*, 5th edition, ed. Horace Newcomb (New York: Oxford University Press, 1994), 563–572; Julie D'Acci, *Defining Woman: Television and the Case of Cagney & Lacy* (Chapel Hill: University of North Carolina Press, 1994); Stuart Hall, "Encoding/Decoding," in *Culture, Media, Language*, ed. S. Hall, D. Hobson, and A. Lowe (London: Hutchinson, 1980).
2. Eloise Salholz, "The Future of Gay America," *Newsweek*, 12 March 1990, 20–25.
3. Andrew Kopkind, "The Gay Moment," *Nation*, 3 May 1993.
4. Benedict Anderson, *Imagined Communities*, 2nd ed. (London: Verso, 1991); Michele Hilmes, *Radio Voices: American Broadcasting, 1922–1952* (Minneapolis: University of Minnesota Press, 1997).
5. Larry Gross, "Out of the Mainstream: Sexual Minorities and the Mass Media," in *Remote Control: Television, Audiences, and Cultural Power*, ed. Ellen Seiter (New York: Routledge, 1989), 130–149. Alexander Doty argues that the absence of openly or explicitly gay and lesbian characters on television doesn't mean that there weren't gay, lesbian, or queer narratives or pleasures available to viewers. Alexander Doty, *Making Things Perfectly Queer: Interpreting Mass Culture* (Minneapolis: University of Minnesota Press, 1993).

 Athough the amount of gay content on 1990s TV was unprecedented, it is important not to simplify the history of gay and lesbian televisibility. As Stephen Tropiano and others have discussed, the 1970s saw a striking increase of gay-themed programming. In other words, this project does not trace the initial rise of gay and lesbian material on television, but rather the emergence of a historically specific gay-themed programming phenomenon driven by various social and industry factors which have their roots in the 1970s and crystalized in the 1990s. Furthermore, the

1990s programming trend I focus on doesn't neatly coincide with the start or end of the decade. During the late 1980s, for example, programs like NBC's quality dramas *Hill Street Blues, St. Elsewhere, Cagney & Lacey, LA Law, thirtysomething,* adult-oriented sitcoms like *Doctor, Doctor, Designing Women,* and *Golden Girls,* and Fox's sketch comedies *The Tracey Ullman Show* and *In Living Color* included gay material and recurring gay, lesbian, and bisexual characters that serve as precursors of what was to become a full-blown programming phenomenon a few years later.

6. Suzanna Danuta Walters, *All the Rage: The Story of Gay Visibility in America* (Chicago: University of Chicago Press, 2001), 10 (italics in original).

7. George Chauncey, *Gay New York: Gender, Urban Culture, and the Making of the Gay Male World, 1890–1940* (New York: Basic Books, 1994), 14.

8. Given such theoretical presumptions, the terms I use in this project to refer to my object of analysis are important and problematic, since they don't simply refer to a self-evident signified. I use the terms "gay and lesbian" and "gay" to refer to the kind of material and characters that appeared on prime-time television and the discourses that circulated in the trade press because those are the categories and terms that were operative in those locations.

9. Van Gosse, "Postmodern America: A New Democratic Order in the Second Gilded Age," in *The World the Sixties Made: Politics and Culture in Recent America,* ed. Van Gosse and Richard Moser (Philadelphia: Temple University Press, 2003), 1–36.

10. As John Fiske aptly puts it, a structure of feeling "refers to a what it feels like to be a member of a particular culture, or to live in a particular society at a particular time. It is a necessarily diffuse concept, because it stretches seamlessly from the realm of the subject to that of the social order. It encompasses the formal political processes and institutions of a society, its law courts, its workplaces, its military, its schools and churches, its health care system, as well as its more informal ones, such as the family and everyday social relations in the streets, stores, and workplaces. It includes the arts and culture industries, sports and entertainment, and, at the micro level, the ordinary ways of talking, thinking, doing, and believing." John Fiske, *Media Matters: Everyday Culture and Political Change* (Minneapolis: University of Minnesota Press, 1994), 8–9.

11. David Roediger, *Colored White: Transcending the Racial Past* (Berkeley: University of California Press, 2002); Mike Hill, *After Whiteness: Unmaking an American Majority* (New York: New York University Press, 2003). With the U.S. Census's addition of multiracial and ethnic identification options in mind, Hill asks, "How can de facto civil rights infringements be the object of legal redress if racial distinctions proliferate to the point of their de jure disappearance?" (42) Hill goes on to investigate the "volatile psychic investments that white heterosexual men have in men of color" by examining the Promise Keepers and American Renaissance movements (13).

12. Cindy Patton, "Refiguring Social Space," in *Social Postmodernism: Beyond Identity Politics,* ed. Linda Nicholson and Steven Seidman (New York: Cambridge University Press, 1995), 240.

13. Lauren Berlant, *The Queen of America Goes to Washington City: Essays on Sex and Citizenship* (Durham: Duke University Press, 1997).

Chapter 1: Straight Panic and American Culture in the 1990s

1. Steve Lopez, "To Be Young and Gay in Wyoming," *Time,* 26 October 1998, 39.

2. Ibid., 38.

3. Betsey Streisand, "A Death on the Prairie," *U.S. News & World Report,* 26 October 1998, 25.

4. Thomas Fields-Meyer, Vickie Bane, and Elizabeth Leonard, "Death in Wyoming," *People Weekly,* 2 November 1998, 56.

5. Mark Miller, "The Final Days and Nights of a Gay Martyr," *Newsweek*, 21 December 1998, 31.
6. Tom Kenworthy, "'Gay Panic' Defense Stirs Wyo. Trial," *Washington Post*, 26 October 1999, LexisNexis Academic Universe Web, http://web.lexis-nexis.com (hereafter L/N).
7. Ibid.
8. Ibid.
9. Patrick O'Driscoll, "Last Witness Alleges Unwanted Advance," *USA Today*, 2 November 1999, L/N.
10. Edward J. Kempf, *Psychopathology* (St. Louis: C.V. Mosby Company, 1920), 477.
11. Henry T. Chuang and Donald Addington, "Homosexual Panic: A Review of Its Concepts," *Canadian Journal of Psychiatry* 33 (October 1988): 613–617.
12. Kempf, *Psychopathology*, 477–478.
13. Barry W. Wall, "Criminal Responsibility, Diminished Capacity, and the Gay Panic Defense," *Journal of the American Academy of Psychiatry and the Law* 28, no. 4 (2000): 454–459.
14. Gary David Comstock, "Dismantling the Homosexual Panic Defense," *Law & Sexuality* 2 (1992): 81–102; Chuang and Addington; Burton S.Glick, "Homosexual Panic: Clinical and Theoretical Considerations," *Journal of Nervous & Mental Disease* 129 (1959): 20–28.
15. Kempf, *Psychopathology*, 477.
16. Comstock, "Dismantling the Homosexual Panic Defense," 87.
17. Peter Freiberg, "Blaming the Victim: New Life for the 'Gay Panic' Defense," *Advocate* 24 May 1988, 10–12.
18. "Man Convicted of Assault in Murder," Associated Press State & Local Wire, 7 October 1998 (BC cycle), L/N; "Accused Killer Claims Self-Defense," Associated Press State & Local Wire, 17 September 1998 (BC cycle), L/N.
19. Since Wyoming law didn't recognize temporary insanity or diminished capacity, the judge declared, the homosexual panic defense would do McKinney no good and evidence suggesting that McKinney's actions were somehow triggered by his aversion to homosexuality or by Shepard's behavior would only "mislead and confuse the jury." Michael Janofsky, "Judge Rejects 'Gay Panic' as Defense in Murder Case," *New York Times*, 2 November 1999, L/N.
20. Eve Kosofksy Sedgwick, *Epistomology of the Closet*, (Berkley: University of California Press, 1990), 21.
21. Ibid., 188. Importantly, Sedgwick argues that homosexual panic may explain anti-gay violence, but she insists that it shouldn't in any way absolve the guilt or culpability of perpetrators of such crimes.
22. Jose Zuniga, "My Life in the Military Closet," *New York Times Magazine*, 11 July 1993, 42.
23. Ibid., 41.
24. Ibid., 42.
25. Todd Gitlin, *The Twilight of Common Dreams: Why America Is Wracked by Culture Wars* (New York: Henry Holt and Company, 1995), 227. The thrust of Gitlin's argument is that identity politics undermined the kind of traditional leftist goals to which he was personally committed—an assertion I wholeheartedly disagree with. In arguing that the left, broadly conceived, should keep its eyes on the prize, so to speak, Gitlin mistakes political expediency for good politics. Just because America has had a difficult time reconciling difference and equality, or difference and community, doesn't mean that politics of difference aren't necessary.
26. Cindy Patton, "Refiguring Social Space," in *Social Postmodernism: Beyond Identity Politics*, ed. Linda Nicholson and Steven Seidman (New York: Cambridge University Press, 1995), 240.

27. Undoubtedly, the early 1990s was part of a much longer history of conflict within American culture between discourses about social difference and unity. The early twentieth century, for example, could easily be described as "a very stewpot of separate identities." Looking back through the post–World War II period during which faith in the value of social unity became so hegemonic as to make it seem (at least to those in the mainstream) as if difference had been overcome, the rise of multiculturalism and social differences seemed utterly un-American. It wasn't, of course. Yet the ways in which subcultural identification functioned during the 1990s was also historically specific. Discourses legitimating social difference and questioning the value of social unity circulated in various levels of American social life. People were encouraged to invest in and identify with subcultural identities in qualitatively different ways. The number of identities and axes of difference proliferated. And the conflict between being part of the mainstream and part of a minority seemed particularly irreconcilable.

28. John Higham, "Cultural Responses to Immigration," in *Diversity and Its Discontents: Cultural Conflict and Common Ground in Contemporary American Society*, ed. Neil J. Smelser and Jeffrey C. Alexander (Princeton: Princeton University Press, 1999), 39–62; Marta Tienda, "Immigration, Opportunity, and Social Cohesion," in Smelser and Alexander, *Diversity and Its Discontents*, 129–146.

29. Although I would be highly skeptical of the science behind both census data collection, racial identity classification, and demographic predictions based on presumptions about differing birth and immigration rates, the more important fact here isn't whether white Americans were or weren't losing their majority status but rather that that prediction was so widely reported and shaped how people felt about the diversity of America.

30. David Gates, "White Male Paranoia," *Newsweek*, 29 March 1993, 50.

31. Martha Farnsworth Richie, "We're All Minorities Now," *American Demographics*, October 1991, 28.

32. Robert Hughes, "The Fraying of America," *Time*, 3 February 1992, 44–49; *Time* (Special Issue), fall 1993.

33. Arthur Schlesinger, Jr., *The Disuniting of America* (New York: Norton, 1992), 18.

34. Pat Buchanan, "The Election Is about Who We Are," *Vital Speeches of the Day*, 15 September 1992, 714.

35. In a 1993 *New Republic* essay entitled "Defining Deviancy Up," Krauthammer argues that the sad (as he saw it) state of contemporary American culture was due to the "moral deconstruction of middle-class normality" advanced by a two-pronged attack on traditional moral value systems. Citing Daniel Patrick Moynihan's 1993 essay "Defining Deviancy Down" (although missing the subtlety of the argument), Krauthammer contends that "the moral deregulation of the 1960s" unleashed "an explosion of deviancy in family life, criminal behavior and public displays of psychosis." Instead of seeing unprecedented levels of mentally ill homeless people, teen pregnancy, divorce, homosexuality, or gun murders as epidemics that demand solutions, Krauthammer claims, America has simply redefined deviancy down, now considering such problems as normal elements of contemporary society. According to Krauthammer, however, "it is not enough for the deviant to be normalized. The normal must be found to be deviant." Thus, he identifies "the new assault on bourgeois life" in which "normal middle-class life" is indicted as a hotbed of such deviancy as date rape, child abuse, and hate speech. Charles Krauthammer, "Defining Deviancy Up," *New Republic*, 22 November 1993, 20.

36. In pointing out the connection between the decline of social hierarchies and status conflict, J.M. Balkin argues that "The paradox of status is that intense social conflict between status groups emerges not at the height of a system of social

stratification but during its decline. The more clear-cut and well-defined that status hierarchies are, the less overt are the kinds of discontent and strife one may see." J.M. Balkin, "The Constitution of Status," *Yale Law Journal* 106, no. 8 (June 1997): 2327.

37. Ibid., 2327.
38. Dan Quayle, "The Family Comes First," *Vital Speeches of the Day*, 15 September 1992, 711.
39. Michael Omi, "Racialization in the Post–Civil Rights Era," in *Mapping Multiculturalism*, ed. Avery F. Gordon and Christopher Newfield (Minneapolis: University of Minnesota Press, 1996), 181.
40. Charles A. Gallagher, "White Reconstruction in the University," *Socialist Review* 94, nos. 1 and 2 (1994): 165.
41. Gitlin, *Twilight*, 125.
42. Linda Martin Alcoff, "What Should White People Do?" in *Decentering the Center: Philosophy for a Multicultural, Postcolonial, and Feminist World*, ed. Uma Nargan and Sandra Harding (Bloomington: Indiana University Press, 2000), 280.
43. In discussing the findings of his study of college students' attitudes about their racial identities, Gallagher argues, "A lack of ethnic identity among my respondents has created an emptiness that is being filled by an identity centered on race" (505). He goes on to say that "Race matters for my respondent because it is racial, not ethnic, identity that is bound up in popular culture and the political order" (506). Charles A. Gallagher, "White Racial Formation: Into the Twenty-First Century," in *Rethinking the Color Line: Readings in Race and Ethnicity*, ed. Charles A. Gallagher (Mountain View: Mayfield Publishing Co., 1999), 503–508.
44. David Gates, "White Male Paranoia," 48–53; See also Liam Kennedy, "Alien Nation: White Male Paranoia and the Imperial Culture in the United States," *Journal of American Studies*, 30 (1996): 87–100.
45. "What We Believe," *Race Traitor*, 6 June 2003, http://racetraitor.org/
46. Roediger, *Colored White*; Hill, *After Whiteness*.
47. Sam Allis, Jordan Bonfante, and Cathy Booth, "Whose America?" *Time*, 8 July 1991, 13.
48. Ibid., 12.
49. Quoted in Michael Weisskopf, "The Lobby in Key Test of Strength," *Washington Post*, 27 January 1993, L/N.
50. Quoted in Richard Lacayo, "The New Gay Struggle," *Time*, 26 October 1998, 35.
51. Quayle, "The Family Comes First," 711.
52. Buchanan, "The Election is About Who We Are," 714.
53. John Gallagher and Chris Bull, *Perfect Enemies: The Religious Right, the Gay Movement, and the Politics of the 1990s* (New York: Crown Publishers, 1996). Key books that helped shape the emergence of what Didi Herman calls "a specific antigay genre" in the early 1990s were William Dannemeyer's *Shadow in the Land: Homosexuality in America* (1989), Chuck and Donna McIlhenny and Frank York's expose of San Francisco *When the Wicked Seize a City: A Grim Look at the Future and a Warning to the Church* (1993), and George Grant and Mark Home's *Legislating Immorality: The Homosexual Movement Comes Out of the Closet* (1993). Didi Herman, *The Antigay Agenda: Orthodox Vision and the Christian Right* (Chicago: University of Chicago Press, 1997).
54. Quoted in David Colker, "Anti-Gay Video Highlights Church's Agenda," *Los Angeles Times* 22 February 1993, L/N.
55. Quoted in Joseph P. Shapiro, "The True State of Gay America," *U.S. News & World Report*, 19 October 1992, 39.
56. Quoted in Robert Sullivan, "Revolution Number 9," *New Yorker*, 9 November 1992, 70.

57. Bill Turque et al., "Gays Under Fire," *Newsweek*, 14 September 1992, 35–36.
58. Quoted in Robert Dreyfuss, "The Holy War on Gays," *Rolling Stone*, 18 March, 1999, L/N.
59. Tom Garrigus, "I'm not a faggot!" *Glamour*, July 1993, 186.
60. Michael Lewis, "Straight Answer," *New Republic*, 10 May 1993, 22.
61. "This Is What You Thought," *Glamour*, April 1993, 159; Bill Turque "Gays Under Fire," 36; Jeffrey Schmalz, "Poll Finds an Even Split on Homosexuality's Cause," *New York Times*, 5 March 1993, 14; Joseph Shapiro, Gareth G. Cook, and Andrew Krackov, "Straight Talk about Gays," *U.S. News & World Report*, 5 July 1993, 42.
62. In fact, some straight people felt the need to broadcast their feelings about homosexuality. Students at Syracuse University, for example, wore T-shirts that read "Homophobic and proud of it" (Stephanie Mansfield, "Gays on Campus," *Redbook*, May 1993, 140). Gay-friendly heterosexuals, on the other hand, could buy T-shirts, bumper stickers, and buttons that informed the world that they were "Straight But Not Narrow."

CHAPTER 2: THINKING ABOUT GAY PEOPLE: CIVIL RIGHTS AND THE CONFUSION OVER SEXUAL IDENTITY

1. Quoted in Paul Richter, "President Shows Why He Won't Duck Gay Rights Fight," *Los Angeles Times*, 24 April 1993, L/N.
2. Chandler Burr, "Homosexuality and Biology," *Atlantic Monthly*, March 1993, 47.
3. Robert Dawidoff, "They're Out of the Closet—What Do We Do Now?" *Los Angeles Times*, 26 November 1995, L/N.
4. Dan Danielsen and Karen Engle, "Introduction," in *After Identity: A Reader in Law and Culture* (New York: Routledge, 1995), xiv–xv. Also see Jeffrey Escoffier, *American Homo: Community and Perversity* (Berkeley: University of California Press, 1998), 212.
5. Lauren Berlant. "Uncle Sam Needs a Wife: Citizenship and Denegation," in *Materializing Democracy: Toward a Revitalized Cultural Politics*, ed. Russ Castronova and Dana D. Nelson (Durham: Duke University Press, 2002), 144.
6. Although these two discourses about sexual identity are contradictory, they are also mutually dependent—two sides of the same socio-linguistic cultural process. The need, desire, and attempt to assert and maintain a clear distinction between social categories like homosexuality and heterosexuality are fueled by nagging fears or anxious realizations that the line between them is actually blurry. The more a culture struggles to bolster the boundaries between gay and straight, the more it seems to question those boundaries. Conversely, the prospect that the lines between important social categories of identity—categories that undergird social relations and individual lives—are actually fluid, arbitrary, and uncertain leads to a renewed effort to reinscribe those boundaries.
7. Barbara Ehrenrich, "The Gap Between Gay and Straight," *Time* 10 May 1993, 76.
8. Most basically, to discriminate is to distinguish or to differentiate. Assimilationist efforts to end discriminatory social policies that had helped classify gay people as distinct from and inferior to straight people led to a nervous reappraisal of the categorical boundary between gay and straight. In other words, gays and lesbians' entry into a mainstream that had long taken heterosexuality as an unproblematic given produced an anxious reassessment of what it meant to be straight, what counted as normal, and what could be taken for granted. As structural-linguists have pointed out, the categories a society uses to make sense of the world are profoundly important to it, and maintaining the boundaries between them are essential to maintaining a specific social order. Thus, social changes that undermine the stability of those categories and try to redraw those boundaries produce confusion and anxiety.

9. Bettina Boxall, "Gays Alter Dynamics of Politics," *Los Angeles Times*, 15 September 1992, L/N.

10. Quoted in Jill Lawrence, "Gays' Higher Political Profile Cuts Both Ways," *Times-Picayune*, 9 August 1992, L/N.

11. Quoted in Jeffrey Schmalz, "Gay Politics Goes Mainstream," *New York Times Magazine*, 11 October 1992, 20.

12. Priscilla Painton, "After Willie Horton Are Gays Next?" *Time*, 3 August 1992, 42.

13. In 1989, for example, ACT UP disrupted mass at St. Patrick's Cathedral in New York City to protest comments made by Cardinal John O'Connor, stopped trading on the New York Stock Exchange to protest pharmaceutical companies' pricing of AIDS drugs, and necked in the Capitol Hill office of conservative senator Jesse Helms to protest him. Queer Nation, in addition to traditional civil rights protests (such as picketing Cracker Barrel restaurants for their antigay employment policy), organized direct-action events designed to generate media attention (e.g., invading suburban shopping malls dressed as go-go boys and biker dykes, holding kiss-ins at straight nightclubs).

14. Mainstream press coverage of the gay movement in the early 1990s often focused on images of "gay rage." A *U.S. News & World Report* editorial, for example, roundly criticized Queer Nation and ACT UP for their so-called "politics of intimidation." A March 29, 1990, *Newsweek* cover story on the state of gay America included a three-quarter-page photo of a protest march. The photo's composition emphasizes a young man that seemingly personifies the confrontational attitude of the gay rights movement. His fist is raised in deviance and his mouth is open as he shouts. A leather jacket, dark sunglasses, and a black T-shirt with a pink triangle and "Silence=Death" slogan identifies him as youthful, militant, and threatening—a feeling heightened by the low angle from which the photo is taken. John Leo, "The Politics of Intimidation," *U.S. News & World Report*, 6 August 1992, 24; Eloise Salholz et al., "The Future of Gay America," *Newsweek*, 12 March 1990, 21.

15. Quoted in Debbie Howlett, "Gay-Rights Activists Move into the Mainstream," *USA Today*, 14 February 1994, L/N.

16. Howard Fineman, "Marching to the Mainstream," *Newsweek*, 3 May 1993, 42.

17. Quoted in Jeffrey Schmalz, "The 1992 Elections: The States—the Gay Issues," *New York Times*, 5 November 1992, L/N.

18. Howlett, "Gay Rights Activists."

19. Quoted in Mary F. Rogers and Phillip B. Lott, "Backlash, the Matrix of Domination, and the Log Cabin Republicans," *Sociological Quarterly* 38, no. 3 (1997): 506.

20. Andrew Kopkind, "Paint It Pink," *Nation*, 17 May 1993, 653.

21. While the simple opposition between such broadly defined camps fails to convey the complex spectrum of positions within the gay movement, changes within gay politics were often framed in terms of such a binary during the 1990s—by both the mainstream press and gay activists. Cathy J. Cohen, "Punks, Bulldaggers, and Welfare Queens: The Radical Potential of Queer Politics?" in *Sexual Identities/Queer Politics*, ed. Mark Blasius (Princeton: Princeton University Press, 2001): 200–227.

22. Mary Bernstein, "Celebration and Suppression: The Strategic Use of Identity by the Lesbian and Gay Movement," *American Journal of Sociology* 103, no. 3 (November 1997): 532.

23. Bruce Bawer, "The Stonewall Myth: Can the Gay Rights Movement Get Beyond the Politics of Nostalgia?" *New Republic*, 13 June 1994, 25.

24. Michael Warner, *The Trouble with Normal: Sex, Politics, and the Ethics of Queer Life* (New York: The Free Press, 1999), 60. Although the politics of access and the assimilationist agenda tended to strengthen its hold on the gay movement (especially at the highly visible and agenda-setting national level), tensions continued. Although a great deal of energy went into the debate between these various camps and the

political consequences of each approach, I don't aim to adjudicate between them. Instead, I want to examine how assimilationist politics and their critics were imbricated within a broader cultural confusion about the nature of sexual identity and the boundary between gay and straight.

25. Amy Hequembourg and Jorge Arditi, "Fractured Resistances: The Debate over Assimilationism Among Gays and Lesbians in the United States," *Sociological Quarterly* 40, no. 4 (fall 1999): 672.

26. Kopkind, "The Gay Moment," 602.

27. Chandler Burr, "Homosexuality and Biology," *Atlantic Monthly*, March 1993, 47.

28. Like sexual identity, race and sex are social categories and not simply terms used to describe preexisting groups of people. Nevertheless, the biological factors at play behind sexual and racial difference (e.g., the genetic factors that produce skin color) are identifiable in a way the factors behind sexual orientation are not.

29. See Sarah A. Wilcox, "Cultural Context and the Conventions of Science Journalism; Drama and Contradictions in Media Coverage of Biological Ideas about Sexuality," *Cultural Studies in Media Communication* 20, no. 3 (September 2003): 225–247.

30. Quoted in Joseph Shapiro, "Genes: Among Twin Men," *U.S. News & World Report*, 6 January 1992, 32.

31. William F. Allman, "The Biology-Behavior Conundrum," *U.S. News & World Report*, 26 July 1993, 6.

32. Quoted in Marcia Barinaga, "Is Homosexuality Biological?" *Science* 253 (August 1991), 957.

33. Quoted in William A. Henry III, "Born Gay?" *Time*, 26 July 1993, 38–39.

34. Darrell Yates Rist, "Are Homosexuals Born That Way?" *Nation*, 19 October 1992, 425.

35. Burr, "Homosexuality and Biology," 64.

36. David Gelman, "Born Or Bred?' *Newsweek*, 24 February 1992, 46.

37. Quoted in Warren King, "The Science of Sexuality," *Seattle Times*, 18 October 1994, L/N.

38. Anastasia Toufexis, "Bisexuality: What Is It?" *Time*, 17 August 1992, 51.

39. Quoted in John Leland and Mark Miller, "Can Gays 'Convert'?" *Newsweek*, 17 August 1998, 49.

40. Christine Gorman, "Are Gay Men Born That Way?" *Time*, 9 September 1991, 61.

41. Esther Davidowitz, "The Secret Life of Bisexual Husbands," *Redbook*, September 1993, 137.

42. Kim Painter, "The Breadth of Bisexuals' Experience," *USA Today*, 24 February 1994, L/N.

43. John Leland, "Bisexuality," *Newsweek*, 17 July 1995, 46.

44. Toufexis, "Bisexuality," 50.

45. E.L. Pattullo, "Straight Talk about Gays," *Commentary*, December 1992, 21.

46. Ibid., 22.

47. Erica E. Goode, "Intimate Friendships," *U.S. News & World Report*, 5 July 1993, 49.

48. Ibid., 52.

49. Quoted in Carmen J. Lee, "Biologist Reassures Gays about His Research," *Pittsburgh Post-Gazette*, 24 January 1994, L/N.

50. Burr, "Homosexuality and Biology," 47.

51. Quoted in Adam Clymer, "Lawmakers Revolt on Lifting Gay Ban in Military Service," *New York Times*, 27 January 1993, L/N.

52. Presidential Press Conference, "Remarks Announcing the New Policy on Gays and Lesbians in the Military," 19 July 1993, dont.stanford.edu/casestudy/casestudy.html (accessed May 3, 2004).

53. Quoted in David H. Hackworth, "The Key Issue Is Trust," *Newsweek*, 23 November 1992, 27.

54. Thomas Sowell, "Homosexuals in the Military," *Forbes'*, 21 December 1993, 146.

55. Quoted in Scott Tucker, "Choosing Sides in the Culture War," *Humanist*, July/August 1993, 30.

56. Mike Royko, "Gays in the Military?" The Issue Is *Not* Discrimination," *Reader's Digest*, June 1993, 148.

57. Eric Schmitt, "Gay Shipmates? Senators Listen as Sailors Talk," *New York Times*, 11 May 1993, L/N.

58. "'My Son Is a Homosexual,'" *Newsweek*, 24 May 1993, 24.

59. Quoted in Dirk Johnson, "Military People Split Over Ban on Homosexuals," *New York Times*, 28 January 1993, L/N.

60. Quoted in ibid.

61. Quoted in T.R. Reid, "Sailor 'Didn't Regret' Killing Gay Shipmate," *Chicago Sun-Times*, 26 May 1993, L/N.

62. Department of Defense, *Enlisted Administrative Separations, Directive 1332.14* (Washington, DC: U.S. Government Printing Office, 1982).

63. In theory, the debate over gays in the military was gender-neutral. As concern about AIDS-inflicted soldiers and the prevalence of examples about gay male sexual aggression suggest, underlying anxieties were clearly linked to gender—specifically the maintenance of normative masculinity within the homosocial context of the military—for many of those supporting the ban. Nevertheless, the debate simultaneously framed the issue in terms of the rights of a more-or-less gender-neutral gay and lesbian minority versus the rights, stability, and order of a straight majority. As the circulation of both discourses throughout the process indicates, the debate served as a site were both male homosexual panic and straight panic operated.

64. As the quote above indicates, the specter of AIDS did circulate, but it was subordinated to the dominant discourse about unit cohesion. Its absence is surprising, given how powerful it had been just a few years earlier. The military's aggressive regime of AIDS testing along with more prevalent HIV- and AIDS awareness campaigns that focused on risky behaviors rather than risk groups are likely explanations.

65. House Committee on Armed Service, *Policy Implications of Lifting the Ban on Homosexuals in the Military*, 103rd Cong., 1st sess., 1993, 90–91.

66. Senate Committee on Armed Services, *Policy Concerning Homosexuality in the Armed Forces*, 103rd Cong., 2d sess., 1993, 542. Various military reports ranging from the 1957 U.S. Navy's *Crittenden Report* to a Department-of-Defense-commissioned study in 1988–1989 told military officials that gay and lesbian soldiers could serve with distinction. See Janet Halley, "Reasoning About Sodomy: Act and Identity In and After *Bowers v. Hardwick*," *Virginia Law Review* 79, no. 7 (October 1993): 1803.

67. Quoted in Frank Browning, "Boys in the Barracks," *Mother Jones*, March/April 1993, 24.

68. Presidential Press Conference, "Remarks Announcing the New Policy."

69. William A. Henry III, "A Mind-Set Under Siege," *Time*, 30 November 1992, 41.

70. Bruce B. Auster, "Shape Up or Ship Out," *U.S. News & World Report*, 5 April 1993, 31.

71. Senate Committee, *Policy Concerning Homosexuality in the Armed Forces*, 597.

72. House Committee, *Policy Implications of Lifting the Ban on Homosexuals in the Military*, 197.

73. Tom Morganthau, "Gays and the Military," *Newsweek*, 1 February 1993, 55.

74. Quoted in Bruce B. Auster, "Shape Up or Ship Out," 25.

75. Senate Committee, *Policy Concerning Homosexuality in the Armed Forces*, 595.

76. Ibid., 604.

77. Quoted in Bruce B. Auster, "Dropping a Bomb on the Pentagon," *U.S. News & World Report*, 1 February, 1993, 41

78. Kenneth T. Walsh. "Why Clinton Fights For Gays," *U.S. News & World Report*, 8 February, 1993, 33.

79. Although certain mainstream understandings of race assumed it was biologically determined, scientists have repeatedly pointed out that race is a social construct. The fact that markers of racial identity—most notably skin color—can be explained genetically helps reinforce cultural assumptions about the fixed and stable nature of racial identity. That isn't to say that those assumptions are unchallenged, of course. Discourses about biraciality and racial passing revealed similar anxieties about the nature of the boundary between various racial identities. The much-discussed cover of *Time*'s 1993 issue on the changing racial profile of America, which featured a computer-generated multiracial Eve in order to underscore the "browning" of the nation, reveals that like sexual identity, racial taxonomies were destabilized in ways that reflected a white mainstream's anxieties about its status as America's unmarked racial norm. (See Roediger, *Colored White*; Hill, *After Whiteness*; Berlant, *The Queen of America*). Nevertheless, I'd argue that within the debate, race was constructed as a stable, categorical given.

80. Henry III, "A Mind-Set Under Siege," 42. Not surprisingly, few military personnel admitted that their discomfort with homosexuals arose from a sense of insecurity about their own sexual identity. Most cited strong religious belief or privacy concerns as the reason for their support of the ban.

81. E.L. Pattullo, "Why Not Gays in the Military?" *National Review*, 1 March 1993, 40.

82. Catherine S. Manegold, "The Odd Place of Homosexuality in the Military," *New York Times*, 18 April 1993, L/N.

83. David Gelman, "Homoeroticism in the Ranks," *Newsweek*, 26 July 1993, 28.

84. Manegold, "The Odd Place."

85. Quoted in Patricia Holt, "Selective Service: The Military's Indecisiveness on Gays in the Ranks," *San Francisco Chronicle*, 11 April 1993, L/N.

86. Department of Defense, *Enlisted Administrative Separations, Directive 1332.14*. For further discussion of policy, see Janet E. Halley, "The Status/Conduct Distinction in the 1993 Revisions to Military Anti-Gay Policies," *GLQ* 3, nos. 2–3 (1996): 159–252.

87. Jose Zuniga, "My Life in the Military Closet," *New York Times Magazine*, 11 July 1993, 42. The idea of well-disciplined gay soldiers being visibly indistinguishable from straight soldiers had its counterpart in civilian life. Coverage of the 1993 March on Washington, for example, included footage of drag queens, bare-breasted dykes on bikes, and members of the leather community in chaps and harnesses. However, photos also showed countless people that conformed to standard (i.e., heteronormative) norms of appearance. David Mixner, for example, told *Newsweek* that "98 percent of the marchers are people America will recognize as their sons and daughters" (William Henry III, "Not Marching Together," *Time*, 3 May 1993, 51). In assessing how the media covered the March, some observers claimed that the media actually went out of its way to shown images of gay people who were visibly indistinguishable from straight people. According to Andrew Kopkind, "the reporters and TV cameras that jammed Washington for the weekend seemed to concentrate on the nice young men in jeans and white T-shirts who could have been going to an office picnic or Michael Bolton concert." Quoted in Alicia C. Shepard, "Did the Networks Sanitize the Gay Rights March?" *American Journalism Review* (July/August 1993): 28.

88. Henry III, "A Mind-Set Under Siege," 42.

89. Quoted in John Barry and Daniel Glick, "Crossing the Gay Minefield," *Newsweek*, 23 November 1992, 26.

90. Amy Hequembourg and Jorge Arditi, "Fractured Resistances," 672.

91. Presidential Press Conference, "Remarks Announcing the New Policy."

92. Ibid.

93. Department of Defense, "Qualification Standards for Enlistment, Appointment, and Induction," *Department of Defense Directive 1304.26*, Enclosure 2 (1993), dont.stanford.edu/doclist.html (accessed May 3, 2004).

94. Before *Lawrence v. Texas* recently overturned Texas' antigay sodomy law and with it *Bowers v. Hardwick*, the conflation of homosexual status/identity with homosexual conduct/sodomy in legal precedent had been an important way in which the courts upheld laws that discriminate against gays and lesbians. Many laws that prohibit sodomy were facially neutral; they simply prohibit sex involving anal-genital or oral-genital contact and pertain to both homosexual and heterosexual sex. Historically, however, such laws had been applied with bias both by law enforcement and the courts. The conflation of sodomy and homosexuality was made glaringly official in Justice White's opinion in *Bowers v. Hardwick* that repeatedly conflated homosexual sex with sodomy. In *Padula v. Webster*, the D.C. circuit court denied granting gays and lesbians suspect class standing on the grounds that *Bowers* had upheld sodomy statutes which, in the words of *Padula* "criminalize the behavior that defines the class" (*Padula v. Webster*, 822 F. 2d 97 [D.C. Cir. 1987]: 103). In other words, homosexual identity was coterminous with sodomy redefined as homosexual conduct. This conflation undergirded the military's logic for the ban on gays and lesbians. Although straight soldiers presumably commit sodomy off-base with open immunity, celibate gays and lesbians (or those who don't practice anal or oral sex) were banned from service. By allowing closeted gays to serve, "don't ask, don't tell" theoretically acknowledged that homosexual identity and behavior aren't always the same. But since soldiers who simply admitted to being gay were barred, it simultaneously reasserted the conflation. Queer activists argued that if gays and lesbians could reassert the facial neutrality of sodomy and implicate heterosexual behavior (oral sex and anal sex), the heteronormative burden of deviancy could be shared by straights. Presumably, redrawing the lines of sodomy to include such widespread heterosexual behavior would make it easier to challenge the regulatory power of sodomy laws.

95. Diane Helene Miller, *Freedom to Differ: The Shaping of the Gay and Lesbian Struggle for Civil Rights* (New York: New York University Press: 1998), 87. Miller specifically examines the rhetoric surrounding the Senate nomination hearings for Roberta Achtenberg (whom Clinton appointed to be an assistant secretary for Housing and Urban Development) and the military's case against Margarethe Cammermeyer.

96. Eloise Salholz, "The Power and the Pride," *Newsweek*, 21 June 1993, 60.

97. Bill Clinton, "Acceptance Address, Democratic Nominee for President," *Vital Speeches of the Day*, 15 August 1992, 645.

98. Didi Herman, *Rites of Passage: Struggle for Lesbian and Gay Legal Equality*, (Toronto: University of Toronto Press, 1998), 38.

99. Jane S. Schacter, "Skepticism, Culture and the Gay Civil Rights Debate in a Post-Civil-Rights Era," *Harvard Law Review* 110 (January 1997): 698.

100. Ibid., 720–721. While I agree with Schacter's basic premise (i.e., that ostensibly neutral categories aren't "read" as neutral because of the processes of ex-nomination), I argue that in the early 1990s, as multiculturalism and the politics of social difference increasingly nominated dominant social positions, such laws became even more anxiety-producing for the mainstream.

101. Miller, *Freedom*, 5. Also see Janet E. Halley, "The Politics of the Closet: Towards Equal Protection for Gay, Lesbian, and Bisexual Identity," *UCLA Law Review* 36, no. 5 (June 1989): 915–976; Janet E. Halley, "Reasoning About Sodomy: Act and Identity In and After *Bowers v. Hardwick*," *Virginia Law Review* 79, no. 7 (October

1993): 1721–1780; Janet E. Halley, "The Construction of Heterosexuality," in *Fear of a Queer Planet*, ed. Michael Warner (Minneapolis: University of Minnesota Press, 1993).

102. Miller, *Freedom*, 142.

103. Paisley Currah, "Searching for Immutability: Homosexuality, Race and the Rights Discourse," in *A Simple Matter of Justice? Theorizing Lesbian and Gay Politics*, ed. Angela R. Wilson (London: Cassell, 1995), 57. Also see Darren Lenard Hutchinson, "'Gay Rights' for 'Gay Whites'?: Race, Sexual Identity, and Equal Protection Discourse," *Cornell Law Review* 85, no. 5 (July 2000): 1385; Patricia A. Cain, "Litigating for Lesbian and Gay Rights: A Legal History," *Virginia Law Review* 79, no. 7 (October 1993): 1551–1641.

104. Chuck Stewart, *Homosexuality and the Law: A Dictionary* (Santa Barbara: ABC Clio, 2001), 287.

105. The courts have also identified an intermediate (quasi-suspect class), which requires heightened, rather than strict scrutiny. Gender and illegitimacy have been given quasi-suspect class standing.

106. See Cain, "Litigating"; Currah, "Searching for Immutability."

107. See Miller, *Freedom*; Craig A. Rimmerman, "Beyond Political Mainstreaming: Reflections on Lesbian and Gay Organizations and the Grassroots," in *The Politics of Gay Rights*, ed. Craig A. Zimerman, Kenneth D. Wold, and Clyde Wilcox (Chicago: University of Chicago Press, 2000), 54–78; Joshua Gameson, "Publicity Traps: Television Talk Shows and Lesbian, Gay, Bisexual, and Transgender Visibility," *Sexualities* 1, no. 1 (1998): 11–41; Simon Watney, "Queer Epistomology: Activism, 'Outing,' and the Politics of Sexual Identities," *Critical Inquiry* 36, no. 1 (spring 1994): 13–27; Ralph R. Smith and Russell R. Winds, "The Progay and Antigay Issue Culture: Interpretation, Influence and Dissent," *Quarterly Journal of Speech* 83 (1997): 28–48; Carlos A. Ball, "Communitarianism and Gay Rights," *Cornell Law Review*, 85, no. 2 (January 2000): 443–517.

108. Jon E. Yang, "Lines Drawn in Oregon Gay Rights Battle," *Washington Post*, 27 September 1992, L/N.

109. Quoted in Jane S. Schacter, "The Gay Civil Rights Debate in the States: Decoding the Discourse of Equivalents," *Harvard Law Review* 29, no. 2 (June 1994): 283–317. The full text of Oregon's Ballot Measure 9 reads: "(1) This state shall not recognize any categorical provision such as 'sexual orientation,' 'sexual preference,' and similar phrases that include homosexuality. Quotas, minority status, affirmative action, or any similar concepts shall not apply to these forms of conduct, nor shall government promote these behaviors. (2) State, regional, and local governments and their monies shall not be used to promote, encourage, or facilitate homosexuality, pedophilia, sadism or masochism. (3) State, regional and local governments and their departments, agencies and other entities, including specifically the public Department of Higher Education and the public schools, shall assist in setting a standard for Oregon's youth that recognizes homosexuality, pedophilia, sadism and masochism as abnormal, wrong, unnatural, and perverse and that these behaviors are to be discouraged and avoided."

110. Quoted in Robert E. Sullivan Junior, "Bashers," *New Republic*, 21 September 1992, 9.

111. Quoted in Robert Sullivan, "Revolution Number 9," *New Yorker*, 11 September 1992, 69.

112. Quoted in J.M. Balkin, "The Constitution of Status," *Yale Law Journal* 106, no. 8 (June 1994): 2316.

113. Quoted in Gallagher and Bull, *Perfect Enemies*, 51.

114. Quoted in Bella Stumbo, "The State of Hate," *Esquire*, September 1993, 73.

115. Quoted in Schmalz, "Gay Politics Goes Mainstream," 20.

116. Gallagher and Bull, *Perfect Enemies*, 117.

117. Quoted in Yang. Christian Action Network produced a 30-second TV ad that aired during the 1992 presidential campaign and even more explicitly linked support for nondiscrimination policies with affirmative action policies. It included a voiceover that said, "Bill Clinton's vision for a better America includes job quotas for homosexuals. Is this your vision for a better America?"

118. Jane Schacter, "The Gay Civil Rights Debate in the States," 305.

119. Quoted in Gallagher and Bull, *Perfect Enemies*, 112.

120. Quoted in Barbara Vobejda, "Gay Rights Ruling Highlights Society's Fault Lines," *Washington Post*, 22 May 1996, L/N.

121. Didi Herman, *The Antigay Agenda: Orthodox Vision and the Christian Right* (Chicago: University of Chicago Press, 1997), 134. In defending the law before the Supreme Court, Colorado argued that gays and lesbians were already protected from arbitrary discrimination by a Colorado law (the Smokers' Bill of Rights) that prohibited employers from arbitrarily discriminating on the basis of personal behavior that is legal. Since sodomy was legal in Colorado, the state argued, adding sexual orientation to a list of categories gives it a special status. Jeffrey Rosen, "Disoriented," *New Republic*, 23 October 1995, 24–26.

122. John Leo, "No More Rights Turns," *U.S. News & World Report*, 23 October 1995, 34.

123. Quoted in Richard Corliss, "Colorado's Deep Freeze," *Time* 14 December 1992, 54.

124. Katia Hetter, "Gay Rights Issues," 71.

125. Ronald Dworkin, "Sex, Death, and the Courts," *New York Review*, 8 August 1996, 44.

126. *Romer v. Evans*, 517 U.S. 620 (1996), 633.

127. *Romer v. Evans*, 631. Kennedy pointed out that the anti-bias ordinances in Aspen, Boulder, and Denver enumerated extensive lists of traits that couldn't be the basis for discrimination, including military status, age, marital status, parenthood, pregnancy, custody of a minor child, political affiliation, and mental or physical disability. To argue that adding sexual orientation to such lists offered gays and lesbians special privileges was illogical.

128. *Romer v. Evans*, 635.

129. Ibid., 636 (dissenting opinion).

130. *Bowers v. Hardwick*, 478 U.S. 186 (1986), 196.

131. *Romer v. Evans*, 636 (dissenting opinion).

132. Quoted in Joyce Murdoch and Deb Price, *Courting Justice: Gay Men and Lesbians v. the Supreme Court* (New York: Basic Books, 2001), 462.

133. "Should the Senate Approve Nondiscrimination Act?" *Congressional Digest*, November 1996, 267–287. Georgia Senator Paul Coverdall, for example, declared, "we should not be creating a new special category of citizens" (281). As in Colorado, the anti-discrimination law was easily framed as affirmative action. Missouri Senator John Ashcroft, for example, argued that "legislation that gives special standing to a particular category of conduct . . . sends a signal that says that conduct is to be elevated, it is to be approved" (285). Although the bill explicitly prohibited quotas for gays and lesbians, senators like Ashcroft argued that once caught up in the bureaucracy of the Equal Opportunity Employment Commission and the psychology of nondiscrimination policies, such a laws would lead to de facto job preferences for gays.

134. "So Different, So Much the Same," *People*, 10 June 1996, 56–57. In discussing the ways parenthood can transform gay people's lives and blur the boundary between being gay and straight, the article claimed that "Parenthood trumped sexual preference as the governing social factor in their lives." Carpooling kids to school and soccer, going to PTA meetings, and other parental responsibilities have made these gay parents realize they have more in common with straight couples than gay

people without kids. "Now our friends are mostly heterosexual couples," one gay man says (53).

135. In the summer of 1998, a coalition of eighteen conservative groups spent $600,000 on a print campaign that appeared in nine newspapers and ignited a national debate. The August 17, 1998 cover of *Newsweek*, for example, featured John and Anne Paulk—a married couple who emerged as the poster couple for the ex-gay movement. The cover's title read, "Gay for Life? Going Straight: The Uproar over Sexual 'Conversion.'"

136. Jonathan Van Meter, "The Post-Gay Man," *Esquire*, November 1996, 88–89.

137. James Collard, "Leaving the Gay Ghetto," *Newsweek*, 17 August 1998, 53; Rick Nelson, "Straight Ahead," *Utne Reader*, March–April 1997, 18.

CHAPTER 3: NETWORK NARROWCASTING AND THE SLUMPY DEMOGRAPHIC

1. Quoted in Rick Du Brow, "Television; Networking '90s Style," *Los Angeles Times*, 9 April 1995, L/N.

2. In 1976, 86 percent of the nation's 710 television stations were affiliated to one of the Big 3 networks. There were only 94 independent or PBS-affiliated stations in the country. See Christopher H. Sterling and John M. Kitross, *Stay Tuned: A Concise History of American Broadcasting*, 2d ed. (Belmont, California: Wadsworth, 1990), 637, 663.

3. J. Fred McDonald, *One Nation Under Television: The Rise and Fall of Network TV* (New York: Pantheon Books, 1990), 221.

4. Ibid.

5. Ibid, 201

6. Joseph Turow, *Breaking Up America: Advertisers and the New Media World* (Chicago: University of Chicago Press, 1997), 40; Lizabeth Cohen, *A Consumer's Republic* (New York: Alfred A, Knopf, 2003), 292–344.

7. Whether Americans were or weren't more divided during and after the 1970s than they had been before isn't the point, of course; the fact that advertisers believed them to be more fractured is. Turow, *Breaking Up America*, 40–47.

8. Cohen, *A Consumer's Republic*, 312.

9. See Turow, *Breaking Up America*, 43–49; Thomas Moore, "Selling: Different Folks, Different Strokes," *Fortune*, 16 September 1985; Bickley Townsend, "Psychographic Glitter and Gold," *American Demographics*, November 1985; Jeff Dejoseph, "Standing at the Crossroads," *Marketing & Media Decisions*, October 1983; Jack J. Honomichl, "Marketing Information Service Business Growing," *Advertising Age*, 23 May 1985; B.G. Yovovich, "For the Rich, Home Is Where the Heart Is," *Advertising Age*, 23 August 1984; David Tracey, "Progress Toward Lifestyle Analyses," *Marketing & Media Decisions*, June 1981; Philip Maher, "Psychographics and Corporate Advertising: Powerful Techniques Are Slowly Taking Hold," *Industrial Marketing*, February 1983; Mitchell, Arnold, *The Nine American Lifestyles: Who We Are and Where We're Going* (New York: Warner Books, 1983).

10. Robin Murray, "Fordism and Post-Fordism," in *New Times: The Changing Face of Politics in the 1990s*, ed. Stuart Hall and Martin Jacques (London: Verso, 1990), 41. Of course, the relationship between market research and consumer behavior is a two-way street. While market research ostensibly only reported on real consumers' behavior, marketers' work was hardly passive. As consumerism intensified, Americans were increasingly encouraged to define their identities through their consumption of niche-oriented products and media.

11. See Murray, "Fordism and Post-Fordism," 38–43; Robin Murray, "Benetton Britain: The New Economic Order," in Hall and Jacques, *New Times*, 54–64; Turow, 32; David Harvey, *The Conditions of Postmodernity* (Oxford: Blackwell, 1989).

12. Quoted in Lisa Marie Peterson, "Targeted Audiences Help Break New Categories," *Adweek*, 14 September 1992, 52.
13. Turow, *Breaking Up America*, chapters 5 and 6.
14. Carol Dannhauser, "The Era of Micro-Marketing," *Brandweek*, 14 December 1992.
15. Quoted in "Classic Patrick," *Broadcasting*, 24 July 1989, 33.
16. See Katherine Barrett, "Taking a Closer Look," *Madison Avenue*, August 1984; "Season Tally, CBS-TV Chalks Three in a Row," *Broadcasting*, 26 April 1982, 75; "The Prime Time Honors Goes to CBS," *Broadcasting*, 25 April 1983, 23–24; "CBS Runs Away with the '83–'84 TV Season," *Broadcasting*, 23 April 1984, 35–36; "Fierce Struggle for Shrinking Market," *Broadcasting*, 29 April 1985, 37–38; "After 31 Years, It's NBC," *Broadcasting*, 28 April 1986, 35–37; "NBC-TV's Season Victory Overshadowed by Viewer Erosion," *Broadcasting*, 20 April 1987, 42.
17. Although frequently dismissed by network executives as derivative, low-budget, and full of reruns of old network shows, cable programming had successfully established a positive reputation with viewers. A 1989 Roper poll of viewers' attitudes toward cable versus "regular TV," for example, found a clear preference for cable in every category except news. MacDonald, *One Nation*, 229.
18. Nathan Cobb, "Prime Time Sex," *Boston Globe*, 30 April 1989, L/N.
19. Joe Mandese, "Power Surge: With Daytime and Kids' TV as Stronghold, Syndicators Are Taking Aim at Prime Time," *Advertising Age*, 8 March 1993; Eric Schmuckler, "Special Report: Syndicated TV—The Prime-Time Assault Is Paying Off," *Adweek*, 14 September 1992, 56.
20. If cable and broadcast competition struck at the heart of network market share, other developments in this period hurt the networks' overall ratings. VCRs, for example, went from being the expensive plaything of the 1970s technophile to a standard-issue appliance in most American homes. In 1982 only 4 percent of American households with a TV set (Houses Using Television) also had a VCR; just six years later, however, over 60 percent did. Like video games and the remote control, VCRs transformed the way people used their television sets. By the late 1980s, for example, Americans rented an average of 2.3 videos per month and VCR use accounted for 9 percent of TV use on Saturday nights, drawing their attention away from network programs ("VCR Usage on Fast Forward," *Broadcasting & Cable*, 4 April 1988, 114, 118; "NBC-TV's Season Victory Overshadowed by Viewer Erosion," *Broadcasting*, 20 April 1987, 42; MacDonald, *One Nation*, 223). At the same time, viewers seemed increasingly disenchanted with television. A 1983 National Association of Broadcasters report found that television was less important in people's lives than it had been five years earlier. (MacDonald, 258). Not surprisingly, reports showed that television viewing had begun to decline. In the 1986–1987 season, A.C. Nielsen reported that the minutes spent watching television in the average household dropped for the first time. The trend continued in 1987–1988 (MacDonald, 259).
21. Ken Auletta, *Three Blind Mice: How the TV Networks Lost Their Way* (New York: Vintage Books, 1991), 469.
22. In 1988, for example, the networks experienced their most lucrative upfront market in history, pre-selling $3.4 billion dollars of ad time and increasing their prime-time cost per thousand by nearly 10 percent. Ibid, 471.
23. A relatively strong ad market didn't completely blind the networks to the increased competition they faced. Throughout the late 1980s, they took a number of measures aimed at repositioning themselves in this newly competitive industry. They invested in cable channels, cut overhead, renegotiated affiliate compensation deals, developed lean programming formats that brought a higher return on investment, lobbied against FCC renewal of the Fin-Syn Rules, and countered the pro-cable, anti-network buzz that had been circulating among advertisers. Nevertheless, the

networks were slow to abandon a broadcasting mentality and remained optimistic that erosion would soon level off. Their 1970s-era mindset, it seems, was receding more slowly than their market share. Don Ohlmeyer, head of NBC's West Coast operations in the mid-1990s, for example, remembers an NBC executive in the early 1980s who reassured him that network audience share would never drop below 82; extensive network studies had proven it. "Don Ohlmeyer and the Second Coming of TV," *Broadcasting & Cable*, 12 April 1993, 44.

24. Stanley E. Cohen, "The Dangers of Today's Media Revolution," *Advertising Age*, 30 September 1991, 18.

25. Paul Farhi, "'Recession-Resistant' TV Networks Feel Pinch," *Washington Post*, 27 October 1990, L/N; Stuart Elliott, "Networks Having Trouble Peddling Fall's Prime Time," *New York Times*, 19 June 1991, L/N; Charles Trueheart, "Ads & Media, Down with the Recession Flu," *Washington Post*, 24 September 1991, L/N; Richard Huff, "Basic-Cable Survives Recession—and Itself," *Daily Variety*, 3 March 1993, L/N.

26. Tom Eisenmann, "Nets React to Buying Links," *Advertising Age*, 25 July 1988.

27. See Eric Schmuckler, "The Nets Decline but By No Means Fall," *Adweek*, 14 September 1992, 42–43.

28. The only other year-to-year decline in revenues occurred in 1971 in the wake of the cigarette-advertising ban. Diane Mermigas, "TVB: Broadcast Revenues Off 4.9%," *Electronic Media*, 9 September 1991, L/N; Diane Mermigas, "Network Bashing No Longer in Vogue," *Advertising Age*, 11 May 1992, S-14.

29. Diane Mermigas, "Ad Hoc Networks Beating the Odds," *Electronic Media*, 10 February 1992, 12.

30. Peterson, 50. Also see Vicki Contavespi, "Media Wars," *Forbes*, 19 August 1991; Robert Sobel, "Carving Out an Audience," *Advertising Age*, 8 April 1991; "Cable's Ad Allure Strong Despite Some Budget Cuts," *Advertising Age*, 9 December 1991, 28; Alison Hahey, "Media Outlook—Cable TV: Right Place, Right Time," *Advertising Age*, 14 October 1991.

31. Greg Clarkin, "Sex, Lies & Cable," *Marketing & Media Decisions*, April 1990, L/N.

32. The *Advertising Age* and *Electronic Media* survey's more complete results were in 1990: 49 percent network TV, 16 percent cable, 15 percent spot, and 5 percent syndicated TV; in 1993: 36 percent network TV, 21.5 percent cable, 20 percent spot, and 11.5 percent syndicated. Joe Mandese, "Love It/Hate It, Buyers Stick with Network TV," *Advertising Age*, 24 May 1993, L/N. Of course some advertisers still preferred network television's broad national reach and in fact feared cable's threat to the efficiency of national marketing. Paul Shulman of Paul Shulman Associates, a major buyer of commercial time, for example, warned: "The attitude is if the networks lose the ratings and share points, we'll just get them somewhere else. You hear that all the time at agencies, and that's ridiculous. If they go to cable, you'll never get them back. The networks remain the quickest way to get a national audience." Quoted in Jeremy Gerard, "3 Networks Forming Trade Alliance," *New York Times*, 13 February 1989, L/N.

33. Various dayparts, for example, had been divided up according to audience categories—daytime for women, late afternoon for kids, early prime time for families, and late evening for adults. The networks also had a long history of counter-programming with different audience segments in mind. See Erik Barnouw, *The Sponsor* (New York: Oxford University Press, 1978).

34. Julie D'Acci, *Defining Women: Television and the Case of Cagney & Lacey* (Chapel Hill: University of North Carolina Press, 1994)

35. Turrow, *Breaking Up America*, 26.

36. D'Acci, *Defining Women*, 101–104.

37. Quoted in Mandese, "Love It/ Hate It."

38. Quoted in ibid. Ad revenue went up tremendously in the mid-1990s.
39. Quoted in Sharon D. Moshavi, "Post Baby-Boomers: Elusive Target for Advertisers," *Broadcasting*, 7 December 1992, 44.
40. Quoted in Daniel Cerone, "The Fountain of Youth Equation," *Los Angeles Times*, 7 June 1992, L/N.
41. Quoted in Lynette Rice, "Moonves Urges Broadcast Solidarity," *Broadcasting & Cable*, 30 September 1996, 27.
42. Quoted in Rick Du Brow, "Television; It's Not a Dream," *Los Angeles Times*, 5 April 1992, L/N.
43. When the Big 3 tried to counter the cable industry's successful PR campaigns that touted the great demographics cable offered advertisers, the Big 3 started to play the demographics game, claiming that if you wanted to reach upscale adults with incomes over $50,000 or any other demographic, the place to reach them was network TV because with the networks' huge audiences, advertiser's messages would reach more of that target audience. According to George Schwitzer, vice-president of marketing and communications for CBS, ". . . the beauty of network TV is that we can deliver a target audience in greater numbers than any cable programming or network package" (Mermigas, "Network Bashing No Longer in Vogue"). Of course the networks conveniently overlooked the fact that advertisers were also looking for audience purity and the cheap ad rates that came with it. Advertisers didn't want to pay for all the eyes outside their target audience that they would have to pay for in order to buy network time.
44. "Robert Iger on Prime Time, Prime Demos and the Business of Entertainment," *Broadcasting*, 1 June 1992, 12.
45. Quoted in Cerone, "The Fountain of Youth Equation."
46. Quoted in Brian Lowry, "Television; Family? Values," *Los Angeles Times*, 14 June 1998, L/N.
47. According to one buyer, the dynamics of the ad market in the 1990s included the tastes of New York–based advertisers who tended to love the hip, urban attitude of *Seinfeld*. "There's always some show that is hot with the brand managers," he claims. "It used to be 'thirtysomething.' Right now it's *Seinfeld*.' *Seinfeld*' is the most popular show among critics and media buyers, but it's not that big in terms of viewers. It might not even be demographically right for your brand, but if you want to make your brand manager living in New York happy, you put them in 'Seinfeld,' because it's the show brand managers watch." Quoted in Joe Mandese, "TV Net's Pursuit of Youth Creates Void," *Advertising Age*, 16 November 1992, L/N.
48. "Robert Iger on Prime Time, Prime Demos," 12.
49. Quoted in Rick Du Brow, "Television; Networking '90s Style," 9 April 1995, L/N.
50. According to Nielsen Media Research, the average number of hours different adult segments spent watching TV per week in 1992 were as follows: women 18–34, 26 hours 58 minutes; women 35–54, 29 hours 55 minutes; women 55+, 39 hours 52 minutes; men 18–34, 23 hours 38 minutes; men 35–54, 26 hours 02 minutes; men 55+, 36 hours 35 minutes. Moshavi, "Post Baby-Boomers," 44. Also see Brian Lowry, et al., "TV's Diversity Dilemma," *Los Angeles Times*, 20 July 1999, L/N.
51. Quoted in Cerone, "The Fountain of Youth Equation."
52. Vicki Thomas and David B. Wolfe, "Why Won't Television Grow Up?" *American Demographics*, May 1995, L/N. Similarly, in 1996, CBS's *Touched by an Angel* actually won its time slot with total viewers, but its $150,000 per 30-second spot was the lowest ad rate of the four programs aired at that time because of its older-skewing demographics. NBC, for example, demanded $225,000 for *3rd Rock from the Sun*, Fox got $185,000 for *The Simpsons*, and ABC earned $175,000 for *Lois & Clark: The New Adventures of Superman*. Jefferson Graham, "It's Spin City at No. 3; ABC

Network Says Demographics Favor Its New Shows, Stars," *USA Today*, 30 September 1996, L/N.

53. Quoted in Moshavi, "Post Baby-Boomers," 44.

54. While there was a general consensus about the primacy of 18-to-49 year olds among major manufacturers and retailers, there was, in the 1990s, a growing debate over the validity of many marketing assumptions. Despite huge investments in consumer research and the widespread use of survey results and number-crunching techniques, marketing was still strongly influenced by speculation and unfounded generalizations. A number of marketers supported by media outlets like CBS (which had a vested interest in the issue because of its older-skewing audiences) challenged what they believed to be an over-valuation of 18-to-49 year olds and an under-valuation of the strength of the 50+ demographic. Such critics argued that the demographic trends of an aging population would inevitably swell the ranks of the 50+ segment and that aging baby boomers, improved quality of life for seniors, and other social changes were dramatically altering the consumer behavior of older Americans. Instead of reassessing older consumer markets, these critics complained, marketers and media outlets were actually turning their attention the opposite way and were fixated on increasingly younger demographics. In fact, one could rightly say that while 18-to-49 year olds officially remained the key demo, 18-to-34 year olds were the hot market segment advertisers had in mind when they thought about reaching adults.

There were a number of explanations for this youth craze. Some critics blamed the marketing world's fear of change. David Poltrack, CBS vice president of research and one of the major voices trying to debunk the youth obsession, claimed: "Once [media buyers] establish a ritualized way of doing business, to change the demos creates uncertainty and a lot of work" (quoted in Lisa de Moraes, "ABC's Lowest Rating Has the Alphabet Net in the Soup," *Hollywood Reporter*, 16 April 1997, L/N). Some also cited the demographics of the media-buying world itself. Most advertising representatives are in their late twenties or early thirties and, the argument goes, more easily appreciate their peers than those consumers old enough to be their parents or grandparents. In one illuminating anecdote, a salesperson for cable's older-skewing Goodlife TV Network remembers trying to sell time to a manufacturer of products for menopausal women. The young media buyer wasn't impressed with his presentation, claiming that the age of the network's average viewer (52.1) was too old (Michael Schneider, "The Young Make Them Restless," *Electronic Media*, 1 March 1999, L/N). Finally, critics also complained that Nielsen marketing research (the industry's main source of information) lumped a wide range of consumers into one imprecise category of 50+ and thus obscured the important consumer activities of people in their fifties or sixties.

Throughout the 1990s, CBS tried to redefine the primary demographic as 18-to-54 or 25-to-54. In 1994, Howard Stringer, President of the CBS Broadcasting Group, dismissed the other networks' interest in the under-25 demographic, snidely claiming that "The only ones under 25 with disposable income are drug dealers or Sagansky's children." Jeff Sagansky was an ABC executive who touted ABC's strength with younger viewers (quoted in Jon Lafayette, "CBS, ABC Tote Up '93–94 Season Gains," *Electronic Media*, 25 April 1994, L/N). By 1997, CBS pushed a more narrowly targeted 35-to-54 baby boomer category to ad buyers with little success. As the decade came to a close, such efforts did little to stop the appeal of the youth market (18-to-34 or even younger). The success of the WB's youth-targeted lineup of shows like *Buffy the Vampire Slayer*, *Dawson's Creek*, and *Felicity* seemed to indicate that the draw of young adults with advertisers was growing, not diminishing. Nevertheless, there was some indication that more marketers and media outlets were willing to consider expanding the 18-to-49 demographic to

include aging baby boomers entering their fifties. A 1993 *Advertising Age* and *Electronic Media* study of advertiser attitudes found that while the 18-to-49 demographic was, according to respondents, the most desired prime-time demo in 1990 with 51.5 percent of the vote, by 1993 25-to-54 had become the most desired, with 48.5 percent (Julie Steenhuysen, "TV Advertisers Play Follow the Aging Baby Boomer," *Advertising Age*, 24 May 1993, L/N).

In fact, as demographic trends continue and marketers become interested in the huge population bulges of the baby boomers and their children—the so-called echo boomers, one might predict a bifurcation of the 18-to-49 demo into two separate, but equally desirable markets. See Richard Katz, "CBS Boomer Pitch Off Target," *Mediaweek*, 13 October 1997, 6–8.

55. Quoted in Steenhuysen, "TV Advertisers Play."
56. Turow, *Breaking Up America*, 59.
57. The networks also favored an urban-skewing demographic of upscale adults because of a longtime, self-serving bias toward urban demographics. Much of the networks' overall profitability has always come from revenue generated by local ad sales in the five broadcast stations they owned and operated (O & Os) in the nation's most lucrative—meaning largest—markets. In 1970, CBS executives realized that although their top-rated schedule of rural sitcoms like *Hee Haw*, *Petticoat Junction*, and *The Beverly Hillbillies* brought in a national audience, they didn't maximize the income potential of their O&O stations. Thus, in what has been dubbed the "turn to relevance," CBS dumped those rural-skewing shows in favor of more urban-skewing sitcoms like *All in the Family*, *Maude*, and *Good Times*. The importance of the urban-market O&Os and thus of urban audiences was still significant in the 1990s and helps to further explain why the key demographic was conceived as being socially liberal and especially urban.

I use the term *urban-minded* rather than just *urban*, however, to indicate that the well-educated, "hip" viewers that networks and marketers were interested in weren't geographically limited to major urban markets (any more than upscale viewers were limited to the very upper-income brackets). By using urban minded, I want to underscore that the networks were interested in reaching viewers who were located in a psychographic location. Thus, "urban minded" reflects a set of common cultural associations that links urban to hipness, sophistication, progressive values, and diversity. As urban's semiotic other, *rural* signifies homogeneity, simplicity, and traditional values. The geographic binary of urban and rural operated in media and marketing discourse as a psychographic binary that inevitably reduced the complexity of people's lived experiences and attitudes—a simplification that helped make network programming and marketing decisions manageable. That isn't to say that viewers', consumers', and citizens' sense of self weren't negotiated in terms of urban and rural—as we will explore in chapter 4, they likely were. By 2000, of course, political pundits identified a new voter/consumer psychographic binary—one mapped out onto the geography of presidential politics. A genealogy of blue state and red state American voters would, no doubt, lead to the kind of marketing conceptions of urban and rural consumers/viewers I see operating in the 1990s.

58. Cerone, "The Fountain of Youth Equation."
59. Xiaoming Hoa, "Television Viewing among American Adults in the 1990s," *Journal of Broadcasting and Electronic Media*, (summer 1994): 353–60; Jackie Byars and Eileen Meehan, "Once in a Lifetime: Constructing 'The Working Woman' through Cable Narrowcasting," *camera obscura* 33–34 (1994–1995): 13–41.
60. Quoted in Len Strazewski, "Advertisers Wired about Cable's Reach," *Advertising Age*, 19 October 1987, L/N.
61. Ibid. Of course, the networks rightly pointed out that subscribing to cable and

watching cable weren't the same thing. As previously noted, they also argued that because of its unequaled penetration rates and overall audience size, TV was still the best place for advertisers to reach affluent consumers.

62. Meg Cox, "Cable Television Gets Better Grades in Viewers Survey," *Wall Street Journal*, 30 March 1989, L/N; "Cable Comes on Strong in TIO Roper Poll," *Broadcasting*, 3 April 1989, 27; MacDonald, *One Nation*, 229.

63. Quoted in Rick Du Brow, "Television; It's Not a Dream."

64. David Lerner, "Understanding Erosion, Part I," *Marketing & Media Decisions*, June 1988, 114.

65. Monica Collins, "TV's Safe New Season," *USA Today*, 24 May 1989, L/N.

66. Michael Burgi, "Welcome to the 500 Club," *Brandweek*, 13 September 1993, 44.

67. Cerone, "The Fountain of Youth Equation."

68. All three shows were picked up by other networks. ABC picked up *Matlock*, primarily to serve a midseason counter-programming need. They scheduled it at 8:00 on Thursdays—a time slot in which both Fox and NBC aggressively targeted the 18-to-49 audience.

69. Quoted in Cerone, "The Fountain of Youth Equation."

70. Quoted in Cyndee Miller, "ABC, NBC Think Young Despite Power of Mature Market," *Marketing News*, 22 June 1992, L/N.

71. NBC's foray onto the ice was initially dismissed as a failure. At the time, NBC's "granny dumping" efforts were seen as part of a wider and utterly misguided attempt on the part of broadcasters in general to target a youthful under-thirty audience at the expense of all other viewers. In addition to NBC's new shows, viewers were presented with a slew of programs designed to appeal to Generation X. ABC offered *Going to Extremes*, an offbeat twentysomething dramedy in the vein of *Northern Exposure*, and CBS floated the short-lived and out-of-character *2000 Malibu Road*, a sex-filled, Aaron Spelling-style serial. Fox, however, was responsible for the worst excesses of the fad. Looking to expand its prime-time schedule to a full seven nights while simultaneously strengthening its reputation as the Gen X network, Fox flooded the market with shows like *The Ben Stiller Show*, *Key West*, *The Edge*, *Likely Suspects*, *Class of '96*, *The Heights*, *Melrose Place*, and *Flying Blind*. Almost all of these shows, including most of NBC's entries, failed quickly. NBC's ratings, both among households and key demographics, plummeted, and the trend seemed over.

72. The assumption that viewers were drawn to cable by risqué content was, of course, challenged. Former CBS president Gene F. Jankowski, for example, rightly pointed out that reruns of *Murder, She Wrote* were the number-one rated drama on cable. Nevertheless, the general discourse around cable indicates that cable's appeal was still believed to be its ability to explore material that broadcasters were fearful of.

73. Quoted in Gene F. Jankowski, "Something to Lose," *Broadcasting*, 13 September 1993, 32.

74. "Robert Iger on Prime Time, Prime Demos and the Business of Entertainment," 23.

75. Brian Lowry, "Controversy Boosts 'Blue's' Big Ratings," *Daily Variety*, 23 September 1993, L/N.

76. Frank McConnell, "Smart, Hip & Real," *Commonweal*, 8 October 1993, 20.

77. Quoted in Du Brow, "Television; Networking '90s Style," L/N.

78. Lowry, "Controversy."

79. Marc Silver, "Sex and Violence on TV," *U.S. News & World Report*, 11 September 1995; Susan Karlin, "TV Standards Execs Say They've Seen It All Before," *Electronic Media*, 11 September 1995, L/N; Tom Walter, "'Family Hour' Deflowered, Networks Take More Prime Time Liberties," *Commercial Appeal*, 10 September 1995, L/N.

80. Quoted in Du Brow, "Television; Networking '90s Style."
81. The median viewer ages of each network for the 1994–1995 season were: Fox, 29.6; ABC, 38.3; NBC, 42.8; CBS, 50. Jennifer DeCoursey, "Median TV Viewers Aging," *Advertising Age*, 17 April 1995, L/N.
82. As I will discuss in chapter 4, the trend also ignored the interests of many minority viewers.
83. Sheryl Stolberg, "Fatally Wholesome: Jilting TV's *Christy*," *Los Angeles Times*, 4 August 1996, L/N.

CHAPTER 4: THE AFFORDABLE, MULTICULTURAL POLITICS OF GAY CHIC

1. See Ien Ang, *Desperately Seeking the Audience* (London: Routledge, 1991).
2. Like Julie D'Acci's analysis of the working women's audience and Jane Feuer's work on the yuppie audience, this chapter explores the complex relationship between programming strategies and target audiences. D'Acci, *Defining Women*; Jane Feuer, *Seeing Through the Eighties: Television and Reaganism* (Durham: Duke University Press, 1995).
3. In doing so, I map out what might be called a slumpy sensibility—an analytic construct that can help us theorize the ways in which some viewers, positioned by specific discourses and social experiences, may have made meanings and found pleasure in 1990s television programs—specifically those with gay material. In her analysis of yuppie television in the 1980s, Feuer offers the category of the yuppie spectator, which she defines as "a construct of the analyst, i.e., anyone who can even momentarily be placed in a yuppie subject position" (44). Although the term's theoretical baggage makes it somewhat problematic, the slumpy sensibility might usefully be thought of as something of a spectator position. While I'd argue that the well-educated, upscale, creative professionals I profile below would more easily and perhaps more likely adopt that position, anyone could theoretically approach and interpret television texts through such a sensibility. Alluding to spectator theory also raises the possibility of slumpy texts, i.e., programs whose narratives position all viewers in specific ways and encourage them to read the text from a slumpy subject position. The extent to which the cultural tastes and political common sense of a certain well-educated, cosmopolitan-specific elite had become hegemonic in the 1990s would suggest that one could make such an ideologically-inflected argument.
4. David Brooks, *Bobos in Paradise: The New Upper Class and How They Got There* (New York: Simon & Schuster, 2000), 10.
5. Richard Florida, *The Rise of the Creative Class: And How It's Transforming Work, Leisure, Community and Everyday Life* (New York: Basic Books, 2002), 66.
6. Asserting the difference between the Creative Class and more widely discussed concepts like white-collar workers or the professional-managerial class doesn't mean that there aren't important connections between them. Early studies of the professional-managerial class likely identified many of the roots of this new social class and of the postindustrial economy that Florida and others have linked it to, and many creative professionals would conform to most people's definition of white-collar workers. The categories, however, aren't synonymous.
7. Average annual salaries by class for 1999: Creative Class, $48,751; Working Class, $27,799; Service Class, $22,059; entire U.S., $31,571. Florida, *The Rise of the Creative Class*, 77.
8. Ibid., 79.
9. The Creative Class hasn't been alone in this development. In analyzing U.S. Census data, Florida argues that the "U.S. working population is re-sorting itself geographically along class lines." Old migration patterns from Rust Belt to Sun Belt

became more complex in the 1990s as Creative Class workers moved to cities like San Francisco, Austin, Madison, and Burlington. Meanwhile the Working Class dominates manufacturing centers like Detroit, Decatur (Alabama), and Hickory (North Carolina), and the Service Class dominates resort towns like Las Vegas, Honolulu, and Cape Cod, as well as Sioux Falls, Rapid City, and Bismarck. In many locations, the Creative Class, especially the Super-Creative Core, have virtually no presence. This segregation is "disturbing" to Florida, because he argues that in a postindustrial economy, a high concentration of Creative Class workers is essential to a region's economic growth, income levels, and high-tech development. Cities dominated by the Service and Working Classes (and the people living there) face being shut out of the information economy. The growing income gap between the Creative Class and other social groups may be an indicator of this trend. Florida, *The Rise of the Creative Class*, 236–243.

10. Ibid., 249–266. Florida's primary goal is to help local leaders improve their city's economic health, asserting that the presence of high concentrations of members of the Creative Class is a key predictor of economic vitality. Cities looking for rising population figures, higher incomes, and strong high-tech industry, he argues, need to be focused on the T's: Technology, Talent, and Tolerance. Drawing the talent of the Creative Class by fostering a tolerant environment will bring around the kind of technological innovation that fuels economic growth in the information economy. In fact, Florida maintains that in analyzing data for the 1990s, tools that measure openness to tolerance and creativity (like the Gay Index, Melting Pot Index, and Bohemian Index) were actually better predictors of a region's growth than conventional tools that measured human capital, high-tech industry, and corporate presence.

11. Quoted in Peter S. Prescott, "Learning to Love the PC Canon," *Newsweek*, 24 December 1990, 50.

12. Gregory S. Jay, "Not Born on the Fourth of July: Cultural Differences and American Literary Studies," in *After Political Correctness: The Humanities and Society in the 1990s*, ed. Christopher Newfield and Ronald Strickland (Boulder: Westview Press, 1995), 169.

13. Jerry Adler et al., "Taking Offense," *Newsweek*, 24 December 1990, 51.

14. By the early 1990s, the American Assembly of Collegiate Schools of Business had endorsed diversity issues as a necessary element of business school curricula. The 1992 theme for the Annual Academy of Management Meeting was "The Management of Diversity." See J. Michael Cavanaugh, "(In)corporating the Other? Managing the Politics of Workplace Difference," in *Managing the Organizational Melting Pot: Dilemmas of Workplace Diversity*, ed. Pushkala Prasda, Albert J. Mills, Michael Elmes, and Anshuman Prasad (Thousand Oaks: SAGE Publications, 1997), 42; Mary C. Gentile, "Introduction," in *Differences That Work: Organizational Excellence through Diversity*, ed. Mary C. Gentile (Boston: Harvard Business Review Book, 1994), xiii–xxv.

15. W.B. Johnston and A.H. Packard, *Workforce 2000: Work and Workers for the 21ᵗ Century* (Indianapolis: Hudson, 1987).

16. Howard Bowens et al., "Managing Cultural Diversity towards True Multiculturalism: Some Knowledge from the Black Perspective," in *Diversity and Differences in Organizations: An Agenda for Answers and Questions*, ed. Ronald R. Sims and Robert F. Dennehy (Westport: Quorum Books, 1993), 36.

17. Pushkala Prasad and Albert J. Mills, "From Showcase to Shadow: Understanding the Dilemmas of Workplace Diversity," in Prasda, Mills, Elmes and Prasad, *Managing the Organizational Melting Pot*, 3–27.

18. Gray Allen, "Valuing Cultural Diversity; Industry Woos a New Work Force," *IABC Communications World*, May 1991, 16.

19. Quoted in ibid., 16.
20. Heather MacDonald, "The Diversity Industry," *New Republic*, 5 July 1993, 24; Allen, 16.
21. In fact, direct links were made to the specific battle over multiculturalism on college campuses by conservative critics who lambasted the appointment of University of Wisconsin chancellor Donna Shalala to head the Department of Health and Human Services. According to several reports, Shalala was known for turning her university into an "epicenter of multiculturalism" and was known in academic circles as the "queen of PC." Roland Evan, "Shalala Belies Clinton's Centrist Image," *Chicago Sun-Times*, 8 January 1993; Armstrong Williams, "Merit Is All That Matters," *USA Today*, 6 January 1993; "Clinton Right to Stress Diversity in His Cabinet," *USA Today*, 6 January 1993; Ellen Goodman, "Celebrate America's Bean Pot," *Atlanta Journal and Constitution*, 3 January 1993; Jack Nelson, "Clinton Vows to Rebuild U.S.," *Los Angeles Times*, 20 October 1992.
22. Quoted in Lynn Elber, "MTV's Reality Based Soap Opera, 'Real World' Returns," Associated Press PM Cycle, 22 June 1993, L/N.
23. Quoted in ibid.
24. Comments by Peter Schneider, Disney's animation president, underscores the extent to which discourses of multiculturalism shaped cultural productions like *Pocahontas* and were simultaneously used as promotional selling points that marked product differentiation: "We wanted to offer an ennobling and empowering view of Native Americans that hadn't been provided in cinema before. . . . This is a stupendous reaffirmation of a culture and language that's been lost." Quoted in Elaine Dutka, "Disney's History Lesson," *Los Angeles Times*, 9 February 1995, L/N.
25. Ellin Willis, *Don't Think, Smile!: Notes on a Decade of Denial* (Boston: Beacon Press, 1999), 22.
26. Richard Berenstein, "The Rising Hegemony of the Politically Correct," *New York Times*, 28 October 1990, L/N; Jerry Adler et al., "Taking Offense," 48–54; Patrick Houston, "He Wants to Pull the Plug on the PC," *Newsweek*, 24 December 1990, 52–53; Peter S. Prescott, "Learning to Love the PC Canon," *Newsweek*, 24 December 1990, 50–51; Dinesh D'Souza, "Sins of Admission," *New Republic*, 18 February 1991, 30–33; Dinesh D'Souza, "Illiberal Education," *Atlantic Monthly*, March 1991; "Academic in Opposition," *Time*, 1 April 1991, 66–69; Dinesh D'Souza, "The Visogoths in Tweeds," *Forbes*, 1 April 1991, 81–86; George Will, "Literary Politics," *Newsweek*, 22 April 1991, 72; George Will, "Curdled Politics on Campus," *Newsweek*, 6 May 1991, 72.
27. John K. Wilson, *The Myth of Political Correctness: The Conservative Attack on Higher Education* (Durham: Duke University Press, 1995), 14.
28. John Taylor, "Are You Politically Correct?" *New York*, 21 January 1991, 32–40.
29. Richard Zoglin, "The Shock of the Blue: Beavis and Butthead, Ted and Whoopi, Howard Stern and his Private Parts: Whatever Happened to Political Correctness—and Good Manners?" *Time*, 25 October 1993, 71.
30. Adler et al., "Taking Offense," 48.
31. Prasad and Mills, "From Showcase to Shadow," 8.
32. I wouldn't argue that multicultural discourses didn't reach members of the working or service class or rural residents, the elderly, and the working poor. Instead, I argue that the educated elite working in occupations enumerated by Florida were more likely to be exposed to certain kinds of multicultural discourses repeatedly and that a certain brand of politically correct tolerance gained a currency among that social class in ways different than among other social groups. Members of the working or service classes participating in union organizing or inner city residents dealing with local coalition politics likely interacted with multiculturalism in different ways than their slumpy counterparts.

33. After all, with shared roots in the fragmentation of an increasingly diverse, identitarian, and global U.S. society, multiculturalism and Post-Fordism were ontologically connected. Multiculturalism's refutation of the American Melting Pot model can be seen as the ideological counterpart to the economic logic of market segmentation and the practice of niche marketing. Multiculturalism's celebrations of difference, though, didn't just legitimize social fragmentation (and by extension market fragmentation) through encouraging people to acknowledge and celebrate the differences that separated them. Additionally, as I discuss below, the fetishization of difference also helped to make the differences of the Other, especially the marginalized Other, appealing commodities to consume. In his comment about the commodification of cultural differences in Britain's new Post-Fordist global marketplace of products/identities, Jonathan Rutherford makes the link: "It's no longer about keeping up with the Jones, it's about being different from them. From World Music to exotic holidays in Third World locations, ethnic TV dinners to Peruvian knitted hats, cultural difference *sells*. . . . Otherness is sought after for its exchange value." I certainly don't ascribe to a simplistic economic reductionism, however. The relationship between multiculturalism and Post-Fordism is certainly not a simple base/superstructure one. Jonathan Rutherford, "A Place Called Home: Identity and the Cultural Politics of Difference," *Identity, Community, Culture, Difference*, ed. Jonathan Rutherford (London: Lawrence & Wishart, 1990), 11.

34. David N. Berkowitz. "Finally, Barbie Doll Ads Go Ethnic," *Newsweek*, 13 August 1990, 48.

35. Denise Smith Amos, "Companies Crusading for a Cause," *Publisher's Weekly*, 18 July 1993, 12; Stuart Elliott, "A Survey Says that Cause-Oriented Campaigns Don't Just Make People Feel Good, They Work, Too," *New York Times*, 6 December 1993.

36. Colman McCarthy, "Here Comes Santa Cause," *Washington Post*, 14 December 1993.

37. Some critics have pessimistically argued that Benetton's ads simply represent the commercial exploitation of cultural difference and social oppression. Stephan Harold Riggins argues: "Just as Benetton's two-tone campaign was about the containment of difference, the small world campaign also is about the channeling and the containment of the incipient consciousness and activism of young people primarily in the global North" (20). In the early 1990s, Benetton also published *Colors: A Magazine about the Rest of the World*. According to the back cover of the magazine's fall/winter 1992–1993 issue, the trendy youth-oriented magazine was "about the cultural differences that make the world exciting. And how savoring those differences (rather than killing each other over them) could make the world a little less crazy." See Henry A. Giroux, "Consuming Social Change: The "United Colors of Benetton," *Cultural Critique*, (winter 1993–1994): 5–32; Stephan Harold Riggins, "The Rhetoric of Othering," in *The Language and Politics of Exclusion: Others in Discourse*, ed. Stephan Harold Riggins (Thousand Oaks: Sage, 1997), 1–30; Michael Hoechsmann, "Benetton Culture: Marketing Difference to the New Global Consumer," in Riggins, *The Language and Politics of Exclusion*, 183–202.

38. Tolerance itself is a highly complicated notion. Critics argue that multicultural tolerance is a disguised way to reproduce structures of power while making things appear equal. As Ghassan Hage argues, "It is a form of symbolic violence in which a mode of domination is presented as a form of egalitarianism" (28–29). After all, only those in power are asked to be tolerant, and asking people to be tolerant does nothing to change their capability of being intolerant since the structures of power that privilege them in the first place remain unaltered. See Ghassan Hage, "Locating Multiculturalism's Other: A Critique of Practical Tolerance," *New Formations* 24 (winter 1994): 19–34.

39. bell hooks, *Black Looks* (Boston: South End Press, 1992), 22. hooks gives anecdotal

evidence of this process when she recounts a conversation she overheard among a group of white, male college students talking about their plans to have sex with as many nonwhite women as possible. For hooks, their conversation is different from (though not entirely free from) traditional white supremacist and patriarchal deployments of sex: "Unlike racist white men who historically violated the bodies of black women/women of color to assert their position as colonizer/conqueror, these young men see themselves as non-racists, who choose to transgress racial boundaries within the sexual realm not to dominate the Other, but rather so that they can be acted upon, so that they can be utterly changed" (24). Importantly, hooks maintains that despite their professed progressive goals, these young men's sexual fantasies "irrevocably link them to collective white racist domination" (24).

40. George Yudice, "Neither Impugning nor Disavowing Whiteness Does a Viable Politics Make: The Limits of Identity Politics," in *After Political Correctness: The Humanities and Society in the 1990s*, ed. Christopher Newfield and Ronald Strickland (Boulder, Westview Press, 1995), 258. Exnomination has been a powerful strategy of the dominant, allowing whiteness, patriarchy, heterosexuality, etc. to serve as the naturalized norm against which all subordinated others are judged. This strategy has some limitations, however, in a social context where markers of difference are valued, at least culturally.

41. Andrew Gamble, "Neo-Liberalism," *Capital & Class* no. 75 (autumn 2001): 127–134.

42. Judith Goode and Jeff Maskovsky, "Introduction," in *The New Poverty Studies: The Ethnography of Power, Politics, and Impoverished People in the United States*, ed. Judith Goode and Jeff Mushovsky (New York: New York University Press, 2001), 1–34.

43. See Frances Fox Piven, "Welfare Reform and the Economic and Cultural Reconstruction of Low Wage Labor Markets," in Goode and Mashovsky, *The New Poverty Studies*, 135–151; Mimi Abramovitz and Ann Withorn, "Playing by the Rules: Welfare Reform and the New Authoritarian States," in *Without Justice for All: The New Liberalism and Our Retreat from Racial Equality*, ed. Adolph Reed, Jr. (Boulder: Westview Press, 1999), 151–173; Michael K. Brown, "Race in the American Welfare State: The Ambiguities of 'Universalistic' Social Policy since the New Deal," in Reed, Jr., *Without Justice for All*, 93–122.

44. Michael A. Peters, *Poststructuralism, Marxism, and Neoliberalism: Between Theory and Politics* (Lanham: Rowman & Littlefield, 2001), 192. Also see Preston H. Smith, "'Self-Help,' Black Conservatives, and the Reemergence of Black Privatism," in Reed, Jr., *Without Justice for All*, 257–289.

45. Terry Nichols Clark and Ronald Inglehart, "The New Political Culture: Changing Dynamics of Support for the Welfare State and other Policies in Postindustrial Societies," in *The New Political Culture*, ed. Clark and Inglehart (Boulder: Westview Press, 1998), 9–72.

46. In an unscientific but telling *Glamour* magazine reader poll, 75 percent of respondents agreed that the United States needed a third party, and of those 52 percent said that their "ideal third party candidate" would be "fiscally conservative but at the same time socially liberal." ("This Is What You Thought," *Glamour*, June 1996, 141.) The 1990s, like most periods, saw a reformulation of political identities and voting blocks. By the mid-1990s, political pundits repeatedly referred to the emergence of a new block of intensely disgruntled voters who were dissatisfied with the political platforms of both the Democrats and the Republicans. These voters were frequently described as a somewhat undifferentiated group of centrists calling for a third party candidate to represent their unified interests. Michael Lund problematized this simplistic approach, and his analysis helps to bring into better focus a picture of the shifting political landscape and the social group I'm trying to map out here. He argued that these alienated voters (approximately 33 percent of the

electorate) are actually strongly divided into two distinct camps. The first, which he calls the moderate middle, were highly suburban managers and professionals with advanced degrees who were socially liberal, fiscally conservative, pro-gay, pro-environmentalist. Many of them, he claims, were Rockefeller-styled Republicans alienated by the increasing influence of the Religious Right on the GOP. The second block he calls the radical center, using a term coined by sociologist Donald Warren in the 1970s. These voters had often been Reagan Democrats (white, blue-collar, high-school educated workers from the Midwest, South and West) who were alienated by New Deal welfare programs. They tended to be "liberal, even radical in matters of economics, but conservative in morals and mores" (72). Such voters were drawn to the charismatic populism of Ross Perot and Pat Buchanan. Although these two blocks had formulations specific to the 1990s, Lund sees them linked to longer trends in American political history: "The difference is reminiscent of the class and cultural divide between upper-middle-class metropolitan Progressives and the rural and small-town Populists at the turn of the century, who viewed each other with suspicion even though they shared many criticisms of the existing order" (72). Michael Lund, "The Radical Center or the Moderate Middle," *New York Times Magazine*, 3 December 1995, 72.

47. Pat Buchanan, "The Election Is about Who We Are," *Vital Speeches of the Day*, 15 September 1992, 714.
48. Quoted in Virginia I. Postrel, "Lost Causes," *Reason*, January 1993, 4.
49. Quoted in "This Is What You Thought," *Glamour*, June 1996, 141.
50. Quoted in Dan Gardner, "Gen X at UA," *The Ottawa Citizen*, 29 January 2000, L/N.
51. Quoted in "'Liberal' Specter Joins GOP Race," *St. Petersburg Times*, 31 March 1995, L/N.
52. Stuart Elliott, "This Weekend a Business Expo Will Show the Breadth of Interest in Gay Consumer," *New York Times*, 14 April 1994, L/N.
53. Quoted in Jeffrey Scott, "Media Talk; Formerly Standoffish Advertisers Openly Courting Gay Consumers," *Atlanta Journal and Constitution,* 5 April 1994, L/N.
54. Quoted in Charles Feldman, "Advertising Aimed at Gay Community Surges," CNN Transcript #200-1, 7 October 1992, L/N.
55. See Paul Colford, "The Scotch Ad That's Got 'Em Buzzing," *Newsday*, February 1989, L/N; and Bernice Kanner, "Normally Gay," *New York,* 4 April 1994, 24.
56. Quoted in Kara Swisher, "Gay Spending Power Draws More Attention," *Washington Post*, 18 June 1990, L/N.
57. Kanner, "Normally Gay," 24.
58. See Rodger Streitmatter, *Unspeakable: The Rise of the Gay and Lesbian Press in America* (Boston: Faber and Faber, 1995), 308–337; Daniel Harris, *The Rise and Fall of Gay Culture* (New York: Hyperion, 1997), 64–85.
59. See Diane Cyr, "The Emerging Gay Market," *Catalogue Age*, November 1993, 112. Some of this information came from national surveys like the longstanding Yankelovich Monitor survey. In 1994 Yankelovich added a question about sexual orientation to its annual survey that had tracked consumer values and attitudes since 1971. Of the 2,503 participants, 5.7 percent described themselves as "gay/homosexual/lesbian." See Stuart Elliott, "A Sharper View of Gay Consumers," *New York Times*, 9 June 1994, L/N.
60. Kathy Kalafut, "Alternative Demos; Profile on Aka Communications Inc," *Mediaweek* 14 September 1992, 32.
61. Sarah Schulman, "Gay Marketeers," *Progressive* July 1995, 28.
62. Rodger Streitmatter, *Unspeakable*, 314.
63. Teresa Carson, "Agencies Push Gay Market Ads to Banks," *American Banker*, 21 May 1992, L/N.

64. Swisher, "Gay Spending Power."

65. Hazel Kahan and David Mulryan, "Out of the Closet," *American Demographics*, May 1995, 46–47.

66. Schulman, "Gay Marketeers," 28.

67. Quoted in Cyndee Miller, "'The Ultimate Taboo,' Slowly But Surely, Companies Overcome Reluctance to Target the Lesbian Market," *Marketing News TM* , 14 August 1995, L/N. Miller uses the term "hip, young consumer" to introduce the quote from Laurie Acosta.

68. Gary Levin, "List-Generating Hot—to Direct Mail's Delight," *Advertising Age,* 30 May 1994.

69. Quoted in Martha Moore, "Courting the Gay Market—Advertisers: It's Business, Not Politics," *USA Today* 23 April 1993, B1; Susan Reda, "Marketing to Gays & Lesbians: The Last Taboo," *Stores*, September 1994, 19; Hillary Chura, "Miller Reconsiders Gay-Themed TV Spot," *Advertising Age*, 12 July 1999, L/N. For more on the construction of the affluent gay market, see; Alexandra Chasin, *Selling Out: The Gay & Lesbian Movement Goes to Market* (New York: St. Martin's Press, 2000); *Homo Economics: Capitalism, Community, and Lesbian and Gay Life*, ed. Amy Gluckman and Betsy Reed (New York: Routledge, 1997).

70. Thomas A. Stewart, "Gay in Corporate America," *Fortune*, 16 December 1991, 50.

71. Ibid., 50.

72. Urvashi Vaid, *Virtual Equality: The Mainstreaming of Gay & Lesbian Liberation*, (New York: Anchor Books, 1995), 20.

73. Of course, this attitude cut both ways. While voters in Oregon rejected Measure 9, which would have amended the state constitution to state that homosexuality was "abnormal, wrong, unnatural, and perverse," voters in Colorado passed a proposition to overturn existing antidiscrimination laws when antigay forces successfully framed the issue as a case of special rights and excessive legislation. Lisa Duggan argues that much of the mainstream gay rights agenda spearheaded by conservative gay male writers like Andrew Sullivan and Bruce Bawer in the 1990s was symptomatic of a wider neoliberal shift in American politics during the decade. Lisa Duggan, "The New Heteronormativity. The Sexual Politics of Neoliberalism," in *Materializing Democracy: Toward a Revitalized Cultural Politics*, ed. Russ Castronova and Dana D. Nelson (Durham: Duke University Press, 2002), 175–194.

74. Alan S. Yang, "Attitudes toward Homosexuality," *Public Opinion Quarterly* 61, no. 3 (1997): 477–507.

75. David Kamp, "The Straight A Queer," *Gentleman's Quarterly*, July 1993, 95.

76. Russell Kasindorf, "Lesbian Chic: The Brave, New World of Gay Women," *New York*, 10 May 1993, 30–37; Kara Swisher, "We Love Lesbians! Or Do We?" *Washington Post*, 18 July 1993; Alexis Jetter, "Goodbye to the Last Taboo," *Vogue*, July 1993; Eloise Salholtz et al., "The Power and the Pride," *Newsweek*, 21 June 1993, 54–60; Barbara Kantrowitz and Danzy Senna, "A Town Like No Other," *Newsweek*, 21 June 1993, 56–57; Melinda Beck et al., "A (Quiet) Uprising in the Ranks," *Newsweek*, 21 June 1993, 60; Sylvia Rubin, "The New Lesbian Chic," *San Francisco Chronicle*, 22 June 1993; Elizabeth Snead, "Lesbians in the Limelight," *USA Today*, 13 July 1993.

77. Ann Powers, "Queer in the Streets, Straight in the Sheets," *Village Voice*, 29 June 1993, 30.

78. Kamp, "The Straight A Queer," 97. The Queer-Straight phenomenon and a growing support for gay civil rights protections also indicates, I'd argue, that more and more people, perhaps motivated by the growing visibility of the Christian Right, identified with gays and lesbians as sexual outlaws of some sort. They may not have had same-sex intercourse, but they fancied themselves as living outside of the very restrictive sexual norms of traditional heterosexual sexuality.

79. Powers, "Queer in the Streets," 30; Kurt Cobain, "Letter to the Editor," *Advocate* 24 January, 1994.
80. The economic realities and cultural discourses of American race relations don't exist separately from the emergence of 1990s'-style neoliberalism. Racist discourses about black poverty, laziness, and criminality were likely key factors behind the growing popularity of fiscal conservatism and antiwelfare policies that came along with it.
81. See Douglas S. Masey and Nacy A. Denton, *American Apartheid: Segregation and the Making of the Underclass* (Cambridge: Harvard University Press, 1993); Rhonda M. Williams, "Accumulation as Evisceration: Urban Rebellion and the New Growth Dynamics," in *Reading Rodney King, Reading Urban Uprising*, ed. Robert Gooding-Williams (New York: Routledge, 1993), 82–96; Melvin L. Oliver, James H. Johnson, Jr., and Walter C. Farrell, Jr., "Anatomy of a Rebellion: A Political-Economic Analysis," in Gooding-Williams, *Reading Rodney King*, 117–141.
82. See John Fiske, *Media Matters: Everyday Culture and Political Change* (Minneapolis: University of Minnesota Press, 1994).
83. Quoted in ibid., 172.
84. Studies claim that while baby boomers and Generation Xers were noticeably more tolerant of newer lifestyles and supportive of the idea of equality, they shared virtually the same intolerant attitudes towards blacks as older generations. Kevin A. Hill, "Generations and Tolerance: Is Youth Really a Liberalizing Factor?" in *After the Boom: The Politics of Generation X*, ed. Stephan C. Craig and Stephan Earl Bennett (Lanham: Rowman and Littfield Publishing, 1997), 122.
85. Florida, The Rise of the Creative Class, 263.
86. Sabrina Sawhney, "The Joke and the Hoax: (Not) Speaking as the Other," in *Who Can Speak? Authority and Critical Identity*, ed. Judith Roof and Robyn Wiegman (Urbana: University of Illinois Press, 1995), 208.

Chapter 5: Gay Material and Prime-Time
Network Television in the 1990s

1. William Mahoney, "'Thirtysomething' Producers Undaunted By Ad Pullouts," *Electronic Media*, 27 November 1989, L/N; Matt Roush, "'Gay' Episode of 'Thirtysomething' Will Not Be Repeated," *Gannett News Service*, 19 July 1990, L/N.
2. Quoted in Matt Roush, "'Thirtysomething' Addresses Gay Issues," Gannett News Service, 6 November 1989, L/N.
3. "ABC-TV Loses $14 Million to Disgruntled Advertisers," Gannett News Service, 22 July 1990, L/N; Chick Ross, "Gay Stays on 'thirtysomething,'" *San Francisco Chronicle*, 18 November 1989, L/N.
4. Quoted in Ross, "Gay Stays on 'thirtysomething.'"
5. Quoted in William Mahoney, "'Thirtysomething,'" 4.
6. Quoted in Deborah Hastings, "Boycotts Cost Network," *Record*, 24 July 1990, L/N.
7. Quoted in Nathan Cobb, "Prime Time Sex," *Boston Globe*, 30 April 1989, L/N.
8. Ibid.
9. Quoted in Geraldine Fabrikant, "Ads Reportedly Lost Because of Gay Scene," *New York Times*, 14 November 1989, L/N.
10. Steve Weinstein, "NBC Puts Message Over Money With AIDS Show Television," *Los Angeles Times*, 18 December 1990, L/N. NBC had originally scheduled the episode for December 2 as part of World AIDS Day weekend but pulled it.
11. Quoted in Michael McWilliams, "'Thirtysomething' Breaks Ground, Which Is Just More of the Same Dirt," Gannett News Service, 15 April 1991, L/N.
12. Tommy's own sexual orientation is never clearly established, and Sam wonders whether he might be gay. He's a virgin who's nervous around girls, and when

Phillip asks him for help exposing homophobic students, the group's leader calls him gay.

13. John Lippman, "Producer Asked to Pay if Show Offends," *Los Angeles Times*, 28 September 1991, L/N.
14. Quoted in ibid.
15. Quoted in "Gay Suicide Theme Holds Up 'Leap' Episode," *Broadcasting*, 7 October 1991, L/N.
16. Quoted in ibid.
17. Quoted in Lisa de Morales, "NBC, 'Quantum Leap' Producers Differ on 'Gay Episode,'" BPI Entertainment News Wire, 30 September 1991, L/N. There was disagreement over exactly what changes had been made to the shooting script. Bellisario claimed that the only change they made was to make the cadets older, in response to NBC's concerns over the message a teen suicide would have. GLAAD's Richard Jennings, who claimed to have read the initial script, said there were far more changes, including the addition of the sympathetic track coach as a positive gay character and dialogue that rebutted homophobic comments made by various characters. Howard Rosenberg, "NBC Takes Hit Over Gay Issue on 'Leap' Show," *Los Angeles Times*, 17 January 1992, L/N.
18. Rosenberg, "NBC Takes Hit."
19. ABC's Robert Iger summarized the general sentiments at the time: "Unfortunately, dealing with the subject of homosexuality frequently results in financial hardship." Quoted in Steve Weinstein, "Back into the Closet," *Los Angeles Times*, 7 April 1991, L/N.
20. Quoted in Weinstein, "NBC Puts Message."
21. Quoted in ibid.
22. John J. O'Connor, "Gay Images: TV's Mixed Signals," *New York Times*, 19 May 1991, L/N.
23. Virginia Mann, "Networks Dance with the Taboo," *Record*, 19 May 1991, L/N.
24. Quoted in O'Connor, "Gay Images,"
25. Quoted in Weinstein, "NBC Puts Message."
26. Quoted in "Gay Suicide Theme Holds Up 'Leap' Episode."
27. Quoted in Rick DuBrow, "When Does TV Cross the Line?" *Los Angeles Times*, 3 November 1991, L/N.
28. Quoted in ibid.
29. "Gay Activists Urge Boycott over Pulled Ads," *Hollywood Reporter*, 29 June 1992, L/N.
30. A May 16, 1991, episode of *LA Law* featured a case in which a gay man with AIDS sues his insurance company when it refuses to pay for experimental treatments. The following October, Douglas Brackman is the unwitting victim of a gay-bashing attack, and that December C.J. tackles the custody case of her former lesbian lover. For a September 1991 episode, producers of *Dear John* went out of their way to consult with GLAAD on an episode in which one of the male lead characters runs into his ex-wife and her lesbian lover at a grocery store. In an October 1991 episode of *Coach*, Hayden discovers one of his players is gay and has a hard time treating him like all of the other guys. That same month, *Roc* included a gay wedding between Roc's brother Russell and his white lover. In May 1992, a critically-praised episode of *Northern Exposure* described how Cicely had been settled as "the Paris of the North" by a strong, free-thinking woman and her female companion.
31. The episode includes an interesting tension between the A and B plot lines. The main storyline could be described as the heterosexualization of Darlene, the middle daughter who had been a typical tomboy up to that point in the series. When a boy asks Darlene to her first dance, Roseanne, glad to finally have the chance to bond with her daughter over something besides sports, goes overboard in her efforts to

buy Darlene the right dress, the right shoes, and the right makeup. Although Darlene is clearly uncomfortable with the primping and tells Roseanne that unlike her older sister, she's not into makeup and stuff, in the end, she assures her mom that she likes boys. Roseanne also tries to play matchmaker at work when she finds out the attractive, female efficiency consultant from corporate headquarters is interested in Leon. Despite the fact that a little flirting would undoubtedly help him get a good evaluation, Leon kindly deflects her advances. Both Roseanne and the viewer are left wondering why, until the episode's coda when a man comes in to pick Leon up. From their dialogue and physical interaction, it's clear that they are a couple. The episode ends with Roseanne and her coworker giving each other a knowing look.

32. Quoted in John Kiesewetter, "Homosexual Images Need Improvement," *Cincinnati Enquirer*, 16 March 1992, L/N.
33. Quoted in Susan Wyatt, "Northern Exposure Ends Season on 'Gay' Note," BC Cycle, 10 May 1992, L/N.
34. Michael McWilliams, "TV No Longer Ignoring Gays," Gannett News Service, 7 May 1992, L/N.
35. Joseph Hanania, "Resurgence of Gay Roles on Television," *Los Angeles Times*, 3 November 1994, L/N.
36. Quoted in Colin Covert, "Gaytime TV," (Minneapolis) *Star Tribune*, 3 December 1995, L/N.
37. Daniel Cerone, "'Melrose' to Tackle Gay Bashing," *Los Angeles Times*, 26 October 1992, L/N; Peter Johnson, "Trial for Gay Character Soon on 'Melrose Place,'" *USA Today*, 6 October 1992, L/N.
38. Quoted in Cerone, "'Melrose.'"
39. Ibid.
40. Leon returned in May 1993 and became a series regular again the following season when he become a partner in Roseanne's restaurant. After Leon marries his lover Scott ("December Bride," December 12, 1995), the couple remained recurring characters until the series 1997 conclusion. Roseanne and Jackie's mother Bev also came out of the closet in the final season ("Home Is Where the Afghan Is," November 26, 1996). In the much-maligned series finale, we learn that the final year (and much of the series, in fact) had all been the product of Roseanne's imagination and that "in reality" her sister Jackie, not Bev, was gay.
41. "Hey, Big Spender," *Advertising Age*, 15 March 1993, 29.
42. News divisions, however, can respond much more quickly to changing social climates, and in January 26, 1993, at the height of the initial furor over gays in the military, NBC aired an installment of *First Person with Maria Shiver* entitled "The Gay 90s: Sex, Power, and Influence." The program provided viewers an inside look at the gay community. One reviewer lambasted the show and Shriver: "Shriver reacts as though it were 1975 and she'd just been let out of seclusion at Catholic school to explore what for her is a Martian landscape of homosexuality." Reports claimed that although the documentary was "timely," it was also "costly," since NBC's sales division had a very hard time selling ad spots. John Carman, "Maria Shriver Looks Into the Gay '90s'," *San Francisco Chronicle*, 26 January 1993, L/N; Stuart Elliott, "Few Advertisers For Gay Program," *New York Times*, 28 January 1993, L/N.
43. *The John Laroquette Show*, "The Past Comes Back," October 26, 1993; *The Commish*, "Keeping Secrets," January 22, 1994; *Murphy Brown*, "The Anchorman," January 24, 1994. *Roc*, "Brothers," April 5, 1994; *Sisters*, "Something in Common," November 6, 1993, "Life Upside Down," May 7, 1994; *Northern Exposure*, "I Feel the Earth Move," May 5, 1994.
44. Greg Braxton, "Roseanne's Kiss: And Now the Aftermath," *Los Angeles Times*, 3 March 1994, L/N.

45. Drew Jubera, "Cost of a Gay Kiss," *Atlanta Journal and Constitution*, 16 July 1994, L/N; David Zurawik, "In 'Silence,' Close Speaks Volumes," *Baltimore Sun*, 6 February 1995, L/N.
46. In talking to TV critics about the series, Fierstein was asked whether there would be a same-sex kiss. Fierstein's typically scandalous response: "Well, I think we're going to skip the kissing and I'll go straight to my knees." Bob Blakey, "Openly Gay Actor To Play Homosexual in Prime Time," *Calgary Herald*, 22 July 1994, L/N.
47. Joseph Hanania, "Resurgence of Gay Roles on Television," *Los Angeles Times*, 3 November 1994, L/N; John O'Connor, "On TV, a Heightened Gay Presence," *New York Times*, 23 November 1994, L/N.
48. David Crane, interview by author, tape recording, Los Angeles, Calif., 29 June 2000.
49. Dennis McDougal, "The Static over 'Silence,'" *TV Guide*, 4–10 February 1995, 32, L/N.
50. Ginia Bellafante, "Serving in Silence: The Margarethe Cammermeyer Story," *Time*, 6 February 1995, 70; Joyce Millman, "Gays on TV Starting to Look Like Real People," *San Francisco Chronicle*, 5 February 1995, L/N; David Zurawik, "In 'Silence,' Close Speaks Volumes," *Baltimore Sun*, 6 February 1995, L/N.
51. Susan Karlin, "Climate Warming for Gay Characters, Say TV Executives," *Electronic Media*, 6 February 1995, 1.
52. Matt Roush, "Hearts Young and Gay," *USA Today*, 18 January 1996, L/N
53. Julia Dunn, "Homosexuality Is 'In' on Prime-time Television," *Washington Times*, 25 January 1996, L/N.
54. Matt Roush, "For Gays, Out Programming Finds Its Way In," *USA Today*, 11 October 1995, L/N.
55. Colin Covert, "Gaytime TV."
56. Tom Hopkins, "Gays On TV," *Dayton Daily News*, 20 August 1995, L/N.
57. Kinney Littlefield, "On TV, It's a Prime Time for Gays," *Pittsburgh Post-Gazette*, 26 December 1995, L/N.
58. Julia Dunn, "Homosexuality Is 'In.'"
59. David W. Dunlap, "Gay Images, Once Kept Out, Are Out Big Time," *New York Times*, 21 January 1996, L/N.
60. Quoted in "Couple of NBC Stations Said 'I Don't' to Lesbian 'Friends,'" *Daily News*, 19 January 1996, L/N.
61. David Ehrenstein, "More than Friends," *Los Angeles*, May 1996, 61. The article was reprinted in newspapers and became a story itself, warranting a quick summary in *USA Today*. "Jeannie Williams, "Spotlight on Sitcoms' Bright 'Gay Sensibility,'" *USA Today*, 23 April 1996, L/N.
62. Sixteen of the top-thirty shows in the 1995–96 season were sitcoms. Only five (*ER*, *NYPD Blue*, *Walker, Texas Ranger*, *Chicago Hope*, and *Law & Order*) were dramas. There were four newsmagazine shows, three movie-of-the-week spots, and *Monday Night Football*.
63. Quoted in Covert, "Gaytime TV."
64. Although *Lush Life* and *Party Girl* lasted only a month and Fox pulled *Public Morals* after just one episode, the gay characters were never cited as a reason for the cancellations.
65. Skip Wollenberg, "Is Madison Avenue Ready for a Lesbian 'Ellen'?" Associated Press, 19 September 1996, L/N.
66. "Problems & Questions Loom Large if Degeneres' 'Ellen' Comes Out," *Daily News*, 16 September 1996, L/N.
67. Michael White, "Sponsors Ponder 'Ellen' Plotline," *Advertising Age*, 7 October 1996, L/N.
68. Jean Seligmann, "A Sitcom Coming Out?" *Newsweek*, 23 September 1996, 87.
69. Although some sponsors claimed an out Ellen Morgan would not affect their

sponsorship of the series, most took a wait-and-see approach immediately after the announcement. In general, advertisers seemed more irritated by their belief that ABC/Disney had leaked the rumors in order to test advertiser reaction than by the prospect of a coming-out episode.

70. Jefferson Graham, "Ellen Happy with Women at Helm," *USA Weekend*, 19 December 1995, L/N.

71. Bruce Fretts, "This Week," *Entertainment Weekly*, 25 October 1996, 102.

72. Gail Shister, "Gay Producers, Actors Urge Ellen to Come Out," *Wisconsin State Journal*, 18 September 1996, L/N.

73. According to SPINdex, a service that tracks a sample of influential print and electronic media outlets, an "incredible" 161 news stories about *Ellen* appeared during the month leading up to the April 30 episode. With 19.5 minutes of TV-news airtime and 104,811 words of copy devoted to it, the episode "scored sufficient media impressions to qualify as a 'national affairs' story by SPINdex's standards." Joe Mandese and Mark Weiner, "ABC Scores As "Ellen" Comes Out," *Advertising Age*, 5 May 1997, L/N.

74. Alan Bash, "Liberating 'Ellen,' *USA Today*, 30 April 1997, L/N.

75. Quoted in Tom Shales, "Closet Space and Selling 'Ellen,'" *Washington Post*, 27 April 1997, L/N.

76. Bettina Boxall, "Is 'Ellen' an Opportunity—Or Just Opportunist?" *Los Angeles Times*, 30 April 1997, L/N; Shales, "Closet Space."

77. Alan Bash, "Lesbian Lead Doesn't Faze Most," *USA Today*, 25 April 1997, L/N. The poll also reported that roughly 50 percent of respondents said they were neither pleased nor bothered by the decision to have Ellen Morgan come out of the closet. Thirty-seven percent said they were bothered and 7 percent said they were pleased.

78. Alan Bash, "Liberating 'Ellen.'"

79. Joe Flint, "Out 'Ellen' Gives ABC Rating Rout," *Daily Variety*, 2 May 1997, L/N.

80. When in May 2000 *Dawson's Creek* included what it claimed to be the first romantic kiss between two men, there was virtually no advertiser resistance. By the late 1990s, movies like *In & Out* and cable programming like *Oz*, *Queer as Folk*, and *The Real World* exposed more and more Americans to images of same-sex sexual intimacy, the networks' ban seemed increasingly anachronistic (although that fact did little to loosen restrictions).

81. Quoted in Dana Canedy, "As the Main Character in *Ellen* Comes Out, Some Companies See an Opportunity; Others Steer Clear," *New York Times*, 30 April 1997, L/N.

82. Junu Bryan Kim, "Computer Ads Become a Player in Prime Time," *Advertising Age*, 11 November 1995, L/N.

83. Quoted in Canedy, "As the Main Character in *Ellen* Comes Out."

84. Lynette Rice, "TV Finds More Room for Gays," *Broadcasting & Cable*, 18 August 1997, 27.

85. Ed Martin, "Gay New World Doesn't Make 'Ellen' Funny," *USA Today*, 25 February 1998, L/N.

86. Quoted in Brian Lowry, "Ratings, Not Sexuality, Steer Future of 'Ellen,'" *Los Angeles Times*, 11 March 1998, L/N.

87. Mark A. Perigard, "Scared Straight," *Boston Herald*, 26 August 1998, L/N.

88. Lisa de Moraes, "The Outer Limits," *Washington Post*, 3 March 1999, L/N.

89. Ibid. The proposal was either disregarded or condemned by the industry. MPAA president Jack Valenti called it an "inhumane proposal that should be ignored." Already-existing ratings included V-violence, S-sex, D-suggestive dialogue, L-language, and F-fantasy violence.

90. Julia Duin, "'Will & Grace' Makes Splash, but Few Waves," *Washington Times*, 16 October 1998, L/N.

91. Brian Lowry, "When a Kiss Is Not Just a Kiss on 'Relativity,'" *Los Angeles Times*, 11 January 1997, L/N.

92. See Kathleen Battles and Wendy Hilton-Morrow, "Gay Characters in Conventional Spaces: *Will & Grace* and the Situation Comedy Genre," *Critical Studies in Media Communication* 19, no. 1 (March 2002): 87–105; Helene A. Shugart, "Reinventing Privilege: The New (Gay) Man in Contemporary Popular Media," *Critical Studies in Media Communication* 20, no. 1 (March 2003): 67–91.

93. The description for the September 28, 1999, episode, for example, offers no clue that Will is gay. "Will and Grace's friendship becomes strained when he encourages her to find a place of her own—and then quickly discourages her idea to move in with him."

94. Quoted in De Moraes, "The Outer Limits."

95. Mark Hudis, "Gays Back in Prime Time," *Mediaweek*, 13 December 1993, 14. Also see David W. Dunlap, "Gay Images, Once Kept Out Are Out Big Time," *New York Times*, 21 January 1996, L/N.

96. Most network explanations for the spate of gay and lesbian characters claimed that the trend was simply mirroring social reality. Marc Cherry, executive producer of *The Crew*, for example, asserts, "Gay people are now more than ever becoming a part of American life. . . . You can't deny the existence of gay people throughout the country. They should be represented." John Carman, "Gay Characters Get a Life on TV," *San Francisco Chronicle*, 17 August 1995, L/N. Such comments efface the hard-nosed economics behind television programming and reflect the power of a long-lasting discursive construction of television as a medium meant to serve the public interest.

97. The economies of cable, on the other hand, made it possible for them to explore targeting a gay market, and during the 1993–94 season, production companies like Gay Entertainment Television (GET) made a push to sell by-gay, for-gay programs (talk shows, newsmagazines) to cable channels that could then create gay-targeted lineups. "TV Networks Bring Gays and Lesbians to Forefront," *CNN Showbiz Today*, 1 February 1994, transcript #470-2, L/N. Although there would be talk of full blown gay-targeted cable channels for years, plans always fell through.

98. In the early 70s, urban-centered programming like *All in the Family* and *The Jeffersons* attracted not only the white urban audience CBS so badly wanted but also the increasingly prosperous black middle class. For further work on the dynamics of gay-targeted marketing in other industries, see Danae Clark, "Commodity Lesbianism," in *The Lesbian and Gay Studies Reader*, ed. Henry Abelove, Michele Asina Bardale, and David M. Halperin (New York: Routledge, 1993), 186–201; Gregory Woods, "We're Here, We're Queer and We're Not Going Catalogue Shopping," in *A Queer Romance: Lesbians, Gay Men and Popular Culture*, ed. Paul Burston and Colin Richardson (London: Routledge, 1995), 147–163; Eve M. Kahn, "The Glass Closet," *Print* 48, no. 5 (September–October 1994): 21–32.

99. That fact may have started to change with the continuing erosion of audience shares in the late 1990s. When a show like *Will & Grace*, for example, can be a hit and draw top advertiser dollars with only 17 million viewers, the interests of a gay audience, especially when it's considered to be disproportionately affluent, may have become a more significant consideration.

100. Quoted in John Gallagher, "Ikea's Gay Gamble," *Advocate*, 3 May 1994, 24–26.

101. Quoted in Drew Jubera, "Cost of a Gay Kiss," *Atlanta Journal and Constitution*, 16 July 1994, L/N.

102. Suzanna Danuta Walters, *All The Rage: The Story of Gay Visibility in America* (Chicago: University of Chicago Press, 2001), 12. See also Battles and Hilton-Morrow, "Gay Characters"; Anna McCarthy, "*Ellen*: Making Queer Television History," *GLQ* 7, no. 4 (2001): 593–620; Bonnie Dow, "Ellen, Television, and the Politics of

Gay and Lesbian Visibility," *Critical Studies in Media Communication* 18 (June 2001): 123–140.

103. The act of racial identification is certainly not unproblematic. In most cases, I have categorized characters by race in line with explicit narrative clues. In a few cases, however, placement in a racial category was dependent upon my own reading of a character's racial identity. Notably erased in this taxonomy, of course, are biracial identity positions. As far as I know, though, none of the LGB characters listed here explicitly identified as biracial.

104. An episode of *Mad About You* provides another glaring example of such hetero-centric gay-themed narratives. The episode "Ovulation Day" weaves two storylines together. The A-plot (which starts and ends the narrative) focuses on Jamie and Paul's effort to conceive and their pent-up horniness as they wait for Jamie to ovu-late. Halfway through the episode, Jamie is ready and calls Paul at work, telling him to meet her at home. Predictably, a series of sitcom mishaps (e.g., a stalled subway, a broken laundry room door) delay their union. Meanwhile, in the B-plot, Jamie has lunch with her up-until-then-heterosexual sister-in-law Debbie, who reveals that she is having an affair with a woman. Although completely supportive, Jamie gets more excited about hearing the sexy details of the two women's first encounter (in front of a roaring fire while on a ski-weekend in Vermont) than listening to Debbie's coming-out anxiety. When Debbie tells Jamie that she was going to come out to Paul and her parents at dinner, Jamie offers her $1,000 to wait until the next day to tell Paul (since the news would presumably distract him from having sex—which Jamie obviously needs badly). Debbie agrees. Later, Jamie and Paul do get together in their apartment. Just as they are about to release their built-up sexual tension, however, Debbie and her parents interrupt them. Although Debbie tries to get her parents to leave with her, their mother insists that Debbie tell them her big news right then. Eventually, Debbie lets the cat out of the bag: "I'm dating a woman. I'm a lesbian." Jamie sighs in dismay; clearly the mood is broken. As it plays out, Debbie's coming-out story becomes yet one more roadblock in Jamie and Paul's path to heterosexual satisfaction—a tool of the heterocentric narrative. Not to worry, though. Jamie and Paul do make it to the bedroom. When the parents and Debbie finally leave, Jamie tries to get Paul back in the mood. He first says it's use-less, but when Jamie starts to tell him a story about her and a college roommate getting it on in front of a roaring fire on a ski-weekend in Vermont, Paul's interest returns.

105. Walters, *All the Rage*, 15.

106. Suzanna Danuta Walters, "The Gay Next Door (Now In Prime Time)," *Harvard Gay & Lesbian Review* 5, no. 4 (spring 1998): 40.

CHAPTER 6: "WE'RE NOT GAY!": HETEROSEXUALITY
AND GAY-THEMED PROGRAMMING

1. I don't maintain that these tropes are entirely unique to the 1990s or are the only tropes on television in this period that negotiated America's straight panic. Neither is the case. I would, however, argue that these tropes became increasingly common in this period because they express an anxiety that was particularly salient at this time.

2. *ER*, "Stuck on You," November 5, 1998; *NYPD Blue*, "The Bank Dick," May 16, 1995.

3. In this regard, such episodes also fit into standard liberal-lesson narratives. Many gay-themed episodes, especially in the 1970s and 1980s, focused on straight char-acters who are initially troubled when they discover that someone they know is gay. By the end of the episode, however, they inevitably come to accept their gay friend,

coworker, or neighbor. Such narratives personalize the problem of homophobia and, as Walters points out, reduce it "to ignorance, bewilderment, and discomfort" (185). Since the straight characters' homophobia is often overcome in thirty minutes or an hour, homophobia is trivialized, and heteronormativity is left unexamined. Although such narratives continued in the 1990s (e.g., *Dr. Quinn, Medicine Woman*, "The Body Electric," 1997; *Hearts Afire*, "Birth of a Donation," 1994; *Wings*, "Sons and Lovers," 1996), they tended to be replaced by gay-savvier tropes.

4. *Veronica's Closet*, "Pilot," September 25, 1997.

5. *Roseanne*, "Ladies' Choice," November 10, 1992.

6. Despite the preponderance of straight male characters, for example, a number of straight-panic narratives focused on straight women. Roseanne's nervous reaction to her same-sex kiss is only the most obvious example. On *The Nanny*, Fran momentarily freaks out when she thinks another woman is putting the moves on her. On *Caroline in the City*, Annie accidentally ends up dating a lesbian. On *3rd Rock from the Sun*, Sally accidentally ends up dating a gay man (who thinks she's a drag queen). On *Lush Life*, roommates and best friends "George" and Margot get mistaken for being a lesbian couple. On *Frasier*, Roz discovers she has a female admirer. Of course, these narratives have their own straight-panic gender politics.

7. Yet one more on-point example comes from *Caroline in the City*. When the gang attends the gay art show at which Richard's painting is being displayed, Del constantly plays an over-the-top version of the nervous heterosexual. When a man approaches him and asks him for the time, he replies, "Oh, hey, no offense man, but I'm straight." To which the gay man responds, "Oh, oh, I guess you people don't tell time." Later, Del actually becomes bothered by the fact that no gay men seem to find him attractive. The shift from the nervous to the slighted heterosexual is common in such episodes and serves as yet another way to mock their homophobic responses and establish that, despite their anxiety over being read as gay, they are actually gay-friendly and even desirous of gay attention, at some level.

8. *Ned & Stacey*, "The Gay Cabelleros," February 19, 1996; *The Naked Truth*, "Women Get Plastered, Stars Get Even," January 23, 1997; *Caroline in the City*, "Caroline & the Little White Lies," April 6, 1998; *The Drew Carey Show*, "Man's Best Same-Sex Companion," March 5, 1997.

9. Of course it could also be read as a victimhood narrative for a conservative, straight, white male paranoia that sees itself as the victim of multiculturalism and the proliferation of social differences. Such an interpretation would have to read against the grain, however.

10. *Homicide* would ultimately play up the instability of sexual identity several seasons later when Tim explores his bisexuality ("Closet Cases," January 2, 1998; "Sins of the Father," January 9, 1998; "Homicide.com," February 5, 1999).

Conclusion: Straight Panic in the 2000s

1. Special thanks to Jennifer Fuller for sharing this story with me.

2. Laurie Goodstein, "After the Attacks: Finding Fault; Falwell's Finger-Pointing Inappropriate, Bush Says," *New York Times*, 15 September 2001, L/N.

3. Lincoln Caplan, "Forget the Tone. It's Dissent That Matters," *Washington Post*, 6 July 2003, L/N; "Supreme Court Rules on Laws on Homosexual Sex," *NBC Nightly News*, NBC News Transcripts, 26 June 2003, L/N; T. Trent Gegax et al., "The War Over Gay Marriage," *Newsweek*, 7 July 2003, L/N.

4. *Lawrence et al. v. Texas*, 539 U.S. (2003), 10.

5. *Lawrence*, 15, 7 (dissenting opinion).

6. *Lawrence*, 15.

7. *Lawrence*, 20–21 (dissenting opinion).

8. Debra Rosenberg, "A Wedge Is Born: Gay Marriage and 2004," *Newsweek* 14 July 2003, L/N.
9. Susan Page, "Americans Less Tolerant on Gay Issues," *USA Today* 29 July 2003, L/N.
10. Calvin Trillin, "Out on a Wedge," *Time*, 17 June 1996, 26.
11. Charles Krauthammer, "When John and Jim Say, 'I Do,'" *Time*, 22 July 1996, 102.
12. Doug Stumpf, "You May Now Kiss the Groom," *New York*, 20 June 1994, 59; Kenneth L. Woodward, "Do You, Paul, Take Ralph . . . ," *Newsweek*, 20 June 1994, 76; Sam Allis, Wendy Cole, and Jeane McDowell, "The Unmarrying Kind," *Time*, 29 April 1996, 68.
13. Anne Underwood and Bruce Shenitz, "Do You, Tom, Take Harry . . ." *Newsweek*, 11 December 1995, 82.
14. Katrine Ames, "Domesticated Bliss," *Newsweek*, 23 March 1992, 62–63.
15. Mark Simpson, "MetroDaddy Speaks!" *Salon*, January 5, 2004, www.salon.com/ent /feature/2004/01/05/metrosexual_ii/index_np.html.
16. Sam Fullwood III, "Metrosexual Jumps Out of the Closet," *(Cleveland) Plain Dealer*, 1 July 2003, L/N.
17. Richard Goldstein, "What Queer Eye?" *Village Voice*, 23–29 July 2003, 48.
18. Such twists were certainly standard elements in such dating reality shows—a genre in which producers were always trying to find an innovative variation. The inclusion of Andra (Grace to James' Will) also gave female viewers a narrative stand-in. Whether or not producers needed to shift the narrative pleasure in this way to attract straight women is debatable.

Index

About the Author

RON BECKER is assistant professor of communication at Miami University. He has published work on early television history and the politics of gay and lesbian representation in *The Television Studies Reader*, *Television & New Media*, *The Historical Journal of Film, Radio, and Television*, and *The Velvet Light Trap*.